M

RAINFORESTS
OF THE WORLD

WATER, FIRE, EARTH & AIR

RAINFORESTS OF THE WORLD

WATER, FIRE, EARTH & AIR

Photographs by
Art Wolfe

Text by
Ghillean T. Prance
Director, ROYAL BOTANIC GARDENS, KEW

Foreword by
George B. Schaller

CROWN PUBLISHERS, INC.
New York

WE WISH TO DEDICATE this book to Brandt Aymar, our ever-vigilant editor at Crown.

He completed nine books together with Art Wolfe in only seven years and three with Ghillean Prance. We will

be forever grateful to him for his support, his encouragement, and his inspiration.

PREVIOUS SPREAD: *The magnificent temperate rainforests on Vancouver Island, British Columbia.*

Published by Crown Publishers, Inc., 201 East 50th Street, New York, New York 10022.

Member of the Crown Publishing Group.

Random House, Inc. New York, Toronto, London, Sydney, Auckland

www.randomhouse.com

Crown is a trademark of Crown Publishers, Inc.

Printed in Hong Kong

DESIGN BY LYNNE AMFT

Library of Congress Cataloging-in-Publication Data

Wolfe, Art.

Rainforests of the world: water, fire, earth and air/photographs by Art Wolfe; text by Ghillean T. Prance.

1. Rain forests. 2. Rain forests—Pictorial works. 3. Rain forest ecology. 4. Rain forest ecology—Pictorial works. I. Prance,
Ghillean T. II. Title.

QH86.W64 1997

578.734—dc21

97-4087

CIP

ISBN 0-609-60364-7

10 9 8 7 6 5 4 3 2 1

First Edition

A portion of the royalties of this book have been contributed to the Rainforest Alliance in New York City. For information on how to contact the
Rainforest Alliance and other organizations dedicated to preserving the world's rainforests, see page 296.

Acknowledgments

I AM MOST GRATEFUL to Anne Prance for carefully reading the manuscript and for making many helpful suggestions, to Pam Arnold for typing various versions of the manuscript, and to Eleanor Bunnell for much help with the final stages of editing and preliminarily indexing. I am also most grateful to our editor, Brandt Aymar, who put me in touch with Art Wolfe and suggested that we combine our efforts to produce this book.

—G. P.

IT OCCURRED TO ME as I was creating this list of acknowledgments how many people have afforded me the luxury of safe travel and expedient work. Though I photograph alone, it often takes a team of planners, scientists, and researchers to arrange these photo expeditions.

Countries are realizing that wildlife and wilderness are valuable commodities, and there are increasingly difficult obstacles of politics and permits to hurdle prior to reaching these destinations. I am forever grateful to

the many who have diligently worked on my behalf to place and guide me in these remote and protected destinations. It becomes then extremely important to make the most of these opportunities, to bring an awareness of the endangered wilderness and the wildlife that survives there to create in each reader a desire to help protect them.

My deepest thanks to Masako and Greg Wescott; Scott Gates; Juan Carlos Lopez; Simon Cabrera; Luis Gorrin; Dr. Omar Gonzáles, Direcciön de Asuntos Indígenas, Ministerio de Educación, Venezuela; Dr. Herman Luis Soriano, Corporación de Turismo de Venezuela; Dr. Cesar Narryo, CORPOTURISMO, Venezuela; Elena Colmenares, CORPOTURISMO, Venezuela; Rafael Reyes Madriz, De Parques Nacionales, Venezuela; Edgar Fortune; Steve Cooper; Bokman Dong; Jim and Teri Martin; Smithsonian Tropical Research Institute; National Museum of Natural History, Smithsonian Institute: Dr. Alma Solis, Mr. Warren Steiner, Dr. Ronald Hodges, Dr. George Zug, Mr. Ron Crombie, Mr. Steve Gotte, Dr. David Nickle, and Dr. Roy McDiarmid; U.S. Fish and Wildlife Service; Jennifer O'Neil; Dr. George B. Schaller, Wildlife Conservation Society; Dr. William Conway, Wildlife Conservation Society; Ian Mackenzie; Aldo Brando, Colombia; Diego Amorocho, Director, Environmental Division, FES Foundation, Columbia; The Tunguragua Nature Preserve, Colombia; Emilio Constantino, Colombia; Alejandro Del Llano, Colombia; Lori Hayes, Josie and Tom Harding, Chan Chich Lodge; Drew Thate; Ellen Riechsteiner; Jurong Bird Park; Singapore Zoological Gardens; Peter Jenson, Pam Bucur; Exploraciones Amazonicas S.A.; Alex Enriquez, Peru; Eduardo Nycander von Massenbach, Wildlife Conservation Society, Peru; Gregory A. Green; Steve Turner; Kaye Clayton; Jaimie Rabey; Jennifer O'Neil; and Carolyn Jenkins.

Special recognition is due to Professor Gary M. Stolz, the U.S. Fish and Wildlife Service, and the University of Idaho.

This book is greatly due to the efforts of my staff. I thank them sincerely for their intelligence, support, and dedication—Ray Pfortner, Lisa Pestke, Craig Scheak, Deirdre Skillman, Mel Calvan, Gavriel Jecan, Christine Eckhoff, and Kimberly Ryseff.

—A.W.

Contents

~~~~~~~~~~~~~~~~~~~~~~~~

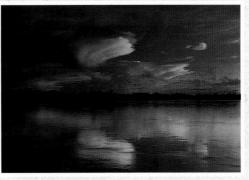

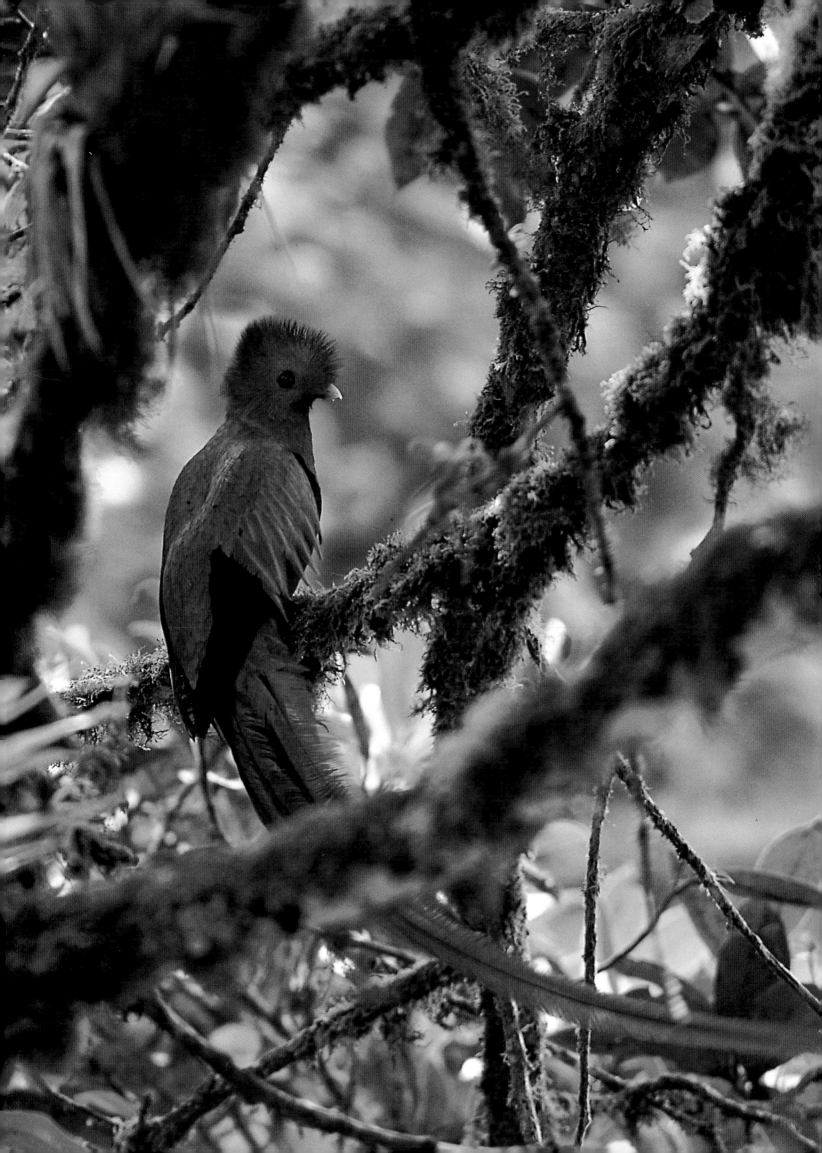

# Foreword

~~~~~~~~~~~~~~~~~~~~~~~~~~~~~~~~~~~~~~~~~~~~~~~~~~~~~~~~~~~
~~~~~~~~~~~~~~~~~~~~~~~~~~~~~~~~~~~~~~~~~~~~~~~~~~~~~~~~~~~

A RAINFOREST CAN CHANGE ONE'S PERCEPTION OF life. Its massive trees, crowded with epiphytes and swerving lianas, and its humid warmth engulf an intruder. Everything is lush, serene, brooding; there is no horizon, no sky. Here is the greatest celebration of life our planet has ever seen. To be surrounded by a million species is exhilarating, yet even to a naturalist like myself, such luxuriance is difficult to comprehend, almost intimidating. I come from a temperate climate, from the fringe of biological diversity, where life seems spacious and exposed.

Rainforest animals are furtive, filled with secrets and solitudes. In the Amazon, a ground of howler monkeys may proclaim the dawn with voices that, like the approach of a storm, fuse into a loud roar. Then, silence. Or a line of three-toed tracks may trace the edge of a slough, the tracks of a capybara, the world's largest rodent, but the imagination conjures a small dinosaur to fit the primal scene. Such contacts add to a feeling of isolation. A cluster of orange-colored *Dryas* butterflies on an ocelot dropping provides a rare flash of visual delight, as well as an appreciation of nature's complexity: They are all males in search of salts in the dropping which they will later transfer with their sperm to females. The forest itself provides no sense of recognition. A hundred tree species may crowd on an acre. Ghillean Prance and I once made a vegetation survey in Brazil's Mato Grosso. To identify certain trees, he looked not at the uniform leaves but nicked the trunk with a machete and sniffed the cut. He well fit William Beebe's description of a tropical biologist: "Supreme enthusiasm, tempered with infinite patience and a complete devotion to truth . . . keen eyes, ears, and nose."

Because of its overpowering size, a rainforest requires close examination; its beauty lies in the detail. Seen from the ground, most birds are fleeting silhouettes in the canopy, difficult to identify and a strain on the neck. To be near such birds, I climbed a giant *Anisoptera* tree near Kuala Lumpur

in Malaysia. As I ascended to a precarious platform, the air became brighter, warmer, and drier, an environment different from that in the shadows below. Here, 140 feet above the forest floor, *Draco* lizards glided among the branches, and mixed flocks of scarlet minivets, fairy bluebirds, green iornis, and others searched the foliage around me for insects. The rainforest is a three-dimensional world unlike any other, its layered canopy and many tree species offering orchids, ferns, and bromeliads a roof garden and animals innumerable niches in which to feed and hide.

An intriguing aspect of rainforest life is its extraordinary mutualism, a dependence of organisms upon each other. For instance, each of the many fig species has its own wasp pollinators. Fruit-eating birds, fish, and especially bats disperse the seeds. How wonderful to visualize bats on velvet wings swooping over forest clearings softly sowing seeds in the darkness. A rainforest is remarkably complex yet its stability tenuous. The extinction of a pollinator or seed disperser may cause the death of a plant species and with it many other species, especially invertebrates, which depend on it. Such responses are subtle and perhaps long-delayed. How many key species can a rainforest lose before order becomes chaos, before the community collapses in an avalanche of extinctions?

Although biology is at the forefront of science today, tropical ecology is in its infancy. We are still ignorant of most biological processes. We know little about where most biodiversity is and lack adequate techniques to inventory it. Indeed most species of invertebrates remain unknown, anonymous. What determines species abundance? Various theories have been proposed, including levels of soil fertility and speciation in refugia during the Pleistocene when temperatures were lower and the forests fragmented. The laws of biological evolution—genetic variation and natural selection—are probably incomplete without adding the physical and chemical systems of air and soil. The rainforest, which Charles Darwin called the "glories of another world," can provide basic new insights.

Species diversity in rainforest became reality for me one November night by the Madeirinha River in the Amazon. Day and night, a huge floating dredge sifted the sand and silt for diamonds. Bright lights illuminated the night work and these were almost obscured by swarms of moths so varied in size, color, and structure that even a casual count at a light revealed more than fifty species.

The dredge was also a reminder that just as we become aware of the splendor of the rainforest, we are in danger of losing it. More than half of our rainforests have been cut during this century and such destruction is accelerating. An estimated nineteen million trees are felled *daily*. How many species have already been lost? The rainforests have become a battleground between those who want short-term gain and those who decry the ethos of greed and indifference with which our biodiversity is casually squandered. Ranchers cut century-old trees to make short-lived cattle pastures; developers, often with international cooperation, destroy forests by

PAGE 8: *Inhabiting higher layers of Panamanian rainforest, the resplendent quetzal* (Pharomachrus mocinno) *was considered a sacred bird by ancient Mayan and Aztec civilizations.*

building roads, hydroelectric dams, and mines; and loggers denude the landscape with cut-and-run practices. Pillaging pays. The cost is born by society, nature, and the future. Much old-growth forest is also being destroyed by slash-and-burn cultivators, some who have occupied a region for centuries and others who are poor immigrants in search of a plot of land.

Politicians and policy makers like to give benefits, not impose restraints; they are concerned with immediate gain, not long-term issues. Arguments on behalf of rainforest conservation, whether climatic stability, watershed protection, or the potential economic value of species, tend to be ignored in favor of development. It seems to me that human survival, even if promoted by self-interest, is a good argument for saving rainforests. These forests are nature's greatest pharmacy and supermarket, the genes of which will provide us with new foods and drugs. We cannot predict which species, no matter how insignificant, will ultimately be essential to us. It is a sad reflection on current attitudes that conservationists must argue why something should be saved rather than that exploiters must explain why it should be destroyed.

Conservation is in crisis. Conventional approaches have not succeeded. With the human population ever increasing—now at the rate of 95 million a year—every social, economic, and environmental problem is accentuated. "Sustainable development," meaning the use of a resource without using it up, is often promoted as a solution that will satisfy both human needs and conservation. Development strives for economic growth, a way to satisfy consumers—not to protect biodiversity. You cannot increase the quality of life without degrading the environment. Market forces will not save species unless these are highly profitable. We desperately need plans *for* the environment, not just development to supply us with resources.

It has even been suggested that all wilderness areas, including reserves, be simply turned over to local peoples on the mistaken and romantic notion that they live in harmony with nature. As the archaeological record shows, native peoples have often abused their own environment. Today half of all forest destruction is caused by shifting cultivators. True, if people are few, there is no commercial incentive, technology is simple, and social restraints exist; then, indeed, the environmental impact can be modest. However, such peoples have almost vanished; isolation is not possible in the modern world. Traditional lives have usually unraveled under the stress of market forces, a desire for consumer products, and rising expectations.

Can a rainforest be harvested sustainably? So far no commercial logging has been sustainable. And reforestation is not an easy solution; we can plant trees but cannot re-create the original forest: Ecological processes are so complicated that planted forests are only superficial replicas. Community-based conservation efforts

have emphasized agro-forestry in which people raise a variety of crops—from bananas to cashews—on small plots, gather such forest produce as rubber and Brazil nuts, and practice aquaculture in the rivers, all while preserving much of the forest canopy. Over time, an economy based on gathering forest products can yield more than twice the income of logging or cattle ranching. However, proponents of sustainable development seldom mention limits—limits on the number of persons in an area, on the number of monkeys killed for food, on the amount of forest degraded. Without enforced limits, there can be no sustainability. Who makes the decisions about access to resources and amounts that may be extracted so that harvest rates do not exceed production? Who can make such complicated decisions? We still know too little to manipulate forests and predict the consequences.

Often a forest still looks pristine but certain species have been harvested so intensively that they are locally extinct or rare. In Myanmar, I met rattan collectors deep in the forest because all easily accessible stems of this climbing palm had long been depleted for the global market. In northern Brazil, I walked for several days through the forest with Yamomamo Indians. Instead of carrying traditional bows and arrows, they brought shotguns—with shells sold by a local mission. We did not see or hear any large monkey, and I was told that most had been shot within a radius of more than a day's walk from the Yamomamo village. But a community such as this, with its culture relatively intact, could with some help design a management plan that would enable it to harvest wildlife sustainably. A Machiguenga Indian community in Peru's Manu National Park has already accomplished this. However, if a local population hunts for the market without restraint, certain species will be rapidly depleted, as studies have shown from Sarawak and Gabon to Venezuela. Yet even commercial use can be sustained if the local community is involved in the conservation process and limits are accepted. In Brazil's Mamirauá Reserve on the Amazon, fishermen have done just that.

From a conservation perspective, only one measure is valid: Is biodiversity being preserved? It is unfashionable these days to talk of protecting areas, of limiting access and use. If logging and agricultural practices were less primitive and wasteful, and if degraded lands were used more efficiently for crops, livestock, fuelwood, and tree plantations, no more old-growth forests would have to be cleared. Perhaps this will be accomplished in the future, but action is imperative now. Every nation must protect as much of its biodiversity as possible in a network of large reserves in cooperation with the local population. Decisions about saving biodiversity are made far from forests by governments. Therefore, protection has to be based on laws and sanctified by society.

No comprehensive solution to rainforest destruction is possible until we treat the root causes. One cause is population growth; another is international debt. Poor countries try to repay loans to overdeveloped countries like Japan and the United

States by logging their forests and growing export crops. And the consumer nations buy these resources at unfairly low prices without concern for the social consequences and environmental degradation to much of the world.

Any naturalist is all too aware of nature's wounds. My reflections on rainforest conservation are of the kind that constantly invade my mind when I am afield. During a recent visit to Laos, I marveled at some of the fine forest tracts. But vast areas have also been denuded by slash-and-burn cultivators. Proposed dams would inundate some of the remaining forests. Convoys of trucks carrying logs destined for Japan head east toward the South China Sea. Poachers are eliminating the last tigers and elephants, species often considered natural icons. Bushmeat fills the local markets with everything from squirrel to sambar as well as brilliant bouquets of dead forest birds.

We all have a huge stake in the survival of rainforests such as those in Laos. Humankind is losing its options for the future, but it is not yet ready to make painful choices, it does not yet feel threatened by the loss of species; denial is much easier. Perhaps during the coming century we will, with an outburst of common sense, become enlightened and protect the remnants of our natural treasures. We will, I hope, recognize that mutualism, so basic to rainforest plants and animals, extends to humans as well, that we remain a part of and not separate from the natural world. The environmental crisis cannot be resolved by science and politics alone: It is a moral issue, determined by culture and character. We need a change in attitude, consciousness, priorities, and expectations, a new strategy for human survival that decries waste and destruction and places a spiritual value on caring for the natural world.

*Rainforests: Water, Fire, Earth & Air*, with its stunning photographs and vibrant text, is a book united in a rare common vision. It bears witness to the splendor of the rainforest and its many inhabitants by fusing feeling and fact. Art Wolfe's photographs present images that provide intimacy, create mood and mystery, appeal to a sense of beauty, and arouse emotions. But photographs cannot adequately convey the life of a species or the terrible plight of its vanishing habitat. Science is needed to explain, to provide context, and Ghillean Prance's text does this superbly. Photographs and text form a bond with the reader, making the book not just an evocation but an exhortation to protect the rainforests. The book is both past and prologue for the next millennium, a reminder that rainforests will endure only if everyone cares for them and fights for their future with hope, passion, and long-term commitment. As Ezra Pound said in one of his poems, "What thou lovest well remains, the rest is dross."

— GEORGE B. SCHALLER

# Introduction

EARTH, WATER, AIR, AND FIRE: THE ANCIENTS FELT that these were the four basic elements of life. Rainforests have such a powerful elemental effect on humans that these ancient categories seem to be appropriate headings for a consideration of forests.

Each of these fundamental elements has a distinct function, but each interacts with the others. Rainforest is the great dynamic world where these relationships are developed into the most sophisticated and intricate systems.

The great trees, hung with epiphytes and lianas, are rooted in earth. From the darkness of the roots, water is absorbed, processed, and transpired to return to the earth. The air receives the breath of the foliage, cleansed and rebalanced. Fire, or light, makes all these processes continue in an everlasting rhythm.

The great cycles benefit the forest, for the earth, air, water, and light nourish its growing things; but no greedy cycles these. Rather, the forest replenishes the earth, gifting it with its foliage and decaying wood and sustaining its creatures; it cleanses the air, absorbing into itself unwanted substances; it clears and purifies the water. All this depends upon light, the fire of the ancients.

## ENTERING THE RAINFOREST

The initial response of people to the rainforest is varied. The rainforest has often been likened to a cathedral, and it certainly inspires the same awe and sense of sanctity. For me, a biologist, it was an exciting and almost overwhelming experience to see the luxuriant growth and the amazing diversity of species that the rainforest contains. The 150- to 200-foot- (45- to 60-m-) tall trees, with their buttressed trunks, are tangled about with large woody vines of all shapes and sizes. This is paradise to a naturalist who is trying to understand how the processes of nature work.

To many of the early travelers who had to endure all kinds of sickness, deprivation, and fre-

quent battles with the rightful inhabitants of the forest, it was often thought of as something oppressive and evil and in need of removal. For some of these early explorers, and for some more modern travelers, it is not surprising that "green hell" seems to be a more fitting description. However, in most cases this attitude can be changed when people learn about the wonders. Perhaps the text and photographs of this book will help to show these wonders of the rainforests, which contain more than 50 percent of the living species in the world yet cover only about 7 percent of the land area.

Awe and inspiration or fear are the attitudes of outsiders who have come to the rainforest from faraway places. There are many people who have adapted to the rainforests of the world and have managed to live in reasonable harmony with the environment. Whether we consider the natives of the Pacific Northwest temperate rainforests, the Indian tribes of the Amazon, the peoples of the African forests, or the natives of New Guinea, we find that the forests were inhabited by people long before the Age of Exploration. It is sad that only a small remnant of these people remain to teach us how to respect and manage rainforests more wisely.

*Rainforest exists where the annual rainfall is over 80 inches (2,000 mm) and is spread fairly evenly throughout the year without a long dry season. Rainforest can occur in both tropical and temperate regions given the right weather conditions. This rainforest is in Madagascar.*

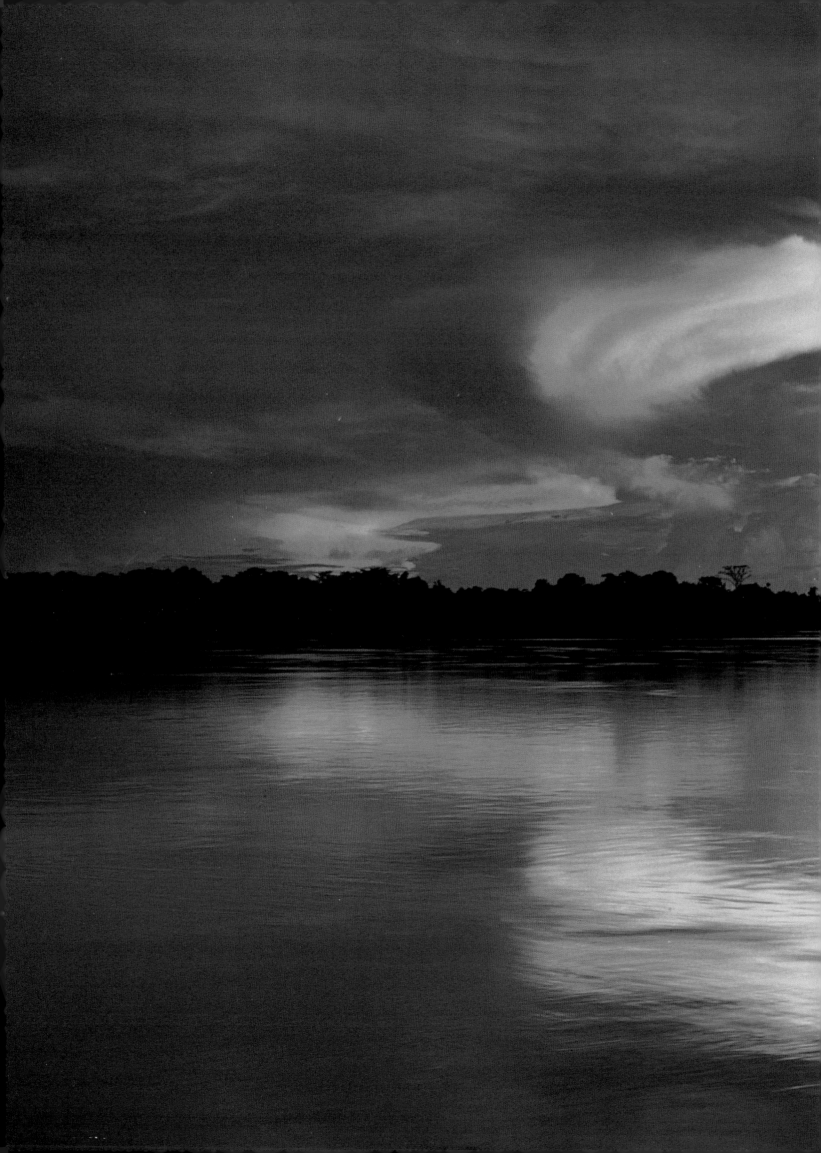

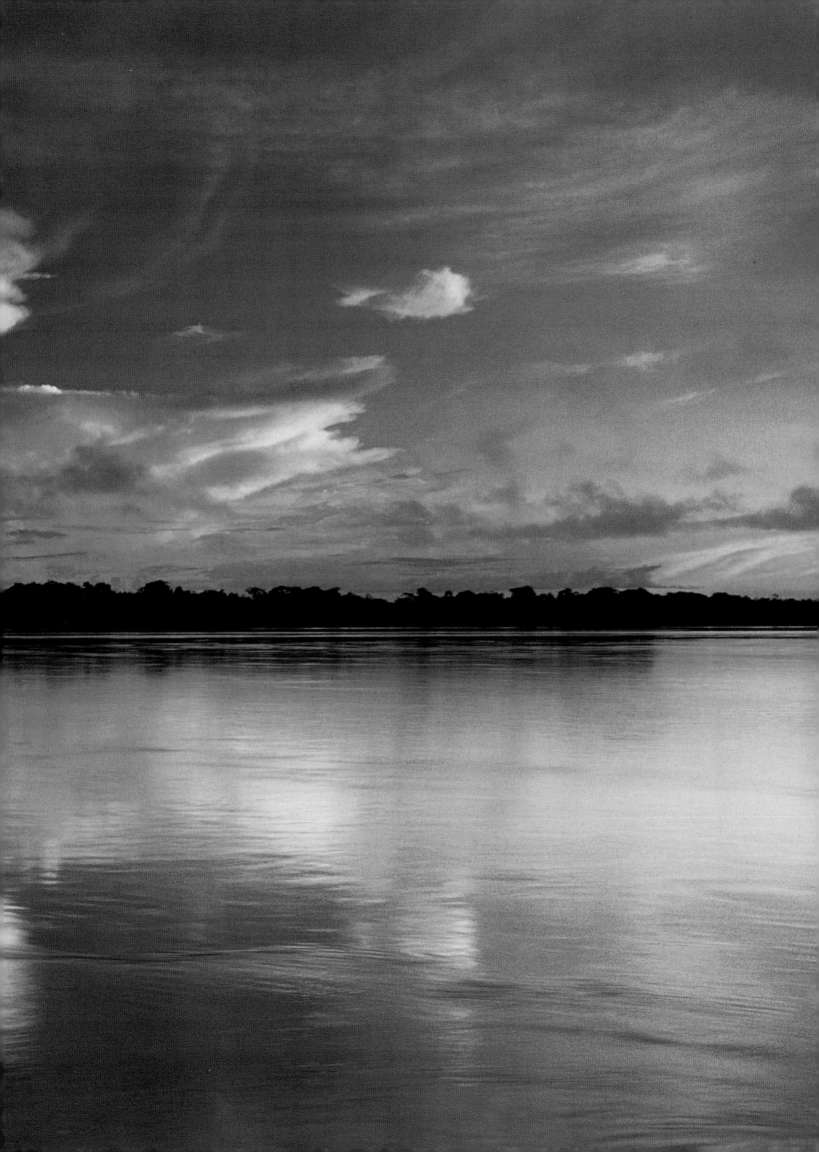

# Water

R AINFOREST EXISTS BECAUSE OF THE AVAILABILITY

of large quantities of an elemental substance of the ancients: water. The combination of one atom of oxygen and two of hydrogen produces a liquid at normal temperature upon which life, as we know it, depends. Rainforests, whether temperate or tropical, occur in areas that have an annual rainfall of over 80 inches (2,000 mm) that is spread throughout most of the year. (Where there is substantial rainfall but a long dry season, seasonal semideciduous forests tend to occur.) The term *rainforest* was coined in 1898 by a famous German botanist and vegetation ecologist named A. F. W. Schimper. Of course, Schimper used the German term *"tropischer Regenwald,"* which was later translated into English as "rainforest." It is the availability of water from

rainfall that defines rainforest and determines its distribution on the planet.

An American forester and long-term resident of Costa Rica, Leslie Holdridge, created an elaborate system to classify Central America in terms of life zones based on the rainfall, humidity, mean annual temperature, elevation, and latitude. He found that vegetation formations are largely controlled by moisture and temperature, and so produced his pyramid-like life-zone system in which each division represents a type of vegetation. Naturally, the rainforest zones are indicated by the wettest and warmest part of his diagram. This system works quite well in an area such as Central America, which has such a varied topography and climate. It is not so applicable in large continental areas such as the Amazon or the Congo rainforests, where the climate is much more uniform over a vast area. Nevertheless, the Holdridge System serves to emphasize the vital importance of water to rainforest.

PREVIOUS SPREAD: *This sunset view of the upper Amazon with beautifully reflected clouds shows the vast size of the river— this is about 2,000 miles inland from its mouth.*

FACING PAGE: *Where there is no erosion and the streams do not originate from tannic areas, some rivers have crystal clear water, such as this one in the Bwindi Impenetrable Forest of Uganda.*

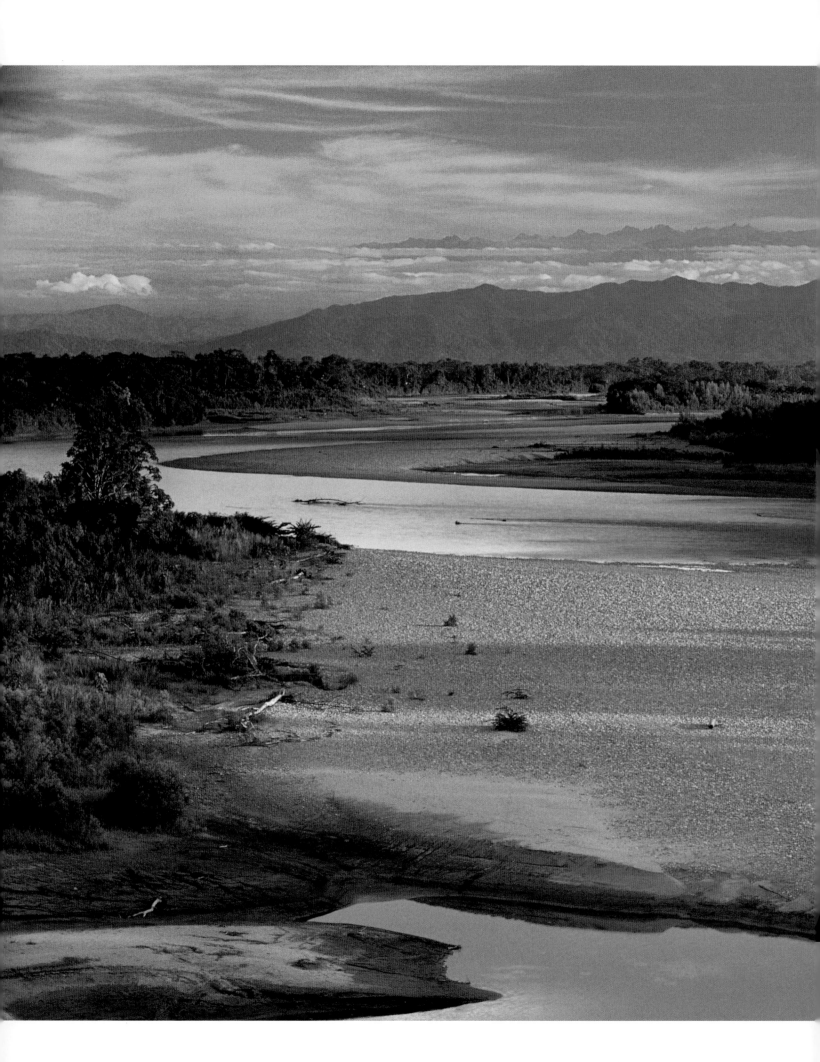

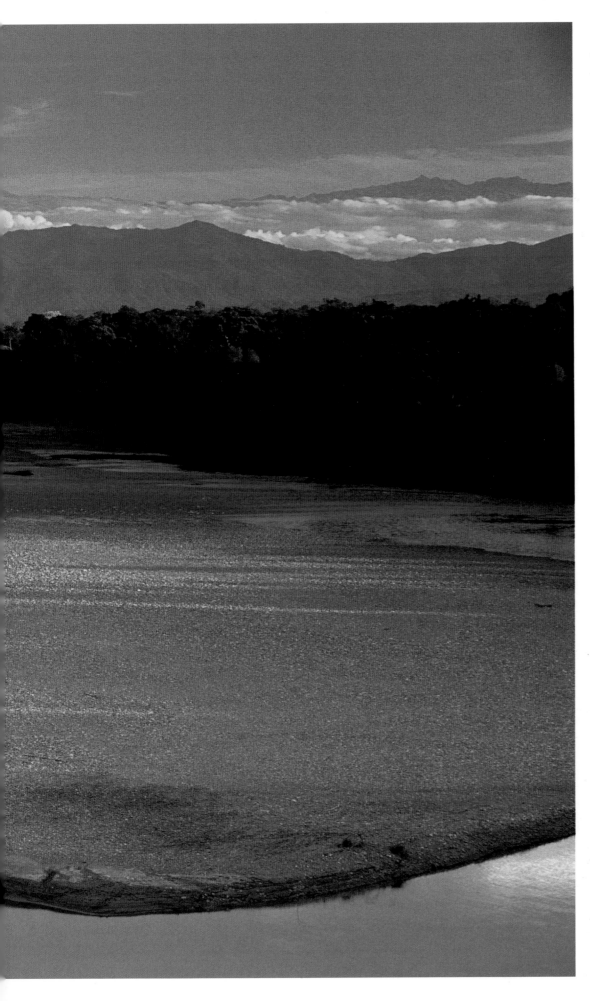

Because of the heavy rain-fall, larger rivers are often a feature of rainforest. The Tambopata River of Peru is actually a small tributary of the Amazon.

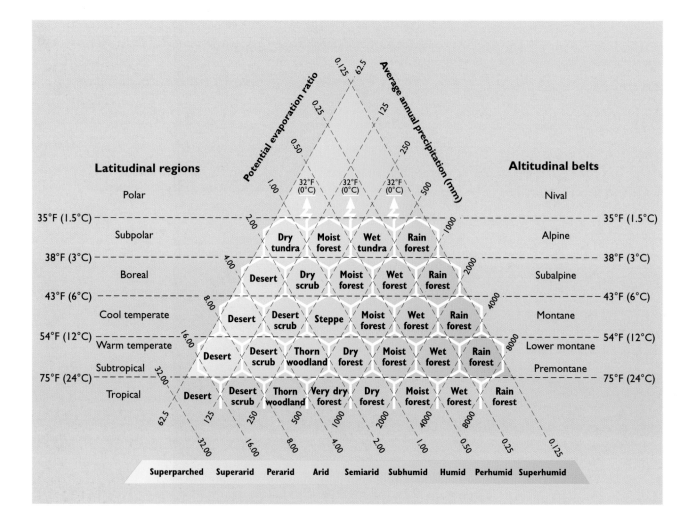

Conditions that allow the growth of tropical rainforest are to be found in three main areas of the world that are floristically diverse and contain different suites of animals. American tropical forests account for 50 percent of the world's total rainforests. They occur in Central and South America, where the most extensive continuous tract is the Amazon rainforest; there is also (or was, since only 6 percent of it remains) an important area of rainforest along the Atlantic coast of Brazil. Another 20 percent of the world's rainforests are found in equatorial Africa, with a large area in the Congo River basin and smaller patches to the east and west. The third rainforest zone, constituting the remaining 30 percent, is that of Southeast Asia. There the forest extends from India and Sri Lanka through South China, Indochina, Malaysia, Myanmar, Thailand, and Indonesia to New Guinea and northern Australia. Other small areas of tropical rainforest can be found on various tropical islands, particularly in the Caribbean and the Pacific.

Temperate rainforest, which is much less species-diverse but nevertheless as majestic and often even taller than tropical rainforest, occurs in the Pacific Northwest of North America, Chile, southeastern Australia, Tasmania, and New Zealand. These regions have a high rainfall of 80 to 152 inches (2,000 to 3,800 mm), and the humidity is augmented by frequent coastal fogs. This type of rainforest is found in coastal areas where the climate is mild and the summers are cool. The

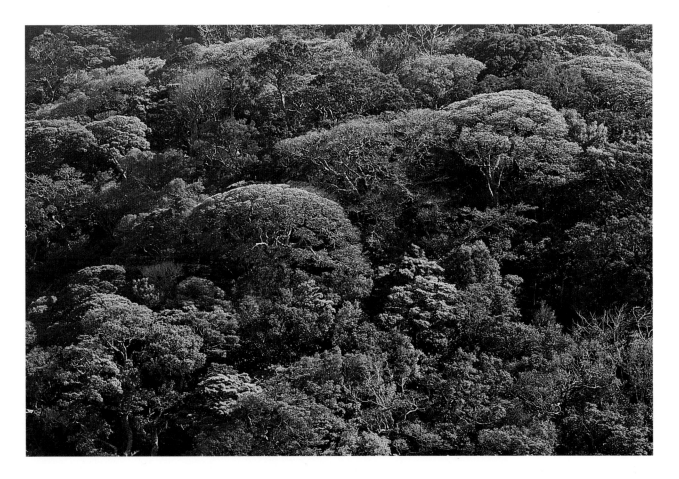

*Rainforest in Costa Rica.*

gigantic cone-bearing trees such as the Douglas fir, Sitka spruce, and western hemlock and the rich epiphytic flora, mainly mosses and lichens, create such a splendid temperate forest that it thoroughly deserves to be called rainforest.

Because there is heavy rainfall in rainforest, there also needs to be a way of disposing of this vast quantity of water. This is accomplished both through the process of evapotranspiration, whereby the plants pump much of the water back into the atmosphere, and by drainage into the network of rivers that traverse all areas of rainforest. In many rainforests, at the height of the rainy season there is just too much water for the rivers to contain and the plants to transpire, and thus river levels can rise dramatically, causing flooding. The various types of forest that are flooded tend to be quite different from those on *terra firme,* or nonflooded ground, which creates different types of habitat for the plants and animals and so increases the overall diversity of the rainforest.

# RIVERS

Although most people are familiar with the Amazon and the Congo Rivers, which drain the two largest areas of rainforest, perhaps less well known are the world's other rainforest rivers, such as the Orinoco in Venezuela, the Niger in West Africa, the Mekong in Indochina, the Irrawaddy in Myanmar, and the Sepik in New Guinea. These rivers play a vital role in the rainforest ecosystem—and in the

*Waterfall in the rainforest of Madagascar. Only a small portion of this forest remains owing to the extensive deforestation in that country. The remnant is most important to conserve because of the large numbers of unique plants and animals that it contains.*

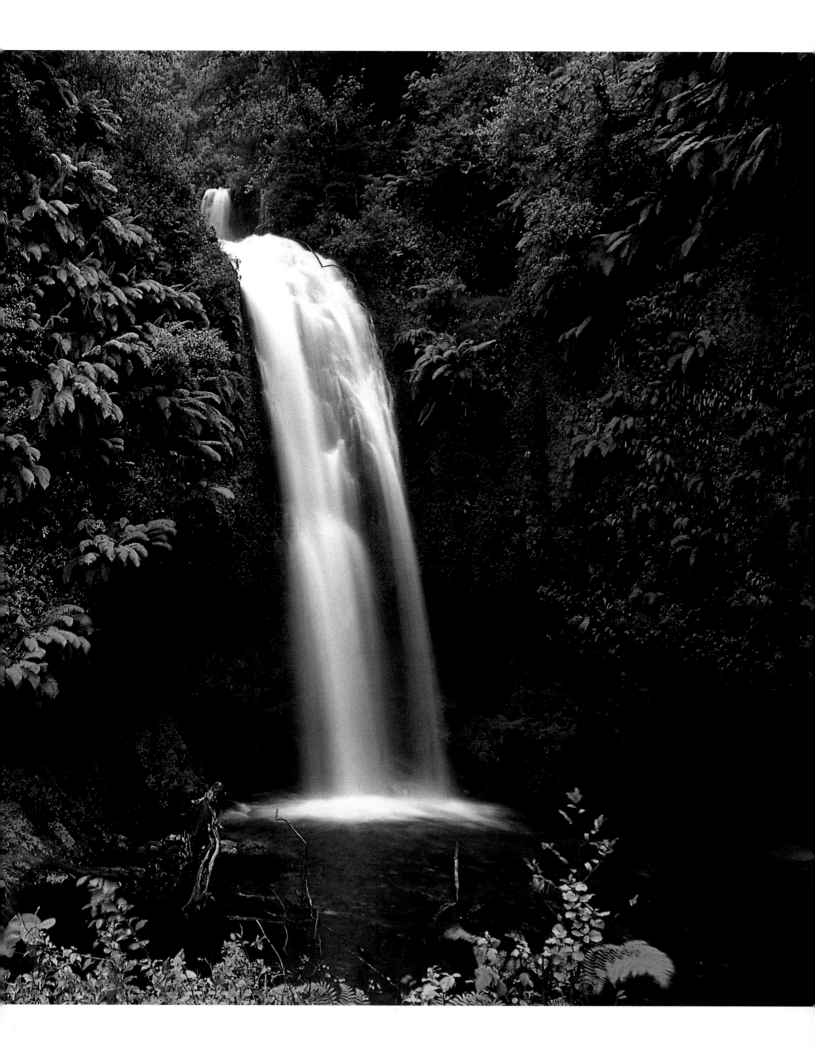

human ecology of each region as well. The rivers remove the excess rainfall, but they are also the main communication highways through these regions of otherwise impenetrable forest.

Not all rainforest rivers are the same. There are three distinct types in the Amazon basin, classified by the color of their water: white water, black water, and clear or crystalline water. The main Amazon River itself and its tributaries that arise in the Andes contain a huge amount of silt. These muddy rivers, which look like café au lait, carry much of their load of silt out into the Atlantic Ocean (prompting one Brazilian politician to complain bitterly that much of his country was being washed out to sea and being deposited on the shores of Florida). When these white-water rivers burst their banks and flood the forest, however, they deposit much of their silt there and create a highly fertile soil. This is one reason why so many of the original indigenous tribes lived along the rivers and have now been followed by a large number of settlers of mixed blood, the *caboclos* or *ribereños*. In the upper Amazon the river constantly changes its course as silt is deposited in one place and washed away in another. As a meander increases, the force of the water eventually breaks through and oxbow lakes are formed. In the lower Amazon the force of the water is too great to allow these meanders to form. The white-water rivers are generally not very acidic and so their floodplain contains a rich vegetation.

The ancient geological formation of the Guyana Shield in Venezuela and the Guianas partially drains into the Amazon. This area has completely different soils than the Andes and is covered mostly by leached sand that contains almost no nutrients. The plants that manage to grow on these poor soils tend to contain large amount of tannins, an evolutionary adaptation that discourages insects from robbing them of the precious nutrients they have managed to accumulate. As the leaves and branches are shed from the trees, these tannins are eventually dissolved in the groundwater. The result is a black water full of tannins and other humic matter but almost devoid of muddy sediments, which drains into rivers that resemble in appearance a cup of strong tea. Because of the amount of tannins in this water, it is highly acidic (pH about 4.5). The Rio Negro, which flows from Venezuela to join the main Amazon River just below the city of Manaus, Brazil, is by far the largest black-water river. Although only a tributary of the Amazon, it is the tenth-largest river in the world. It is amazing to stand in this black water up to one's knees and not be able to see one's feet.

Some tributaries flowing north in the eastern part of the Amazon basin come from the rocky area of the Planalto of central Brazil. These rivers gather neither silt nor tannins and so they are crystal clear. The largest of these clear-water rivers are the Xingu, the Tocantins, and the Tapajós. These are the only rivers of the entire basin to which it is worth taking a snorkel and mask, inasmuch as the

silt and humic matter of white- and black-water rivers preclude visibility.

When a black- or clear-water river meets a white-water river, there is often a spectacular confluence, with the two types of water remaining clearly separated for several miles downstream. The most famous one is the "Meeting of the Waters" 6 miles (10 km) below Manaus where the white-water Amazon and the black-water Rio Negro converge and do not mix for about another 6 miles.

Although some species of trees, fish, and other aquatic animals are found throughout the Amazon in all types of water, many are confined to only one, which increases the diversity of the region. Both black-water and white-water rivers occur in other rainforests of the world and have a similar effect on the biological makeup.

The mightiest rainforest river is the Amazon, which drains a basin of some 2.7 million square miles (7 million km²). The Amazon contains 20 percent of all the river water in the world, and its flow is so vast that it is greater than the total flow of

*White-water rivers are a frequent feature of the temperate rainforest of Olympic National Park, Washington State, USA.*

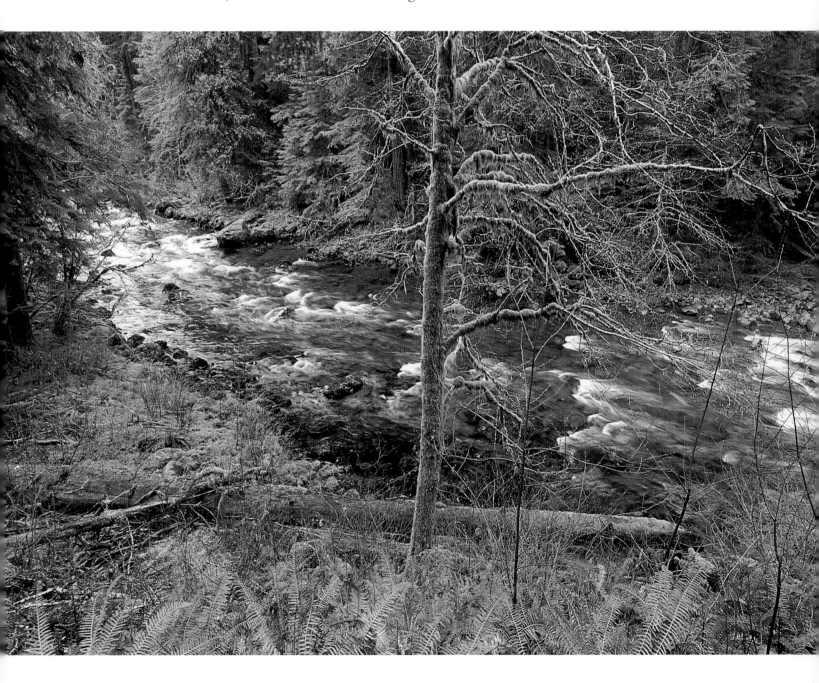

As a result of the frequent heavy rain, rainbows are a common sight in rainforests.

FACING PAGE: *Thunderstorms, rainbows, and heavy showers are a regular feature of the Amazon region, photographed here in Peru.*

the world's next eight largest rivers put together. Its mouth, which is 200 miles (320 km) wide, is filled by Marajó Island, a tract with an area larger than Switzerland. Oceangoing ships can travel inland for 2,300 miles (3,700 km) to the port of Iquitos in Peru, which is much nearer to the Pacific Ocean than to the Atlantic. The quantity of water is hard to imagine, since over 4 trillion gallons (15 trillion L) flow into the Atlantic Ocean each day. It is therefore not surprising that, in 1500, the navigator Vicente Yáñez Pinzón found freshwater 40 miles (60 km) out to sea and concluded that he was not far from a large river. Pinzón was intrigued and even experimented to see how deep the freshwater went by lowering a barber's chafing bowl modified to open at the seabed. The freshwater was in fact to a depth of $2\frac{1}{2}$ fathoms (15 feet, or 4.5 m). (The fact that this phenomenon occurs in some river mouths has been confirmed.) Pinzón named the great river he had discovered Santa Maria de la Mar-Dulce (Saint Mary of the Freshwater Sea), but this name did not hold once the Amazon was actually visited. Offshore from the Amazon, the "Amazon river plain" overrides the denser seawater and can extend more than 60 miles (100 km) from the mouth at certain times of year. This is hardly unexpected from a river with an average flow of about 7 million cubic feet (200,000 m³) per second.

# THE CIRCULATION OF WATER

Although we may be astounded by the quantity of water that flows into the ocean from the Amazon River, it would be much greater if it were not for the role the rainforest plays in capturing much of the rainfall and returning it directly to the atmosphere. In recent years in other parts of the world, there have been frequent, severe floods in areas where the rainforest has been removed, such as in the Philippines and in Bangladesh. Without the forest to slow down the drainage into the rivers, the consequences can be catastrophic and can result in great loss of human life. This is a role of rainforest that is often forgotten but one that provides a strong argument in favor of preserving large areas of forest.

Brazilian scientist Eneas Salati studied the cycling of water in the Amazon basin and showed, through the use of chemically labeled water molecules (isotopes), that about 75 percent of the rainwater that falls on the Amazon basin is recycled directly into the atmosphere by the forest. Of this, 25 percent evaporates from the surface of the leaves and 50 percent is pumped through the trees and other green plants by the process of transpiration, in which the water is absorbed through roots, passes through the plants, and is released into the atmosphere through minute openings on the leaf surface called stomata. This combination of evaporation and transpiration, known as evapotranspiration, is a key process in the life of a rainforest because it returns water to the atmosphere to cause further rainfall, which in turn

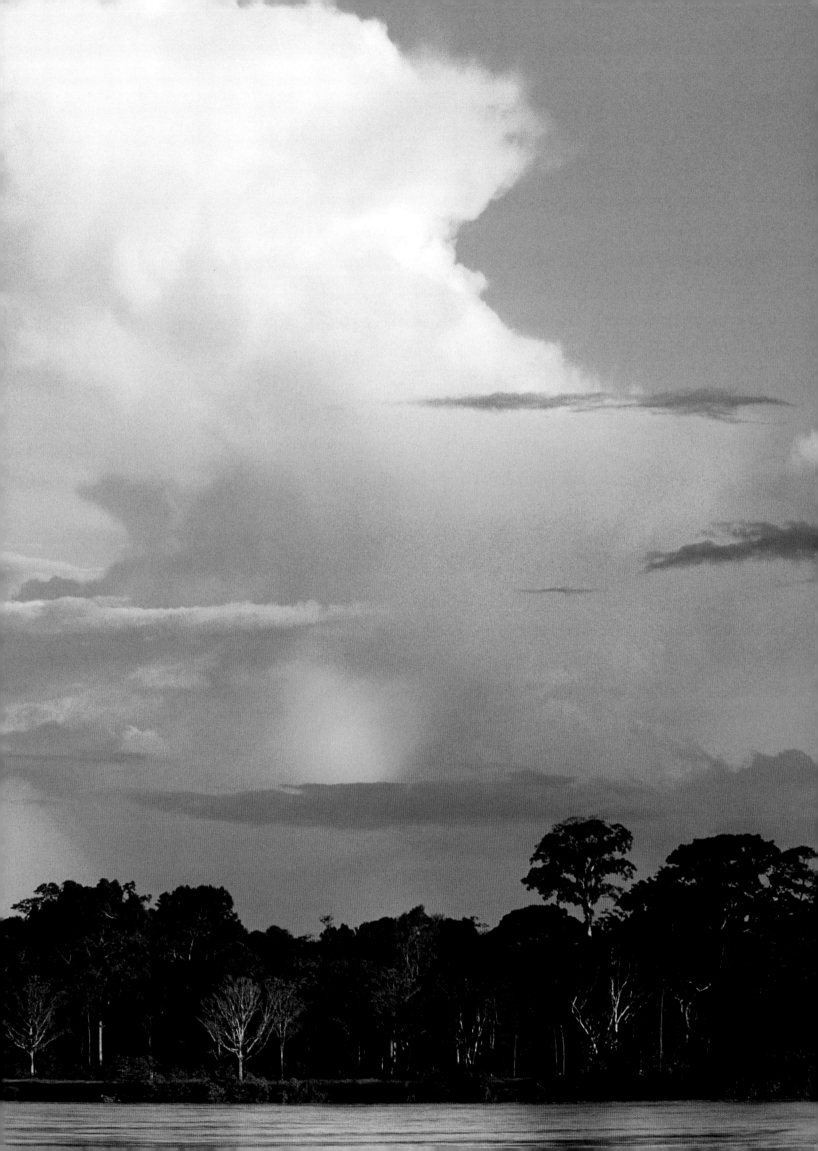

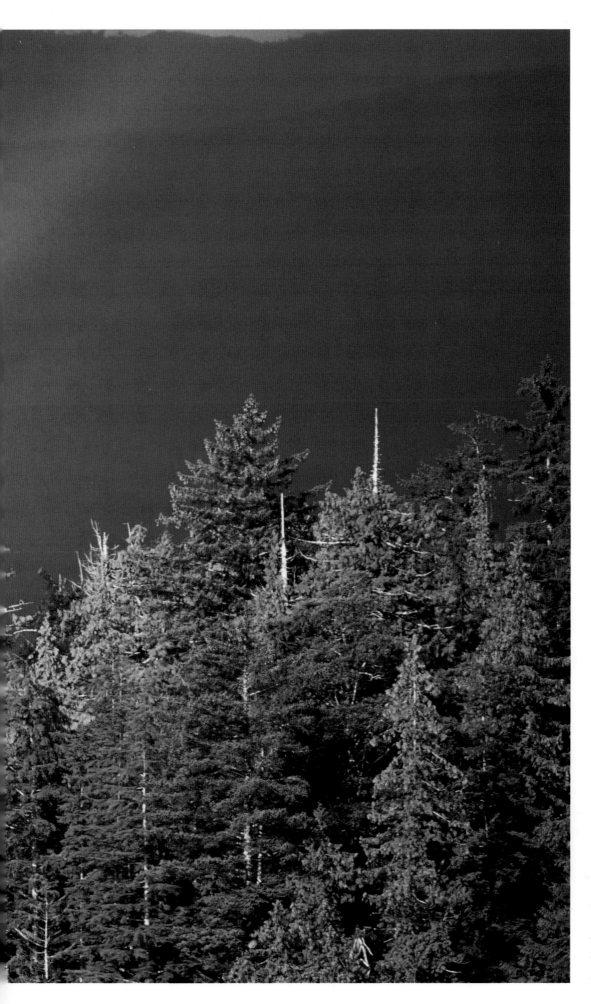

*A rainbow over the rainforest of Queen Charlotte Islands, British Columbia, Canada.*

maintains the cover of rainforest. When rainforest is removed, the precipitation can be greatly reduced and the area might never return to rainforest.

# FLOODED FORESTS

Although rainforest is defined as an area with almost constant rainfall, the amount of rainfall is not steady throughout the year. In most rainforest areas, there are dry seasons when it rains less and rainy or monsoon seasons when it rains much more heavily. As a result, river levels rise and fall markedly. The level of the Rio Negro at Manaus harbor, for example, can vary as much as 46 feet (14 m) between the lowest point in the dry season and the crest in the rainy season. Because of this extreme fluctuation, many tropical rivers overflow their banks and inundate large areas of forest. These flooded forests are quite different from forests on high ground that are never reached by floodwaters. The trees and shrubs of inundated forests have to stand with their roots and often their trunks in water for several months. Only some species have adapted to these stressful conditions, and so flooded forests tend to contain far fewer species of plants than do upland forests. The length of the flooding period also causes considerable variations in the inundated forests. Flooded forests occur in all parts of the tropics, such as in the Mekong River basin in Vietnam and along the Sepik River in New Guinea, but again by far the largest area is in the Amazon basin.

The inundated forests of Amazonia have been divided into various categories depending on the type of water. In Brazil, forest flooded periodically by white water is known as *várzea*. Since the *várzea* is flooded by water containing large amounts of sediment, and hence nutrients, it tends to be much richer and denser than forest flooded by black-water rivers. Unfortunately, this relatively good soil is also preferred by riverside dwellers, and therefore much of the *várzea* has already been destroyed to make way for small farms, cattle and buffalo ranches, and fields of jute and other crops such as beans.

The areas that are flooded by black and clear water are termed *igapó*, which is a native term for this dense and rather low type of vegetation with gnarled-looking trees, adapted to having their trunks submerged for several months each year. The black-water Rio Negro and the clear-water Tapajós River have good examples of *igapó* along their banks. They also have far fewer settlers.

The coastal lowlands of the Malay Peninsula, Borneo, and other areas have extensive swamp forests on peat. These domes of peat can be up to 56 feet (17 m) thick and in some ways are similar to the raised bogs of temperate regions. Like the black-water *igapó* of Amazonia, the peat swamps are extremely acidic (pH 3.5 to 4.5) and are low in nutrients, but they sustain a rich forest. The forest varies in composition according to its distance from the center of the raised dome. The outer portion of a swamp typically is characterized by tall evergreens that can reach as much

FACING PAGE, TOP: *The rainforest beside many tropical rivers is flooded at the height of the rainy season. The water of Peru's Marañón River flows into this forest annually, and many of the fish swim through the forest, eating the fruits of the trees and shrubs.*

FACING PAGE, BOTTOM: *The Tutoh River of Sarawak in Borneo flows through a narrow rocky gorge which can cause dangerous flash flooding after heavy rains. Many of the plants, known as rheophytes, that grow beside such rivers have narrow leaves that do not tear in the strong water currents to which they are frequently subjected. This photograph shows an example of a muddy, sediment-filled, white-water river.*

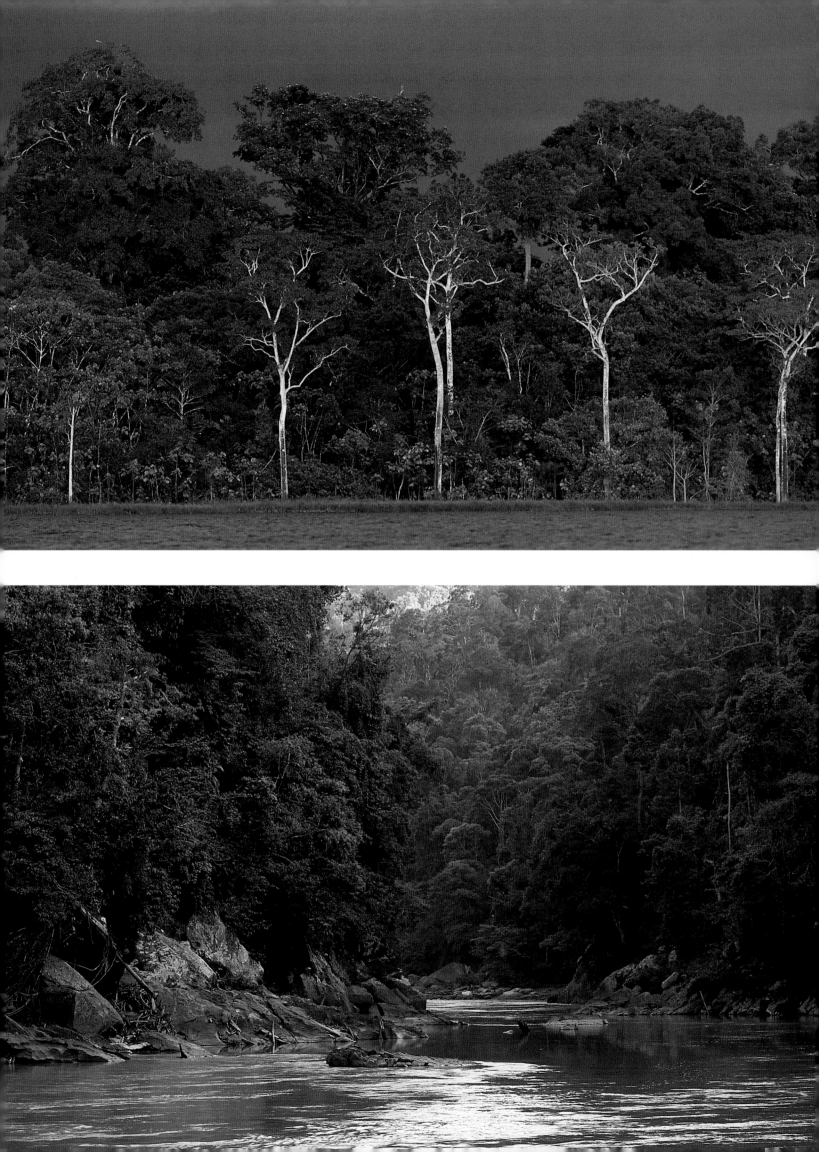

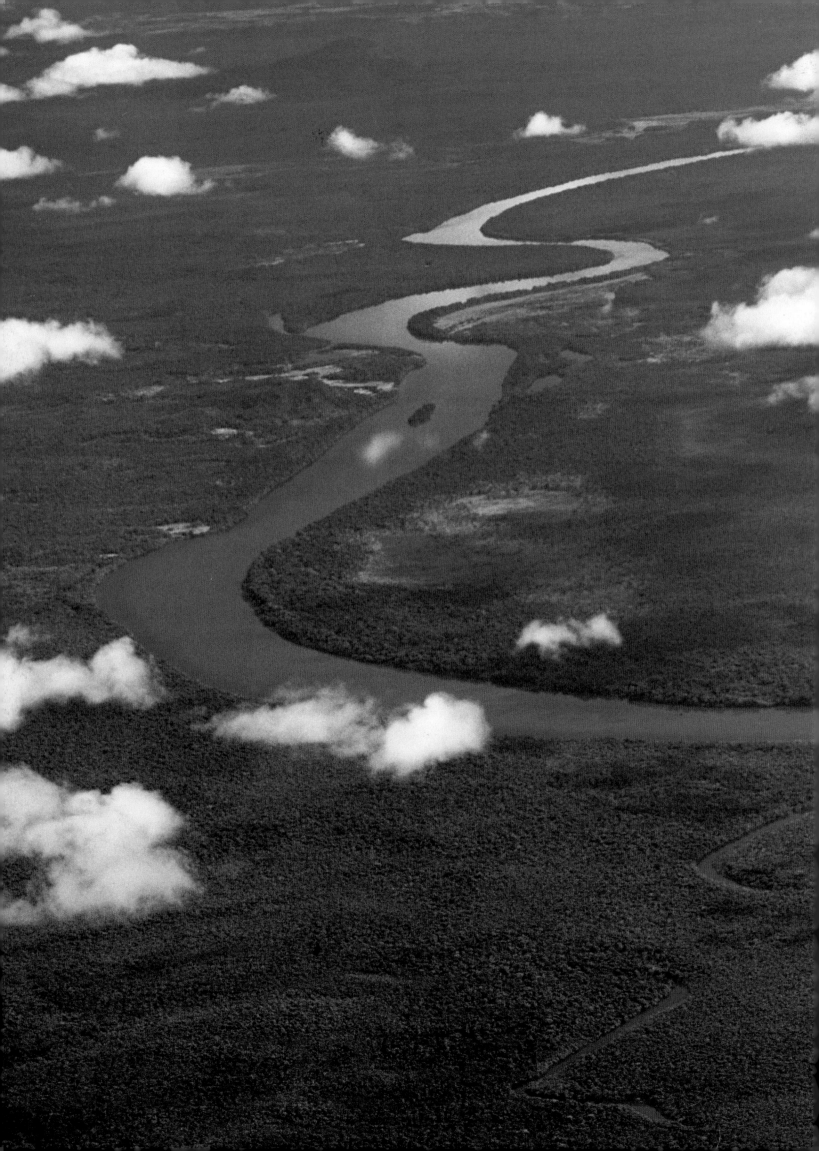

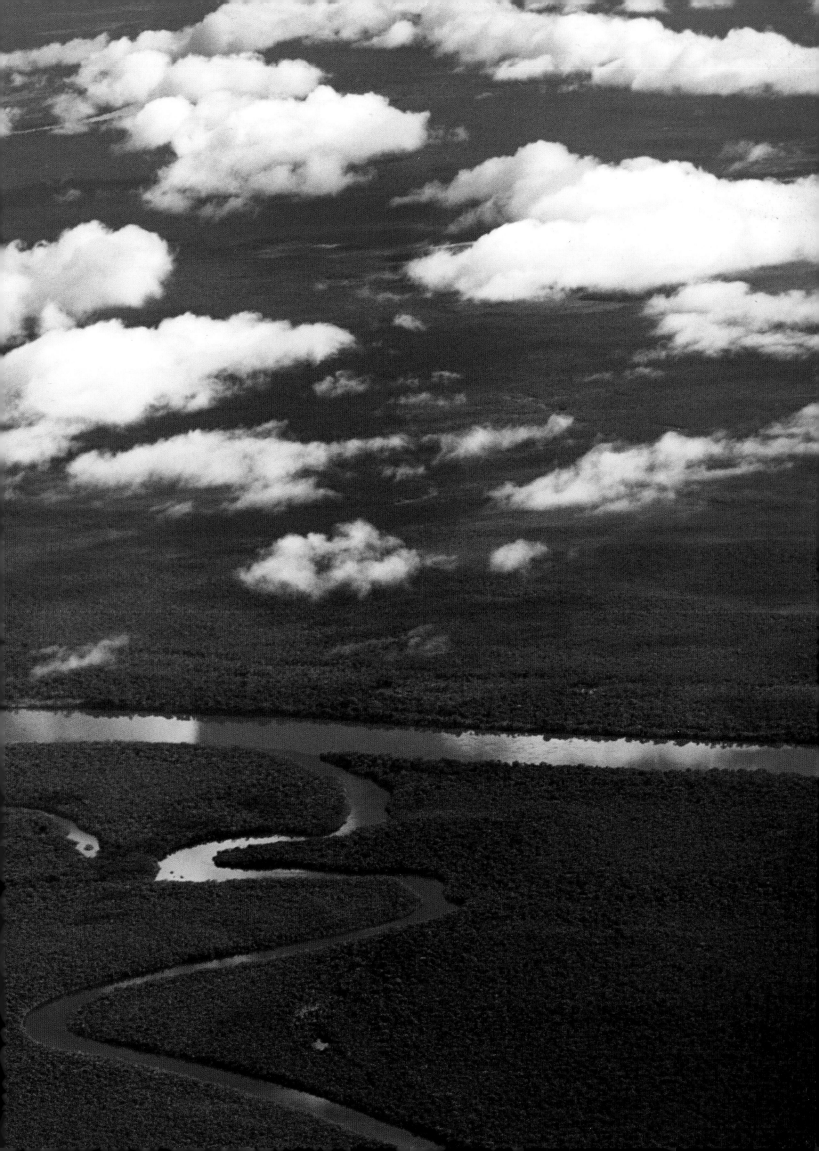

PREVIOUS SPREAD: *This tribu-*
*tary of the Orinoco in the*
*Parima Tapirapecó National*
*Park of Venezuela is a black-*
*water river with little sedi-*
*ment but full of dissolved*
*humic material that makes*
*it look like black coffee.*

as 165 feet (50 m) in height. The forest changes in both physiognomy and species composition toward the center of the swamp, and species diversity declines. The trees are much smaller, usually less than 65 feet (20 m) tall, but they are much more densely distributed. As many as 3,200 individual pole-sized trees have been recorded on a single acre (or 1,300 per hectare) of peat swamp forest. As the forest develops over time, the ground level rises above the water level and the forest is replaced by a scrubby woodland. In 1982–83, because of worldwide climatic patterns influenced by the El Niño effect, there was no real rainy season on Borneo. As a result, when local populations set fires to clear their land, the fires quickly spread into the surrounding peat swamp forest. Large areas where the peat was above the water level smoldered for many months, and some 15,500 square miles (40,000 km²) of this type of rainforest were destroyed.

# MANGROVE FOREST

Scattered around the seashores of the tropics is a special kind of rainforest known as mangrove forest. This is forest that is adapted to grow in areas that are flooded daily by the salt water of the rising tide. Although mangrove occurs throughout the tropics, it is especially rich and abundant in Southeast Asia. The world's most extensive mangrove forest is that of the Sundarbans in the Ganges delta on the border of India and Bangladesh. This is the only sizable tract of rainforest remaining in the deforested country of Bangladesh. There are also large areas of mangrove forests on the Malay Peninsula, in Borneo, and in New Guinea. However, the mouths of the world's two greatest rainforest rivers, the Amazon and the Congo, support only relatively small areas of mangrove.

There are numerous challenges other than the salinity of the water for plants that grow beside the sea, and so the plants of mangrove forests exhibit a variety of fascinating adaptations. In many mangrove trees, such as those of the genus *Rhizophora,* the red mangroves, the trunk does not extend directly into the water but is supported by a tangled mass of arching prop roots that anchor the tree firmly into the soil and prevent it from being washed away by currents. As a result, mangroves play a vital ecological role in the stabilization of tropical coastlines. Many mangrove tree species, such as those of the genus *Avicennia,* the black mangroves, erect above the mud a series of periscope-like roots known as pneumatophores or breathing roots. In the waterlogged mud of a mangrove swamp, there is little oxygen, so the trees absorb it through their breathing roots from the air when the tide is low. Often the tidal movements deposit more and more mud around the roots of mangrove trees, and when this occurs the pneumatophores gradually extend to keep above the mud and so supply the roots with the gas that is vital for the life of the tree.

About forty different plant species are found in the mangrove forests of the Indian and Pacific Oceans, compared with only eight in West Africa and the Americas. Mangrove species have reached many remote tropical islands where suitable environmental conditions occur. This is a result of another adaptation of mangrove species: dispersal by water, whereby the seeds or the fruit float for a considerable period of time. In *Rhizophora,* for instance, the seeds germinate on the tree before they are shed. They form a long, buoyant structure that enables a seedling that falls from the tree to be carried around by sea currents for many weeks before being washed ashore, where it then sprouts roots and attaches itself to the soil.

Mangrove forests help to build up soil along tropical coastlines, buffer coasts from storms, and at the same time provide a habitat for many popular marine organisms such as crabs, shrimps, and oysters. They are also the nesting site of many wading birds. In Borneo there is even a species of primate, the proboscis monkey, that lives in the mangrove forest. Perhaps the best-known and most popular mangrove animals are the mudskippers, small amphibious fish that live in the forests of Southeast Asia, Australia, and Africa. At low tide they can be seen moving across the mudflats, using their pelvic fins as legs or pushing with their tails in a jerky sort of motion.

Despite their important role in the environment and the rich catches they provide for fishermen, the mangrove forests of the world have been severely reduced as the trees have been felled for firewood, the tannins in their bark, or, as has been the case in the Philippines and Ecuador, to make way for fish and shrimp farming. These unique rainforests that are adapted to life in salt water are a precious resource that needs to be restored and preserved.

# AQUATIC LIFE

The rivers and the floodplain areas of rainforest sustain a remarkable diversity of plant and animal life. The Amazon basin alone supports about 2,500 species of freshwater fish, which is eight times as many as the Mississippi and ten times as many as the entire continent of Europe. What is interesting in the floodplains of Amazonia is that many of the fish leave the rivers in the flood season and swim through the flooded forest, feeding on the fruits and leaves of the trees. American zoologist Michael Goulding made a fascinating study of the relationship between fish and the inundated forest and found that many species of fish specialize in fruit eating and subsequently dispersing the seeds. The native peoples know that if they bait their fishing lines with the fruit of a jauari palm (*Astrocaryum jauari*) or an *Alchornea,* they are likely to catch some of the best-tasting fish of the whole region. I have frequently watched the fruits falling off a *Licania* tree or being ejected off a rubber tree by its explosive mechanism of seed dispersal, dropping into the water, and being immedi-

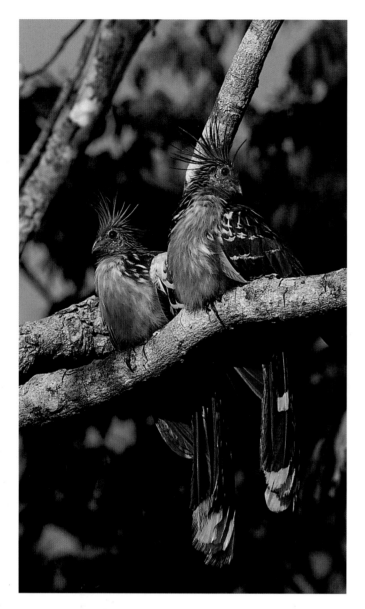

ABOVE: *A bird frequently of the floodplain forests of Amazonia is the hoatzin* (Opisthocomus hoazin). *This bird is unusual for two reasons. First, the young have claws on their wings, which enable them to scramble back up into their nests when they fall out into the river. Second, the hoatzin's diet consists only of leaves, and like a cow, it has a ruminant system with a stomach full of bacteria to digest the leaves.*

RIGHT: *The dry leaves hanging down in this view of floodplain forest are those of the moriche palm* (Mauritia flexuosa), *which has many local uses. The leaves provide a fiber for making hammocks or can be used for thatching, and the edible fruits are one of the favorite Amazonian flavorings.*

ately grabbed by fish that are waiting beneath the trees and hear the fruits falling on the water. In many cases it is not just the fish that benefit from the carefully timed ripening of the cornucopia of fruits produced at the height of the flood season but the plants themselves, since the main method of dispersal of the seeds of many floodplain forest species is by fish. Some riverside shrubs such as the camu camu (*Myrciaria dubia*), the fruits of which contain thirty times more vitamin C than citrus and are used locally in Peru as a juice or an ice-cream flavor, produce their ripe fruit just as the river level rises. Once the shrub is again underwater, the fish can help themselves to the fruit. The fish are nourished by the fleshy pulp of the camu camu but excrete the seeds after they have been carried some distance. The technical term for dispersal of seeds by fish is ichthyochory.

Filmmakers and adventure writers have pictured the piranha as an aggressive evil of the Amazon rivers. Piranha are, however, very unlikely to attack anyone swimming in the fast-flowing rivers, and the large black piranha is mainly a fruit-eating fish. One of the most delicious treats in Amazonia is a barbecued tambaqui (*Collossoma macropomum*). This large fish, which has an impressive row of mammal-like teeth adapted for crushing fruit, is entirely vegetarian. In the flood season it swims through the forest, feasts on the abundance of fruits, and as a result builds up reserves of fatty tissue. During the dry season the tambaquis return to the rivers, where, unless they are caught by fishermen, they live off their fatty reserves until the next time of plenty.

The phenomenon of fruit-eating fish is by no means confined to the Amazon

*Crocodilians are regular inhabitants of rainforest rivers. Each major region has one or more species of these large reptiles.*

RIGHT: *A Nile crocodile* (Crocodylus niloticus) *from Madagascar.*

BELOW: *An immature specta-cled caiman* (Caiman croco-dilus) *in the Napo River region of Peru.*

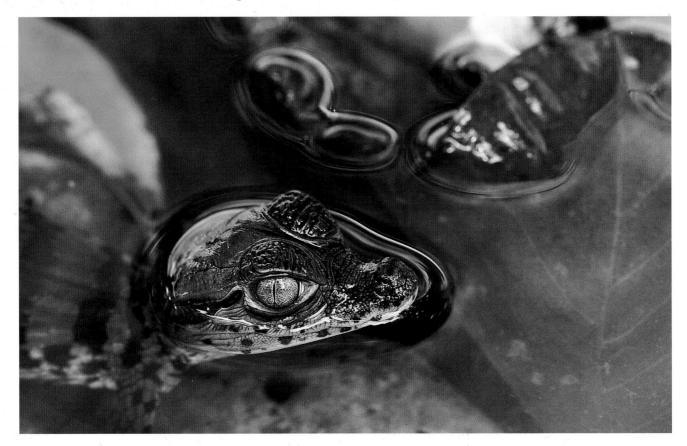

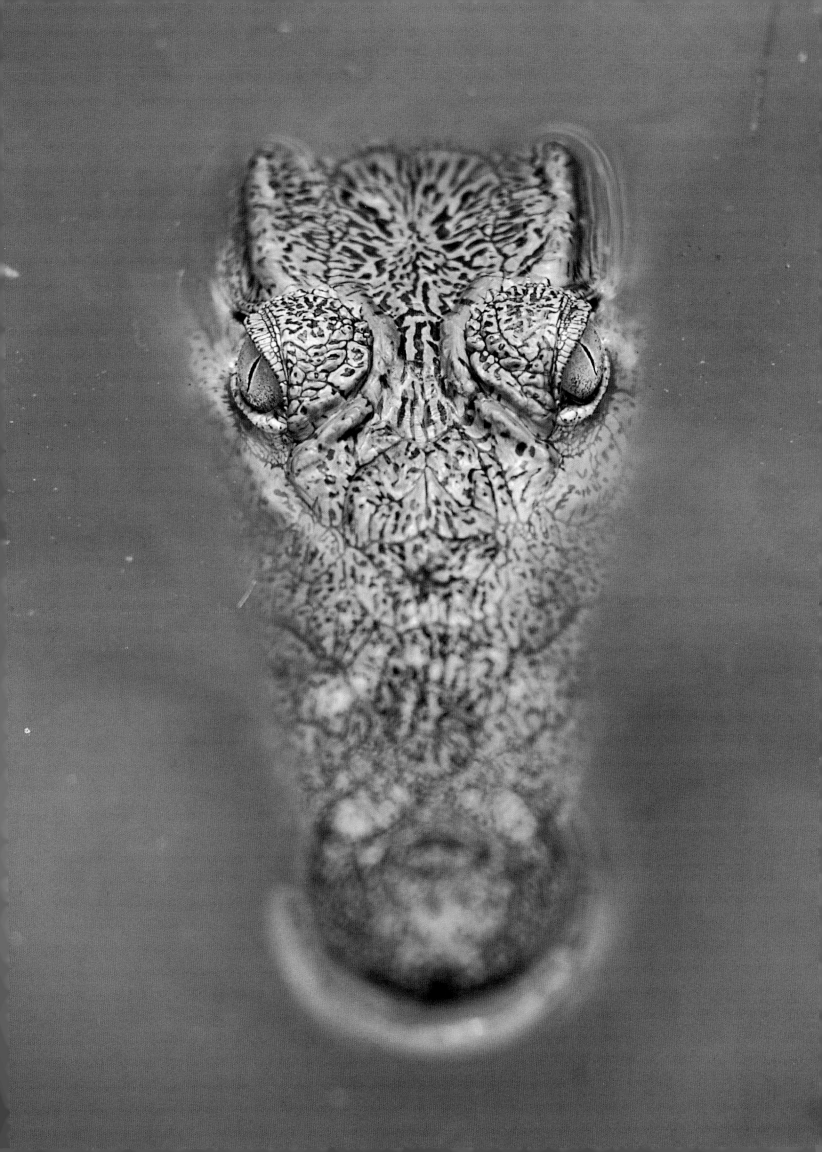

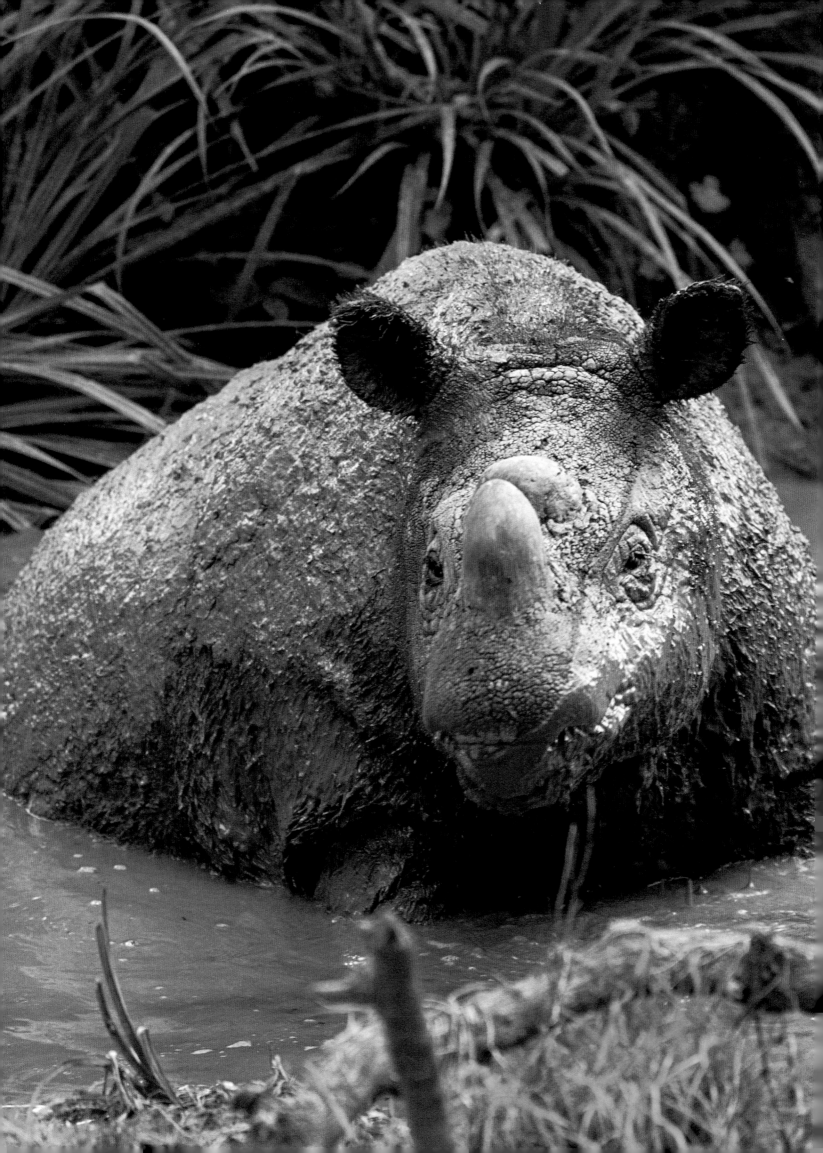

rainforest, although it has been most studied there. There are fruit-eating fish in the Congo River as well as several species that eat the fruits of the plants of the peat swamp forests of Malaysia and Borneo.

One of the most remarkable of all Amazonian fish is the aruana (*Osteoglossum bicirrhosum*). This aggressive-looking fish, with its extraordinarily ferocious-looking mouth, inhabits the *igapó* forests. Its principal source of food is insects, which it obtains by leaping out of the water and helping itself to any unfortunate bug that is on a low leaf or branch overhanging the river. It is quite amazing to be sitting in a canoe in the *igapó* forest and see this fish leap out of the water—often 3 feet (1 m) or more—and with absolute accuracy remove a beetle from a leaf. The fish that inhabit the waters of a rainforest are very much part of the forest ecosystem.

Another surprise to the traveler in the *igapó* forests of the Amazon is the freshwater sponges that are attached to the branches of the trees. In the *igapó* of the Rio Negro, a sure way of determining the high-water level in the dry season is to look up into the branches of the trees and find the highest sponges. They look like spiny excrescences from the branches because they are covered by a tough, spiny outer layer that protects the living organism. The sponge itself remains in a state of dormancy until the river level rises again, when it awakens and continues growth. The small spines from sponges that break off into the water often trigger an allergic reaction in people swimming in the *igapó*. A student of mine even had to transfer the topic of her doctoral dissertation from the study of *igapó* vegetation to that of cloud forest because of her extreme allergy to the sponges.

There are many other fascinating creatures that live in the rivers and lakes of the rainforest. Tropical fish such as catfish, characin, and tetra are familiar to any aquarist, but overcollecting for the aquarium trade is severely reducing their populations in some streams. The Amazon River contains freshwater stingrays and giant electric eels. The latter (*Electrophorus electris*) can grow up to $6\frac{1}{2}$ feet (2 m) in length and produce a shock of 650 volts. However, the fish most feared by local residents is a tiny catfish no more than 2 inches (5 cm) long called the candirú (*Vandellia cirrhosa*). This fish is normally a parasite on the gills of other fish, but it also has the unfortunate habit of entering human orifices. Since it has sharp spines that can firmly anchor it in the urethra, surgery is required to remove a candirú. The Amazon is no place for skinny-dipping!

The largest fish in Amazonia is the pirarucu or paiche (*Arapaima gigas*), which can reach 10 feet (3 m) in length and weigh 220 pounds (100 kg). The pirarucu inhabits stagnant lakes, and since it comes to the surface to breathe because it is a lunged fish, it is an easy target for the fishermen who hunt it with spears.

The aquatic life of the Amazon is by no means confined to fish. The rivers are full of alligator-like caimans, and occasionally one might encounter an anaconda, the largest snake in the world. At one time there were a goodly number of turtles,

FACING PAGE: *A Javan rhinoceros (*Rhinoceros sondaicus*) lives in and near waters of the rainforests of Java and Vietnam, but unfortunately, as a result of poaching, few survive today.*

but their populations have been severely reduced by overhunting of both the creatures and their eggs. On a recent trip to the large Cuyabeno National Park in Ecuador, I observed many turtles sunning themselves on logs and rocks in the river, which demonstrates that areas that are adequately protected still support much of the original wildlife.

The largest aquatic mammal in Amazonia is the Amazonian manatee (*Trichechus inunguis*), which has almost been hunted to extinction. These giant torpedo-like animals are related to the marine manatees but have adapted to freshwater life. They graze on grass overhanging riverbanks and eat vast quantities of water hyacinth and other aquatic plants and thus play a vital role in the control of aquatic vegetation. Interestingly, manatees have also adapted to freshwater in Africa, where a closely related species, the West African manatee (*T. senegalensis*), is found.

There are two species of freshwater dolphin in Amazon waters, the bouto or pink dolphin (*Inia geoffrensis*) and the smaller, gray-colored tucuxi (*Sotalia fluviatilis*). Both are still relatively common because many local superstitions protect these animals from regular hunting, although their sexual organs are often sold in local markets for use as charms in black magic.

The riverbanks of rainforest are home to many interesting animals. Along the Amazon and its tributaries a commonly observed animal is the capybara (*Hydrochoerus hydrochaeris*), the world's largest rodent. These 16- to 30-pound (35- to 65-kilogram) animals with webbed feet are semiaquatic and often dive into the

*A beautiful fan palm (Licuala sp.) from the rainforests of Queensland, Australia.*

water when disturbed. They can remain underwater for a considerable length of time. Their equivalent in the rainforests of western Africa is probably the pigmy hippopotamus (*Choeropsis liberiensis*), which grazes along riverbanks and also has a semi-aquatic lifestyle. This hippo is much smaller than the familiar one and is therefore better adapted to walking through the rainforest. Another frequent inhabitant of Amazon riverbanks is the Brazilian tapir (*Tapirus terrestris*). These odd-toed ungulates (relatives of rhinos, zebras, and horses) are not confined to riverbanks—as we discovered when camped on a hillside far from a river and one entered our camp and completely destroyed our kitchen area. I have often seen these attractive long-nosed animals swimming in the rivers. Their short trunk enables them to completely close their nostrils and is an adaptation for their amphibious lifestyle. A fusion of the upper lip and nose, the trunk has many uses. For example, tapirs like to squirt water like elephants, and when chased by dogs they will spray water toward them in defense. Three species, including the rare mountain tapir of the Andes (*T. pinchaque*) and Baird's tapir (*T. Bairdii*), are native to Central and South America. The other living species (*T. indicus*) occurs in Southeast Asia on the Malay Peninsula and in Thailand. Fossil records show that tapirs formerly were common in North America, Europe, and northern Asia, but the American and Asiatic species of this ancient animal have long become isolated from each other by continental movements and the extinction of other species between their current ranges. Tapirs are leaf-eating animals that play an important part in the recycling of nutrients.

The plants of tropical floodplains are quite as interesting and useful as the animals. One plant family that has been particularly successful in adapting to the aquatic habitat is the palm family (Arecaceae). For example, in the swamp forests of Borneo the sago palm (*Eugeissona utilis*) is abundant. This most useful species furnishes the staple food of many local people. In Amazonia one of the most common swamp-forest palms is the açaí (*Euterpe oleracea*), which furnishes both heart-of-palm and a popular drink and flavor made from the dark purple pulp of the fruit. The açaí is a multistemmed palm that resprouts when cut, and so it is ideal for the production of heart-of-palm, the harvest of which involves cutting down the trunk. (The majority of palms are single stemmed and do not resprout and so cannot be sustainably harvested for heart-of-palm.) Another Amazonian swamp-forest palm is the buriti or moriche palm (*Mauritia flexuosa*), which can occur in large natural stands, particularly in permanently waterlogged areas. Almost every part of this palm has some use. In eastern Amazonia a fiber extracted from the leaf epidermis is much used in local crafts, and in western Amazonia, where it is called aguaje, the fruit is a popular flavoring for ice cream. The buriti trees are either male or female, and unfortunately many of the fruit-bearing female trees have been felled to collect the fruit.

A recently discovered swamp-forest palm is *Ravenea musicalis* from Madagascar. This palm was collected for the first time in 1990 by botanist Henk Beentje of the

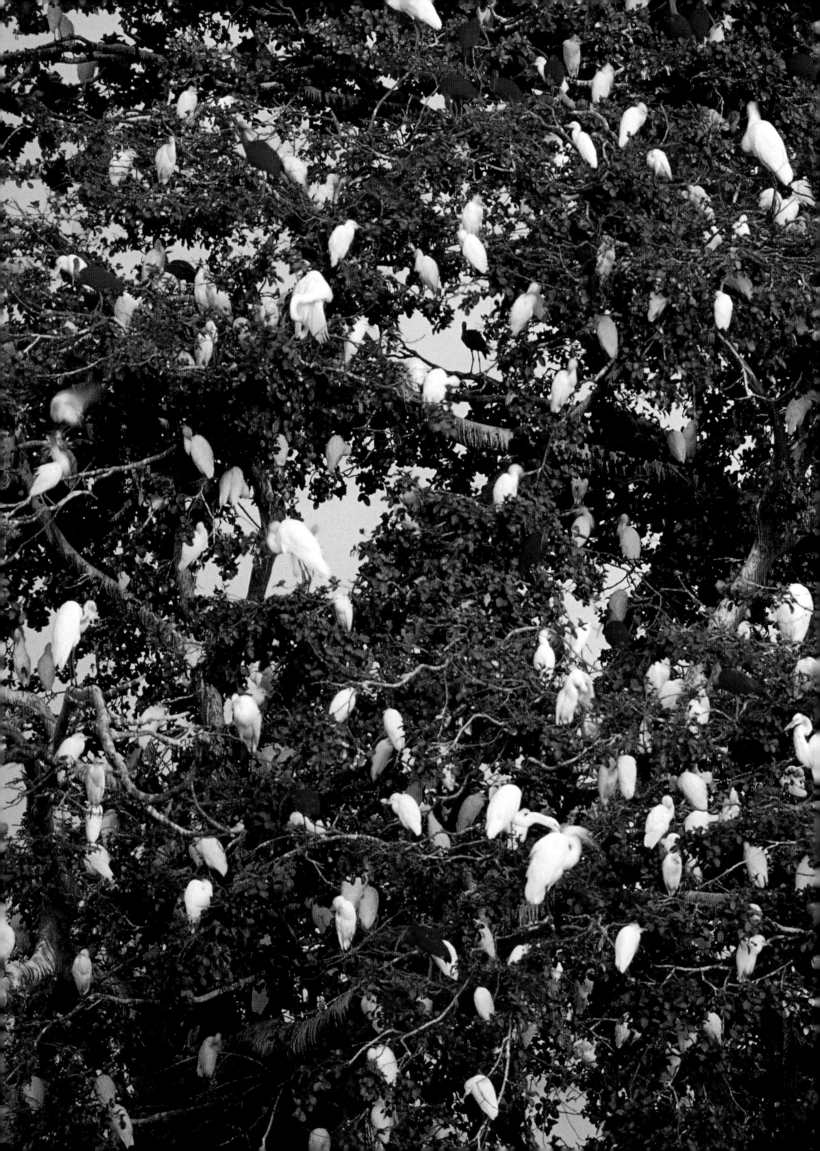

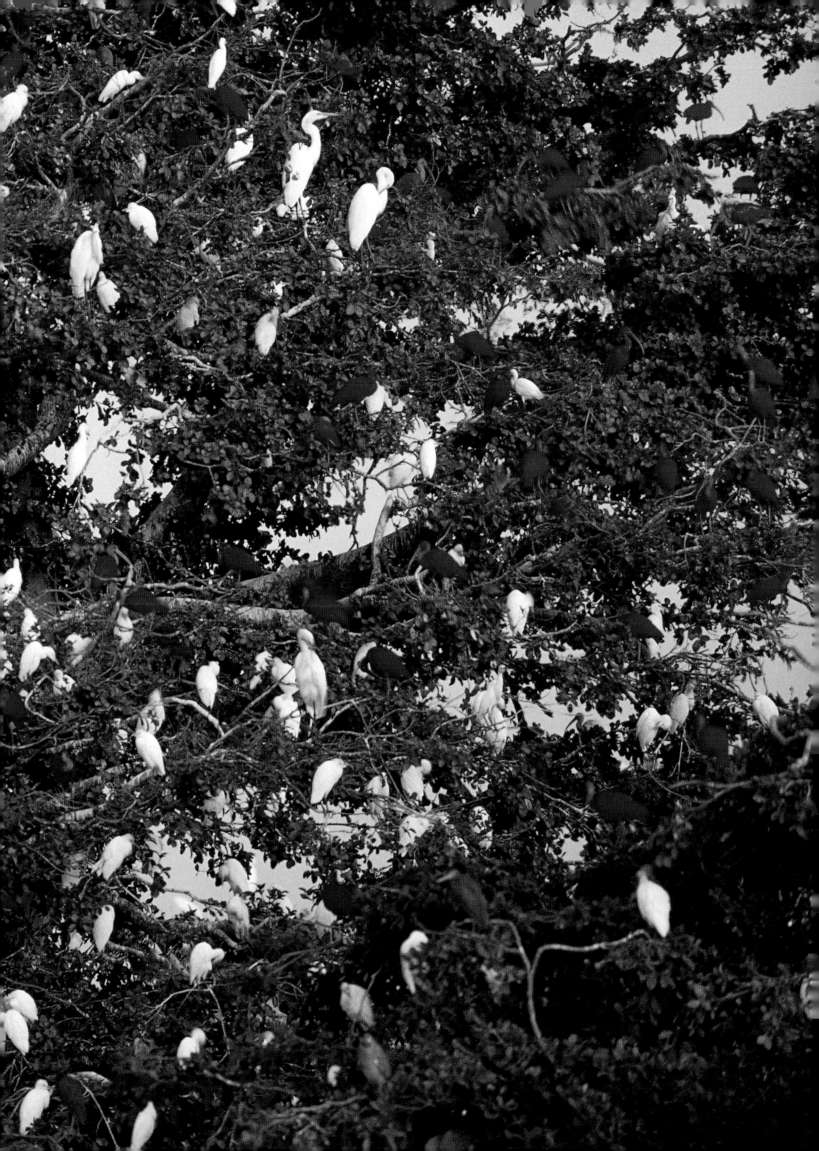

Royal Botanic Gardens, Kew. It grows in standing water, but what is most interesting are the young leaves, which float on the surface of the river like those of any other aquatic plant. Once this floating phase is established, the plant produces a more normal trunk. When Dr. Beentje first discovered this palm, he climbed a tree to collect the leaves and fruit. His activity caused many of the ripe fruits to drop into the river with a most musical sound, which led to his selection of the species name *musicalis,* or "music maker."

My favorite of all Amazonian aquatic plants is the royal water lily (*Victoria amazonica*). This plant produces the world's largest floating leaf. The lily pads can be up to 8 feet (2.5 m) in diameter. With the turned-up margins of flat leaves they look like giant saucers floating on the surface of Amazonian lakes. The leaves are often host to lily trotters or jacanas (*Jacana jacana*), which walk from one leaf to another or fly with a fast wing movement that reveals the yellow on the underside and gives them another common name, butterfly bird. One can often find on the lily pads a small cluster of jacana eggs laid on a crude nest made of a few other aquatic plants.

The flowers of the royal water lily open in the evening, stimulated by the onset of darkness. It is an inspiring sight to float on an Amazonian lake and watch these white starlike flowers, larger than a fist, burst open all over the lake. As the flowers open, the temperature in the cavity inside is 45° to 52°F (7° to 11°C) warmer than the ambient temperature and a strong fruity odor is emitted. This scent coupled with the white flowers attracts large brown scarab beetles (*Cyclocephala hardyi*) over 1 inch (2.5 cm) long. The beetles enter the open flowers and push their way down into the warm central cavity, where they feed on special starchy appendages that hang from the sides of the cavity. While they are contentedly feeding, during the night the flowers close up and trap the beetles inside. Usually only 6 to 8 beetles will feast inside each flower, but I once counted 43 in a single flower. The next day, the flowers gradually change color from white to purple. When they reopen on the second night, pollen is released from the stamens, which now hang over the mouth of the opening. As the beetles emerge all sticky from the plant juices below, they brush against the stamens and get a coating of pollen. They then take off clumsily from the top of the flower and seek another white flower to enter for another warm night with plenty of food. The pollen they carry is brushed off onto the stigma of the new flower, and so fertilization takes place and seeds will form. The most spectacular plant of Amazonia depends on a lowly beetle to ensure its next generation.

Once the beetles have left, the flowers close up and do not open again on the third night. Instead the flower stem contracts and pulls the old flower underwater for the seeds to develop from the fertilized ovaries. Since the exterior of the flower is covered by viciously sharp spines, the developing seeds are well protected. Once they are mature, the whole structure rots and the pea-sized seeds are released.

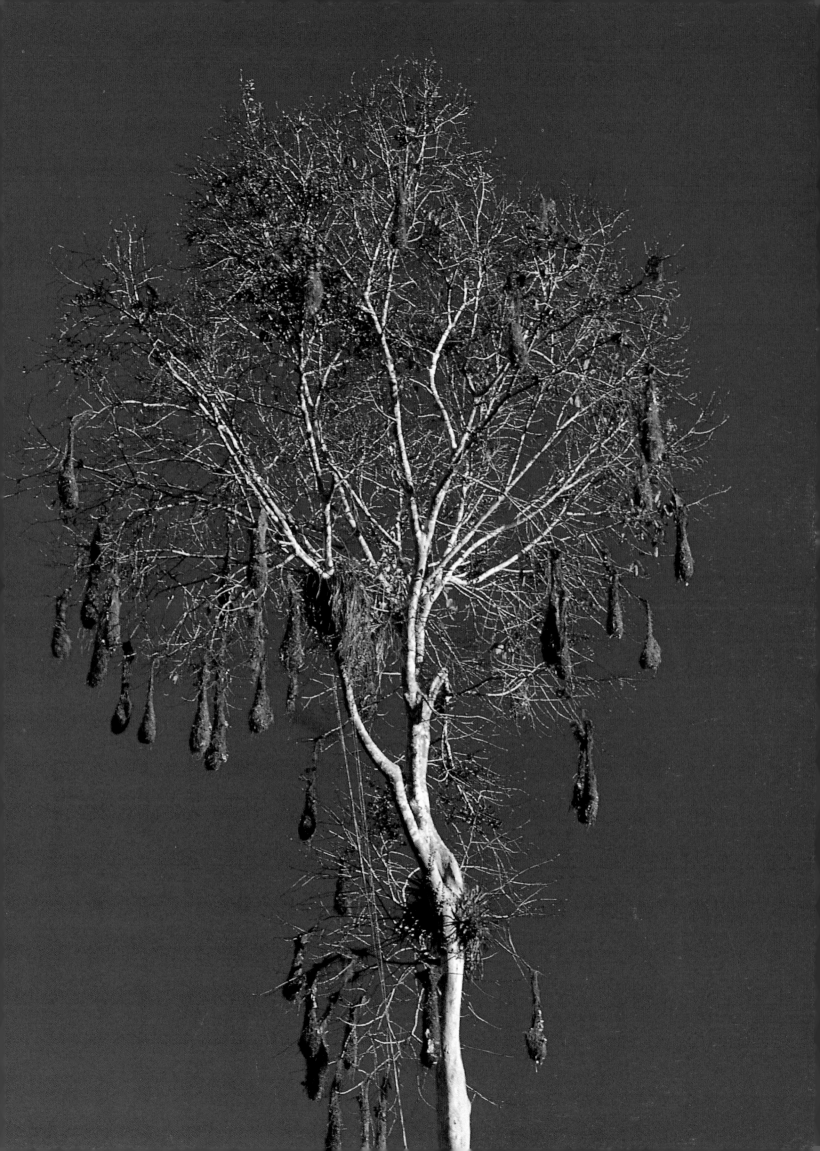

Surrounded by a jelly, they float to the surface and can be carried for some distance from the parent plant before the jelly is washed off and they fall to the bottom of the lake. The seeds are often collected by indigenous people, roasted, and eaten like peas or ground into a flour.

## THE BASILISK LIZARD

The basilisk (*Basiliscus basiliscus*) is also known as the Jesus Christ lizard because of its ability to run over water. These remarkable lizards occur in Central and South America and are able to scoot across water without sinking. Recently two American researchers, J. W. Glasheen and T. A. McMahon of Harvard University, through laboratory studies in glass tanks, worked out the mechanism whereby the basilisk can run on water. These lizards have long toes on the hind feet with skin flaps in between. They slap their feet on the water surface and are supported on the water by air bubbles sucked in behind the foot as it strokes downward like a swimmer in water. The lizards quickly withdraw their feet before the air bubbles collapse, which accounts for the speed with which they traverse water. To perform this feat, they use a great deal of energy. Basilisks, which weigh just 3 ounces (90 g), must develop a mechanical power of about 64 watts per pound (or 29 watts per kilogram) of body weight. (The maximum sustained output a fit human being can manage is about 45 watts per pound, or 20 watts per kilogram.) The lizards have such powerful hind legs that the researchers estimated that they could manage 300 watts per pound (135 watts per kilogram) and that at least 21 percent of the lizard's body mass is involved in powering hind-limb motion. It would be impossible for humans to emulate the basilisk because of the size and shape of our legs and the maximum speed that we can run. Even with the right foot structure to move on before each bubble of air burst, a human runner would need to stroke downward through the water at almost 100 feet (30 m) a second, which is well beyond our capacity. We have to stand by and admire the amazing capability of the basilisk instead.

# PEOPLES
# OF THE FLOODPLAINS

Peoples have favored the floodplains for settlement because the floodplains offer much more fertile soil than the *terra firme* forests, owing to the annual rejuvenation by a layer of fertile silt. The soil fertility coupled with access to water makes floodplain settlement attractive but also challenging because of annual flooding of the fields. Dwellings have to be on stilts above the highest flood level. Historical accounts by early explorers of the Amazon describe huge colonies of indigenous tribes living beside the rivers, but little archaeological evidence remains inasmuch

FACING PAGE: *A Dani tribesman preparing to transport his bundle of reeds containing salt.*

FOLLOWING SPREAD: *Rivers are of great importance to the indigenous peoples who inhabit the rainforest. These Dani villagers of Irian Jaya are extracting salt from reeds.*

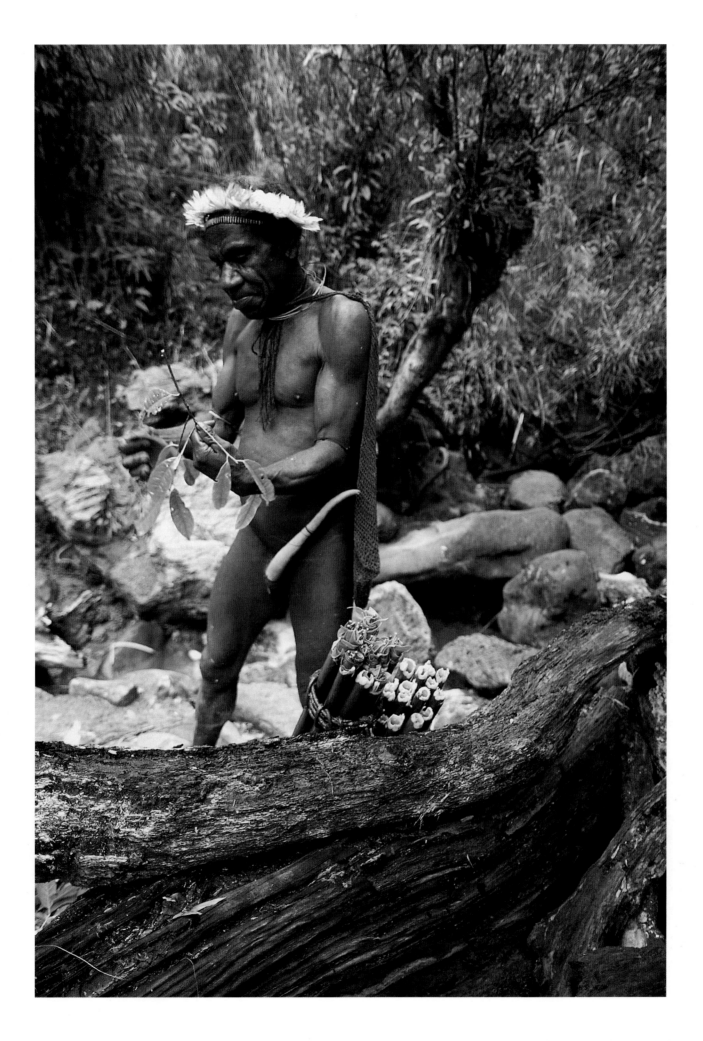

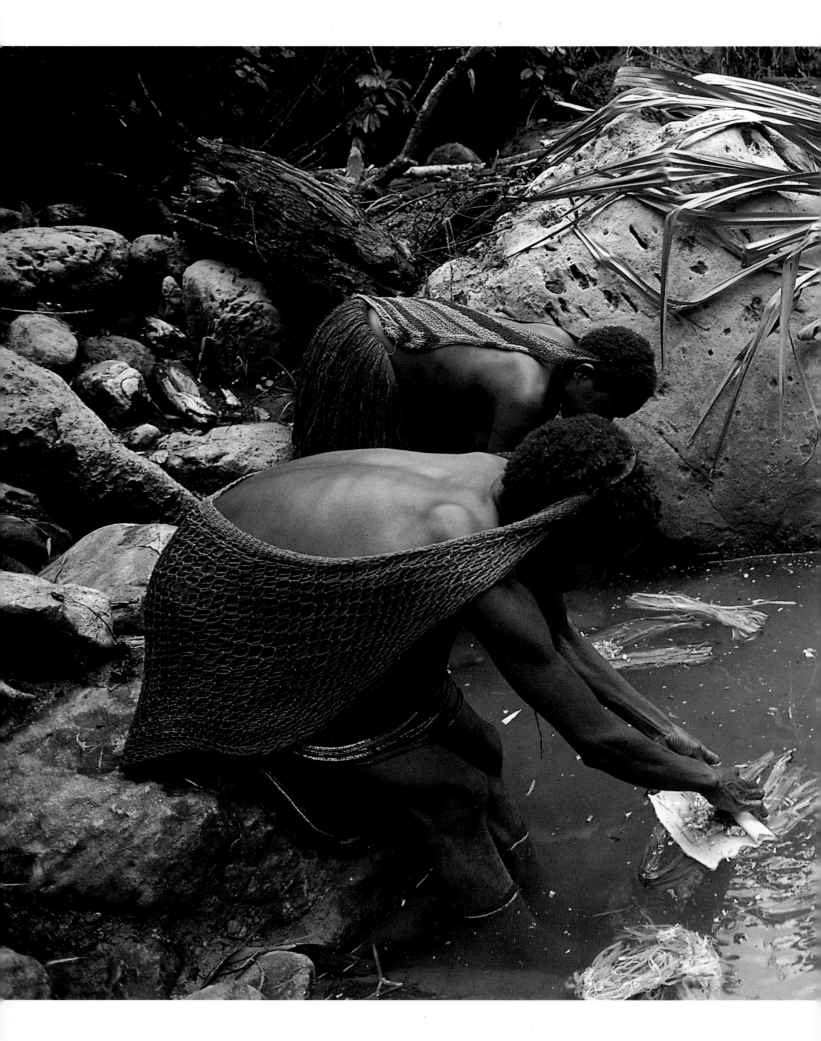

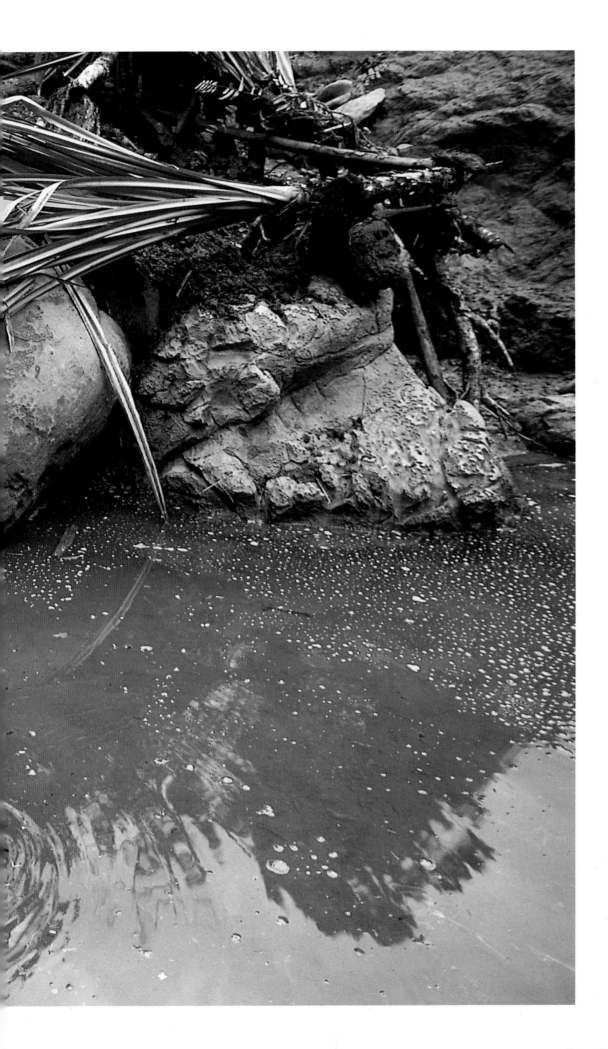

as wood was used for construction. All that we have from the last three millennia are a few examples of pottery. The early chroniclers described large colonies of Omagua people on the middle Amazon, centered on what is now the town of Tefé in Brazil, and of Tapajós people around the mouth of the river named after that tribe, in the vicinity of the contemporary city of Santarém. The size of such communities can be estimated from reports by early writers, such as one who stated that the Tapajós town, situated near the mouth of the Tapajós River, was able to furnish 60,000 warriors.

American archaeologist Betty Meggers of the Smithsonian Institution has reconstructed as much as possible about the riverside life of the Omagua and Tapajós. For example, she quotes the diary of Samuel Fritz, a missionary amongst the Omagua from 1686 to 1723, who said: "The plantations . . . which furnish their sustenance, and the houses or ranches are generally situated on islands, beaches or banks of the River, at low lying lands liable to be flooded. . . . In order that there should be no lack of food during the season of the high-flood, which begins in March and lasts till June, they make a practice of harvesting the fruit of their new plantations in January and February."

These early settlers of the Amazon floodplain were an agricultural society, subsisting on the staple crop of cassava (*Manihot*) and hunting and fishing. However, the great cultures of the Amazon floodplain quickly succumbed to slave trading, European diseases, acculturation by the missionaries, and warfare. The riverside *várzea* was also the preferred site for European colonizers, and the river network offered a ready-made system of transport through this vast area of rainforest. As a result, by the beginning of the eighteenth century the great Amazon cultures were dying out. They have been replaced by settlers of mixed blood who have blended some traditional Indian ways of floodplain management with other methods.

It is not just in Amazonia that people have settled along the rivers of the rainforest. The Dayaks of Borneo, with their great long houses, settled all along the principal rivers within the rainforests of that island. Unfortunately, their way of life is being destroyed by logging. The removal of the trees means that the soil is eroded by the heavy rainfall, and loss of soil means that they are unable to continue their traditional way of life based on the cultivation of rice.

# HYDROELECTRIC DAMS

The great rivers of the rainforests of the world offer an enormous potential for the generation of electricity from hydropower. Tropical countries are eager to harness some of this vast source of clean and nonpolluting energy. It has been calculated that the Amazon basin could generate some 100,000 megawatts of electricity. Already one very large dam, the Tucuruí, has been built on the Tocantins River.

This dam has flooded 675 square miles (1,750 km²) of rainforest and produces 7,600 megawatts. It is now the source of power for the city of Belém, the Carajás iron mine, and the railroad connecting that mine to the Atlantic coast. Although the ecology of the Tocantins River has been severely disrupted below the Tucuruí dam, changes by the Tucuruí are not as severe as others. Some dams, especially the Balbina dam on the Uatumã River, are ecological disasters. Balbina floods a larger area than does Tucuruí yet produces only about 3 percent of the energy produced by Tucuruí. It has not solved the energy problem of the rapidly expanding city of Manaus, for which it was planned, and it has flooded a large portion of the territory of the Atroaris-Waimari Indians. The following table shows the production of some large dams in proportion to the area they flood. Dams such as Balbina and Brokopondo that cause so much rainforest destruction for so little energy cannot be a good investment. What is particularly alarming is the Brazilian government's Plano 2010 proposing 136 new hydroelectric dams by the year 2010 (although it appears that this project is now being rethought). As a result of protests by the Kayapó Indians in Altamira in the state of Pará, the World Bank withdrew funding for Amazonian dams, and this has slowed down plans to dam the larger clear-water Xingu River.

*Rainforest rivers are the logical highways of travel and transport in the region. Today, ironically, they help facilitate their own destruction, because it is easy to remove the timber as floating rafts.*

FOLLOWING SPREAD: *Transport of logs near the Tanjung Uting National Park in Borneo.*

## CAPACITIES OF VARIOUS MAJOR TROPICAL HYDROELECTRIC DAMS IN RELATIONSHIP TO AREA OF THEIR RESERVOIR

| | CAPACITY IN MEGAWATTS | AREA OF RESERVOIR IN ACRES (IN HECTARES) | KILOWATTS PER ACRE (PER HECTARE) |
|---|---|---|---|
| Paulo Afonso, Brazil | 3,984 | 3,950 (1,600) | 6,153 (2,490) |
| Itaipu, Brazil/Paraguay | 12,600 | 333,600 (135,000) | 230 (93) |
| Tucuruí, Brazil | 7,600 | 600,450 (243,000) | 77 (31) |
| Gurí, Venezuela | 6,000 | 790,700 (320,000) | 44 (18) |
| Aswan, Egypt | 2,100 | 98,800 (40,000) | 12 (5) |
| Curuá-Una, Brazil | 40 | 21,250 (8,600) | 12 (5) |
| Samuel, Brazil | 217 | 143,000 (57,900) | 10 (4) |
| Kariba, Zimbabwe | 1,500 | 1,260,200 (510,000) | 7 (3) |
| Balbina, Brazil | 250 | 583,150 (236,000) | 2 (1) |
| Brokopondo, Suriname | 30 | 370,650 (150,000) | 0.5 (0.2) |

There are many problems with poorly planned dams in areas of tropical rainforest. Colombia's Anchicaya dam, for instance, lost 25 percent of its water-storage capacity within two years of construction owing to erosion. In the Philippines life expectancy of the Amuklao dam has been reduced from sixty to thirty-two years

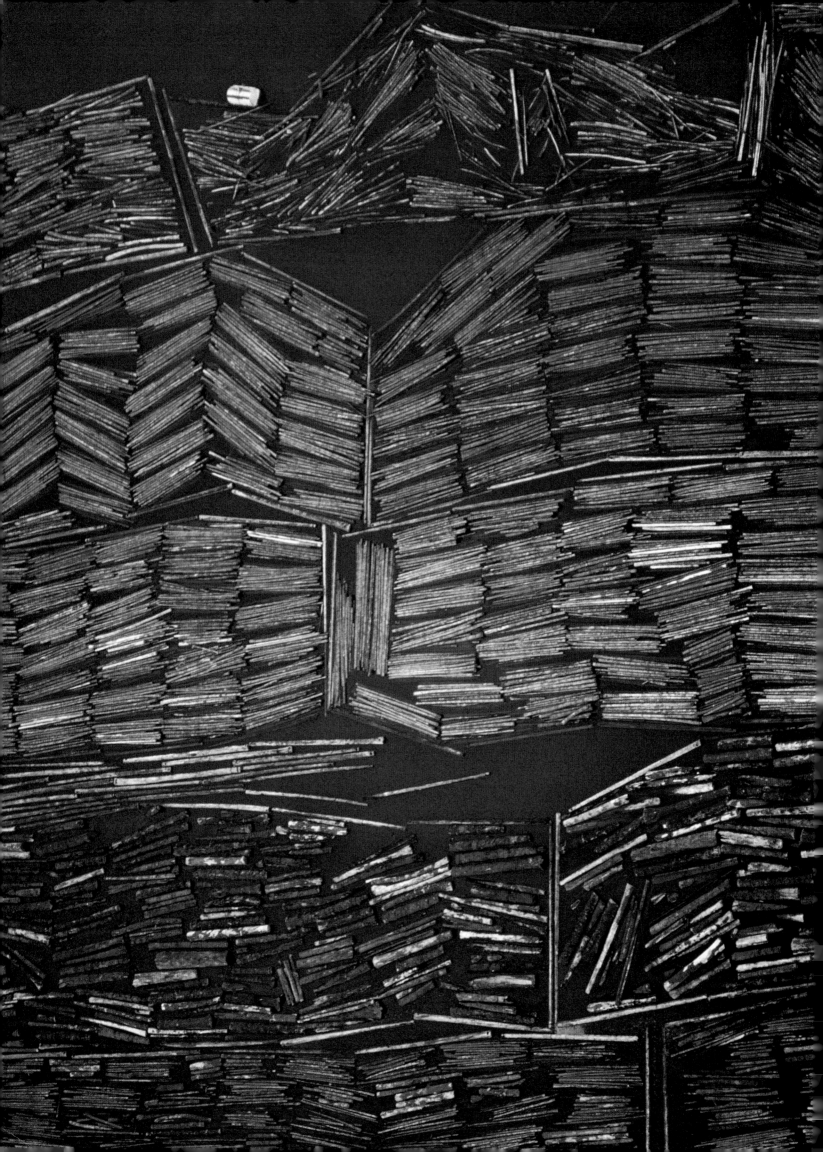

because of siltation. Ecologically, one problem is the abundance of water plants, such as the water hyacinth (*Eichhornia crassipes*), on the surface of the lake, which increases water loss through evapotranspiration. Another serious problem is the increased level of diseases such as malaria and schistosomiasis. Furthermore, the life cycles of many migrating riverine fish have been severely disrupted. And finally, most reservoirs have been created without the removal of the original vegetation. This submerged vegetation produces hydrogen sulfide in the anaerobic conditions. This turns the water so acidic that the turbine blades of several dams have had their life drastically reduced.

The damming of tropical rainforest rivers needs to proceed with utmost caution and only after extremely detailed studies of the environmental impact of each project have been conducted. The rivers are the lifeblood of the forests, and tampering with or destroying them has a severely detrimental effect on the entire rainforest.

FACING PAGE: *Masses of floating logs from the temperate rainforests of Washington State, USA.*

BELOW: *This Madagascan river is so muddy and silt laden because the forests around it have been felled and the soil is now washed away by the heavy rainfall. This eventually leaves land that is impossible to cultivate.*

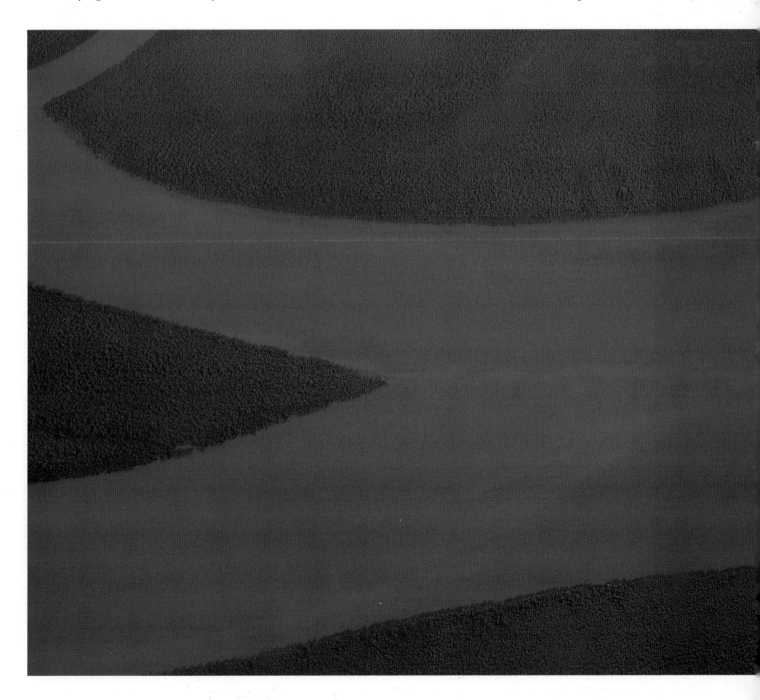

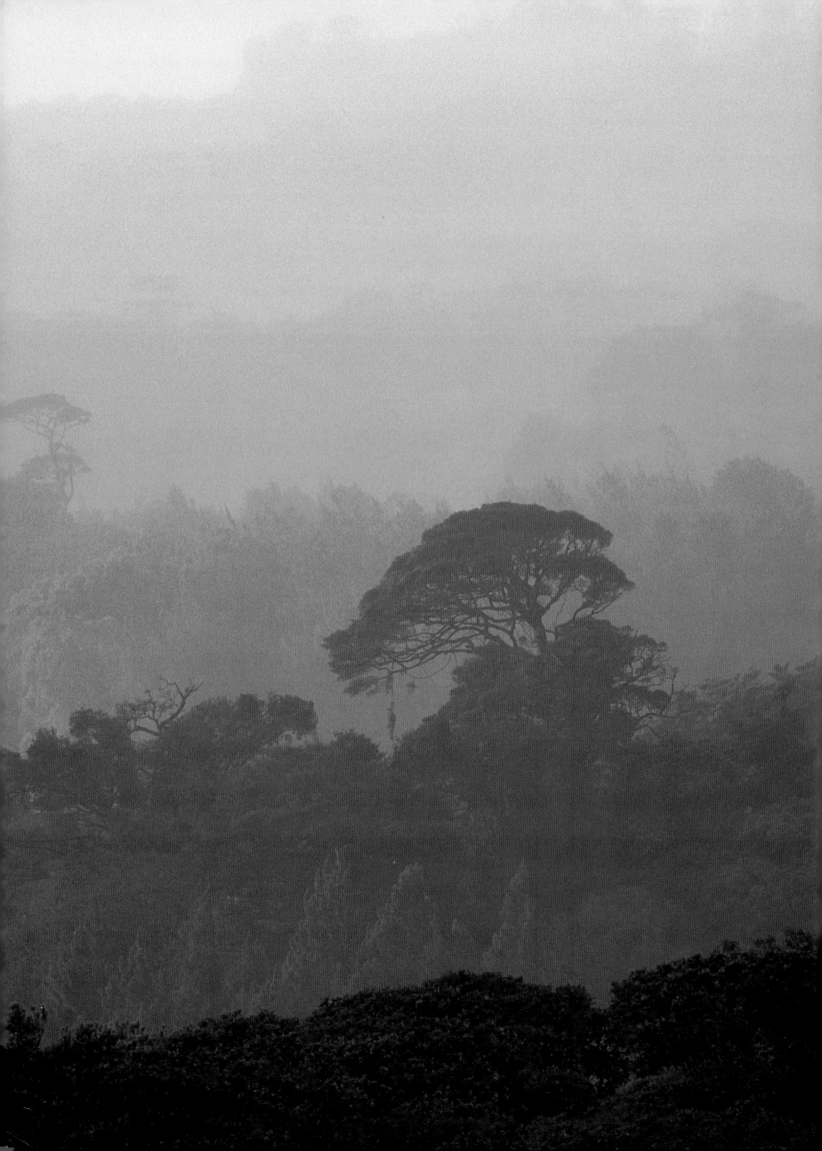

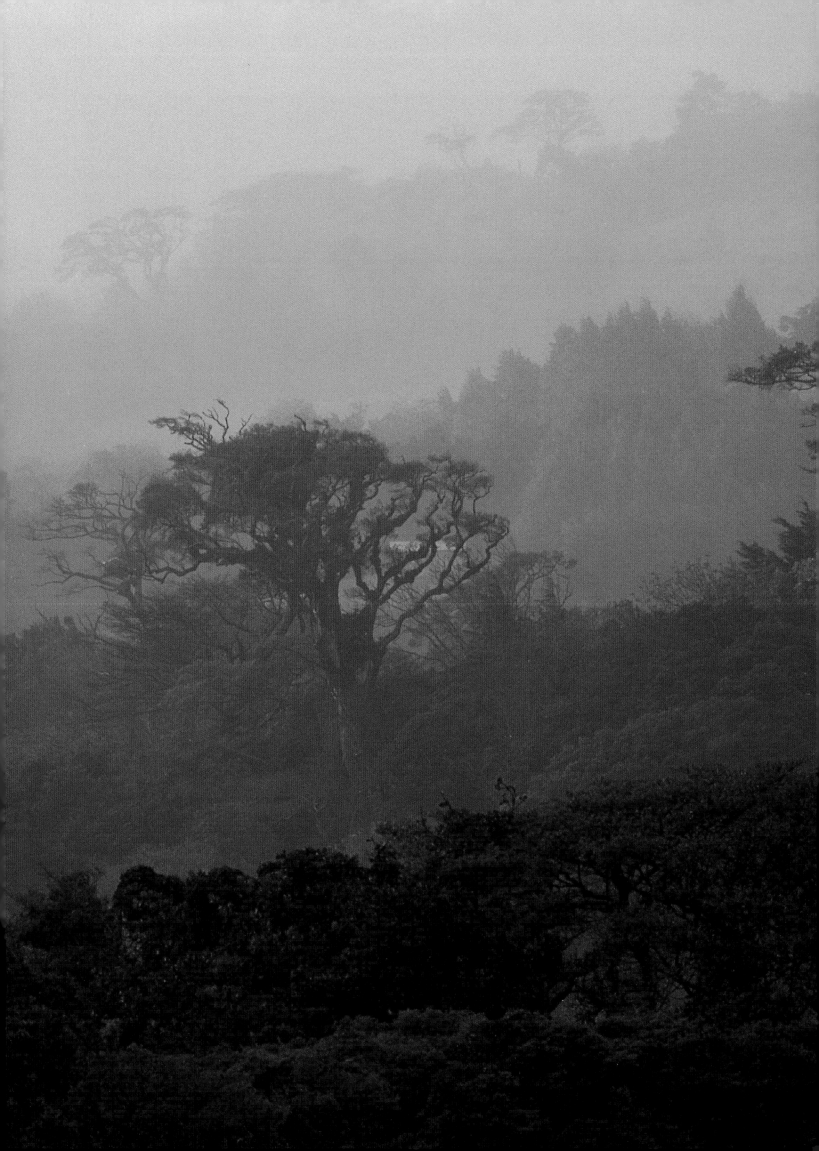

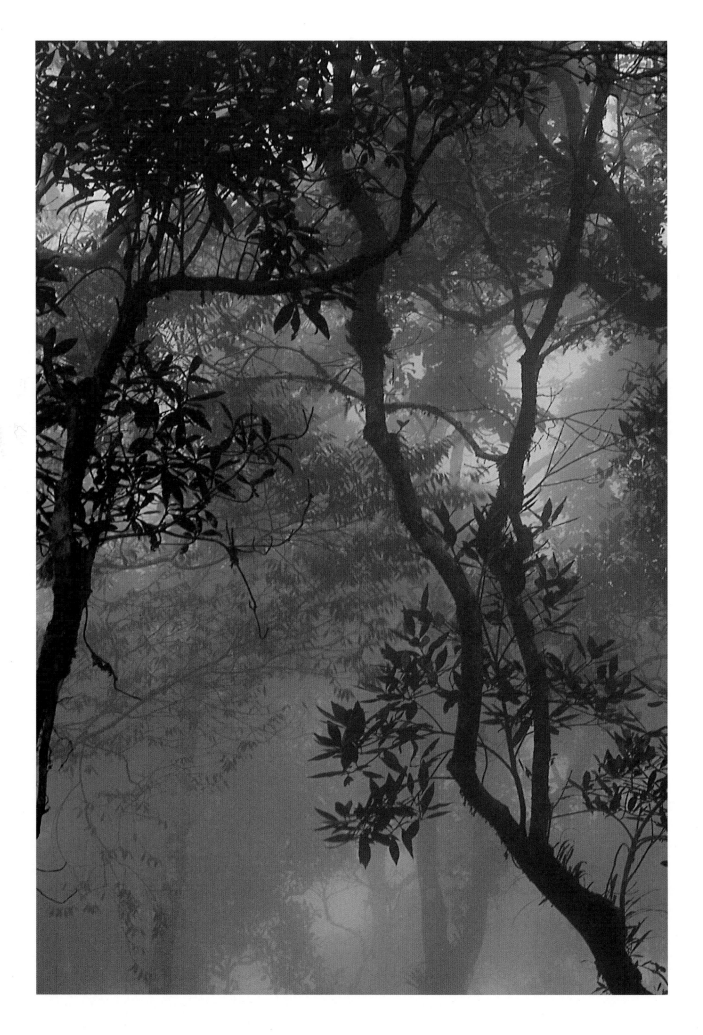

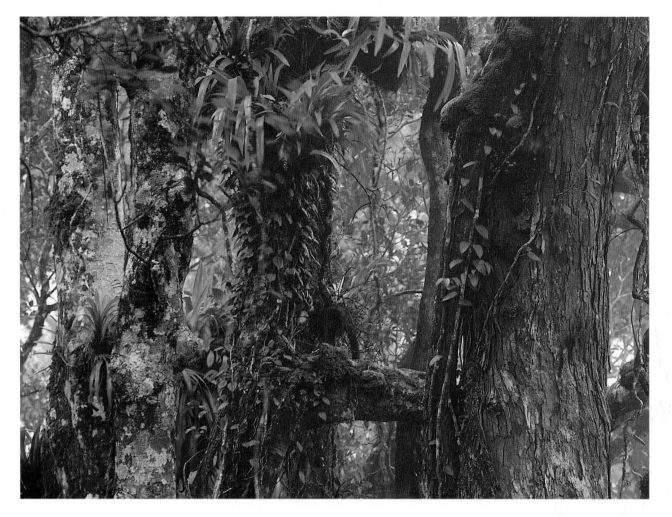

# CLOUD FORESTS

In addition to lowland areas covered by rainforest, there exist considerable areas of mountains around the tropics—for example, the Andes in South America, Mount Cameroon in West Africa, Mount Kinabalu and other mountains in Borneo, and the high mountains of New Guinea. As elevation increases from the lowland rainforest toward mountaintops, the climatic conditions and consequently the type of forest gradually change. Temperature decreases with altitude (about 1°F for every 330 feet, or 0.55°C for every 100 m), and the mountains attract more clouds. Even on the equator the temperature can drop below freezing at about 16,400 feet (5,000 m), which accounts for some of the spectacular ice-capped volcanos of Ecuador such as Cotopaxi and Chimborazo and of Mount Wilhelm in New Guinea. On many tropical mountains a layer of clouds clings to the slopes for much of the day or even for days on end. To the visitor this part of the mountain slope may seem dank and dreary, but to the biologist it offers fascinating specimens of other kinds of tropical vegetation and animals. This is another type of tropical forest that is controlled by water, but in this case clouds rather than rivers. The constant cloud cover reduces the rate of photosynthesis in the plants, and thus growth is much slower there than in the lowland rainforest.

*Cloud forests occur at higher altitudes, above lowland rainforest, where clouds envelop mountains for much of the day. They are usually misty and hence many epiphytes grow on the trees.*

PREVIOUS SPREAD: *Cloud forests of Monteverde Cloud Forest Reserve in Costa Rica.*

FACING PAGE: *Cloud forests of Borneo.*

ABOVE: *Epiphytes in the trees of a cloud forest in Borneo.*

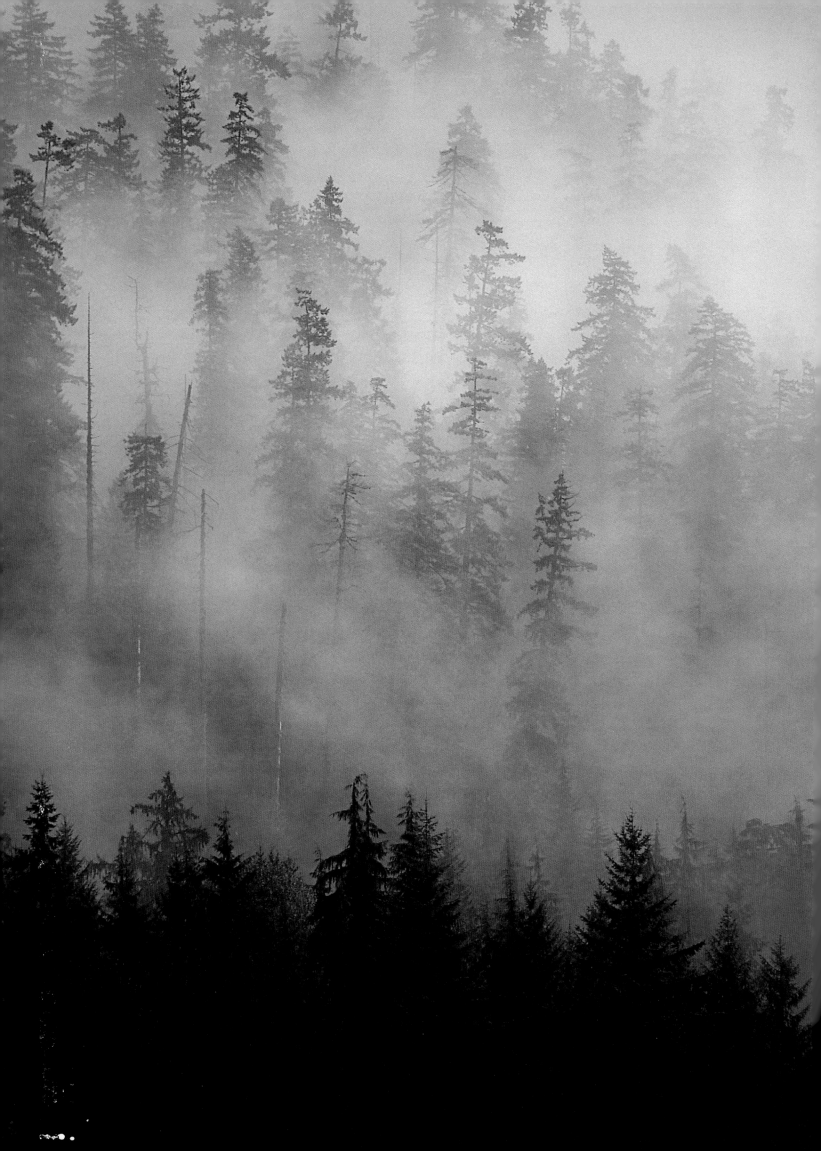

Cloud forest has a beautiful yet eerie appearance. Clouds drift through the trees and moisture condenses on the leaf surfaces, so even if it is not actually raining, there is a constant dripping. The growth seems exuberant because of the quantity of mosses, ferns, and other epiphytes perched on or hanging from the branches of the trees. Exotic-looking tree ferns with feathery fronds and arching bamboos are common and add to the beauty of this forest. Although there are far fewer species of trees than in the lowland forest, there is an abundance of other plants, especially in the herbaceous and epiphyte zones, including many species of begonias and of gesneriads (the African violet family). Orchids are to be found both on the forest floor and perched up in the trees. There are also several plant families that are generally represented by terrestrial species in lowland forest but that are typified by epiphytic species in the cloud forest—for example, the melastome family, which has such epiphytic genera as *Blakea* in the cloud forests of Central America and *Medinilla* in the forests of the Far East.

Most large mammals do not venture up as high as the cloud forests, but these areas are a paradise for the ornithologist. It is in the cloud forests of Central America that one may find the beautiful long-tailed and resplendent quetzals, and in the Andes the spectacular cocks-of-the-rock can be seen perched on the branches of cloud-forest trees. There is also a vast array of different species of hummingbirds in

FACING PAGE: *Temperate rainforests are often misty, as in this view of Douglas firs in the Olympic National Park, Washington State, USA.*

BELOW: *The trees of temperate rainforests are usually covered abundantly with moss due to the constant moist conditions, here in the Hoh Rain Forest, Olympic National Park, Washington State, USA.*

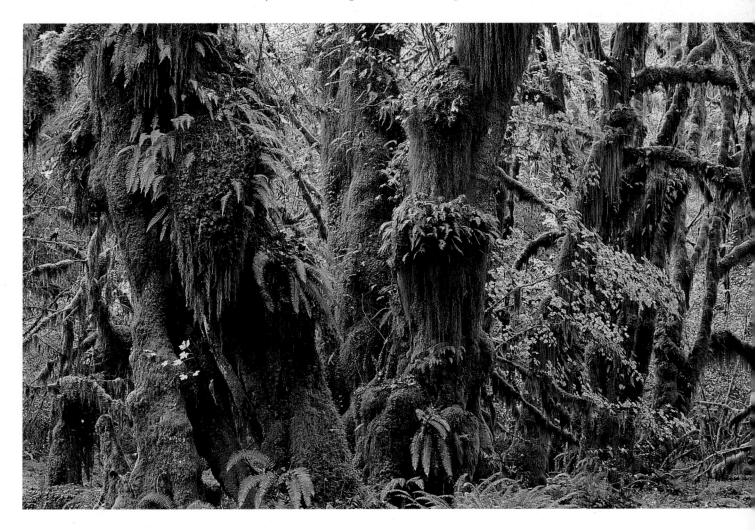

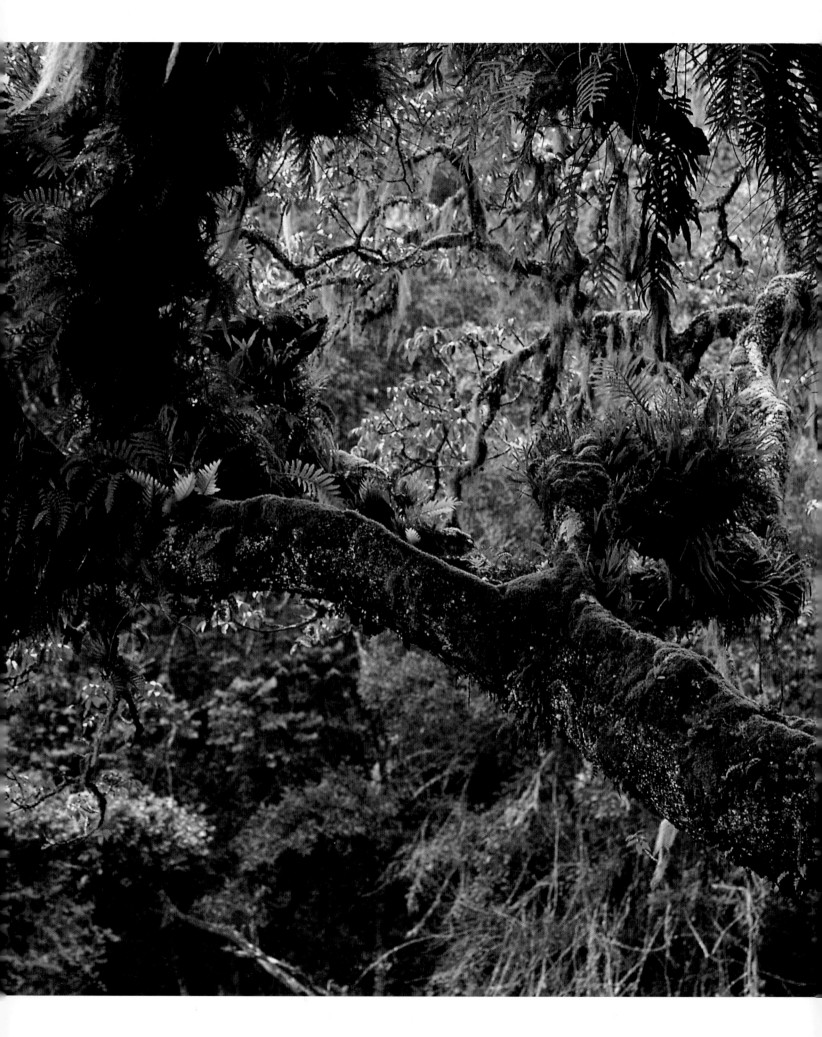

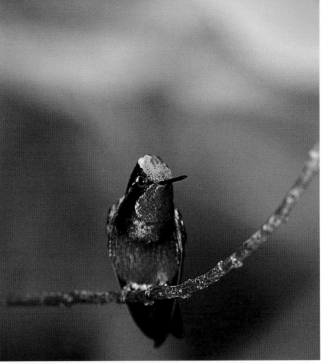

ABOVE: *The iridescent and beautiful male purple-throated moun-tain gem (*Lampornis calolaema*) inhabits the cloud forests of Costa Rica.*

LEFT: *The moss-laden trees of a tropical cloud forest at Arusha National Park, Tanzania.*

BELOW: *A female purple-throated mountain gem (*Lampornis calolaema*) on its nest in the forests of Costa Rica.*

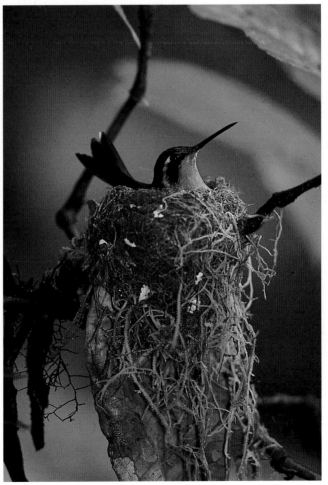

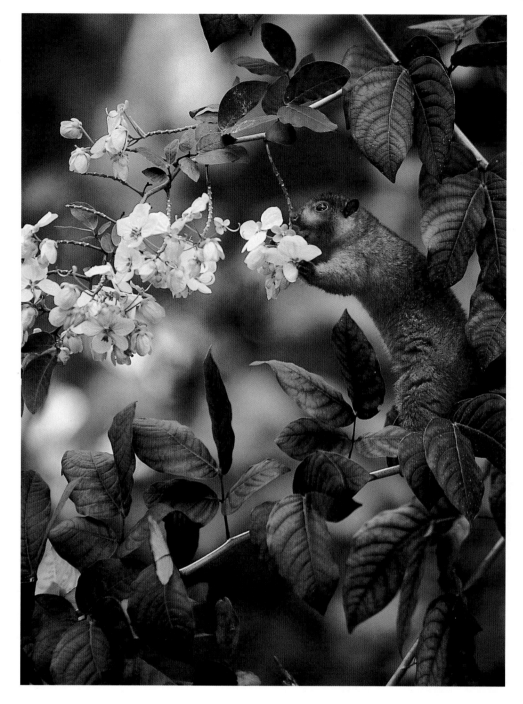

the cloud forests of South and Central America, where they are one of the most important pollinators of the plants. The cloud forests of New Guinea and Australia rainforests are home to the birds of paradise and the honeyeaters, while Africa is home to sunbirds that fill a similar niche.

Although large mammals are rarely seen wandering through the dense growth of tropical cloud forests, there are many smaller ones such as rodents, bats, and marsupial primates, which serve various ecological functions. A former student of mine, Dr. Cecile Lumer, studied the pollination of the cloud-forest genus *Blakea* of the melastome family. Most species of *Blakea,* some of which are epiphytes, have large, spectacular red, purple, or white flowers that are pollinated by bees. At the outset of her study, Dr. Lumer found one shrubby species, *B. chlorantha,* in the beautiful Monteverde Cloud

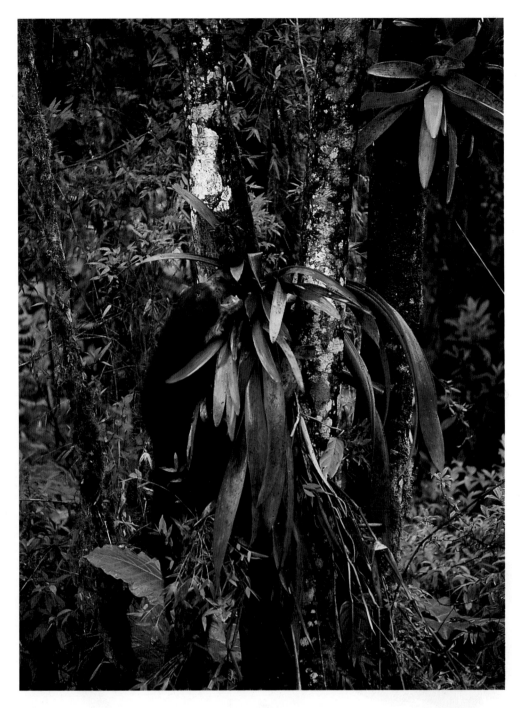

Forest Reserve that, unlike other *Blakea* species, had green flowers. In addition, these flowers exhibited another feature unusual in the melastome family, an abundance of nectar. Since the flowering of this green-flowered species was just finishing when the study began, it took eleven months before Dr. Lumer discovered the pollinator. I had suggested bats when I visited the shrub and she had suggested moths as likely pollinators. Nearly a year after our conversation, I received a long-distance telephone call from Costa Rica to New York with an excited student on the end of the line who simply said, "It's mice!" *B. chlorantha* is pollinated by rice rats and mice (*Oryzomys devius* and *Peromyscus mexicanus*), which climb into the branches and grasp the flowers with their front paws while they drink the nectar. The pollen shoots out of the pores in the anthers when slight pressure is applied to the outside of the petals or when the base of

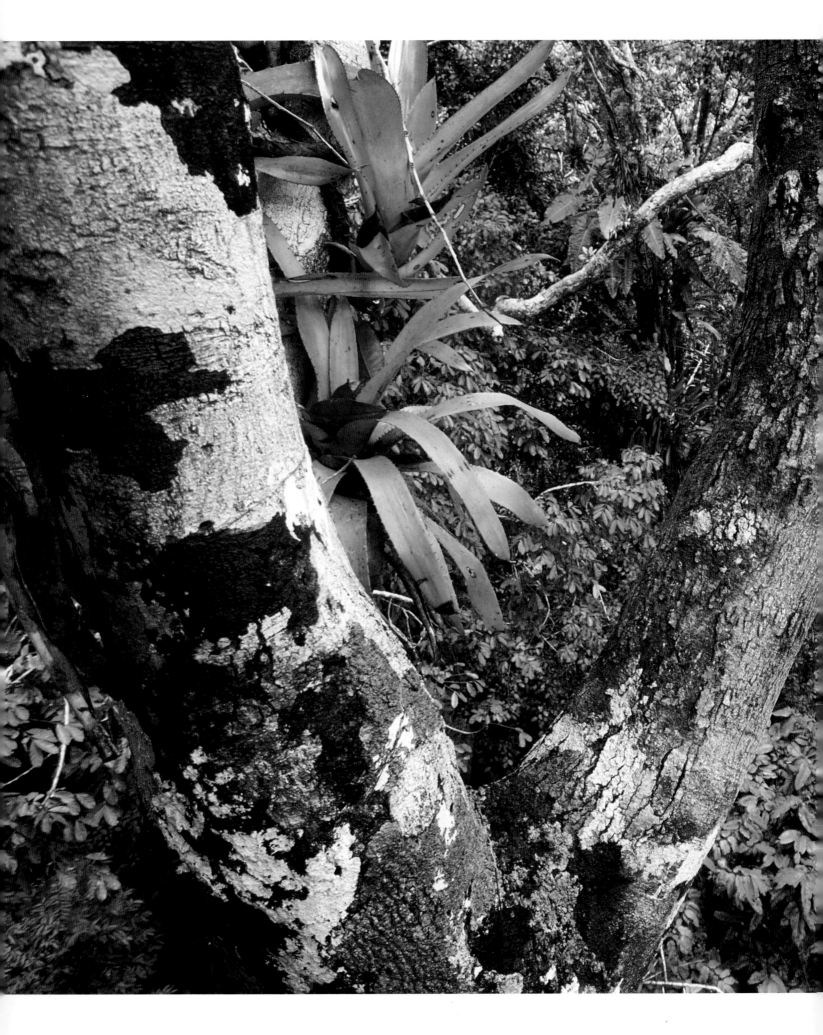

ABOVE: *Raindrops on the tendril of a rainforest vine in the Rio Bravo Conservation Area, Belize.*

LEFT: *The large epiphytes, or air plants, perched on this tree in the Sucusari Nature Reserve of Peru are members of the bromeliad, or pineapple family. Epiphytes use the host trees simply as perches and, unlike parasites, do not take any nutrients from them.*

FACING PAGE: *Epiphyte-laden
trees in the rainforest of
southeastern Alaska, USA,
also harbor black bears
(*Ursus americanus*).*

the anthers is probed, so the rodents cannot help but get well dusted with pollen. This
was the first record of pollination by a nonflying mammal in the neotropics.

# DRIP TIPS

Anyone entering the rainforest can see that many of the leaves of the trees and
shrubs look alike. They are nearly all oblong and have a pointed tip. This has been
termed a "drip tip" because it allows the rain to drain off, preventing both damage
from an excess weight of water and the leaching of precious nutrients out into a
pool of water on the leaves. The drip tips help to keep the leaves dry, which protects
the leaves from colonization by mosses, liverworts, and fungi adapted to growing
on leaves (known as epiphyllous organisms). The understory trees and shrubs most
often exhibit drip tips; because the emergent trees are exposed to sunlight and so
lose water through evaporation, they seldom have drip tips. Drip-tipped leaves are
particularly abundant in cloud forests, where it is constantly wet. Moisture from
the clouds condenses directly onto the leaves and water continually drips from
them. Even long after it has rained, the trees continue dripping as the drip tips per-
form their function of clearing moisture off leaves or of gathering water from clouds
and dripping it down to the roots.

# EPIPHYTES

Epiphytes (from the Greek *epi,* meaning "upon," and *phyton,* "a plant") are simply
plants that perch on other plants. They differ from parasites in that they do not
absorb any nutrients from the living tissues of their host plants. They are especially
common in both rainforest and cloud forest, athough more are found in the rain-
forests of the Americas and Southeast Asia than in those of Africa. Some trees sus-
tain an enormous load of epiphytes. Many plant families (about sixty-five) include
species adapted to the epiphytic habit, and so this type of botanical hitchhiking is
obviously a successful strategy in the tropics, where rainfall is high enough to sus-
tain them. Among the plant families that are particularly rich in epiphytes are the
orchids, the ferns, the aroids, and the bromeliads. The latter, which also includes
the pineapple, a terrestrial species, is one of the largest and most important epi-
phytic families in the tropics of the New World, but it is absent in the Far East and
is represented by only a single species in West Africa, which must have arrived
there by some freak event of dispersal from the Americas.

Being an epiphyte through the dry season is no easy task, and epiphytes have
evolved a huge range of adaptations to preserve water through drier periods. Most
people do not think of cacti as rainforest plants, yet in the lowland rainforest of the

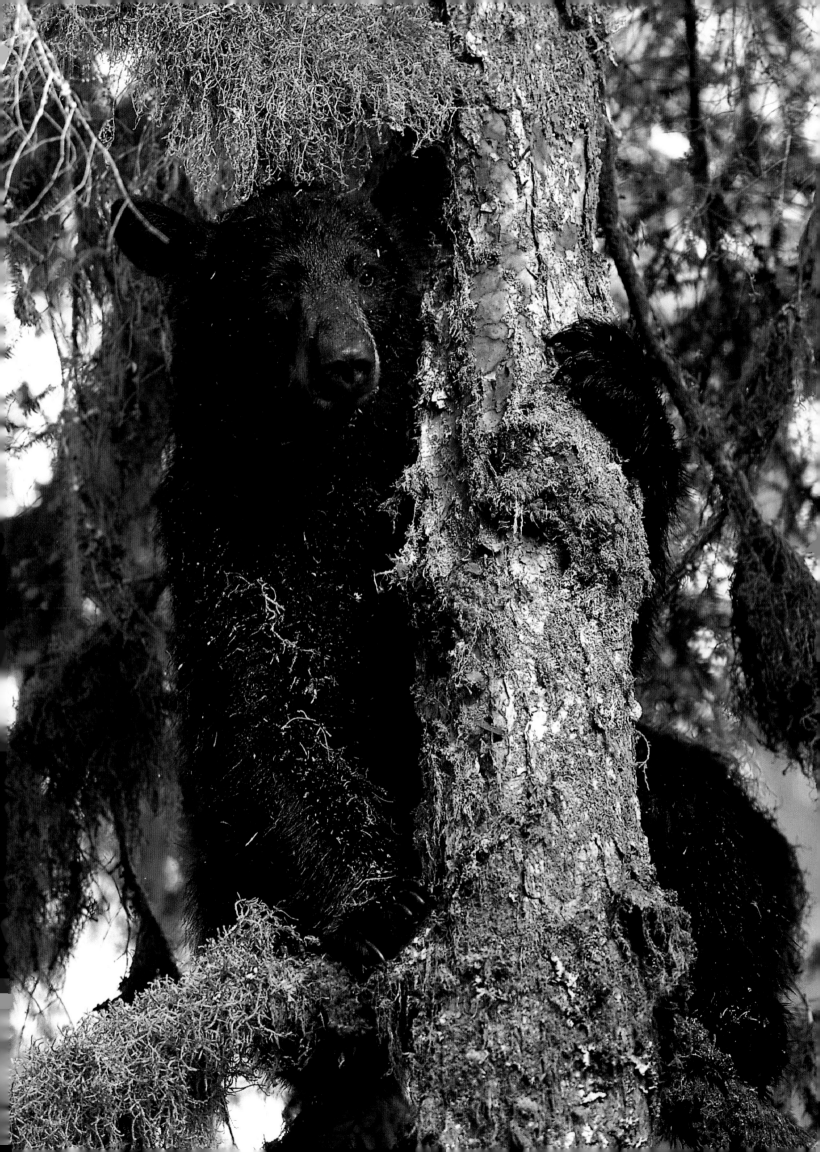

New World tropics, cacti are common epiphytes. Living through the dry season on top of a tree branch offers a desertlike habitat, and so it is not surprising that cacti from the genera *Epiphyllum* and *Rhipsalis* have adapted to the epiphytic habitat. It is common to see a mass of bootlacelike strips of a *Rhipsalis* cactus hanging down from the branch or the crotch of a tree. *Rhipsalis* has small sticky seeds much like those of our northern mistletoe. This sticky mass of seeds is eaten by birds, which clean them off their beaks by rubbing them on branches, and thus incidentally distributing and relocating the seeds. Some members of the genus *Epiphyllum* have long tubular flowers, the petals of which open at night at the end of the tube, which contains nectar at the base. Pollination is by long-tongued hawk moths, which hover at the flowers and probe to the bottom of the tube with a proboscis that is a perfect match for the tube's length.

The strangest of all epiphytic cacti must be the moonflower (*Selenicereus wittii*), which grows in the *igapó* forests of the Rio Negro. Its stems are flattened into large, spiny segments that cling to the trunks of trees at about the high-water flood level. It is unusual to see a cactus with part of its stem underwater at the peak of the flood season. As its common name would imply, this is also a night-flowering cactus and its conspicuous white flowers have a tube with nectar at the base. It is probably

ABOVE: *The purple flowers of the bromeliad (*Tillandsia laxissima*) from the rainforests of Bolivia.*

FACING PAGE: *An epiphytic bromeliad (*Tillandsia lamproda*) from the pineapple family. Bromeliads are abundant in the American tropical rainforests, absent from the Asiatic region and represented by only a single species in West Africa.*

moth pollinated, but no one has yet observed this. The moonflower was made famous by the late Margaret Mee, an intrepid English explorer and artist who lived the latter part of her life in Brazil, painted Amazon flowers, and crusaded for the protection of the Amazonian environment. On some of her early expeditions, she saw the moonflower and painted it with old flowers and fruit, but she vowed to return once again and catch it in full flower. Since the flowers last for a single night and each plant produces only a few flowers, it requires precise timing to see an open flower. In 1988 the octogenarian Mee fulfilled her ambition, producing a most beautiful painting by sitting on top of the canopy of a very small river launch for an entire night. It was to be her last painting, since she died later in 1988 in a car crash in England. This record of the striking flowers of one of the most unusual of all epiphytes is a fitting memorial to one of the great naturalists of Amazonia.

Whereas cacti have succulent stems that store water easily but lose it slowly, allowing them to endure severe dry periods, the bromeliads have evolved a completely different strategy to cope with the water problems of an arboreal habitat. The leaves of many bromeliads form a rosette by closely overlapping. The rosette is usually cone shaped, with a wider opening and a narrow base, and just like a water gauge, it collects water when it rains. Because the tightly packed leaves at the base of the rosette are completely watertight, a reservoir is formed that can hold water to sustain the plants through dry periods. The leaves on the inside of this tank are covered with umbrella-like scales that open to absorb water but close to avoid water loss during dry spells. The tanks soon accumulate detritus (dead insects and the like), and so the water supply also contains many of the nutrients, particularly nitrogen, that are essential for the growth of the plant. Bromeliads of the terrestrial *Brocchinia,* found in the mountains of the highlands of Venezuela, have evolved a stage further and become insectivorous like the pitcher plants (*Nepenthes*) of the rainforests of the Far East. The water tanks of *Brocchinia* contain enzymes that kill and digest insects. This genus is the most recently discovered carnivorous plant.

The water tanks of bromeliads are an ecosystem unto themselves. Bromeliads living in the top of rainforest trees form the equivalent of a whole series of miniature ponds, and it is hardly surprising that many other creatures make use of this abundant supply of water conveniently stored in so many reservoirs, some holding as much as 2 gallons (7.5 L) of water. A microscopic examination of the water in a bromeliad tank would reveal a myriad of microorganisms that are food for larger organisms such as mosquito larvae. Many of the mosquitoes that are so common in rainforests are produced in bromeliad tanks, and tadpoles are also a frequent sight in these aerial ponds. The creatures that live in these water tanks process the nutrients and excrete them in a water-soluble form back into the water, which is just what the bromeliad needs for nutrition. The animals are not a burden to the plant but rather perform the vital function of making nutrients available.

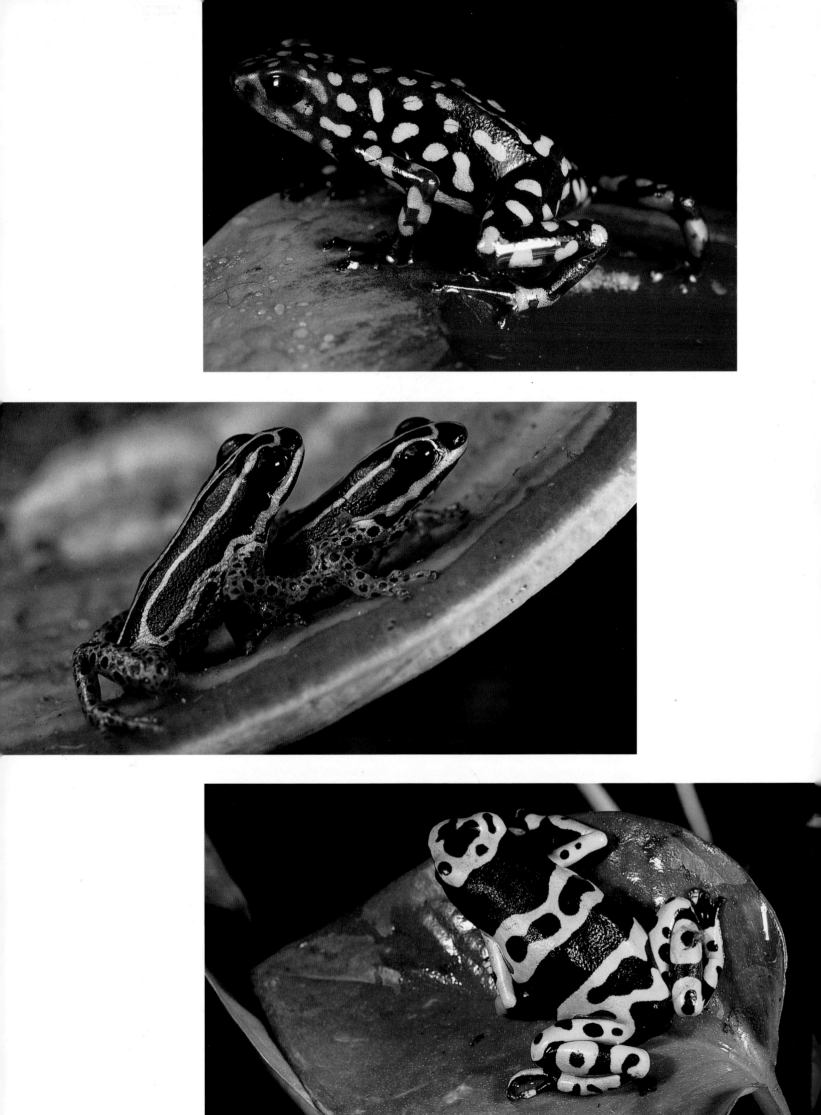

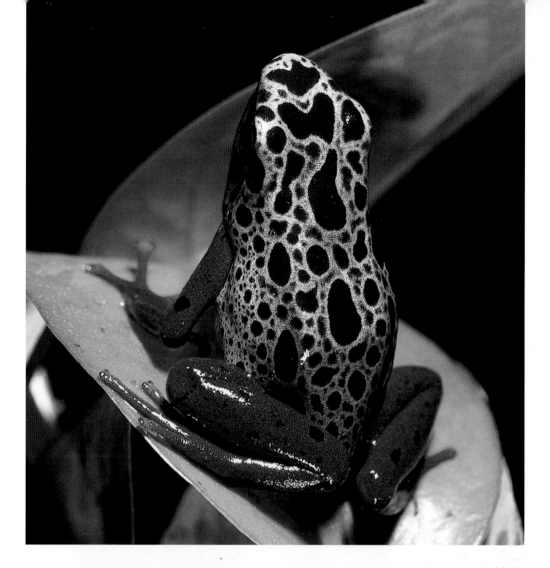

As a warning to predators of their extreme toxicity, poison arrow frogs are spectacularly colored.

FACING PAGE, TOP: Dendrobates histrionicus *from Colombia and Ecuador.*

FACING PAGE, MIDDLE: Dendrobates biolat *from Tambopata, Peru.*

FACING PAGE, BOTTOM: Dendrobates leucomelas *from Venezuela.*

LEFT: Dendrobates azureus, *the blue poison arrow frog from Suriname.*

BELOW: Dendrobates auratus *from Panama.*

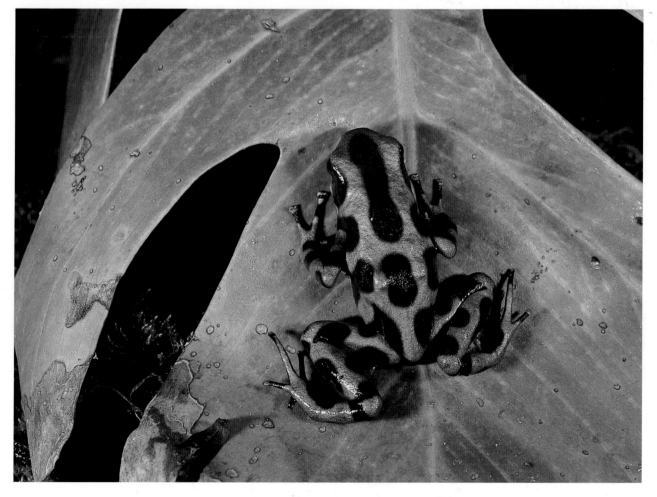

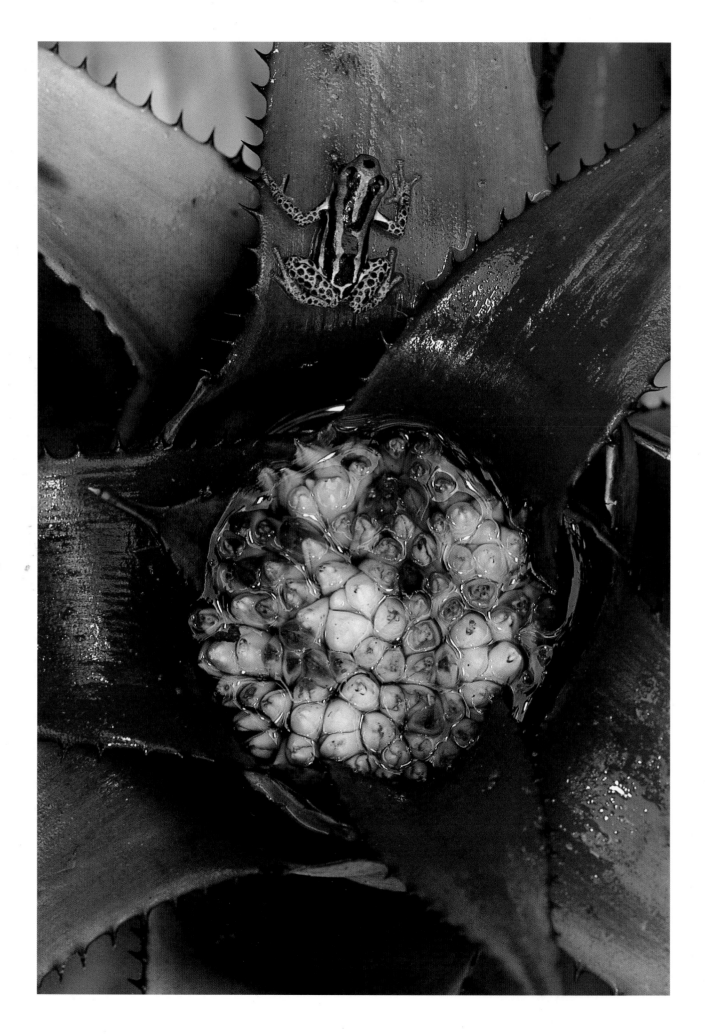

The tadpoles that can be found in bromeliad water tanks are often those of the poison arrow frogs (*Dendrobates* and *Phylobates*), whose skin is so toxic that it is used as a poison for blowgun darts by some tribes of the rainforests of Colombia, and as a deterrent to any would-be predator. As a warning to predators, which quickly learn to avoid them, these frogs are spectacularly colored. Although *Dendrobates* frogs normally live on the forest floor, when breeding they venture into the canopy of the rainforest. Before their ascent, the tadpoles, some of which hatch in small burrows in the ground, squirm onto the backs of the frogs. After the climb, the tadpoles are carefully deposited into the water tanks. However, the frogs do not just climb up and dump all of their precious cargo into a single tank. To ensure survival of some of the tadpoles from predators, and enough nutrients for each of her offspring, the mother frog carefully drops a single tadpole into each water tank. Even more amazing, she does not shed a tadpole if another frog has preceded her visit and already left one in a tank. If a tadpole is already present in a particular water tank and it senses another frog arriving to deposit a rival, it immediately begins a warning ritual, clinging to the side of the water tank and vibrating its tail. This movement is enough for the

ABOVE: *It is almost impossible to spot these extremely well disguised tree frogs* (Hyla vasta) *on the fallen leaves that so closely match, Napo River region of Peru.*

FACING PAGE: *This bromeliad from the Napo River region of Peru, with a small frog* (Dendrobates ventrimaculatus) *on its leaf, has water tanks at its base. These aerial reservoirs are used by many species of frogs as a place for their tadpoles to develop.*

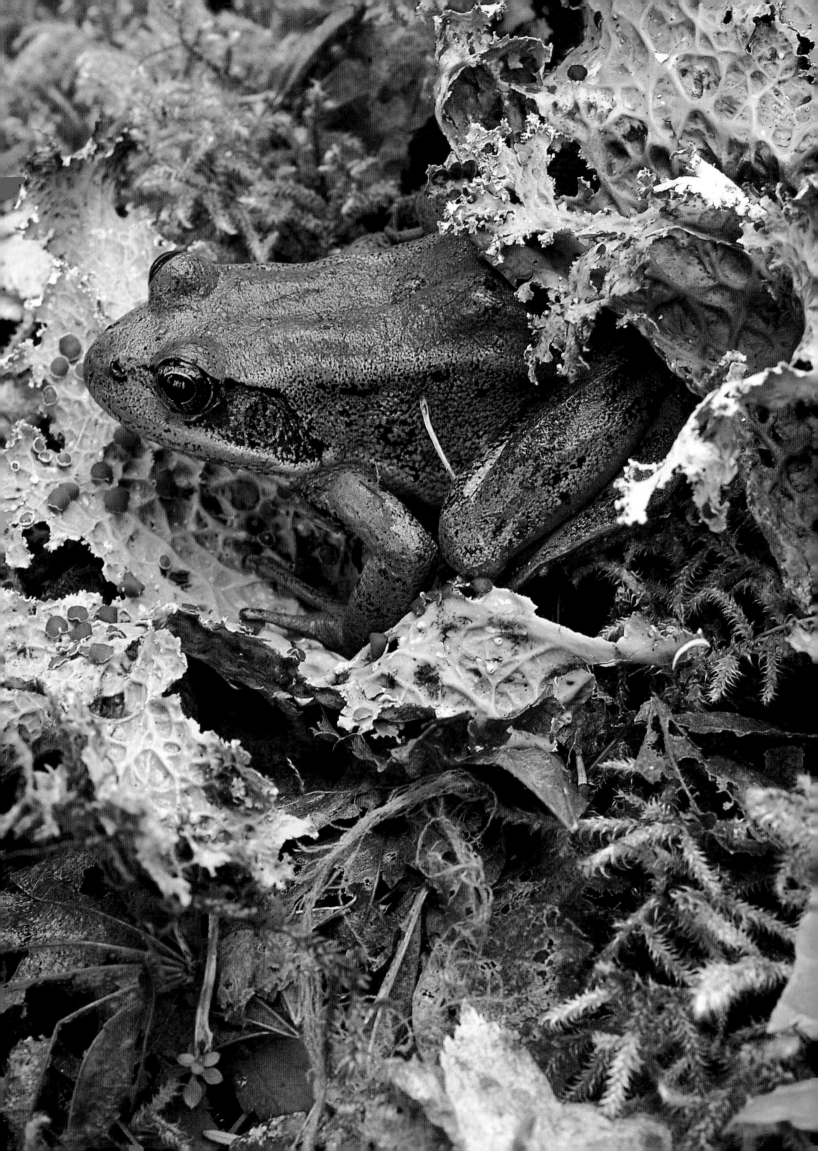

frog to sense, and so she finds another unused water tank for her own tadpole, thereby giving it a better chance for survival. But the story does not end there. The mother frog returns to the forest floor after depositing her load of tadpoles, but in some species, after a few days the mother will return to exactly the same water tanks where she deposited her young. She will then back into the mouth of the water tank. This time when the tadpole excites the water she will not go away but instead will deposit several eggs into the tank. These eggs, however, are sterile and will not produce a new tadpole. They are food for her young and will supplement the food supply available in the bromeliad tanks. Some species apparently make the laborious journey from ground to canopy several times to ensure the survival of their offspring.

Many other creatures inhabit or make use of the water tanks of bromeliads. I once observed a woolly monkey taking a drink from a convenient bromeliad. Another time when we were collecting plants along a river from a canoe, our local guide saw a flowering bromeliad and cut it off the host tree for us. Pandemonium ensued when a small poisonous snake emerged from the bromeliad and caused two of the occupants of the canoe to dive into the water for safety. Once things had calmed down and we had heaved the snake overboard, we were proceeding to pull the bromeliad apart when first a black widow spider and then a scorpion emerged. Bromeliads can be a host to many creatures.

Some tree branches contain hundreds of bromeliads as well as many orchids. When one adds to the weight of the epiphyte the weight of the water, the branches often bear a heavy load. It is quite common to find an epiphyte-laden branch that has fallen from a tree because of overload. Some species appear to encourage epiphytes, but others do their best to shed them. For example, some smooth-barked trees such as the mulatto tree (*Calycophyllum*) or many species of *Bursera* slough off sheets of bark from time to time, which also serves to discard any juvenile epiphyte before it is established. Other species of trees such as sweet bark (*Glycoxylum inophyllum*), a tree of central Amazonia, contain toxic substances in their bark that deter epiphytes. But some species of trees that neither shed their bark nor contain toxic substances and that are suitable hosts for epiphytes make good use of their burden. The mass of roots of the epiphytes accumulates litter that is decomposed by many organisms, creating a rich soil around them. American ecologist Dr. Nalini Nadkarni was the first person to study this ecosystem. She discovered that both in the temperate rainforests of Washington State and New Zealand and in the tropical rainforests of Costa Rica and New Guinea, the trees develop roots on their branches that extend throughout the soil under the epiphytes. Some of the scarce nutrients available in the rainforest environment are recycled back into the trees through this aerial root system before they even reach the forest floor or the soil.

Another group of plants that has adapted well to the epiphytic habitat is the orchids. As the world's largest family of plants, orchids grow as epiphytes in tropical

FACING PAGE: *The frogs of the temperate rainforests of Washington State, USA, are not poisonous and are not brightly colored. Their defense against predators is good camouflage as exhibited by this red-legged frog (*Rana aurora*).*

FACING PAGE: *A Nepenthes pitcher plant from the forests of Malaysia. The pitchers are modified leaves that form a tank that traps and digests insects. When an insect lands at the entrance, it slips down into the digestive liquid at the bottom of the tank.*

rainforests of the world. Although they are most abundant in the neotropics, forty-seven species of orchids were recorded on a single tree in West Africa. The orchids do not collect water in the way that bromeliads do. Instead they have become specialized to conserve water by reducing water loss. Many epiphytic orchids have thick waxy leaves that lose less water than do the leaves of their terrestrial relatives. Many orchids also have bulbous stems or leaf bases that store water. The name of the genus *Bulbophyllum* draws attention to this feature (*bulbus* = bulb; *phyllon* = leaf). In some species of *Bulbophyllum,* the leaves are reduced to mere scales and photosynthesis occurs through the wall of the pseudobulb. A few species of orchids have evolved a reduced root system and leaves that are only small strings. Photosynthesis is carried out by these green roots instead of by leaves that they no longer possess. Other orchids have spongelike roots that soak up moisture. When the air is dry, the roots look dead because they are surrounded by a layer of dead cells. As soon as it rains, these cells absorb water like a sponge and make it available to the living cells.

Epiphytes live in a hard environment that is controlled by the availability of water. The alternating abundance and scarcity of water has led to many adaptations to ensure survival through times of drought, which have incidentally made them some of the most interesting plants of the rainforest.

# NEPENTHES, THE TROPICAL PITCHER PLANT

The most amazing water tanks of all in the rainforest are those of the tropical pitcher plant, *Nepenthes.* This is the most magnificent of all the carnivorous plants that supplement their nutrition through the capture and digestion of insects and occasionally other small animals. *Nepenthes* is predominantly a genus of rainforest climbers and epiphytes, represented by about seventy species that occur mainly in the forests and mountains of the Far East from Assam to northern Queensland. There are also outlying species in Madagascar, the Seychelles, and New Caledonia.

Pitcher plants climb with the help of tendrils that form at the tips of the leaves. Some of the tendrils develop pitchers on their tips, and the first indication that a pitcher is forming is a swelling at the end of a tendril. This enlarges rapidly, and the tendril bends and adjusts to keep the nascent pitcher upright. As the pitcher matures it becomes inflated with air, and after a few days the lid bursts open and it is ready to function.

The different species of *Nepenthes* have pitchers of various sizes and forms. Some resemble horns, beakers, champagne flutes, or toilet bowls. The largest of all pitchers are produced by the rajah pitcher (*N. rajah*), and these are up to 12 inches (30 cm) long and will hold ½ gallon (2 L) of fluid.

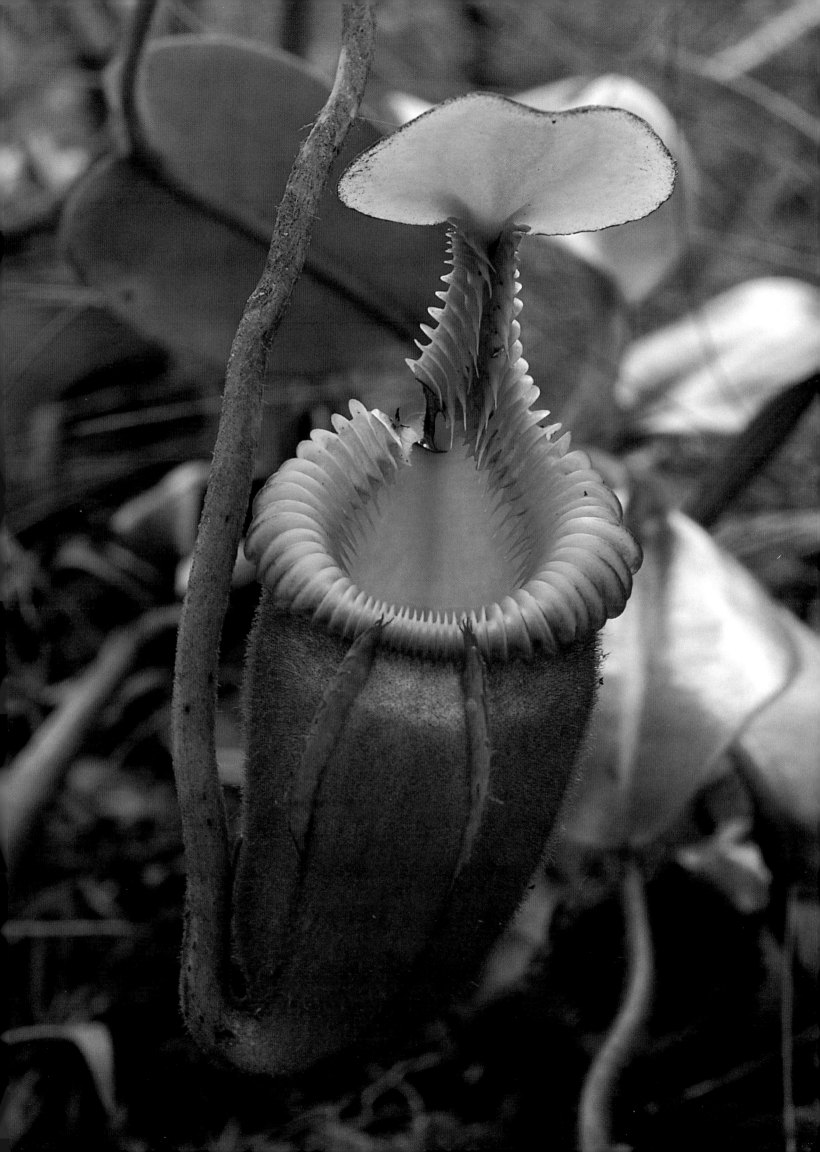

Insects are lured by the bright-colored pitchers and their nectar. Below the rim of the pitcher, which is ribbed and produces the nectar, is a slippery, waxy surface on which the insects slide down into the pool of liquid at the bottom of the pitcher, where they are dissolved by enzymes. The pitchers produce a volatile alkaloid, coniine, which has a mousy smell that attracts some insects but also paralyzes them. When an insect lands in the digestive fluid, the plant responds and there is a marked increase in the acidity as glands are stimulated to produce the digestive enzymes.

Pitcher plants grow where nutrients are scarce in marginal habitats such as bogs or as epiphytes up in trees. In such habitats they are able to compete well because they obtain most of their nutrients by breaking down the insects with the help of bacteria and various other insects that live in their pitchers—strangely, while the pitcher is designed to trap and digest insects, other insects are adapted to live there without being dissolved and digested. Roger Beaver of the University of the South Pacific found that seven different species live in the Malaysian pitchers, including the larvae of two species of mosquito, a midge, a hover fly, a scuttle fly, and two anoetid mites. The community of animals that live inside the pitcher process the detritus that accumulates and so release nitrogen for the plant to absorb. The phial pitcher (*N. ampullaria*) has the strangest lodger of all, a small crab that is about ½ inch (1.5 cm) long and has a red belly and a mottled green-and-black back. There is never more than one crab in a pitcher.

To prevent the liquid in a pitcher from becoming stale and fetid and unable to sustain the life of the fauna that occupy it, the pitcher plant has evolved a mechanism to oxygenate the water. There are cells lining the pitcher that are richer in chlorophyll than the outer cells and are adapted to secrete oxygen directly into the liquid within the pitcher. This wonderful balanced ecosystem produces a well-oxygenated environment in which the well-adapted, beneficial organisms can live.

*N. bicalcarata,* from Borneo, seems to have a problem with digestion and has evolved a novel way in which to get rid of excess insect detritus in the bottom of the pitcher. Australian scientists C. Clarke and R. Kitching from the University of New England have recently shown that small ants make their home in the tendrils that bear the pitchers of this species. The ants are able to swim in the digestive liquid of the pitcher with no apparent harm, yet they rob the plant of its larger prey. The scientists wondered why the plant did not starve from a shortage of vital nutrients stolen by the ants. But when they removed the ants from the plants, they found that the pitchers began to rot. Pitchers stayed green only when the ants were present to carry out their work as collectors of the excess waste. These garbage collectors turned out to have a second vital function for the pitchers. When the pitchers are attacked by any other insects, the ants rush under the rim of the pitcher, and in a frenzy they produce a series of loud clicking noises that scares away the predator. The ants also feed on the nectar produced around the rim and are so contented with

life in a *Nepenthes* pitcher, provided with insects to eat and sweet nectar to sip, that they have never been found in any other place. This sophisticated mutualism feeds the ants well and protects their pitcher homes in two different ways.

# THE BUCKET ORCHID

Not all plant reservoirs serve the purpose of trapping and digesting insects. Perhaps one of the most remarkable of all of nature's water pots is that of the Neotropical bucket orchids (*Coryanthes*). The flowers of this orchid have an extraordinarily complicated structure, with the labellum (the lower petal) adapted to form a small fluid-holding pot with a knoblike gland above that drips a fluid into it. The pot is filled to a depth of about $\frac{1}{4}$ inch (5 mm). Orchid bees (Euglossini) are attracted by the scent of this orchid and attempt to gather oils from the area of the gland. However, as in the pitcher plant, the surface of the flower around the gland is waxy and slippery and many of the bees fall down into the fluid. The design of this bucket is such that the struggling bee can escape. After immersion in the liquid, the bee desperately scrambles onto a step at the mouth of a small exit tunnel on the side of the bucket. As the bee attempts to emerge from the tunnel, the orchid attacks again. It snaps the mouth of the tunnel shut and traps the poor bee, but at the same time, it firmly fixes a pollinium (a mass of pollen) onto the bee's back. After a few minutes the bee is released and flies off, carrying its load of pollen. What is amazing is that bees repeat this performance and endure the same experience time after time. When a bee already has a pollinium on its back, the orchid will collect it onto a conveniently placed hook in the roof of the escape tunnel. If the flower has not been previously visited, the emerging bee will then be presented with a new pollinium to carry on to yet another orchid flower. The *Coryanthes* orchid has one of the most sophisticated and complicated of all mechanisms for transferring pollen from flower to flower.

# SOURCES OF WATER

It is not just plants that suffer from water shortage in the dry season in a rainforest. People can also wander far from streams, and survival can depend upon a knowledge of the resources in the forest, most of which were originally discovered by indigenous peoples around the world. In most rainforests, in addition to the water tanks of terrestrial bromeliads, there are other sources of potable water. For example, in the neotropics aerial vines of the dillenia family (Dilleniaceae) offer an abundance of water. When a 3-foot (1-m) length of a vine such as *Doliocarpus coriacea* is cut and held up, a steady flow of water is produced. In a similar fashion, one can obtain water from the aerial roots of some species of *Cecropia* trees.

# Fire

∿∿∿∿∿∿∿∿∿∿∿∿
∿∿∿∿∿∿∿∿∿∿∿∿

LIGHT, WHICH IS THE BASIC SOURCE OF ENERGY FOR life on our planet, is derived from a huge fire, the sun, that is a mass of hydrogen and helium producing nuclear reactions that are the source of the sun's energy and consequently energy for life on Earth. One of the most important factors in rainforest ecology is the influence of light and the adaptations of different organisms to different light conditions. Since the availability of light determines so much of rainforest ecology, it opens this section on fire.

quantity of radiation reaching the canopy of the rainforest varies according to the degree of cloudiness. The canopy of a typical rainforest will receive between 25 and 100 percent of the insolation. The abundance of light throughout the year during approximately twelve-hour days, combined with the constant warm temperatures, produces the exuberant growth of tropical rainforest.

A temperate-region forest receives about half the amount of insolation of a tropical forest, so it is hardly surprising that there is a difference in its composition and diversity and that it grows much more slowly.

## LIGHT

The tropics, by virtue of their position on our globe, receive about two and a half times more solar radiation than the polar regions. The precise

The luxuriant rainforest growth forms such a dense canopy that only between 1 and 3 percent of the sunlight reaches the forest floor. This difference in light intensity between the canopy and the forest floor accounts for many of the strategies evolved by plants in their quest to secure enough light to survive.

*PREVIOUS SPREAD: Most rainforest plants have rather dull-colored green flowers and fruits. The exceptions stand out and add to the beauty of the forest. These showy flowers are adaptations to attract specialized pollinators. Erythrina, or the coral tree (Erythrina sp.), derives its name from the Greek word* erythros, *meaning "red." The red flowers of this striking tree from Uganda attract bird pollinators.*

*FACING PAGE: Sunlight through the trees of the Monteverde Cloud Forest Reserve, Costa Rica.*

# STRATA

ABOVE: *A rainforest stream-bed flowing over a rock outcropping in the West Highlands of Papua New Guinea.*

PREVIOUS SPREAD: *This black vulture* (Coragyps atratus) *obscures the setting sun over the rainforest of Amazonian Brazil.*

The competition for light among the different plants of a rainforest is really the driving force that determines the vertical structure. Flying over the tropical rainforest, one can see a green carpet of rather even height but with the fascinating variety of shapes of the different species that form the canopy. However, towering above this level there are usually some forest giants known as emergents, so called because they grow so tall that they greatly exceed the canopy level. In Borneo the emergents are likely to be species of the dominant plant family, Dipterocarpaceae (for example, species of *Shorea* or *Dipterocarpus*), or the real rainforest giant, *Koompassia excelsa,* of the legume family, which has been recorded as tall as 275 feet (84 m) in the forests of Sarawak. In the Amazon rainforest the leguminous tree *Dinizia excelsa,* which can reach 200 feet (60 m) in height; the Brazil nut (*Bertholletia excelsa*); and the kapok tree (*Ceiba pentandra*) of the riversides are good examples of emergent species.

The canopy and the emergent species are easily distinguished by even the casual visitor to the rainforest, but what happens beneath has been the topic of extensive debate among vegetation ecologists. In 1952 Professor Paul W. Richards published his landmark book (of which a welcome second edition was published in 1996, shortly after his death) on tropical rainforests that was based mainly on his own observations in Guyana, the Malay Peninsula, and Nigeria. One of his most interesting suggestions was that the forest is vertically stratified into five layers, which he labeled A, B, C, D, and E: A being the emergents; B the canopy; and the three further strata representing the vegetation under the canopy, the E layer being the herbaceous layer on the forest floor that is also full of tree seedlings. This proposal has given rainforest ecologists something to argue about ever since, the reason being that strata are easy to see in some forests and hard to discern in others. Whether or not there are five strata in a particular forest, there are always trees growing at different levels under the canopy of a rainforest. When one looks upward from the ground toward the sky, one is usually looking through the branches of several different trees at different levels. The density of these branches is the reason that very little light reaches the forest floor.

The trees at different levels of a rainforest tend to have different-shaped crowns. Professor Richards also observed this and pointed out that emergent trees tend to have crowns that are broader than deep, while the B layer just below has crowns that are deeper than broad. Since the emergent species are huge trees and therefore require a lot of energy to maintain themselves, a broad crown gives these trees a wide area over which the leaves can gather their high-quality light. Once they have reached above the canopy, the emergents are usually scattered and so they also do not have to compete closely with each other, as do those of the canopy. The trees growing under an emergent are shaded during the noonday sun. However, direct light often reaches them when the sun is lower on the horizon. The deeper crown of the canopy trees consequently is probably an adaptation for the efficient absorption of low-angle light. Progressively lower under the canopy, the light intensity is greatly reduced and in some places is only 1 percent illumination. It is so dark that some people suffer from claustrophobia after a few hours in the rainforest. It is also extremely difficult to take photographs on the forest floor. The plants that live in this shady habitat are termed skiaphilic (meaning "shade loving") and include many ferns, mosses, and liverworts. Direct sunlight reaches the forest floor only in tiny patches and only for a short time in any one place. These sunflecks are vital for the survival of some plants. The rest of the light that reaches the forest floor is transmitted through leaves or reflected from leaves, trunks, and branches and has different spectral qualities from the direct light of sunflecks. The sunflecks give enough light for the forest-floor plants to photosynthesize.

PAGE 96, TOP: *Rainforest in the Rio Bravo Conservation Area, Belize.*

PAGE 96, BOTTOM: *Lichens are common in the rainforest and are a mixture of a fungus and an alga growing together as a single organism. They are often brightly colored, like these from the state of Nariño, Colombia.*

PAGE 97: *Canopy view in the Sucusari Nature Reserve in Peru. Many epiphytes grow at this level where there is more light.*

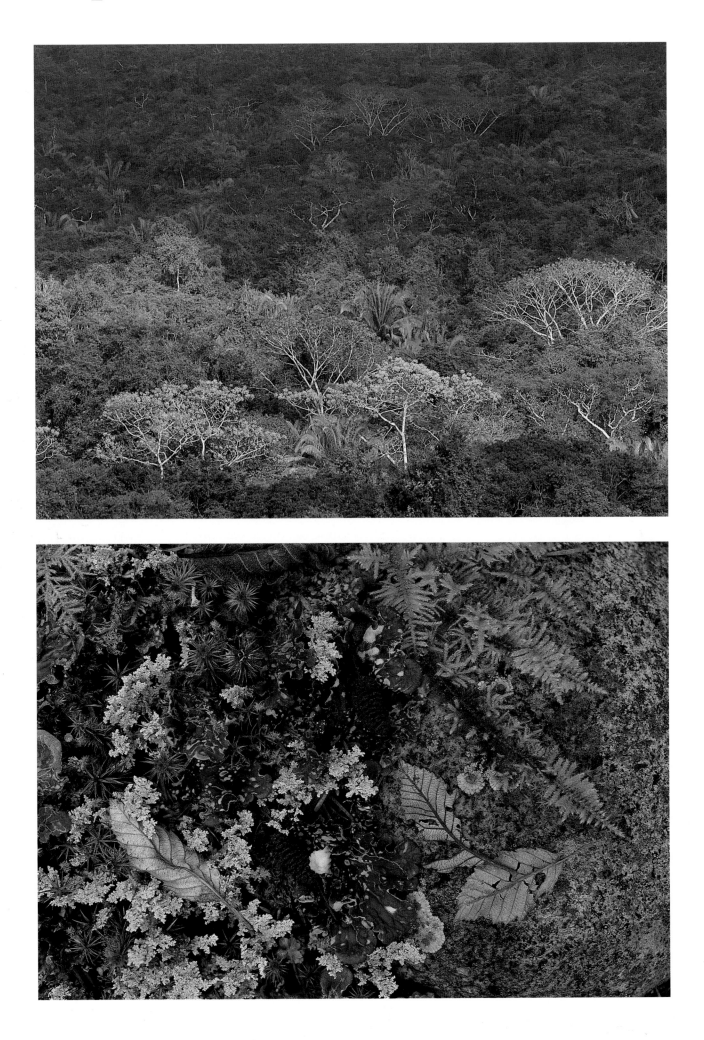

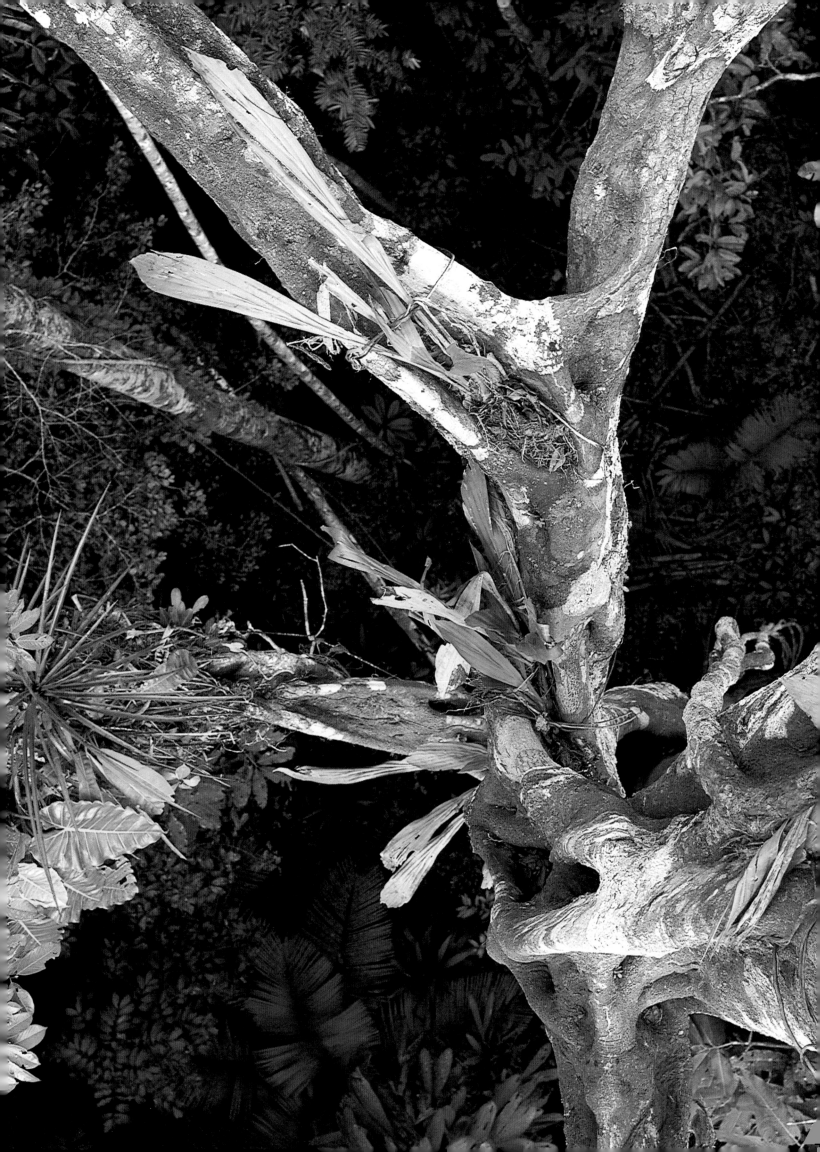

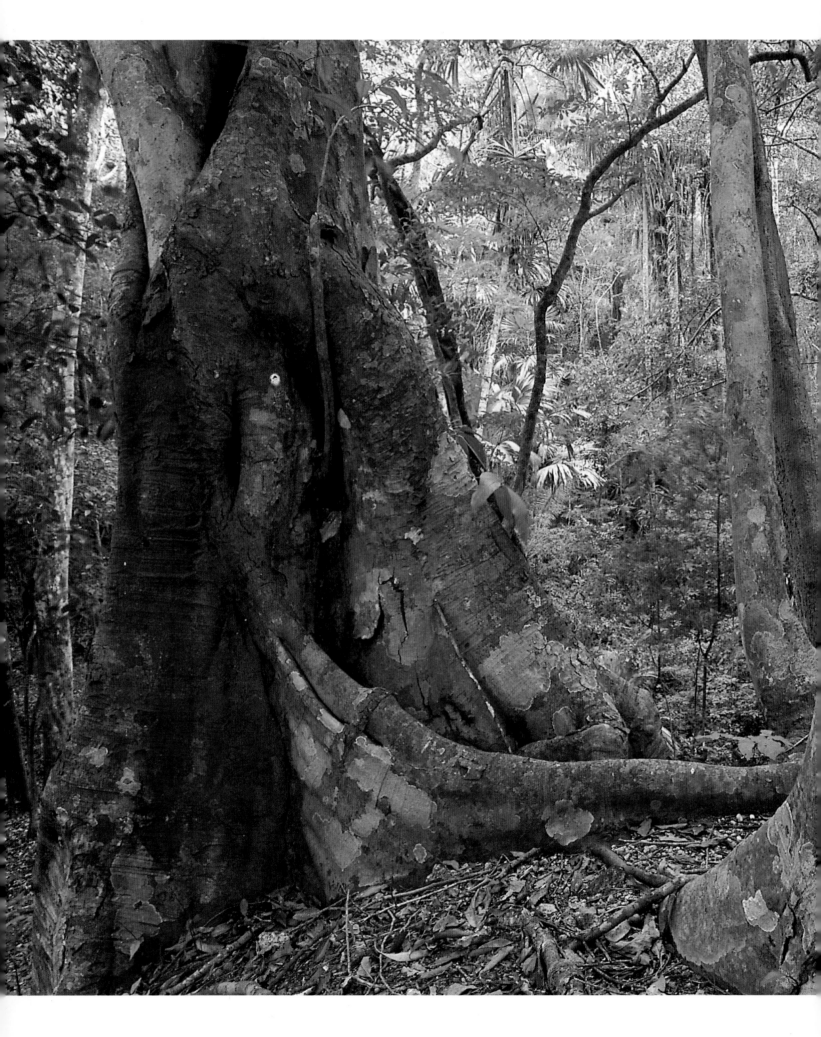

LEFT: *The lower level of the forest of the Rio Bravo Conservation Area in Belize, where only less than 5 percent of the total light penetrates the dense canopy above.*

PAGE 100: *The layer of small trees, in this case a tree fern. Trees and shrubs found at this level in the forest are adapted to grow in low light intensity.*

PAGE 101, TOP: *The rainforest floor in Barro Colorado Island, Panama, showing a buttressed tree. These plant buttresses help to support the trees that have very shallow root systems.*

PAGE 101, BOTTOM: *A view from the ground looking up the trunk of a giant rainforest tree toward the light above.*

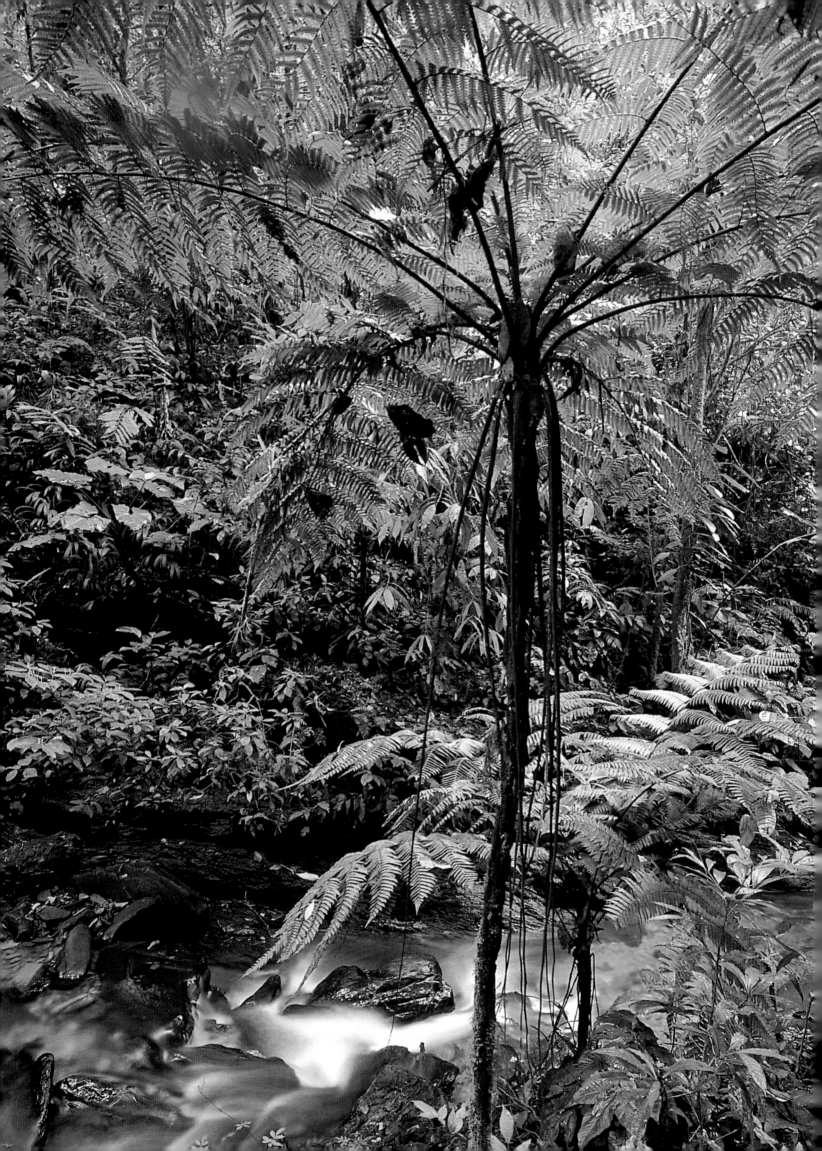

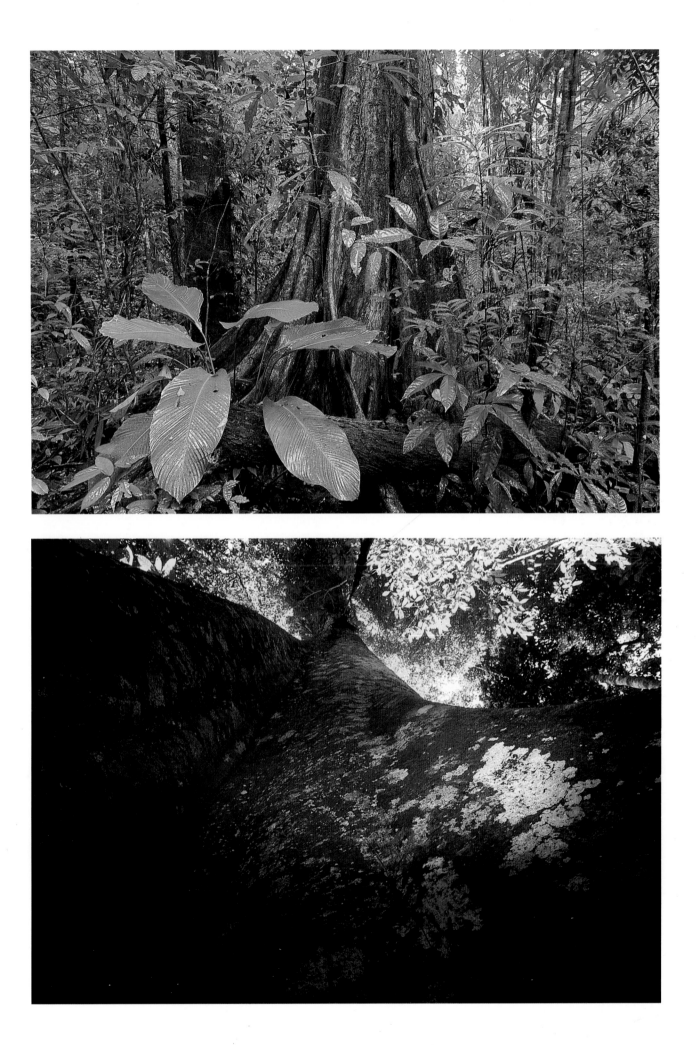

# ANIMALS IN THE STRATA

The variety of strata and the diversity of plant species that occur in each stratum create a wide range of habitats for the rainforest animals. There are different animals and different interactions between the animals and the plants taking place at the various levels. Numerous species of animals have evolved to live in the rainforest canopy, where there is an abundance of flowers, fruits, and leaves to eat. For example, most species of monkey are arboreal and seldom descend to the forest floor. Some animals remain at the same level in the forest for much of their existence, whereas others such as the coati move between the different layers. Still others spend one part of the day at one level and another at a different level. In the forests of West Africa the nocturnal, insect-eating pygmy bush babies are found in the canopy, but beneath them the needle-clawed bush babies leap from tree trunk to tree trunk in search of fruit. In the South American rainforest the giant anteater (*Myrmecophaga tridactyla*) is entirely ground-dwelling and roams around the forest floor hunting for termites, while the tamandua, or lesser anteater (*Tamandua tetradactyla*), exploits both the forest floor and the trees. The pygmy anteaters (*Cyclopes didactylus*) are arboreal and forage for termites at a higher level. To feed, all anteaters open termite and ant nests with their sharp claws and then extend their long, sticky, bootlacelike tongues into the nest to collect their food. Like the various

FACING PAGE: *The short-eared dog (*Atelocynus microtis*) roams the forest floors of the Tambopata River region of Peru. With its streamlined body and short legs, it looks more like a mongoose than a member of the dog family (*Canidae*).*

BELOW: *There are also members of the dog family that climb and hunt in the trees. This gray fox (*Urocyon cinereoargenteus*) is from Belize.*

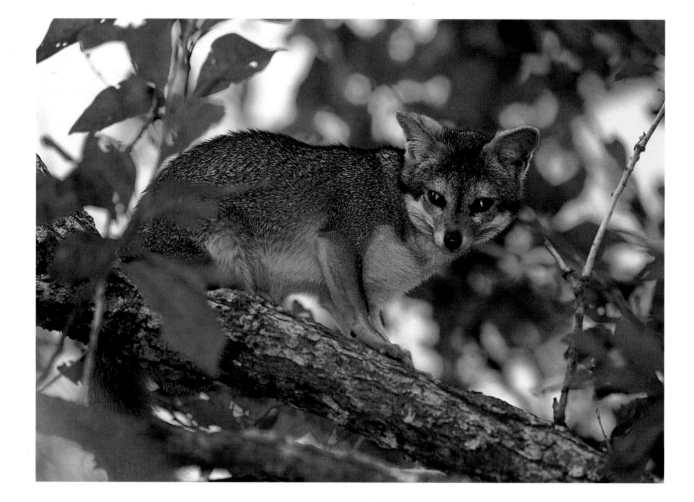

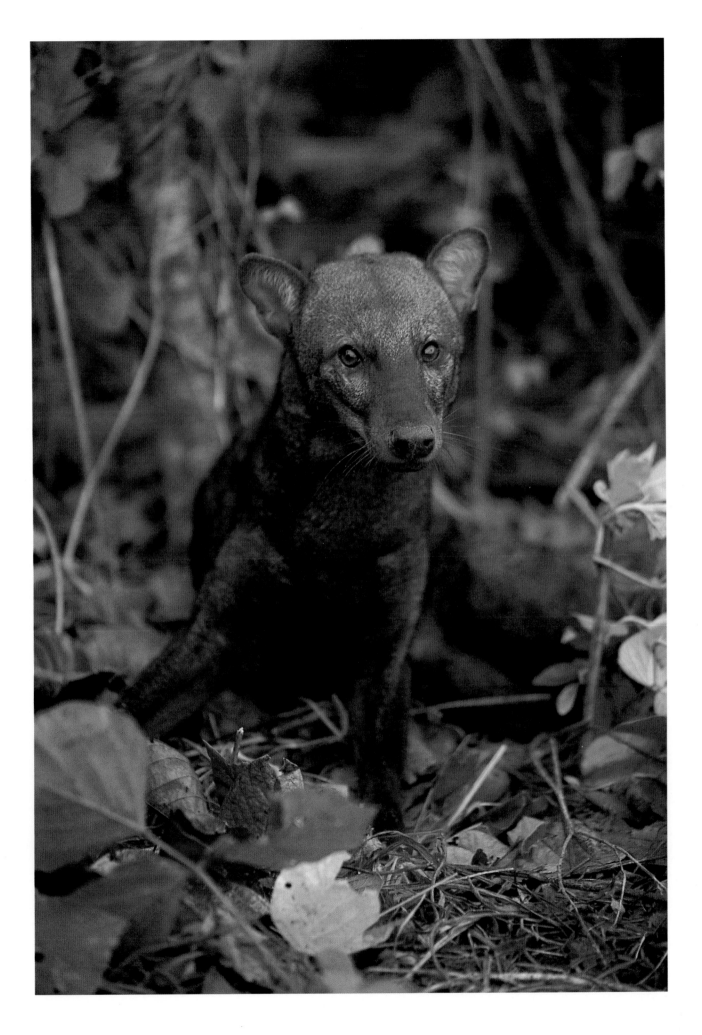

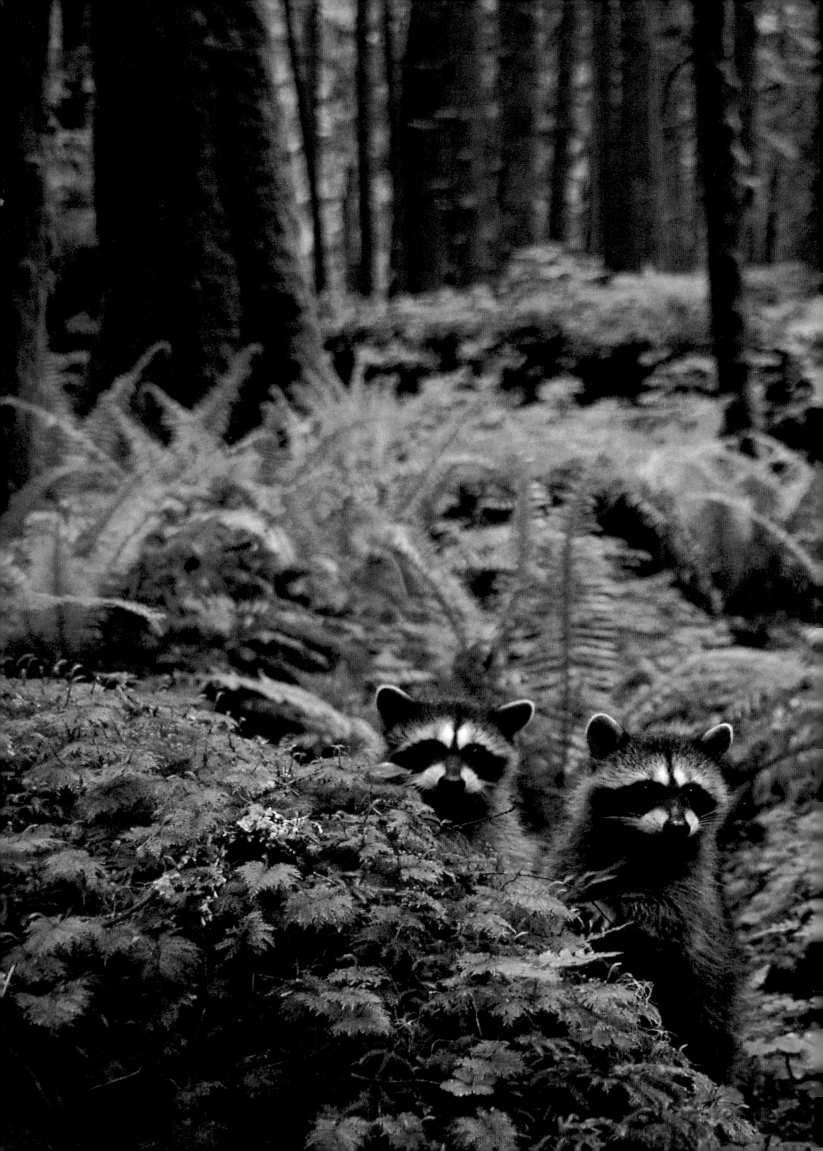

*Raccoons (Procyon lotor) are ubiquitous animals in the Americas and are found in both the rainforests of the Northwestern United States and the tropical rainforests of Panama.*

PREVIOUS SPREAD: *Raccoons in Olympic National Park, Washington State, USA.*

RIGHT: *Raccoons in the forests of Panama.*

BELOW: *A common nocturnal animal of the forest floors of the Amazon forest is the paca (Agouti paca), a rodent that lives in burrows in the ground. The adult can weigh up to 22 pounds (10 kg) and they are much hunted for their meat.*

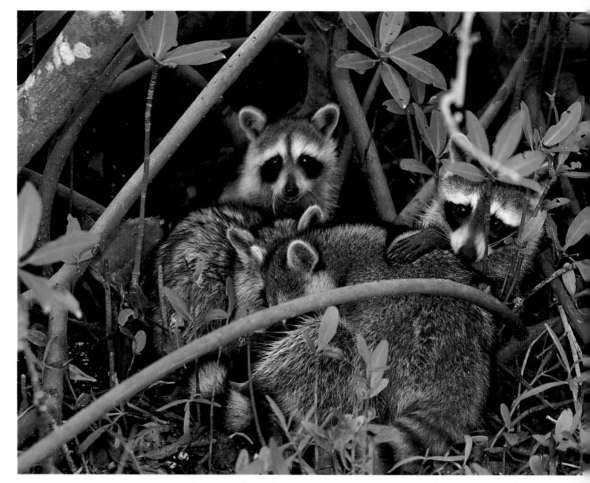

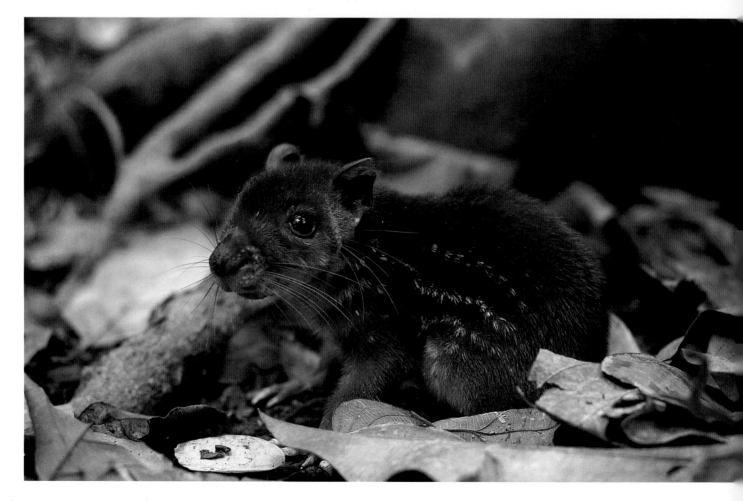

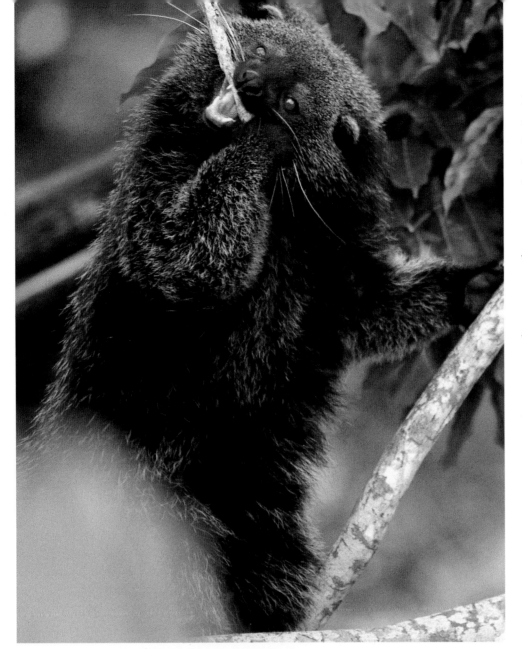

LEFT: *The binturong of Borneo* (Arctictus bintur-ong) *is a small carnivorous animal highly adapted for an arboreal life because of its prehensile tail.*

BELOW: *The Mustelidae family, which contains the weasels and polecats of the Old World and is related to the Procyonidae, or raccoon family, has several Neotropical rainforest species such as this tayra* (Eira barbara). *Tayras usually hunt in pairs, particularly at dawn and dusk, and eat mainly birds and small mammals.*

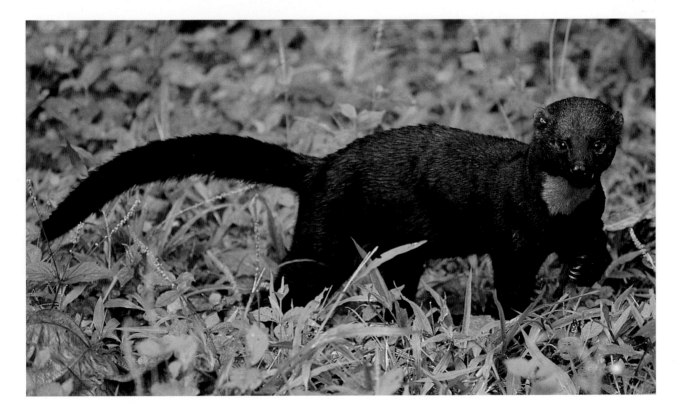

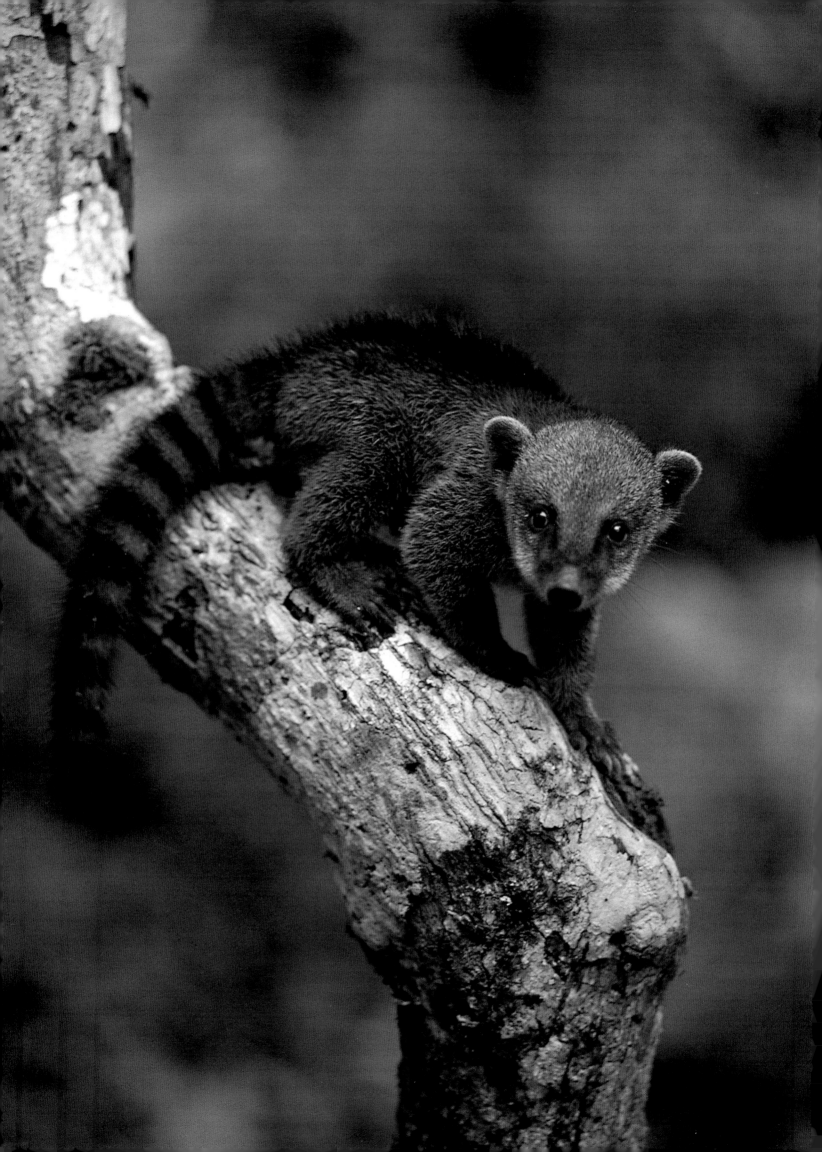

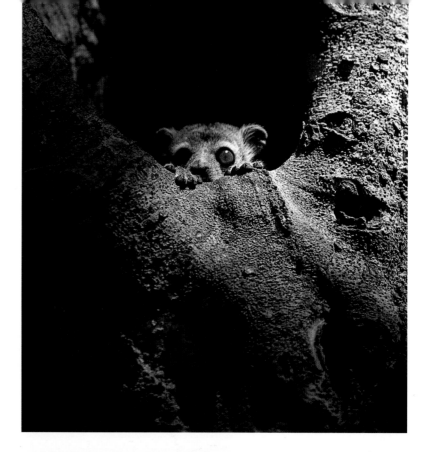

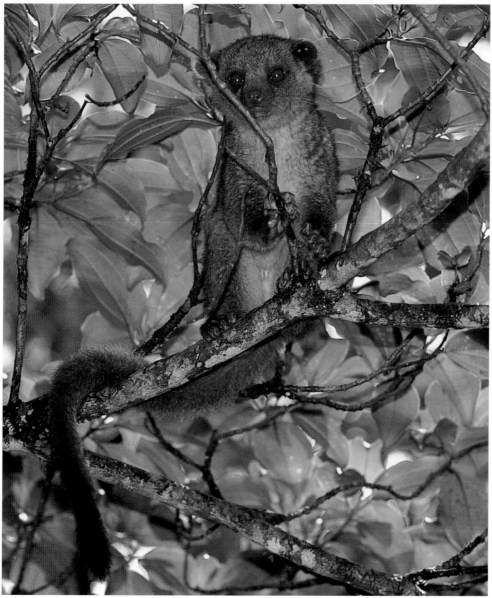

ABOVE: *Many forest animals find refuge in hollow trees. The white-footed sportive lemur (*Lepilemur leucopus*) lives in the few remaining gallery forests and dry forests of southern Madagascar. This is a solitary, nocturnal animal that feeds largely on leaves.*

LEFT: *This olingo (*Bassaricyon gabbii*) from Venezuela, a member of the raccoon family, is entirely nocturnal and lives in trees. It feeds mainly on fruit and builds its nest of leaves.*

FACING PAGE: *The coatimundis, fascinating animals with long snouts and banded tails, are related to raccoons. The common coatimundi (*Nasua nasua*), such as this immature one in Peru, can be found in large colonies in trees, eating berries, roots, snails, frogs, lizards, birds' eggs, and almost anything edible in the forest.*

*An adult coendu or prehensile-tailed porcupine* (Coendu prensilis).

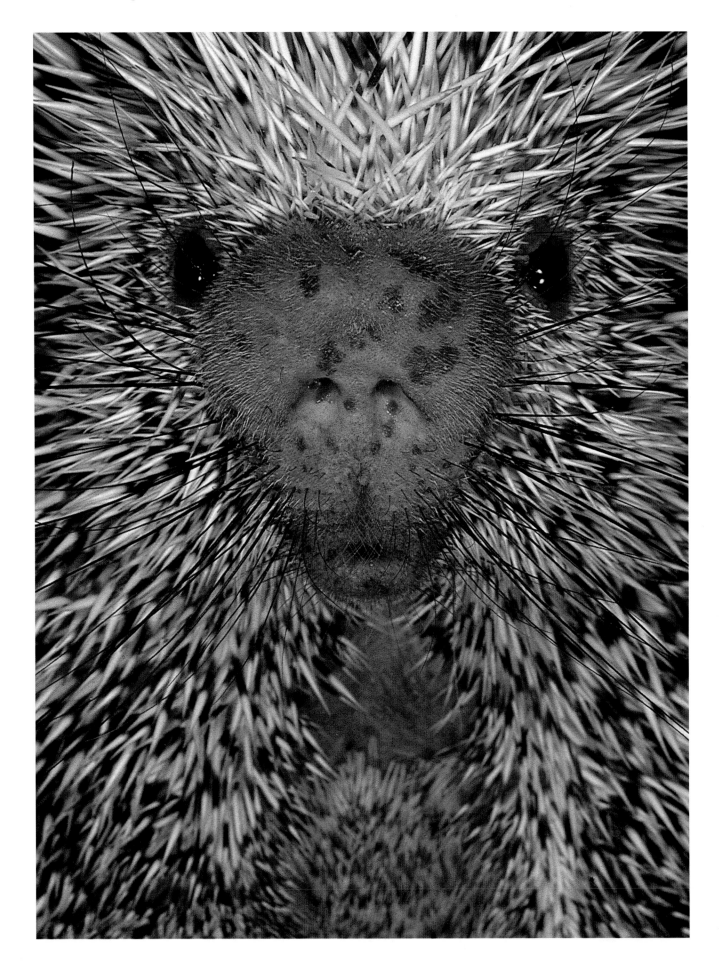

*Center of a beautiful orchid flower* (Dracula wallisii) *photographed in the state of Nariño, Colombia. The yellow object at the top is the pollinium or pollen mass, awaiting removal by an insect pollinator.*

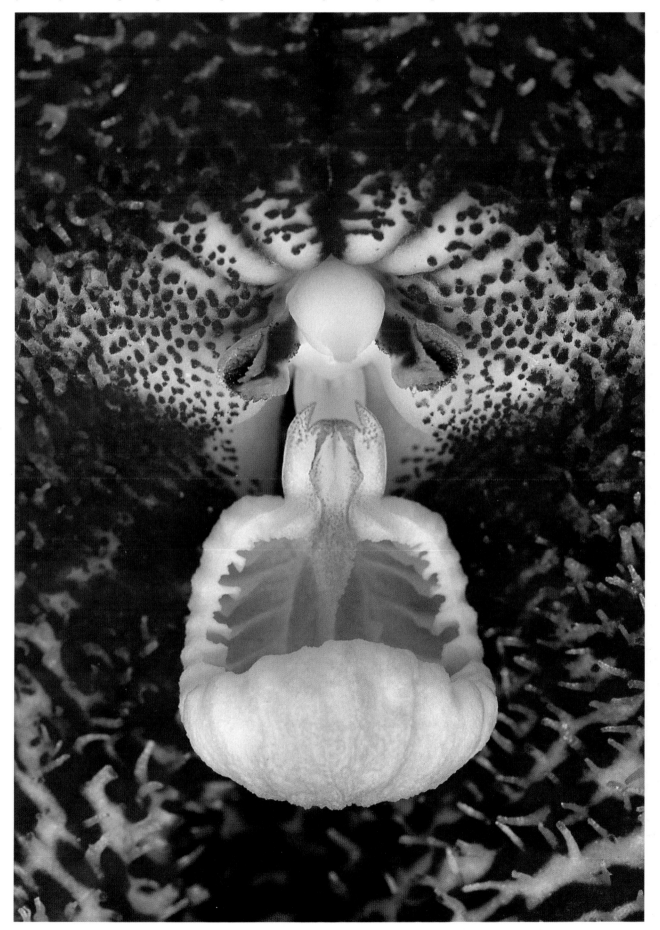

RIGHT: *The coendu, or prehensile-tailed porcupine* (Coendu prehensilis), *is a rodent that resembles the Old World porcupines but is not closely related to them. A tree-dwelling animal that seldom descends to the ground, its spines protect it physically and add greatly to its camouflage as it rests during the day on tree branches. The prehensile tail makes the coendu an adept climber.*

BELOW: *The lesser anteater* (Tamandua tetradactyla) *forages for termites both on the ground and in trees.*

*The giant anteater* (Myrmecophaga tridactyla) *is entirely ground dwelling and feeds largely on termites.*

anteaters, the South American opossum species live at different levels of the rainforest, each exploiting different resources so that they do not compete directly. The woolly opossum (*Caluromys*) and the ashy mouse opossum (*Marmosa*) inhabit the canopy, whereas the common mouse opossum (*Marmosa*) makes its home in the lower branches and the short-tailed opossum (*Monodalphis*) is terrestrial.

If you are a keen bird-watcher and you want to see all the species in a rainforest, you have to look at all levels of the forest and above it. For example, in the rainforests of South and Central America, one can see vultures, hawks, and swifts soaring high above the emergent trees. Toucans, macaws, eagles, parrots, cotingas, and cacique birds largely inhabit the canopy top and the emergent trees where the hawks and vultures also land to perch. Under the canopy in the C strata, woodpeckers, trogons, jacamars, and puffbirds are common. In the understory at eye level you are likely to see hummingbirds, ant birds, tanagers, flycatchers, and manakins, and on the forest floor tinamous, ground doves, and wrens.

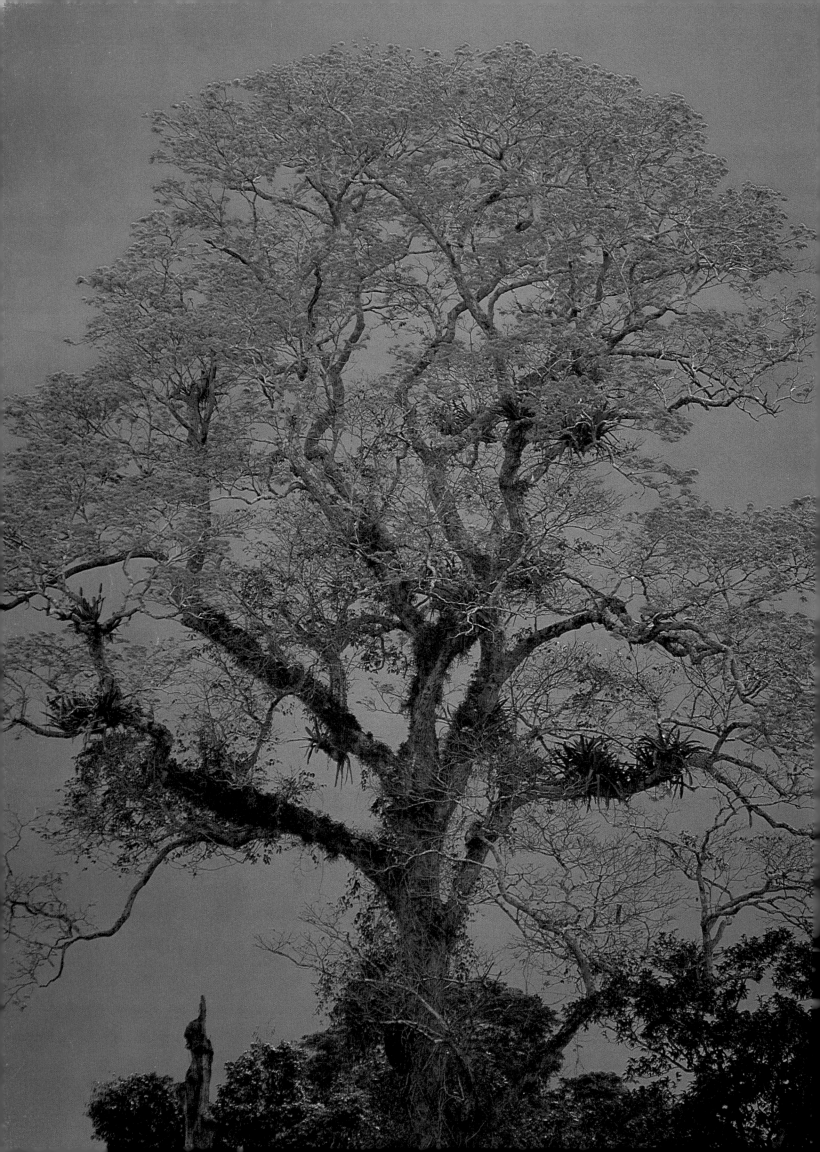

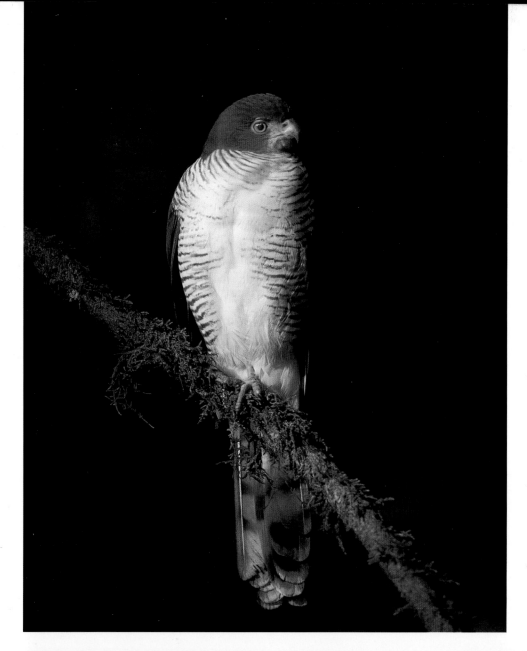

LEFT: *An African goshawk* (Accipiter tachiro), *which inhabits the lowland and riverine forests of East Africa. The male birds make a territorial display early in the morning by flying high with bouts of fast wing beats followed by glides during which they call "krit" at two- to three-second intervals.*

BELOW: *A violaceous trogon* (Trogon violaceus) *from the forests of Trinidad.*

FACING PAGE: *An emergent tree of ipe* (Tabebuia) *in the Tambopata region of Peru. This tree is unusual for rainforest trees in that it is not evergreen. Instead, it sheds its leaves and then produces a spectacular show of pink flowers that attracts the insect pollinators to it because it can be clearly spotted above the forest canopy.*

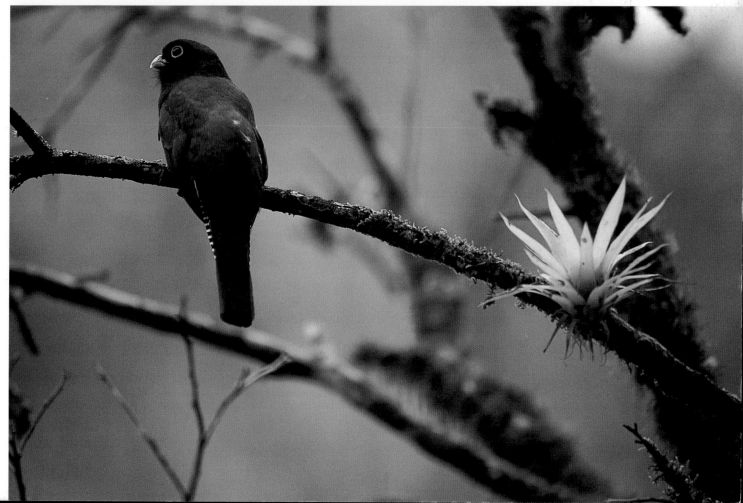

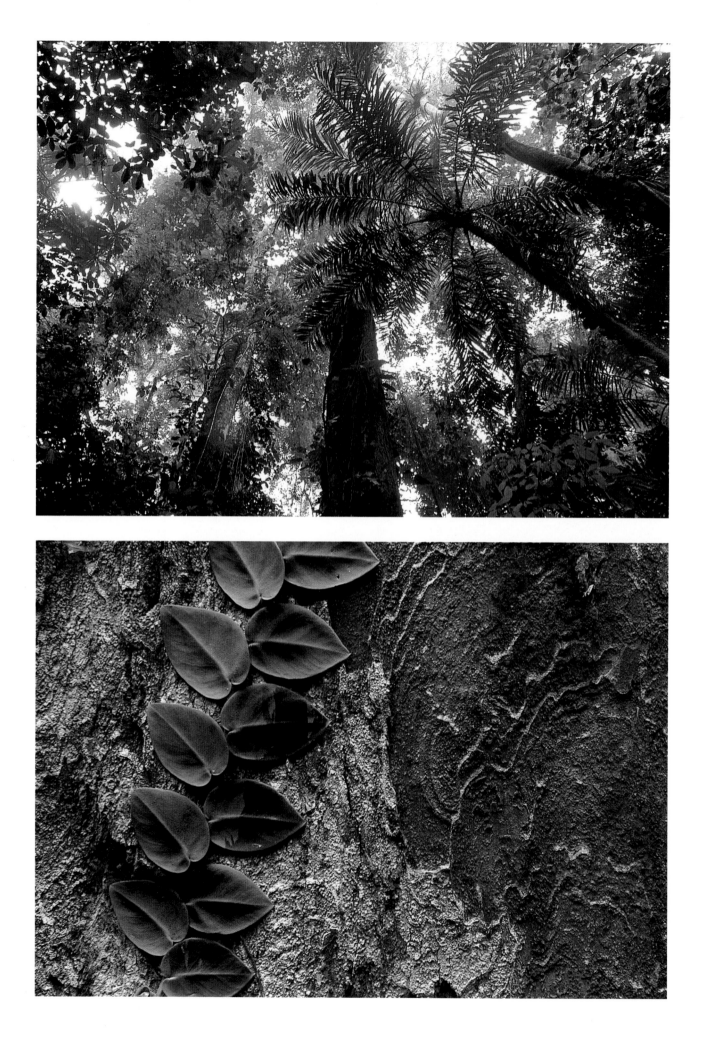

# SHADE-TOLERANT
# VERSUS LIGHT-DEMANDING

It has been shown that some of the species of trees in the rainforest are able to survive and grow slowly under the low light intensities of the lower levels, whereas others need a greater light intensity to grow. The latter are known as light-demanding or shade-intolerant species. Pioneer species of trees and shrubs that grow after a gap occurs in the forest are light demanding. Light stimulates the germination of their seeds and is available long enough for seedlings to grow rapidly and occupy the space. These pioneer species are then gradually replaced by shade-tolerant species because they are often unable to germinate in their own shade. This process ensures that when their task is fulfilled, the pioneer species are unable to replace themselves. Their life is a single generation in any one place, controlled by the availability of light. In contrast, many of the species of mature rainforest are able to germinate and establish themselves under the shade of the canopy. Some species are extremely shade tolerant, and after germination the seedlings continue to grow despite the low light intensity. Many of the species of the lower strata that never reach full sunlight have this ability. The seedlings of other species can remain more or less static for a considerable time but require a bit more light from a small gap in the canopy in order to be released into real growth. Some can remain in a state of semidormancy for many years. Other species such as the Brazil nut trees require a much greater quantity of light to be released. If a gap does not occur, these seedlings will eventually die. Light is therefore a crucial factor in the dynamics of the forest, and the gaps caused by tree falls are vital to the survival of many species. Ecologist Garry Hartschorn calculated that 75 percent of the tree species in a Costa Rican rainforest depend upon light gaps.

# LARGE LIGHT GAPS

In addition to the small light gaps that occur when a single tree falls or a large branch breaks off a tree, there is a surprising frequency of larger gaps in the forest. Brazilian botanist Bruce Nelson has shown that, even within the Amazon rainforest, windthrows that knock down a large number of trees are common during storms. He picked out lines of secondary forest on satellite images and found that these represented areas where the forest had been felled by wind. In the Far East in places such as Indonesia, cyclones are frequent, and in addition, earthquakes and volcanic eruptions can remove large areas of rainforest. Earthquake destruction is also common in the forests of Central America and Colombia. All this adds up to a lot of forest destruction through natural causes. Not surprisingly, there are species of trees that are adapted to the rapid colonization of these areas.

Easy seed dispersal is the prerequisite for any large-gap colonizer. The seeds of

FACING PAGE, TOP: *The rainforest canopy forms a dense cover and little light penetrates to the forest floor. Small gaps in the cover are important since they allow flecks of sun to reach the plants on the floor of this forest in Trinidad.*

FACING PAGE, BOTTOM: *Juvenile leaves of an aroid at Cape Tribulation in Australia.*

most large-gap species are dispersed by birds or bats that fly over these open areas and defecate the seeds in the gap. These species of plants tend to produce a substantial number of small seeds, because crucial to their success is rapid arrival in a gap before it is filled by a tangle of vines or even by the resprouting of the fallen trees. Another property of gap species is their ability to grow quickly to fill the available space.

In the neotropics the most common gap colonizers are species of *Cecropia*, relatives of the fig family (Moraceae) that are now placed in their own plant family, the Cecropiaceae. *Cecropia* species have long, catkinlike fruit clusters that hang down below the leaves and are easily accessible to bats and birds. It is not unusual to see large gaps or abandoned fields filled by an even mass of *Cecropia* trees, their large umbrella-like leaves rustling in the wind and revealing the pale green undersides that contrast with the dark green upper surface. However, there are many other large-gap specialists found in this region, including the beautiful blue-flowered *Jacaranda copaia,* which is often planted as an ornamental tree, and the exceptionally light-wooded balsa (*Ochroma lagopus*). The latter species demonstrates one of the other frequent properties of gap specialists: light, low-density wood. That is why balsa wood is so good for rafts (*balsa* in Spanish means "raft") or for constructing model aircraft. A gap colonist must concentrate on quick growth and not on building up a dense wood structure.

In Africa one of the most prevalent colonizer species is *Musanga cecropioides.* As the Latin name of this species suggests, it closely resembles *Cecropia* in both form and leaf shape. *Musanga* is a member of the fig family and so is closely related to *Cecropia.* However, in the Far East there is also a group of species that look very much like *Cecropia* and *Musanga.* These are the species of *Macaranga.* This genus is not at all closely related to the fig family but belongs to the spurge (Euphorbiaceae) family. Fast-growing, hollow-stemmed trees with an umbrella-shaped crown of large leaves to collect as much light as possible make ideal gap colonizers, which explains why these similar-looking trees have evolved in all three major areas of rainforest.

Another interesting parallel between *Cecropia* and *Macaranga* is that many species of both genera are inhabited by aggressive ants. Ants have adapted to life in the hollow, bamboolike branches and stems of these species. They also afford some protection to the trees both from leaf-eating insect predators and from vines. It has been shown that when a vine begins to twine around the trunk of a *Cecropia* tree, its ant inhabitants, of the genus *Azteca,* will nip off the growing point and thereby protect their home. *Cecropia* is even more helpful to the insects that it hosts. At the base of the leaf stalk there is a pad that produces small, glycogen-rich, capsulelike objects known as Müllerian bodies, named after the famous nineteenth-century German biologist Fritz Müller. These carbohydrate-rich bodies feed the ants. The energy that the plant expends to feed the ants is a small price to pay in return for the protection the ants offer. This is a good strategy for a fast-growing gap colonizer that

*Plant species have many strategies for reaching up from the forest floor to the light above. Many aroids, which belong to the skunk cabbage family, germinate on the forest floor and have juvenile leaves that cling to the tree trunks. Once they have taken the plant up to a position with more light, the adult leaves, which are completely different, develop.*

FACING PAGE: *Juvenile leaves of an aroid in Panama.*

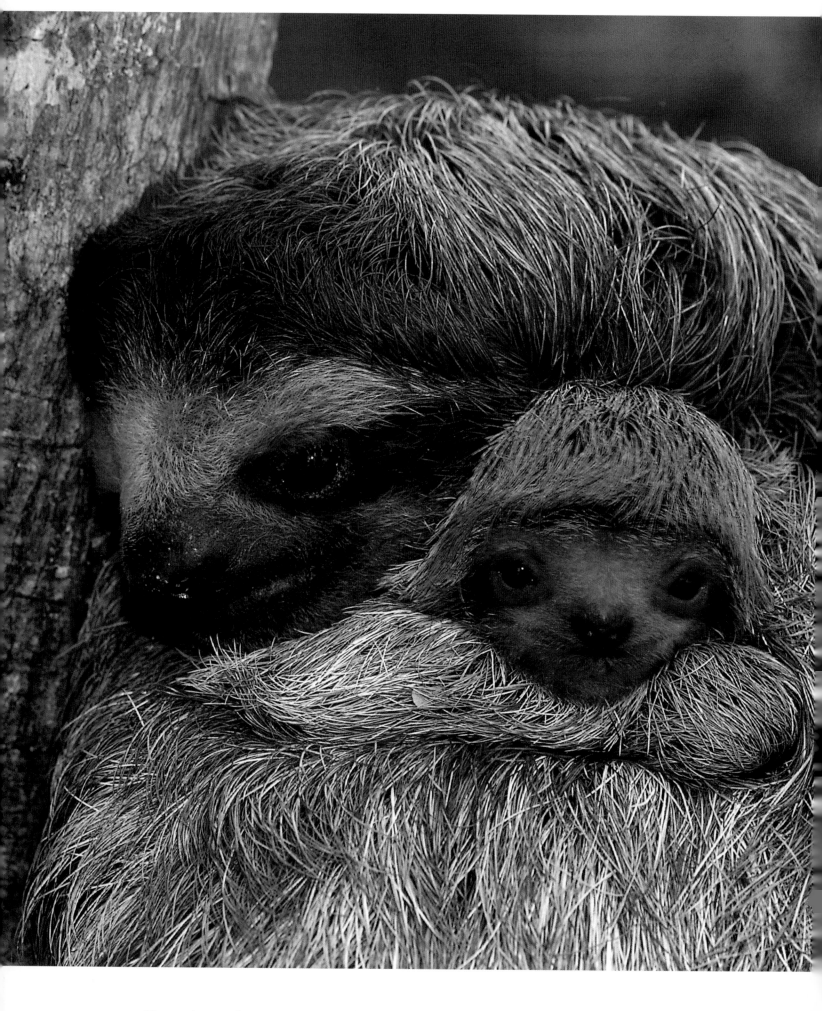

cannot afford to put energy into the production of chemical defense compounds. *Cecropia* leaves contain no toxic substances, which is why they are the favorite food of sloths, animals that are impervious to the presence of the *Azteca* ants.

When Hurricane Joan struck Nicaragua in October 1988, an area of 1.2 million acres (0.5 millon ha) of rainforest was destroyed. This was followed by a rapid colonization by *Cecropia* in parts of the region. Such a large area of *Cecropia* appeared so quickly that there were too many trees for the *Azteca* ants to occupy, and by 1993 many of the trees had already died. The botanists who studied this event found that there was a much greater survival of the few *Cecropia* trees that were inhabited by their protector ants than of those trees that lacked ants. This was a clear demonstration of the benefit of the ants to the *Cecropia* trees. Such a large gap as that caused by the hurricane resulted in an imbalance in the population density of one of the partners in the mutualistic relationship, and so the *Cecropia* phase was shorter than usual.

There are many other gap-colonizing species, some of which occur on more than one continent. For example, *Trema micrantha,* a species of the elm family, is found on all three major continents (South America, Asia, and Africa) with tropical rainforest; it has small bird-dispersed seeds that resemble shot. In Africa and the Americas common colonizers are the many species of *Vismia* in the Hypericaceae, or St.-John's-wort family. It is not unusual to see pure forests of *Vismia* in the abandoned cattle pastures north of Manaus in central Amazonian Brazil. *Vismia* also has small bird-dispersed seeds. Many species of *Vismia* produce a sticky red sap or latex, which used to be used as a substitute for sealing wax, and hence the local name of the tree is the Portuguese word for sealing wax, *lacre.*

The function of all these fast-growing colonists is to occupy the space created by a gap and to form a dense cover of vegetation that eventually allows the mature rainforest species to grow under the shade to replace these pioneer species. An understanding of this natural process is vital to the restoration of forest to areas that have been destroyed by human activities.

# SLOTHS

As previously mentioned, sloths like to feed on the colonist species of *Cecropia.* These slow-moving creatures clamber through the forest at a leisurely pace. Of the five different species of sloth (family Bradypodidae) found in the Neotropical rainforests, the most common is the three-toed sloth (*Bradypus variegatus*). Sloths hang upside down in trees and seldom move, but they feed on large quantities of the leaves. The sharp, curved claws on each foot enable the sloth both to hang and to grip onto the trunk or branches of a tree. Sloths have round faces with attractive eyes and often appear to have a smile on their face. These winsome yet lethargic animals can turn their heads around a 270° radius, which perhaps offers extra protec-

FACING PAGE: *A brown-throated three-toed sloth* (Bradypus variegatus*) with young. Ordinarily carried on the mother's abdomen, the young sloth is dependent on her for mobility from birth to six months.*

tion against would-be enemies such as the harpy eagle. Their fur is shaggy and tan-colored, but it often has a greenish tinge caused by the green algae that grow in it. This probably helps camouflage the animal and protects it from the sharp eyes of large eagles, its main predators. Since a sloth spends much of its life upside down, its fur grows from its belly and hangs down over its sides. A mother sloth gives birth to only one baby at a time, and the baby spends its early months clinging to the fur on its mother's abdomen and being transported wherever she goes (which is not very far at the speed a sloth travels). Sloths do not feed exclusively on *Cecropia.* It has been shown that they eat the leaves of many other species of tree. Since they are so readily visible when they are in *Cecropia* and almost impossible to spot in other trees, naturalists have observed them much more in *Cecropia.* However, if you spot what appears to be a termite nest on the branch of a tree and then notice that it is furry, it is likely to be a sloth instead!

# NIGHT IN THE RAINFOREST

Many visitors to the rainforest avoid exploring at night because of their fear of aggressive animals or poisonous snakes or even being bitten by the malaria-carrying *Anopheles* mosquito. However, if you do not go into the forest at night, you are missing half of the creatures and many other wonderful experiences. There are dangerous snakes and many of the large cats are nocturnal hunters, but despite the fear this may engender, it is worth the minimal risk to venture into the forest at night. The rainforest at night is an experience that you will never forget.

## LUMINESCENCE

Even at night in the rainforest there is no absolute darkness, because many things glow. Often when one is camping in the forest, slung above the ground in a hammock, the whole forest floor beneath is incandescent owing to the presence of luminescent fungi in the rotting leaves. It can create a considerable eerie greenish light in the camp. I remember walking at night in the forests of the Xingu River in Brazil and to my amazement seeing a mound that was glowing all over as if it were a Christmas tree decorated with small candles. This was a termite mound and the luminescent termites were scattered all over its surface. The most common form of luminescence encountered in the forest is that of the firefly. There are often hundreds of these insects, which are actually beetles, flashing their bright white lights as a signal to attract mates. Each species of firefly has a different rate of flashing, so there is no confusion for a female seeking a mate. The male fireflies flash in unison, which is thought to be a form of protection from predators, since they would find it

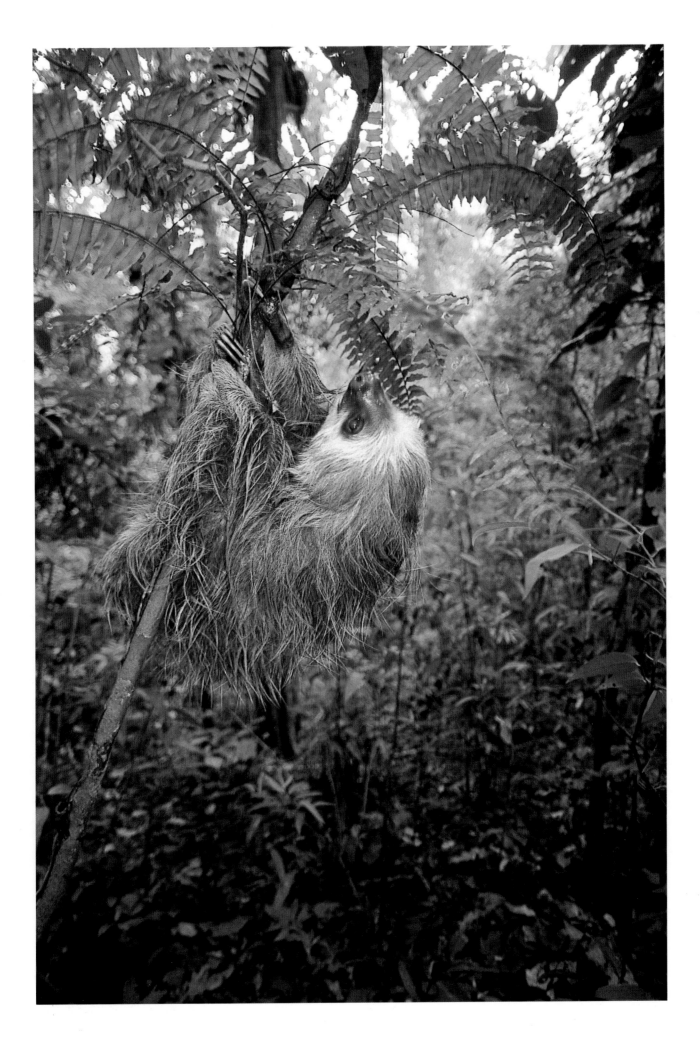

harder to locate an individual. Female fireflies are also luminescent and signal back to their mate. Entomologist Jones Lloyd discovered an even more amazing aspect of female fireflies: some predatory species can flash at the frequency of other species, and they use this property to attract them for their dinner!

## THE NOCTURNAL FAUNA

Just as the different layers of the forest are a resource to be divided among the different competing species of animals that inhabit the forest, time is another dimension that can be partitioned. Many animals that roam the forests during the day have relatives that are active at night. Since the resources required by day and night

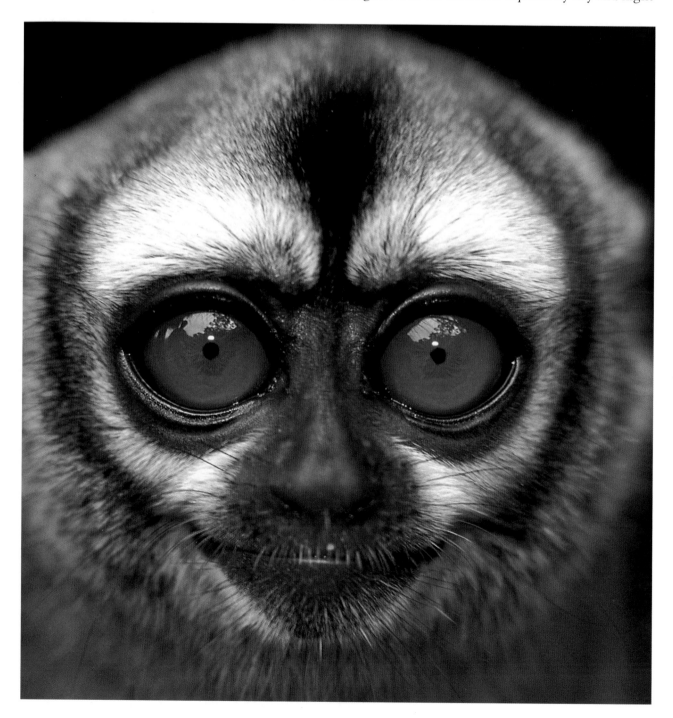

animals are usually quite different, the nocturnal animal is not directly competing with its diurnal cousin.

When I walk through the forest at night, I usually wear a headlamp instead of carrying a flashlight. This frees the hands for work or even to wield a machete. I soon discovered that the headlamp is also one of the best ways of locating nocturnal animals because so many of them have reflective eyes that twinkle back at you. There are reflectors up in the trees that may be from a kinkajou or an owl, beside the lakes from the caiman, and even the bright green or blue eyes of spiders in the bushes at eye level. Many nocturnal animals have a reflective layer behind the retina that casts back into the retina what little light there is. The result for the biologist walking through the forest and wearing a headlamp is that the reflection also comes

*The eerie structure of this orchid resembles a mask. This is* Dracula vinacea, *photographed in the Nariño region of Colombia. The elaborate structure of many orchid flowers have evolved to attract very specific pollinators.*

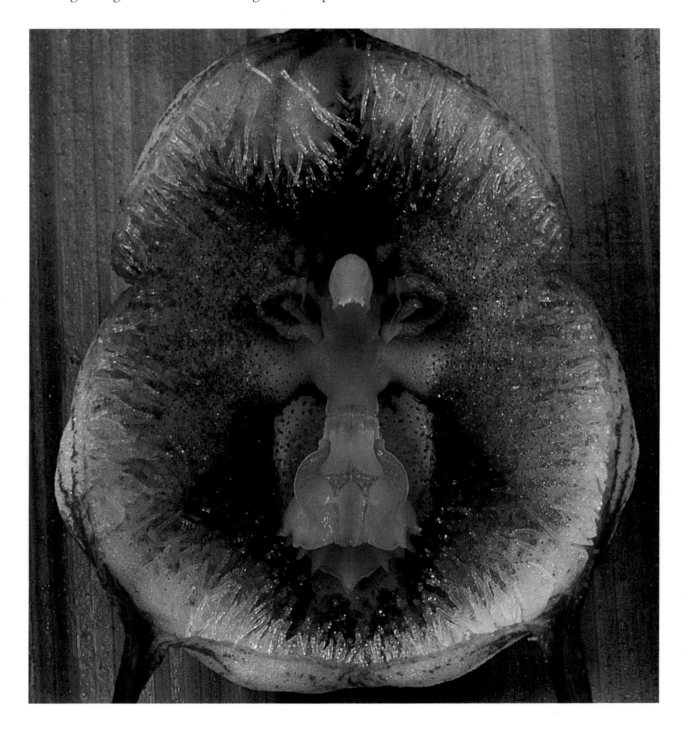

back. I will never forget drawing up to a riverside in a jeep in the world's largest wetland, the Pantanal of Mato Grosso. In this area, unlike in most of the Amazon region, caimans have not been excessively hunted and are still abundant. In the headlights of our jeep, it looked as if there was a large town on the far side of the lake with hundreds of red lights glowing in the darkness. Looking more closely, I could see that the lights were paired. Large ones, middle-sized ones, and small ones, but all were proof of the abundance of the spectacled caiman (*Caiman crocodilus*). Unfortunately, having such reflective eyes has also made the caiman and other nocturnal animals easy prey for the hunter. Many hunters go out at night and aim their rifles between the two red eyes of an unsuspecting beast. Hunting caimans is no longer permitted in Amazonia, but it has already drastically reduced the population of the various crocodilians such as the spectacled and the black caiman.

A favorite nocturnal animal of mine is the kinkajou (*Potos flavus*), with its long, prehensile tail. Since they have large, wide, forward-placed eyes, kinkajous are frequently mistaken for monkeys or called "night monkeys" by local people. Kinkajous are often to be seen foraging amongst the canopy branches of the forest trees. The real night monkey or dourocouli (*Aotus sp.*), a small monkey that is unique because it is the only truly nocturnal monkey in the world. These wide-ranging monkeys occur in forests from Panama to Argentina and are quite common, but difficult to observe, throughout Amazonia. Like other nocturnal mammals, it has large, dark eyes—which immediately distinguishes it from all other species of monkey. Night monkeys eat a diet of fruits and insects. They are not confined to one stratum of the forest but range from the canopy to the lowest branches of small trees in their quest for food. However, for safety they roost during the day, in family groups, in hollow trees. Like many other nocturnal animals, they emit loud calls at night that serve to keep the group together.

In the forests of Borneo a fascinating nocturnal animal is the armor-plated pangolin, which feeds mainly on ants. Although not closely related, it has filled the niche that anteaters occupy in the Neotropical forests. The pangolin also has a prehensile tail, a useful tool for tree-dwelling animals. Instead of fur, the pangolin's exterior is covered with scales resembling those of fish. Scales must be a much better protection against ants than the wiry fur of an anteater. Pangolins, like their terrestrial cousins the armadillos, can curl up into a round ball in defense against a would-be predator. Like anteaters the pangolins have strong claws that enable them to rip open ant and termite nests, and they also have a long snakelike tongue for gathering up the ants.

Strange sounds emanate from the rainforest at night. In the neotropics, as dawn approaches one is likely to hear the unearthly echoes of a troup of howler monkeys (*Alouatta*). This well-named beast marks its territory by howling. The males have a resonating box in their throats that helps produce a ghostly noise that can sound

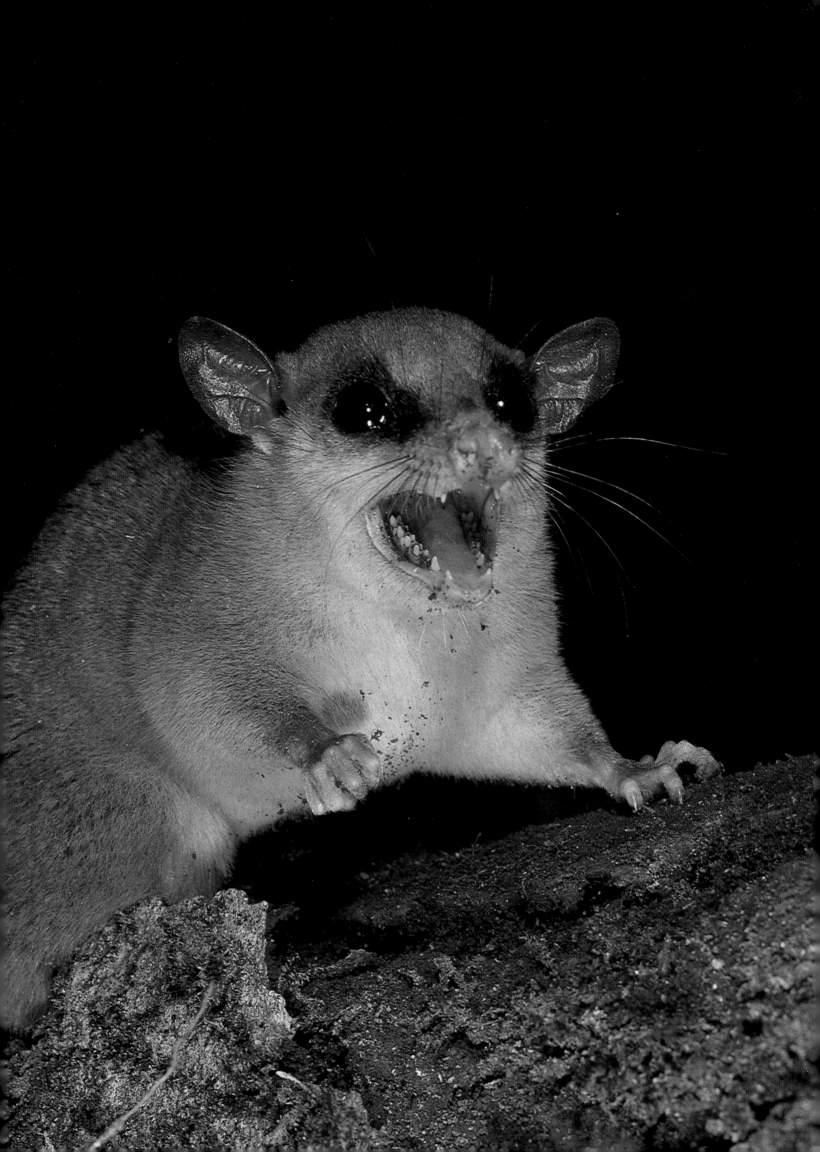

like a flight of jet planes and that carries for long distances through the forest. When there are several troupes in an area, the noise can echo from many different directions as each troupe demarcates its territory. Howlers are also unusual among monkeys because their diet consists mainly of leaves. In Africa an equally eerie sound effect through the nocturnal forests is created by the tree hyrax (*Dendrohyrax sp.*), which produces a bone-chilling screeching sound not unlike that emitted by a hysterical human. The succession of screams become increasingly rapid and louder, ending with a screech of panic. In the forests of Borneo the distinctive sound of the tiny barking or muntjac deer (*Muntiacus muntjak*) resonates through the forest. This sound seemed to carry for miles when I was standing on the top of a small mountain in Brunei and the deer were barking below in the forest.

People expect to be overwhelmed by mosquitoes at night in the rainforest. In actual fact, there are seldom large clouds of mosquitoes in the middle of the night. On the forest floor they are worse at dusk and dawn. Only when I have been up in

*A potto (*Perodicticus potto) *from West Africa.*

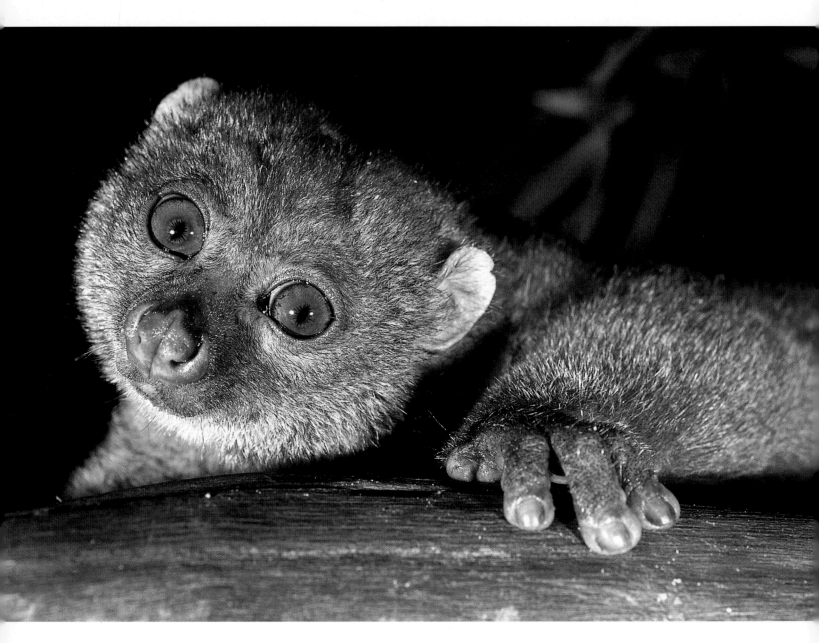

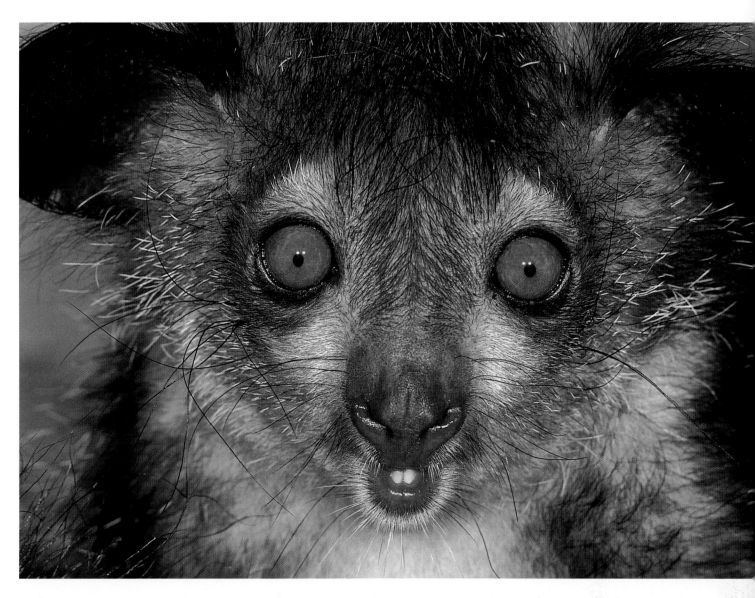

the canopy at night or working in a lake to observe the pollination of water lilies have I been covered with mosquitoes in any way comparable to what is experienced at northern latitudes.

*The aye-aye* (Daubentonia madagascariensis) *from Madagascar.*

Another presumption is that snakes abound at night in the rainforest. Many of the forest snakes are nocturnal, but it is unusual to see more than one or two snakes in a night out in the forest. It was, however, rather disconcerting when a 15-foot- (4.5-m-) long anaconda came through our camp one night and passed directly under our hammocks! Perhaps the nocturnal snakes that are to be found most commonly are the pit vipers of the neotropics and the Far East. These snakes are well adapted to night life because they have a special sensory organ in a pit between their eyes and nose that is sensitive to infrared radiation rather than visible light. This enables them to detect the exact location of any warm-blooded prey from its body heat. As a result, they are then able to strike and kill their prey in the dark with extraordinary accuracy. Nonvenemous boas and pythons also have heat detection organs called labial pits (located on their lips instead of their face) that are used to detect warm-blooded prey.

Of all nocturnal animals, the bats are the best equipped for life in darkness.

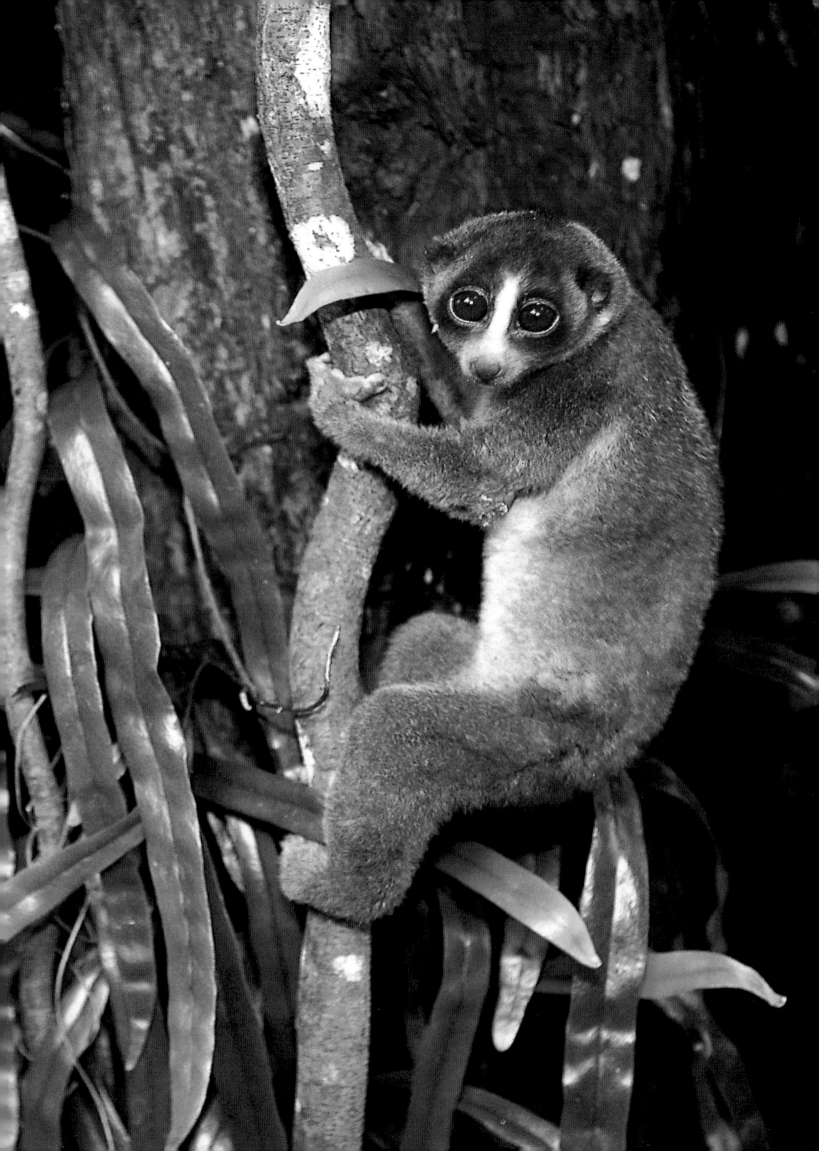

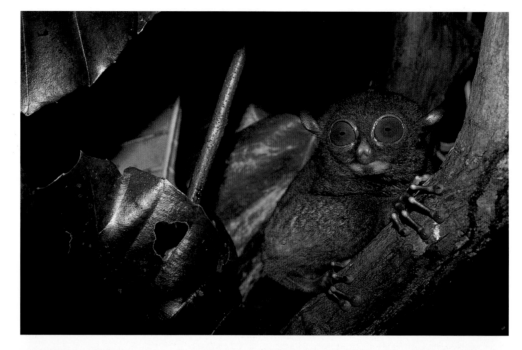

PREVIOUS SPREAD: *A slow loris* (Nycticebus cougang) *from Borneo.*

RIGHT: *A Horsfield's tarsier* (Tarsius bancanus) *from Southeast Asia.*

BELOW: *A greater dwarf lemur* (Cheirogaleus major) *from Madagascar.*

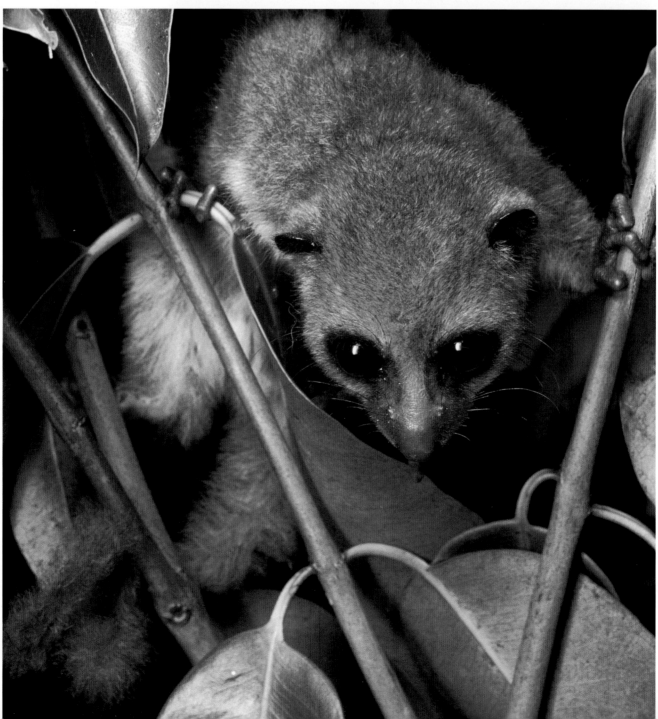

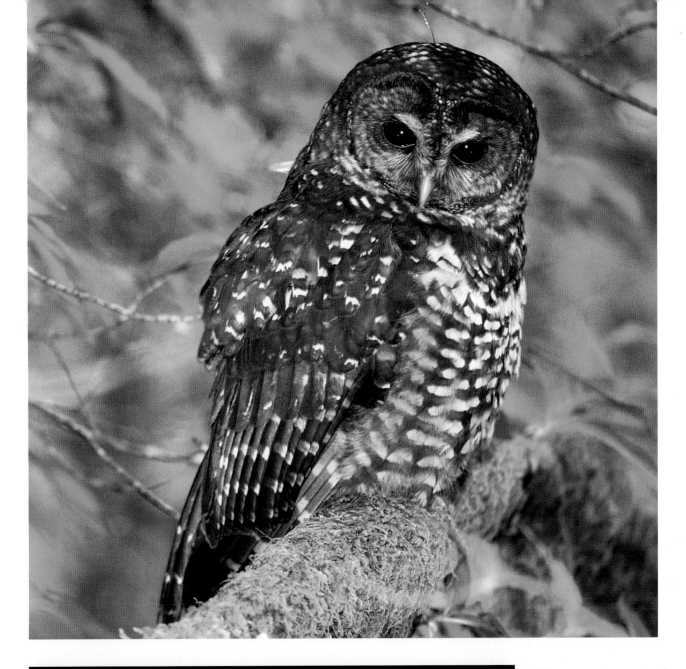

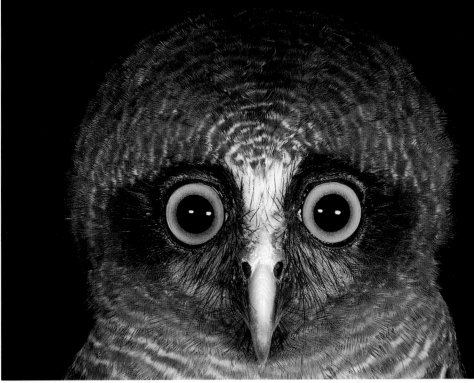

*There are various species of owls in rainforests.*

ABOVE: *A spotted owl (*Strix occidentalis) *from the forests of Washington State, USA.*

LEFT: *A rufous owl (*Ninox rufa) *from Australia.*

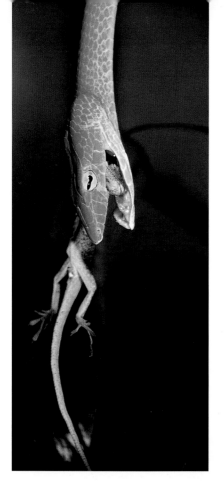

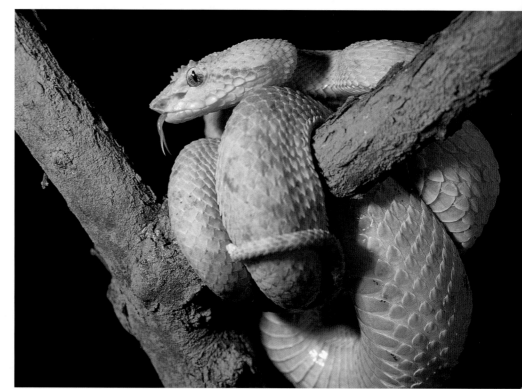

*Snakes climb the trees in rainforest and can be found at all levels from the forest floor to the top of the canopy. One Amazonian snake lies in wait for bats near the flowers of bat-pollinated trees and seizes the bats as they come in to feed on the floral nectar.*

TOP LEFT: *An Asian long-nosed tree snake (*Ahaetulla *sp.) has caught a lizard (*Calotes *sp.).*

TOP RIGHT: *One of the poisonous tree snakes, an eyelash viper (*Bothrops schlegeli*) from South America.*

RIGHT: *A blunt-headed tree snake (*Imantodes lentiferus*) about to strike its anole prey in the Tambopata River region of Peru.*

These agile flying mammals are in fact not blind, as many people believe, but their main method of navigation is by echolocation rather than by sight. Their echolocation or sonar systems are so efficient that the bats can locate a flying insect by the echoes of ultrasonic sounds that they emit as they fly. Ultrasonic sounds are simply sounds that are emitted at a frequency above the range of human hearing. Although humans can hear some of the high-pitched clicks made by bats, most of their sounds are out of our auditory range. Humans can pick up sounds only up to a frequency of 20 kHz (kilohertz), and dogs to about 22 kHz, but bats emit sounds at the much higher frequencies of 50 to 100 kHz.

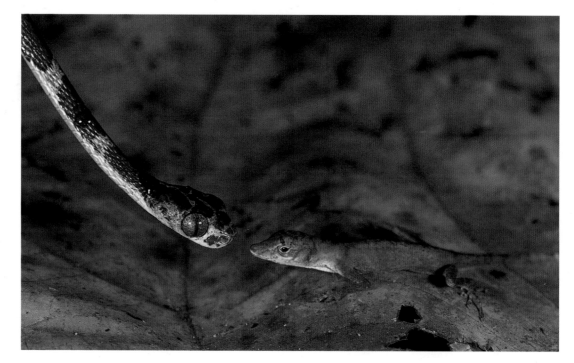

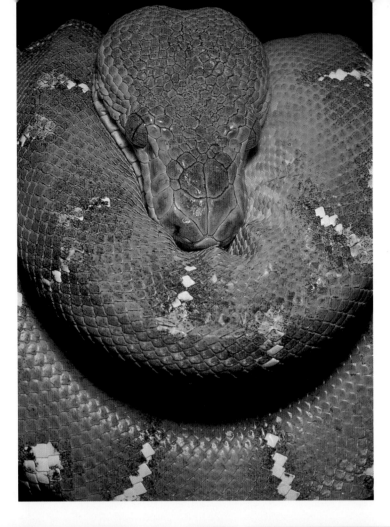

LEFT: *One of the most beautiful tree snakes is the emerald tree boa (*Corallus caninus*), which is a nonvenomous constrictor snake from South America's Amazon Basin.*

BELOW: *A green bush snake (*Philothamus sp.*) from Africa. Several species of tree snakes are colored green to match their green environment amongst the leaves and twigs of the trees, whereas ground snakes usually match the dead leaves on the forest floor.*

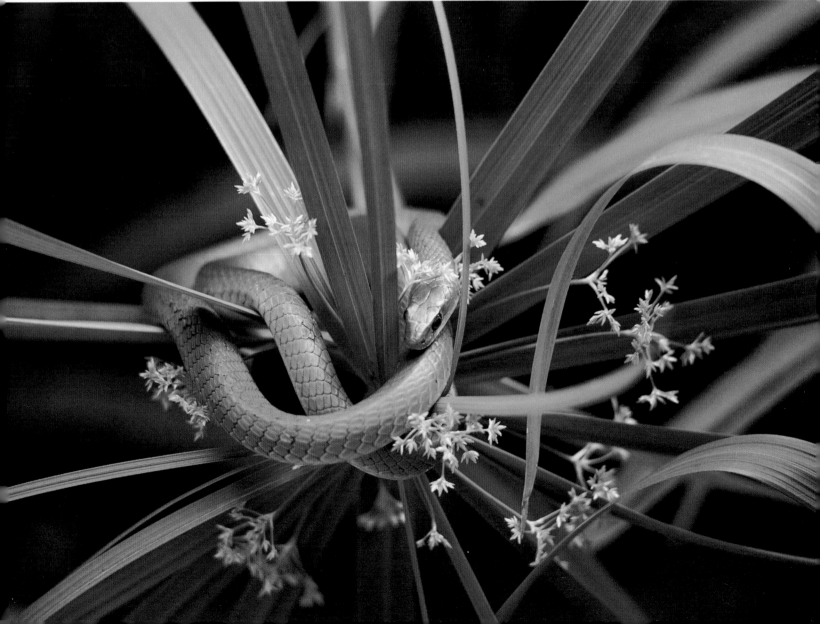

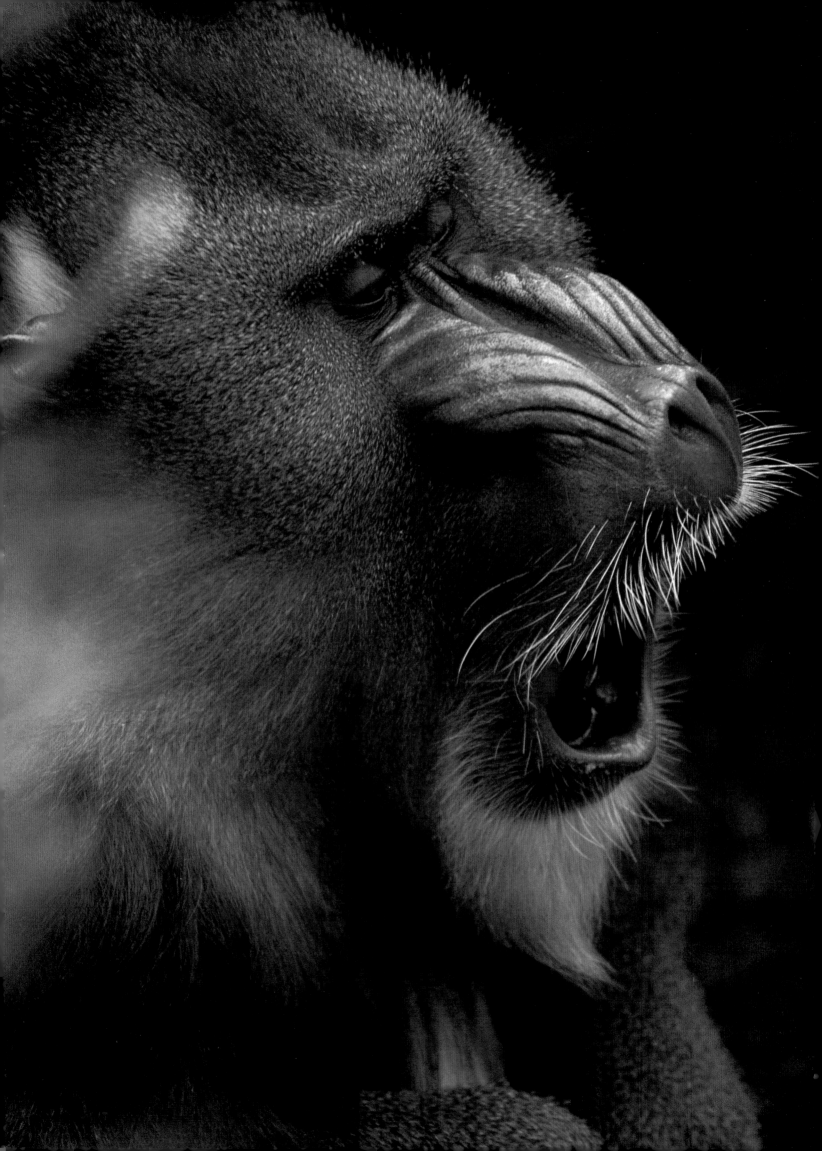

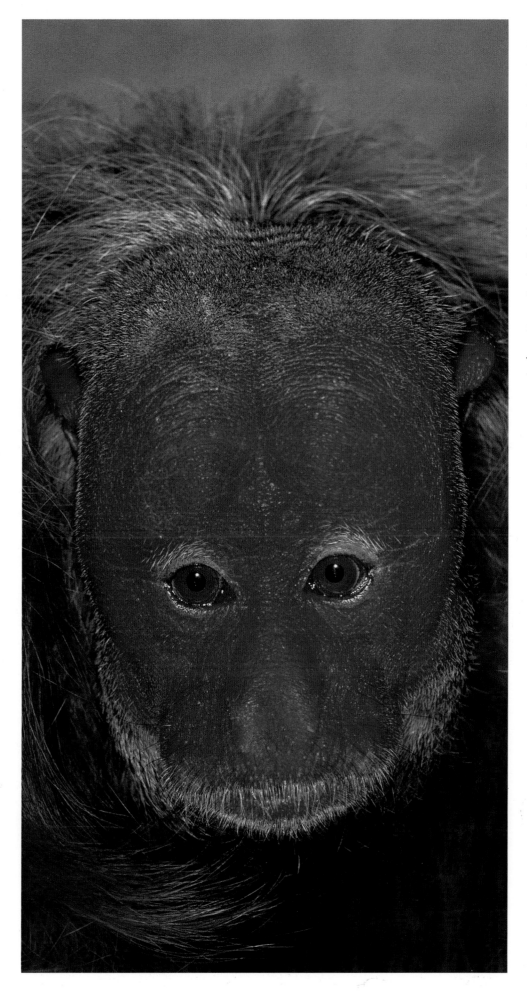

FACING PAGE: *An African monkey with a startling face is the mandrill (*Mandrillus sphinx*), which is related to the baboons. Adult males have colorful faces and buttocks. Mandrills travel on the ground in small family groups and feed mainly on insects and leaves.*

LEFT: *One of the most spectacular monkeys of the Amazon rainforest is the bald-headed red uakari (*Cacajao rubicundus*), which has a scarlet-colored face. This species does not have a prehensile tail.*

RIGHT: *The Bornean orang-utan (*Pongo pygmaeus pygmaeus*) is an ape that lives in the swampy coastal forests of Borneo. It travels through the trees by swinging slowly from branch to branch.*

FACING PAGE: *Primates live at all different levels of the rainforest, although most of them are found in the canopy or the middle layer of the forest. The gorilla is the largest of the apes. These are mountain gorillas (*Gorilla gorilla beringei*) from Bwindi in Uganda. These animals live principally on the ground, and their largest population has recently been severely threatened by the civil war in Rwanda.*

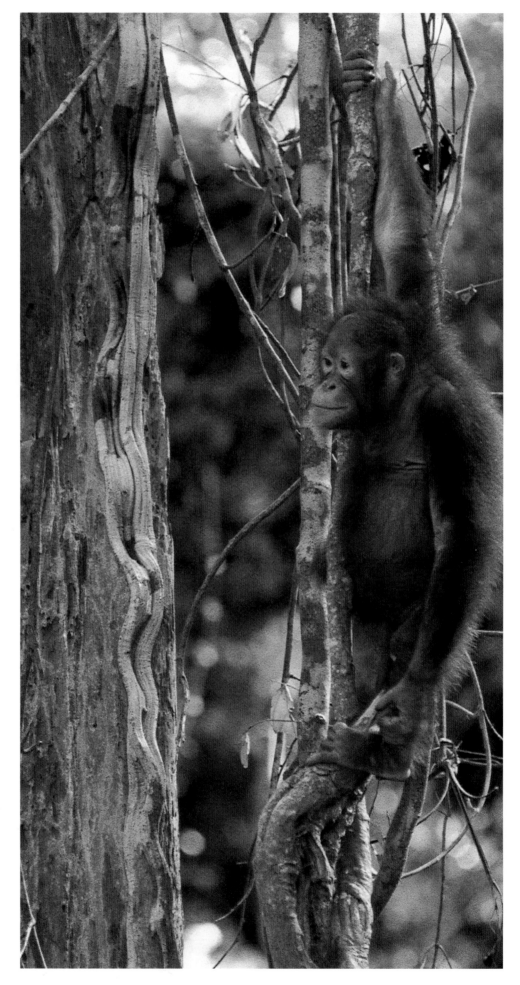

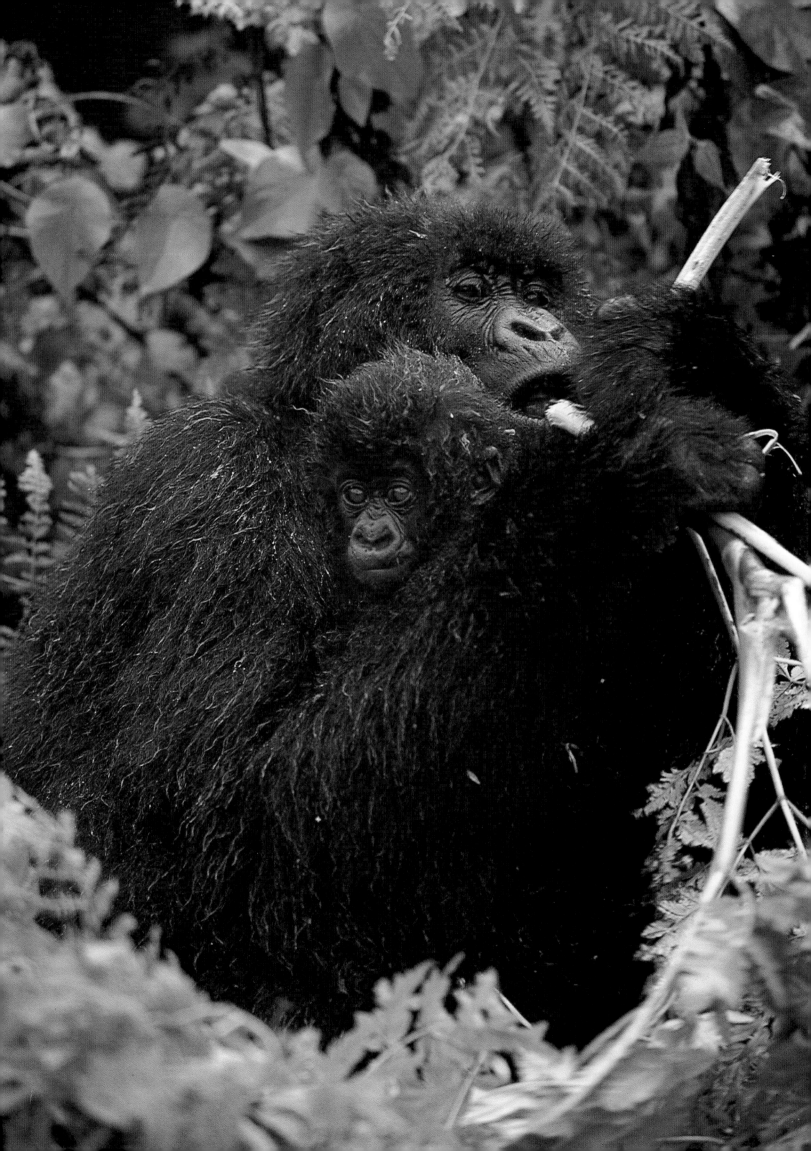

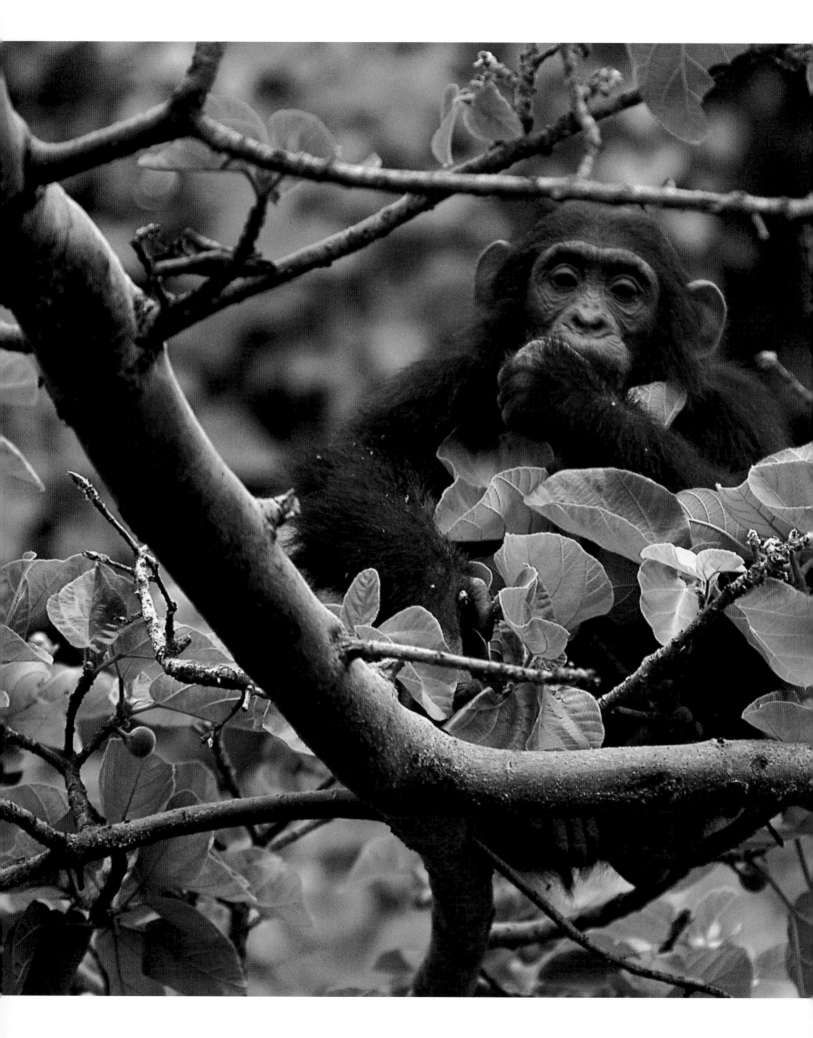

Chimpanzees (Pantroglo-
dytes) *spend most of their
time on the ground walking
on all fours. They also climb
trees to hunt food and to nest.*

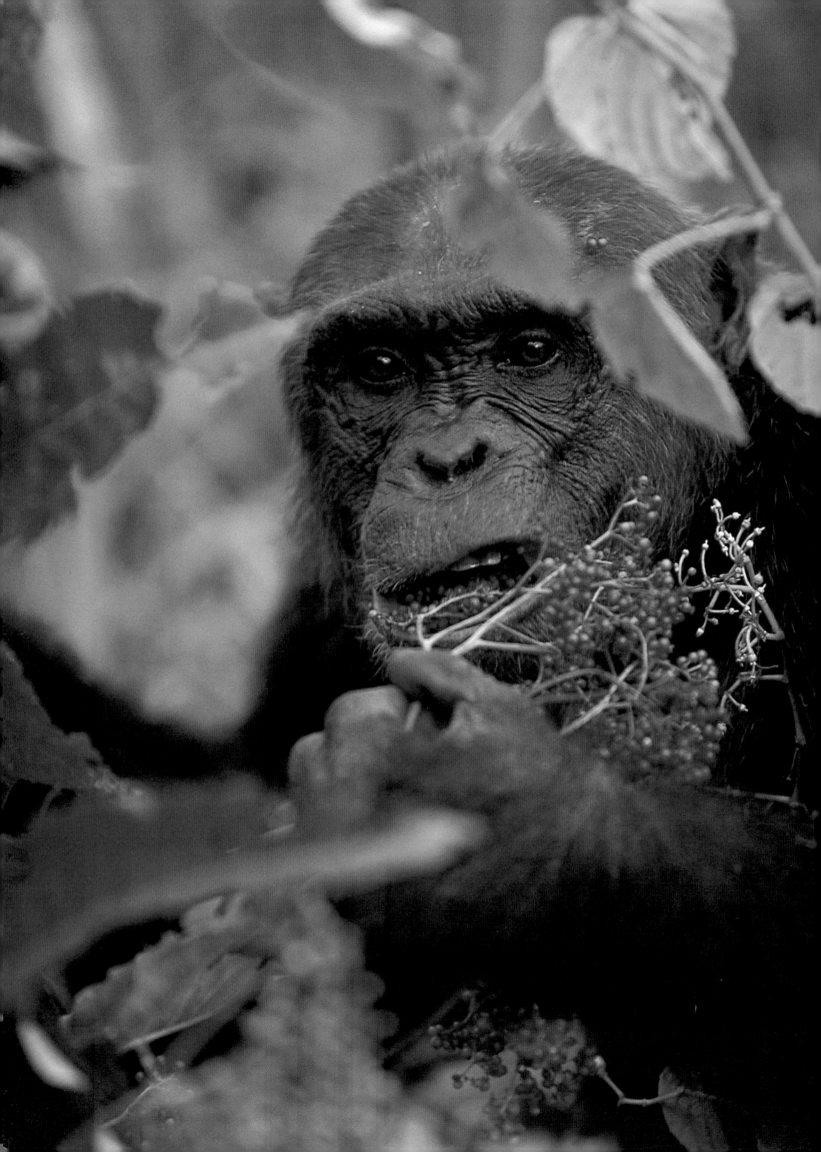

FACING PAGE: *Chimpanzees are apes that live in the equatorial forests of Africa and are the primate most closely related to the human species. This is a common chimpanzee (*Pan troglo-dytes*) in the Mahale National Park in Tanzania.*

LEFT: *Müller's gibbon (*Hylobates muelleri*) from Borneo.*

FOLLOWING SPREAD: *A howler monkey (*Alouatta palliata*), from Barro Colorado Island in Panama, feeds on the light-gap species of Cecropia.*

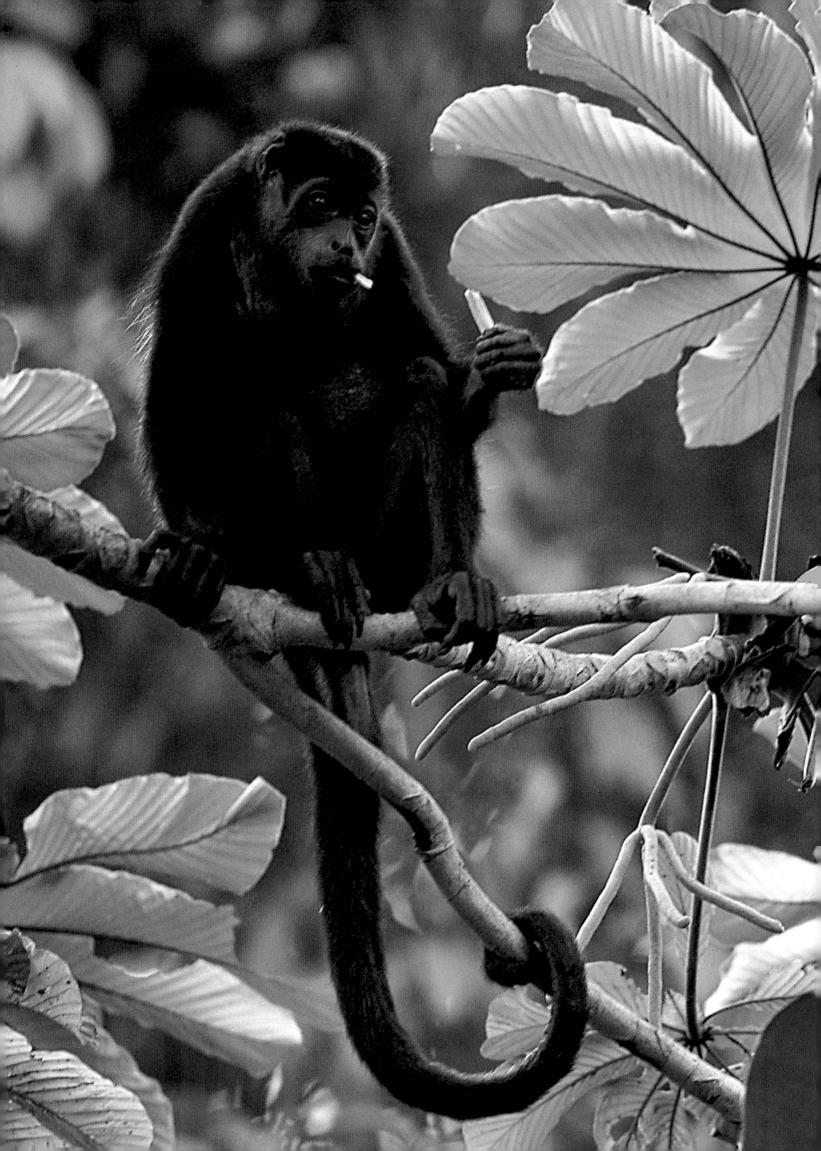

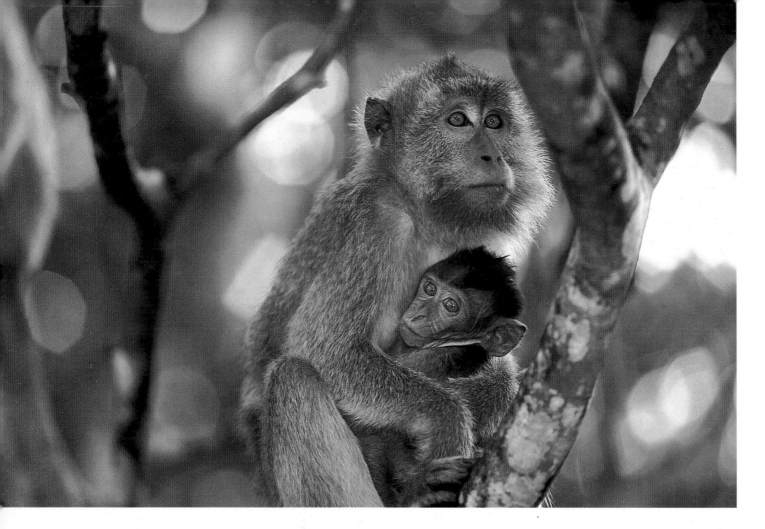

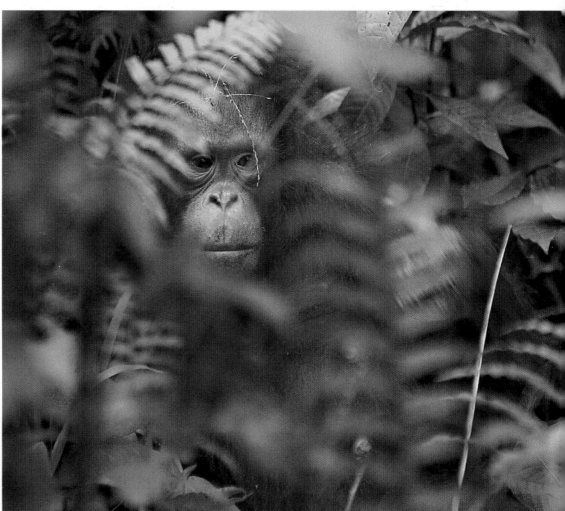

ABOVE: *A long-tailed macaque (*Macaca fascicularis) *from Borneo. Macaques are related to mandrills and baboons and are found principally in the Far East. Most macaques have very short tails—the long-tailed macaque is the exception. Unlike the Amazonian monkeys, those of the Far East do not have prehensile tails.*

RIGHT: *The Bornean orangutan (*Pongo pygmaeus pygmaeus) *seldom descends to the forest floor, but when it does, it walks awkwardly on all fours.*

FACING PAGE: *A whitehanded gibbon (*Hylobates lar) *from the forests of Southeast Asia.*

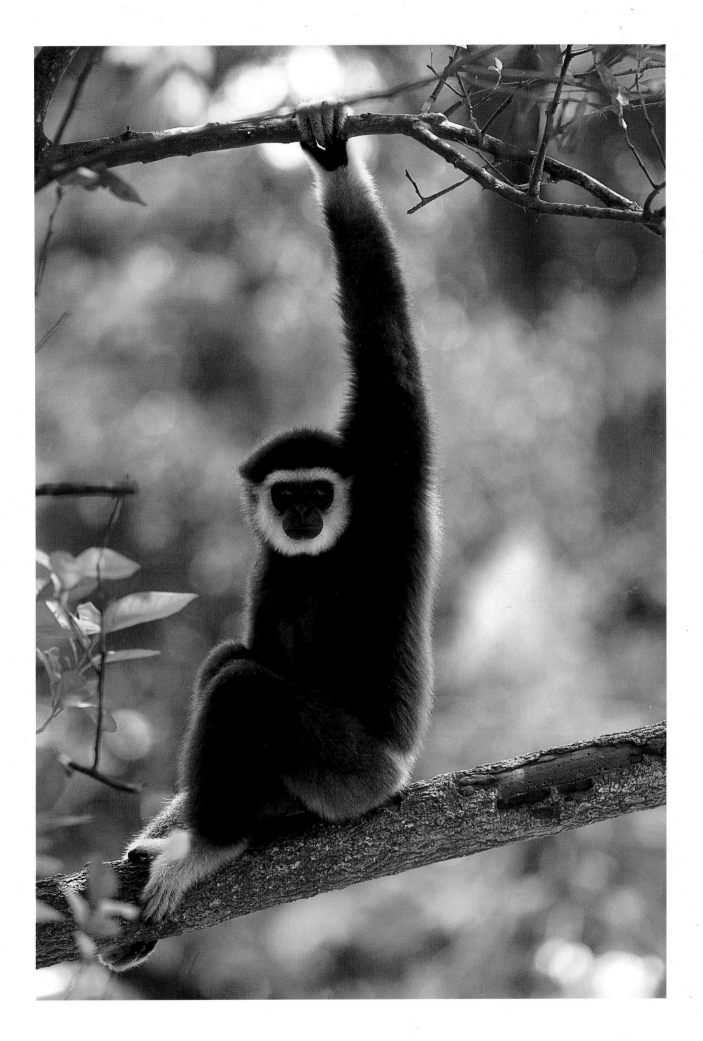

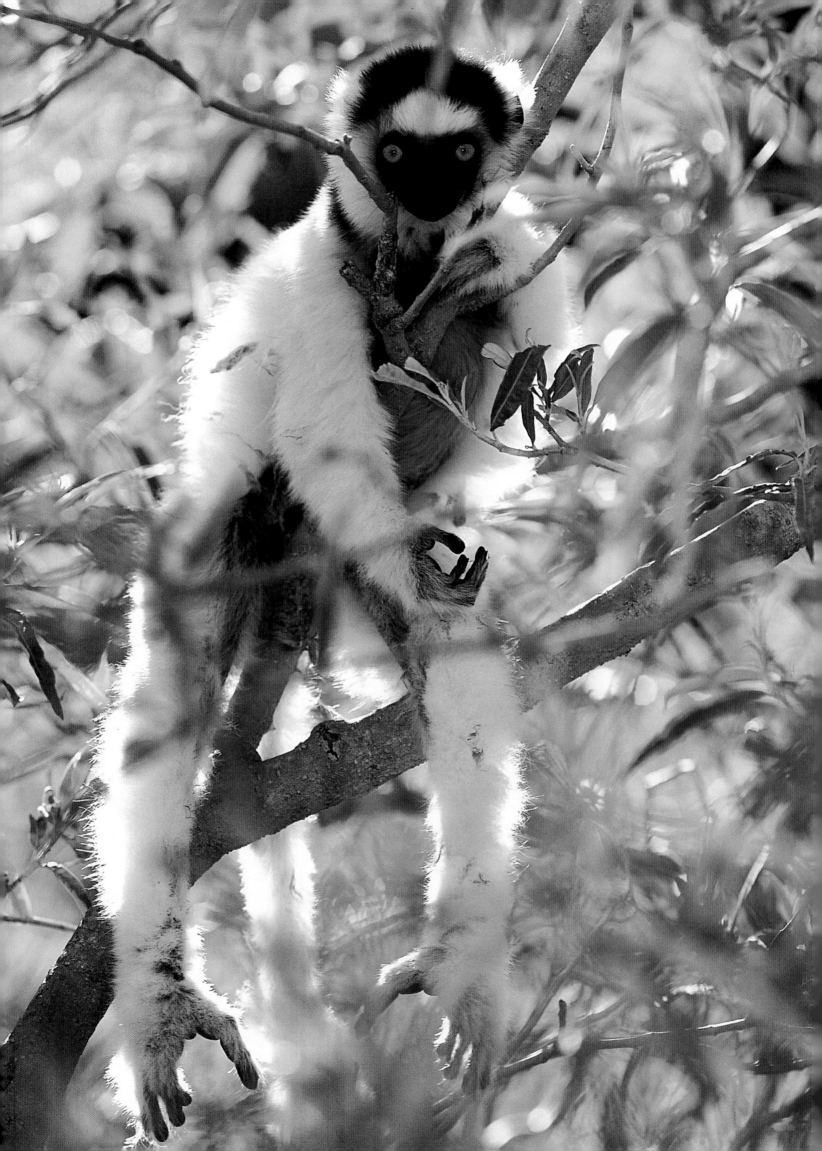

FACING PAGE: *Sifaka (*Propithecus verreauxi verreauxi*) is one of the large Madagascan lemurs and is diurnal.*

LEFT: *The Abyssinian black-and-white colobus monkey (*Colobus guereza occidentalis*) lives in the forest canopy of the Kibale Forest of Uganda.*

BELOW: *Another long-tailed African monkey from the Kibale Forest of Uganda is the red-tailed monkey (*Cercopithecus ascanius*).*

PAGE 150: *The golden lion tamarin (*Leontopithecus rosalia*), being rescued by an international breeding and reintroduction program, inhabits small areas of the almost totally destroyed rainforests of Atlantic coastal Brazil.*

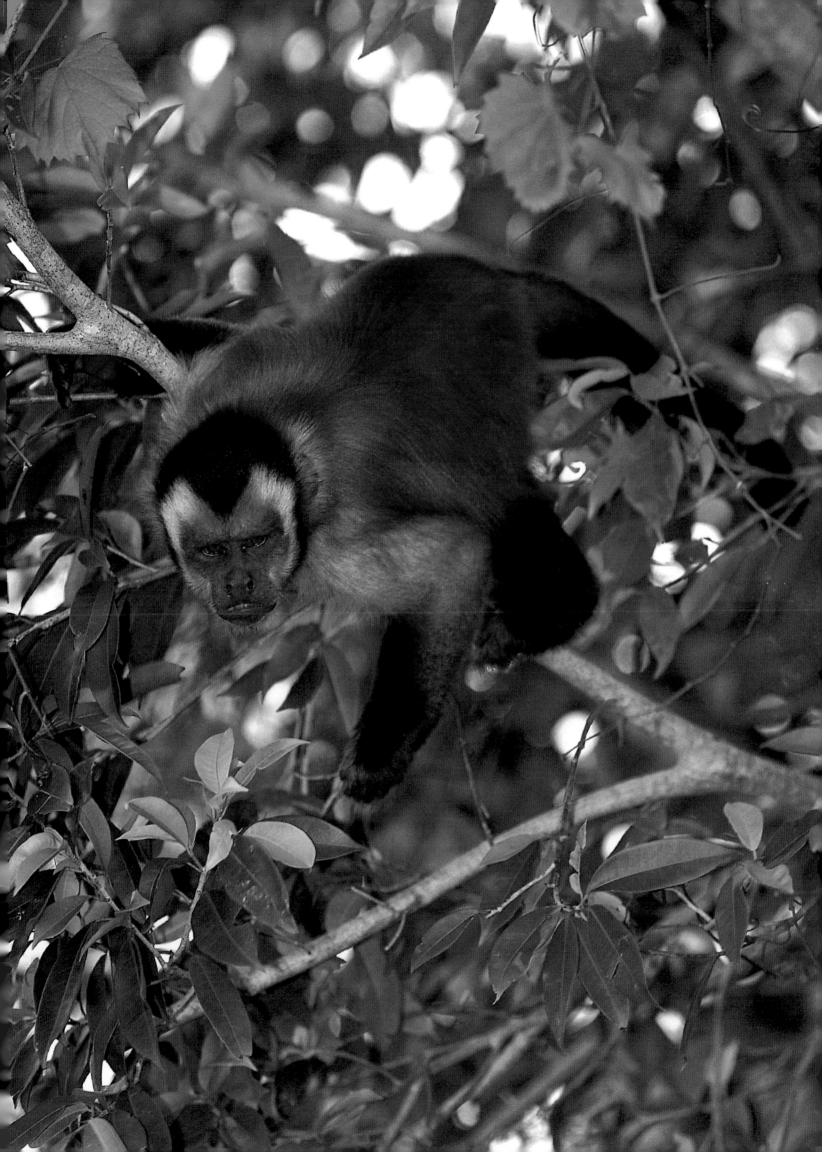

The capuchin monkeys are named for their black and white masked faces that were said to resemble capuchin monks. They belong to the genus Cebus.

PAGE 151: *The black-capped capuchin monkey (*Cebus apella*) is one of the most common in South America.*

RIGHT: *The Abyssinian black-and-white colobus monkey (*Colobus guereza occidentalis*) has an elegant brush-like tail. It is not prehensile, but serves as an excellent rudder as it leaps through the air from tree to tree.*

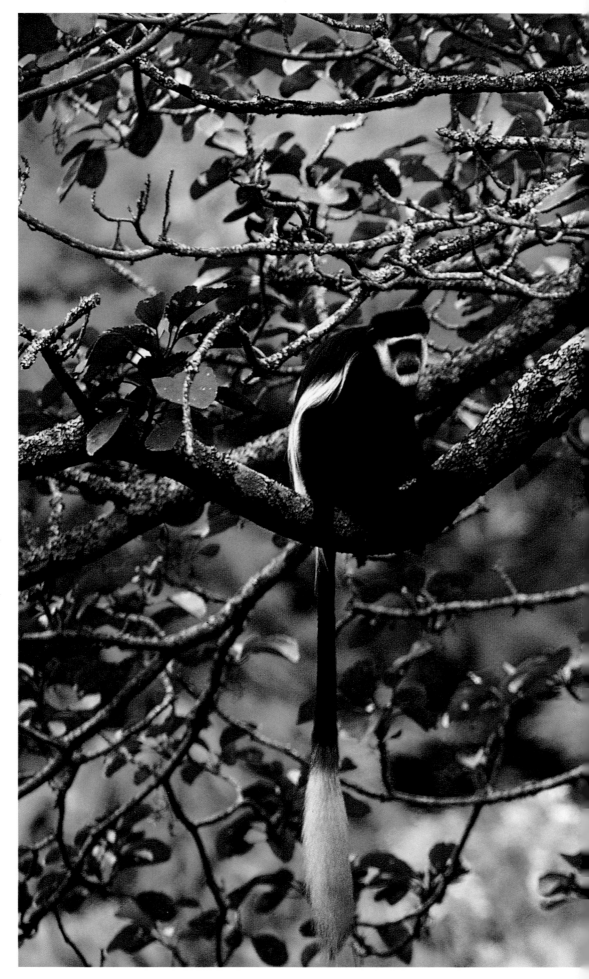

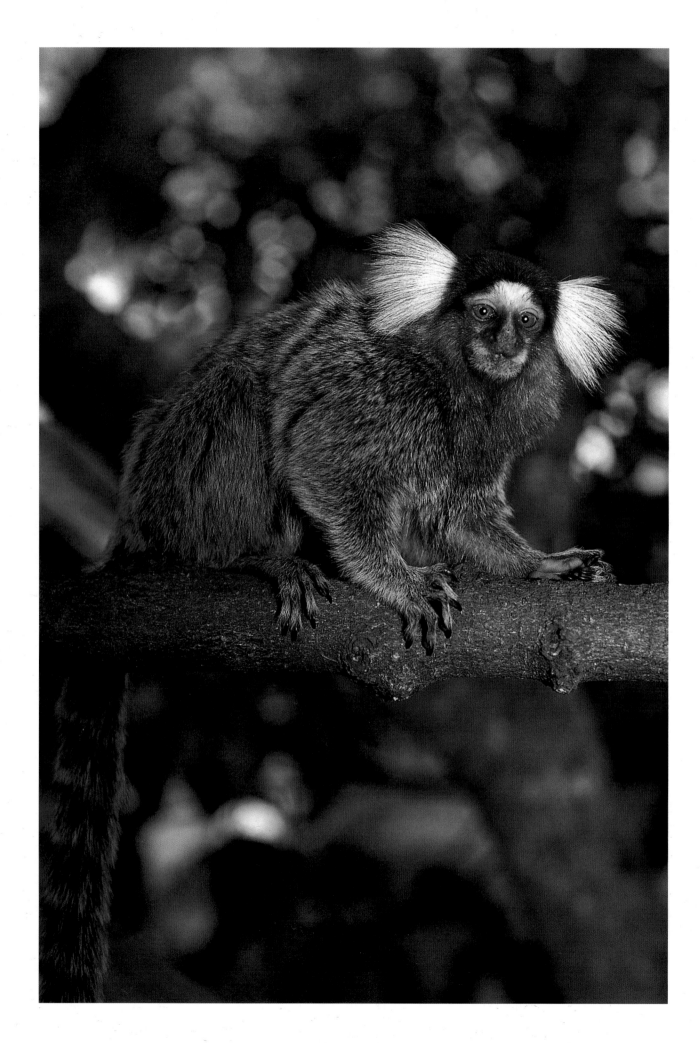

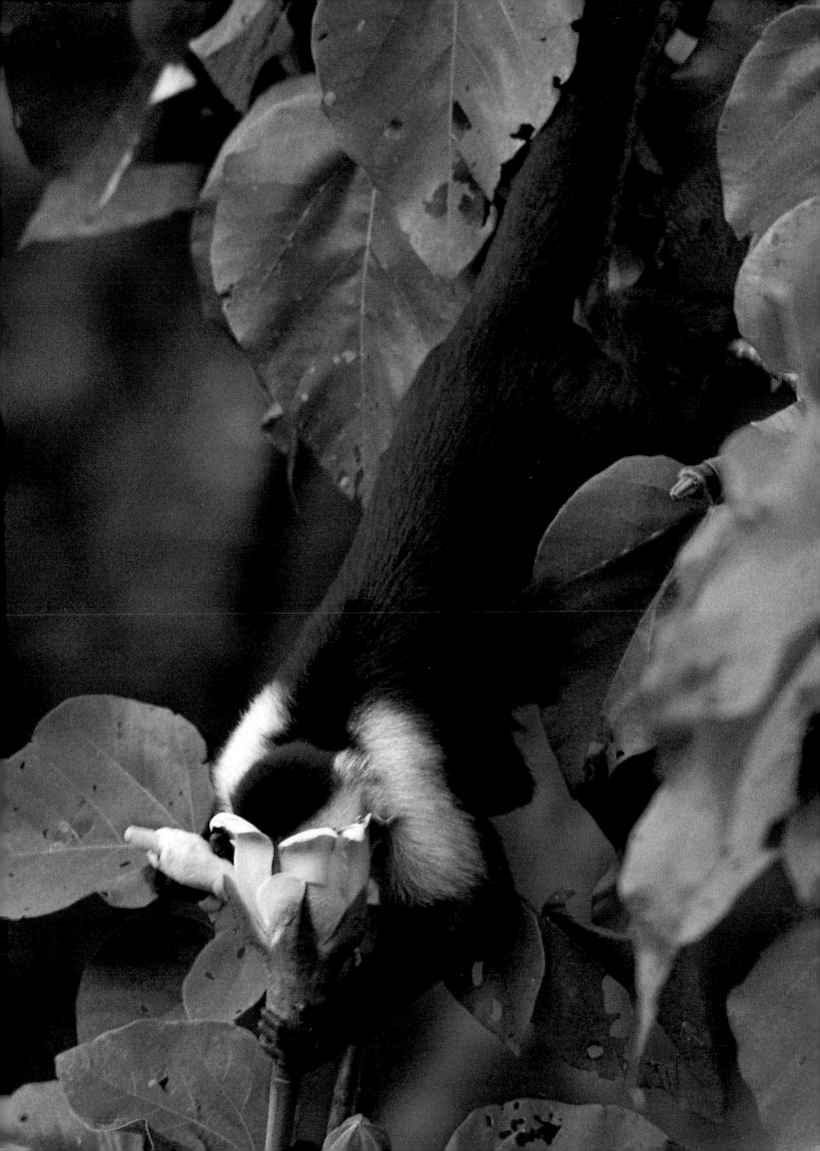

PAGE 154: *The tiny common marmoset (*Callithrix jacchus*) inhabits the rainforests of Central and South America and reaches only 1 pound (0.5 kg) in weight when mature.*

PAGE 155: *This white-faced capuchin monkey (*Cebus capuchinus*) is drinking the nectar from a flower in the rainforests of Belize. These monkeys have been shown to be the pollinators of some species of* Combretum.

RIGHT: *An African relative of the cebus monkey is the gray-cheeked mangabey (*Lophocebus albigena*) in the primate-rich forests of Kibale in Uganda.*

FACING PAGE: *Tamarins are small primates from South America. This is the handsome cotton-top tamarin (*Saguinus oedipus*) from Colombia.*

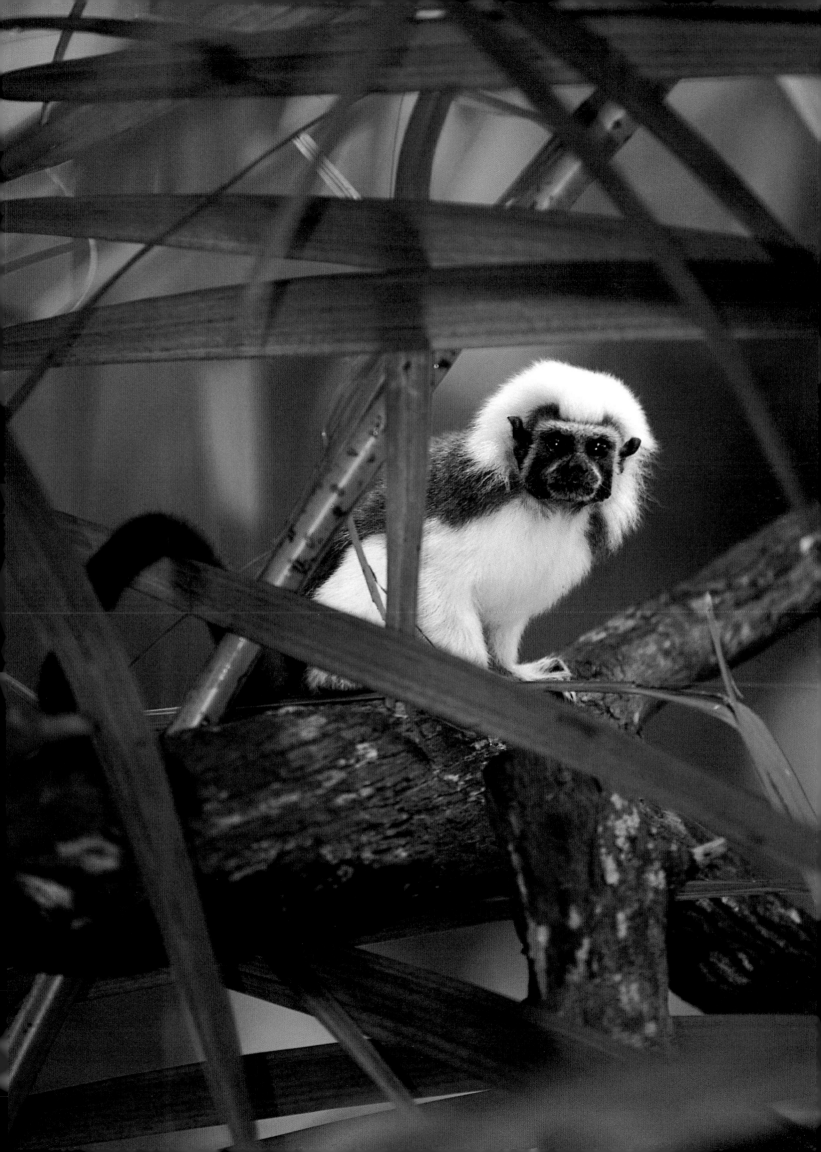

*A De Brazza's monkey*
(Cercopithecus neglectus)
*resting in the crotch of a tree*
*in the African rainforest.*

There are two main evolutionary lines of bats, the Microchiroptera (small-hand wing) and the Megachiroptera (large-hand wing), also known as fruit bats or flying foxes. The former occur worldwide and are mainly insectiverous, animal, or blood eating, although some species eat fruit and nectar. The latter are confined to Africa and Asia and are mostly fruit and nectar eaters. It is the Microchiroptera that have highly developed sonar systems that can locate insects in flight.

The Microchiroptera are by no means all insect eating. Their group contains the blood-drinking vampire, fish-eating, frog-eating, and even bat-eating bats. The vampire bat (*Desmodus rotundus*) feeds entirely on the blood of other mammals. The bat scrapes the skin of its prey with specialized teeth, and because its saliva contains an anticoagulant, the blood flows freely while its prey is unaware of the presence of the blooddrinker. Vampires can be a serious pest of cattle in Central America, and they occasionally attack people. One night, as I was getting ready to fall asleep in my hammock, I saw a vampire on the bare leg of one of our field assistants. At the time, we were sleeping without mosquito nets because there were no mosquitoes on this black-water river. My traveling companions were rather cross when I woke them up and advised them to use their nets. But when they learned the reason for my rousing them, they were quick to comply.

Another amazing bat is the fishing bulldog bat (*Noctilio leporinus*), which uses its sonar to locate fish near the surface of a lake or river. This large bat has long, sharp claws that enable it to pick up the fish out of the water in a manner similar to that employed by various fish eating birds.

To me, as a botanist, bats around the tropics are most important for their role as pollinators of flowers and dispersers of seeds. Both the Microchiroptera in the American tropics and the Megachiroptera of the Old World play a vital part in the dynamics of the forests through their visits to flowers to obtain nectar and because of their habit of eating fruit. Bat-pollinated flowers are termed chiropterophilous ("bat loving"). Bat pollination occurs mainly in the canopy of the forest rather than at ground level, and bat-pollinated trees have evolved various ways to make their flowers accessible. These volant animals that rely on echolocation to navigate would find it difficult to enter amongst twigs and branches, and they generally hover rather than alight on flowers. Accordingly, the flowers of bat-pollinated trees are borne on erect stalks above the canopy, or on long pendulous stalks that hang below the branches or even on the trunks of trees. The calabash tree (*Crescentia cujete*) is a good example of a bat-pollinated tree on which the flowers are cauliflorous or borne on the trunk and major branches. Many bat-pollinated flowers are white and have a musty odor that attracts the bats. One of the most spectacular of all bat-pollinated trees is the *Visgueiro* or *Parkia pendula.* The flowers are grouped into pom-pom-like clusters that hang down on long, thin stalks below a very flat canopy. This phenomenon of pendulous clusters of flowers is called flagelliflory. The bats hover for a second and

PAGE 160: *The lemurs of Madagascar are some of the most endangered primates. The largest is the indiri* (Indiri indiri)*, which is becoming rarer as its rainforest habitat is destroyed. Individual groups of indiris mark their territory and signal to each other early each morning with a haunting, high-pitched song that echoes over the forest.*

PAGE 161, TOP LEFT: *The most threatened subspecies of sifaka is Coquerel's sifaka* (Propithecus verreauxi coquereli) *from northwestern Madagascar.*

PAGE 161, TOP RIGHT: *The douc langur* (Pygathrix nemaeus) *is a primate from Southeast Asia with an attractive beard.*

PAGE 161, BOTTOM LEFT: *The red-fronted lemur* (Eulemur fulvus rufus) *lives mainly in the forest canopy of Madagascar and eats leaves, fruit, flowers, bark, and sap. It is one of the day-feeding species of lemur.*

PAGE 161, BOTTOM RIGHT: *The smallest of all South American primates is the pygmy marmoset* (Cebuella pygmaea)*, which weighs only 3 ounces (85 g). It feeds on fruit and insects.*

FACING PAGE: *This brownheaded spider monkey baby* (Ateles fusiceps robustus) *from Central America is well protected by its mother's fur coat.*

lap up nectar from the easily accessible pom-poms of the *Parkia* tree; at the same time, they are dusted with pollen, which they carry from flower to flower and from tree to tree. Nectar-feeding bats have long tongues covered with fleshy bristles that enable them to rapidly drain a flower of its nectar. The popular but foul-smelling fruit of tropical Asia known as the durian (*Durio*) is another example of a bat-pollinated flower. The durian is pollinated by the fruit bats, and the decline in numbers of this animal, which are hunted by local people for food, is seriously reducing the crop of durians.

Bats are equally valuable for their role as seed dispersers. For tropical trees in the rainforest, it is important to have seeds scattered around as far as possible. We have already seen that the success of many pioneer species hinges on their seeds being quickly dispersed by bats or birds. Some bat fruits, such as many species of figs and the pioneer *Cecropia,* produce numerous small seeds. When the bats eat the fruit, they ingest the seeds, which are later excreted. In other cases bats transport the fruit to their roosts and drop the seeds below. The sapucaia nut (*Lecythis pisonis*), a relative of the Brazil nut, produces large woody capsules. A lid falls off the capsule, and the seeds, which are about $1\frac{1}{2}$ inches (4 cm) long, are left exposed and dangling inside the capsule, attached by a fleshy stalk. Bats remove the seeds together with the stalks and fly away with them. The musty, unpleasant-tasting (to humans) stalk is eaten by the bats, and they discard the seeds and thereby disperse them.

The nocturnal bats are one of the most important groups of animals in the rainforest. The future of many species of trees will depend upon the conservation of many species of tropical bats.

# FIRES IN THE RAINFOREST

Rainforest is not a fire-adapted ecosystem. Fortunately, fire is comparatively rare. Traditional slash and burn farmers know that when they cut down a patch of forest and, once it has dried out a bit in the dry season, set fire to clear the area, the fire does not spread into the forest. The high humidity of rainforest simply protects it from burning. However, this natural protection does not always work because there are sometimes exceptional climatic phenomena that result in prolonged dry periods. The principal cause of droughts in tropical rainforest is the so-called El Niño effect. This disruption of the normal climatic pattern of the tropics, the full name of which is El Niño Southern Oscillation, occurs when the cold Humboldt Current that flows northward up the west coast of South America is replaced by a weak warm ocean current. This usually takes place during the Christmas season, and so the effect is called El Niño ("the boy"), after the Christ child. The changes in the distribution of warm water and cold have considerable atmospheric consequences around the tropics.

In 1982–83 the El Niño effect was particularly strong, and so Borneo suffered a drought with only less than a third of the normal rainfalls between July 1982 and April 1983. In early 1983, fires rampaged through the forests of both Malaysia and Indonesian Borneo (Sabah and East Kalimantan). About 7½ million acres (3 million ha) were burned in Kalimantan and 2½ million acres (1 million ha) in Sabah. How did such an unusual event occur in the normally fire-resistant rainforest? It was subsequently shown that much of the area that was burned had been selectively logged and that a lot of debris from the felled trees remained. When settlers moved in and set fire to their fields or clearings, the fires spread easily into the unusually dry logged forest, which contained a lot of tinder-dry dead wood. In the same year in Sumatra, peat swamp forests blazed with such intensity that Singapore airport was closed at times because of the dense haze of smoke.

During 1982–83 the El Niño event caused similar effects in the Amazon rainforests. Fires set by agriculturists in the vicinity of Paragominas in the Brazilian state of Pará also spread well into the rainforest, although not as extensively as in Borneo. The consequences of the El Niño effect are becoming much more serious because of human disturbance to the rainforest in so many different parts of the world. However, the El Niño effect itself is nothing new and climatic records show that such serious episodes have occurred at other times. The drought is just adding to the dangers of human intervention in the forest.

Recently scientists have found that there are considerable amounts of charcoal in the soil in many places in the Amazon rainforest. Colombian ecologist Juan Saldarriaga studied this topic for his doctoral dissertation and concluded that the charcoal deposits were too great to have been caused solely by the settlements of indigenous populations or by lightning strikes. Radiocarbon dating has shown that there have been several periods of fire in Amazonia coinciding with dry phases in the climate. Although most rainforest will not catch fire easily under normal climatic conditions, it takes only a slight modification in climate for the forest to burn. The studies of charcoal indicate that this is a natural phenomenon but also point to the danger of climatic changes caused by the human-induced greenhouse effect. There is only just enough rainfall in many areas of rainforest to protect it from the danger of fire.

Rainforest is largely destroyed on the rare occasions when it does burn. This is in marked contrast to tropical savannas, which are fire-adapted ecosystems. Grassland savannas occur mostly in drier parts of the tropics, and they experience a long dry season. The result is a lot of dry grassland that easily and naturally catches fire when lightning strikes. Many savanna trees have thick, corky bark that protects them from the fire that burns out the grassy layer around their base. Cork is an extremely good thermal insulator, and so a ½-inch (1-cm) layer of cork around the trunk and branches of a tree affords it excellent protection from fire. That is why so

many savanna species have evolved a much thicker bark than their rainforest relatives. Other savanna species have developed underground trunks and branches, so only the young flowering and fruiting twigs emerge above the soil. When a fire does occur, these are burned, but the surviving underground system soon resprouts. There are many other fascinating adaptations to fire in savannas, but in the rainforest, these sorts of fire adaptations have not evolved because they are normally not necessary for the survival of the species.

However, lightning does not discriminate and it is as common in tropical rainforest as in tropical savannas. The difference is that in the savanna it might cause a widespread fire but in the rainforest it will generally kill only a single tree. One of the most terrifying experiences I have ever had in the rainforest was when lightning struck a tree in our camp in the forests of Suriname. The explosion and the ball of lightning rolling across the clearing of our campsite was like a bomb blast and knocked two of my companions to the ground. Fortunately, in

*Fire is a precious commodity for indigenous peoples, who often start it by spinning two sticks together with tinder. A Yanomami Indian hearth in the Parima Tapirapecó National Park, Venezuela.*

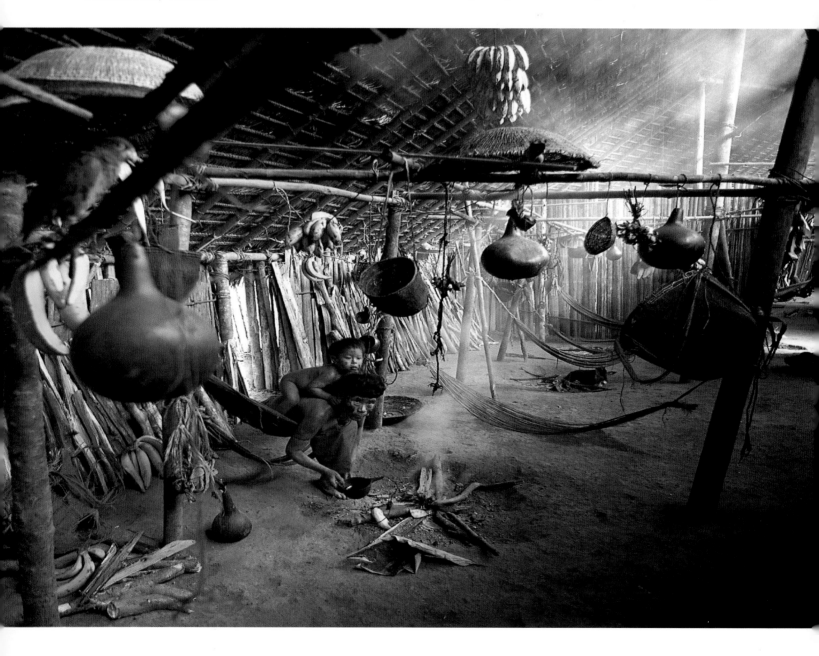

this case no one was hurt, only very frightened. Nevertheless, it did emphasize the power of this form of fire, which completely destroyed a giant forest tree in an instant, only 65 feet (20 m) from where we were standing. Lightning of this sort might seem destructive, but it is playing an essential role by opening up another light gap and allowing the gap-colonist species their chance to grow. It is all part of the disturbance that maintains the diversity and dynamic nature of the forest.

## HUMAN-INDUCED FIRE

Fire from lightning is a natural phenomenon, but humans have also employed fire as a tool for destruction. The use of fire to control natural environments is by no means a recent phenomenon. For many centuries indigenous peoples have set fire to savannas to flush out game. This practice is one of the reasons why some of the large savannas of the Amazon region have not reverted to forest during the current warmer and wetter phase of the natural climatic cycle of the region. Although the fires do not generally spread into the surrounding forest, they kill off the spreading trees and shrubs, and so the recolonization of the savanna by forest is curtailed.

For the last 10,000 years or so, rainforest dwellers have gradually developed agricultural techniques that are fire dependent. Slash-and-burn, or swidden, agriculture is the most commonly used process by indigenous agriculturists around the world. The forest is felled at the beginning of the dry season and allowed to dry before it is set on fire. In this dry state much of the biomass is burned and some of the nutrients contained in the trees remain in the ash. The farmer plants his crops or sows seeds amongst the ashes and the debris of the forest. The initial crop is usually excellent because of the fertilization of the soil by the ash. Soon heavy rains begin to fall, and without a ground cover of trees, shrubs, and herbs, the exposed soil is eroded and the nutrients washed away. Most indigenous peoples felled small areas of forest and allowed long periods of fallow. When such a course is followed, little permanent damage is done to the forest because the result is little different from a natural light gap, and the surrounding forests contain seed parents for the plant species to reestablish themselves. However, as this method has been adopted by land-hungry peasants and colonists, they have cleared increasingly large tracts of land and have drastically shortened the period of fallow. The result is the serious degradation of the land, and the natural process of regeneration takes much longer—if it is possible at all. Large areas of former forest are now permanently degraded. The overfrequent use of fire as a tool can cause permanent destruction. There are now vast areas of former forest in tropical Asia covered by imperata grass (*Imperata arundinacea*), which is of no use at all. This has all been caused by the misuse of fire, an ecological factor to which rainforest is not adapted.

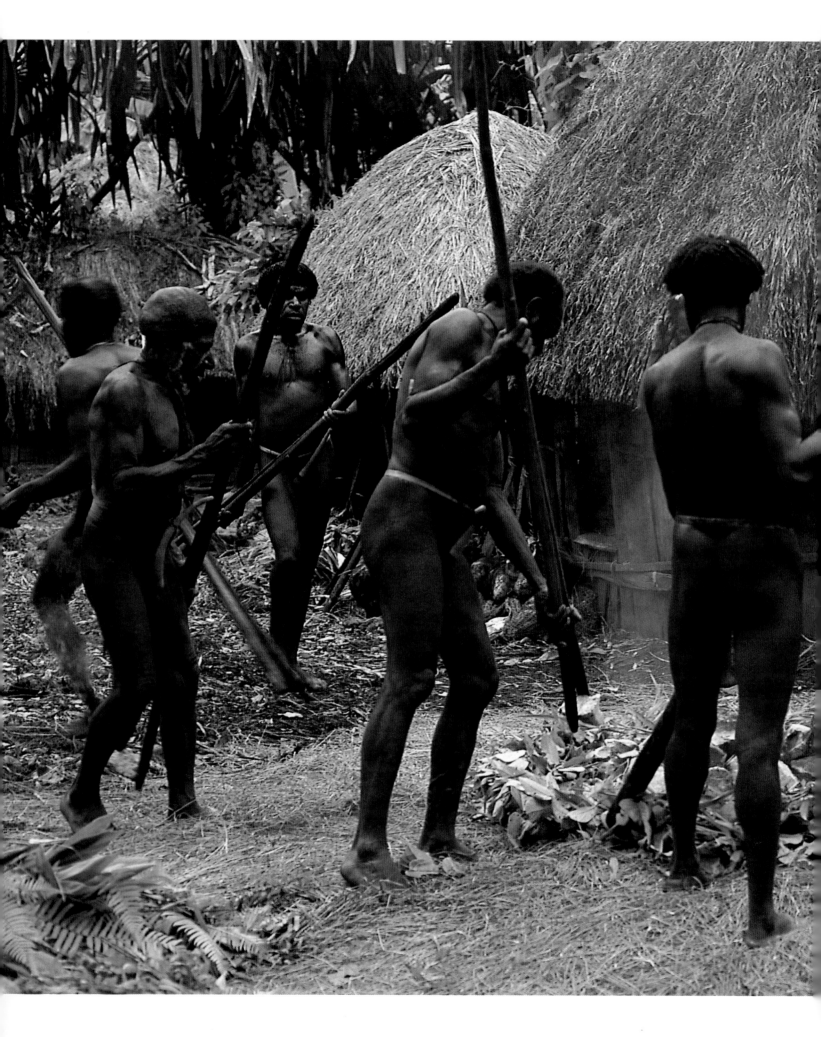

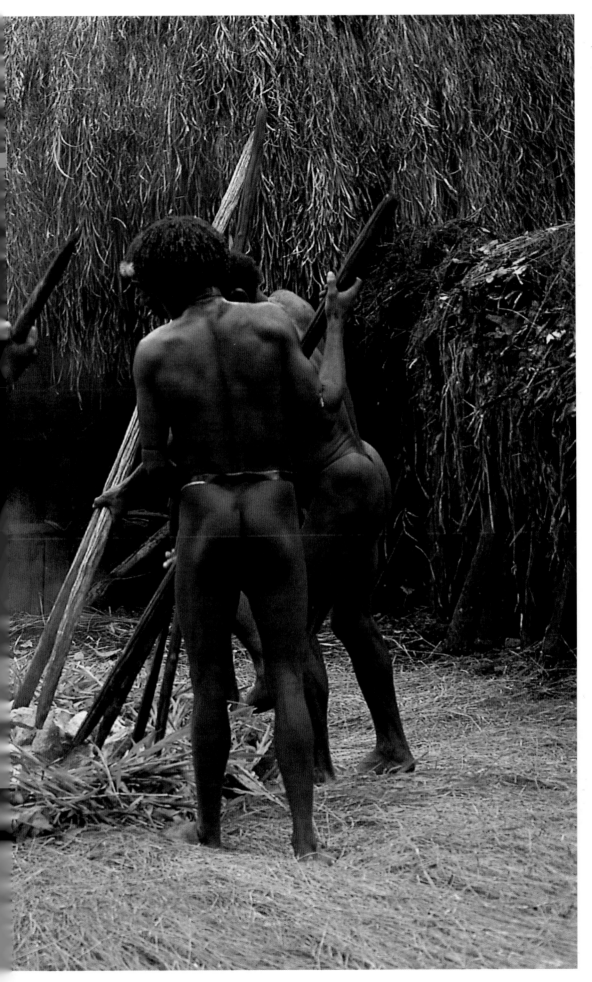

# Earth

〜〜〜〜〜〜〜〜〜〜
〜〜〜〜〜〜〜〜〜〜

WESTERN PEOPLES HAVE LARGELY LOST CONTACT with the earth. We walk in shoes on asphalt and concrete and are frequently insensitive to the hidden world of earth, so important for our sustenance. Native peoples are very aware of the ground because they walk barefooted. I was once walking through the forest with a group of Yanomami Indians when they suddenly showed great excitement, stopped, and began digging into the soil with their machetes. They soon unearthed a large, hard, round object almost as big as a soccer ball. This was what is known in Brazil as *pão dos índios,* or Indian bread. It is in fact a fungus that forms a sclerotium, a large mass of underground hyphae. It is eaten by the Indians, who shave off slivers and boil them. Though it looks like a giant truffle, it is bland and is strictly an emergency food. This incident reminds

PREVIOUS SPREAD: *Ferns in the Cape Tribulation rainforest of Queensland, Australia.*

FACING PAGE: *Fungi play a vital role in the recycling of nutrients in the rainforest through their capacity for rotting downed leaves, branches, and tree trunks, from which they derive their nutrients.*

us of how much we may miss as our contact with the earth under our feet becomes more distant.

## SOIL

Soil is composed of a mixture of mineral particles, organic material, living microorganisms, water, and air and is a resource upon which humans and most of life depend for food.

Many people believe that the soil under tropical rainforest must be extremely rich because of the luxuriant growth that it supports. Actually, the majority of rainforest soils are extremely poor, especially in Amazonia, where 88 percent of the soils have been classified as inappropriate for normal agriculture. The soils are acidic, lack nutrients, and are without the colloidal capacity to retain nutrients. When the forest is cut and burned, the torrential rainfall causes extensive soil erosion. The nutrients in the ash resulting from the burning of the forest are soon washed away, and a poor, infertile soil remains. As a result, crops grow well for the

175

first one or two years after deforestation but soon drop in productivity to an uneconomic level as nutrients are lost from the system.

In undisturbed rainforest the surface layer of the soil is rich in organic material because of the constant fall of leaves and branches. In evergreen rainforest, leaf fall is a continuous process and so the surface of the soil is continually covered with dead leaves. Most of the trees have a large number of superficial roots that grow amongst the litter layer. These roots constantly reabsorb the nutrients from the rotting organic matter. Often there are beneficial fungi known as mycorrhizae that form a direct link between the rotting leaves and the tree roots. This means that the nutrients in the dead leaves are reabsorbed back into the trees before they even enter the lower levels of the soil. I have frequently seen dead logs, or even the trunks of dead trees, that are filled by the roots of living trees—a nearly instant recycling that ensures no wastage of precious nutrients. With the scarcity of nutrients in the soil, the roots of rainforest trees have the capacity to seek out sources of nutrients such as those offered by dead trees. Most roots are geotropic, meaning that they grow downward, but in the rainforest one frequently finds roots that grow several yards upward into a dead tree that is still standing. It is this process of nutrient recycling, as it is called, that is the secret of the exuberant growth of the rainforest, and not the fertility of the soil itself. The trees also have some deeper roots that are particularly important for the absorption of water during dry periods. When the forest is felled and burned, the leaves, the branches, and most of the tree trunks are reduced to ashes and the process of nutrient recycling is broken down. It is the trees themselves that maintain the productivity of the soil, and to remove them is to break down the very process that maintains the forest.

The streams that flow out of undisturbed rainforest are normally of very pure water with little or no dissolved salts. However, as soon as deforestation occurs, the same streams will change from almost distilled water to water that is full of dissolved material. The precious nutrients are consequently carried away rather than being recycled.

Indigenous peoples tend not to create monocultures but rather construct agroforestry systems that preserve the soil and maintain the nutrients. They also allow lengthy periods of fallow, usually of ten to fifteen years, but sometimes as much as forty years, particularly when they are cultivating areas on poor soil. This rest period allows the soil to rebuild and the vegetation to recapture nutrients. Indigenous communities practice short fallow periods only when they are cultivating areas of good soil. Western-style agriculture is inappropriate on the fragile soils that lie under many of the world's rainforests. It is much better to leave the forest cover and harvest sustainably a limited quantity of timber and other products. This approach ensures that the delicate process of nutrient cycling is not broken down.

Many different types of soil occur under areas of tropical rainforest, and the

composition of the forest often depends upon the soil type. The most widely distributed rainforest soil is red soil, technically known as oxisol, ferrasol, or latosol in different soil classifications. These oxisols are by far the most common in Amazonia and in the African rainforest. The striking red color of these soils is due to the presence of iron and to weathering by the plentiful tropical rainfall. These soils are particularly fragile and unsuitable for agriculture because they consist of clay and very few soluble nutrients. Since these leached clay soils cover about two-thirds of the tropics, much of the region is inappropriate for cultivation. Other areas of soil are even poorer in nutrients. These are the arenosols that cover about 7 percent of the tropics. These sandy soils are completely unable to support agriculture. The soil is derived from the erosion of sandstone—for example, in the white-sand forests of the northwest Amazon—or is the result of the uplift of former sea and river beaches. The third major category of rainforest soils is the hydromorphic soils, or soils in poorly drained areas such as floodplain and river deltas. These soils tend to retain more organic material. In really waterlogged areas gleysol occurs. This is a waterlogged anaerobic soil that encourages the reduction of iron compounds by microorganisms and often causes the soil to be mottled into a patchwork that is gray and rust in color.

There are many other subdivisions of soil and several major systems of soil classification, but the most important fact is that rainforest soil varies greatly and this in turn influences what plants and animals occur in a particular area and also what

FOLLOWING SPREAD: *Fungi are important components of both tropical and temperate rainforests. This is a bracket fungus* (Stereum ostrea) *from the forests of the Olympic National Park in Washington State, USA.*

BELOW: *These "stars" on the forest floor are from the earth star fungus* (Geastrum saccatum) *after they have opened and released their spores.*

the appropriate human uses are for that area. Only about 20 percent of tropical soils are suitable for sustainable agriculture. The tragedy is that this has not been properly taken into consideration before deforestation has occurred. I have seen large areas of white-sand arenosols that supported good forest cut down for the purpose of agriculture. Needless to say, the property owners were disappointed by the results of their efforts. Fertile soils tend to occur in areas of volcanic activity in the tropics. For example, there are rich soils in Indonesia, the Philippines, and Central America where volcanic ash has added to the nutrients in the soil. The other type of soil that can be used sustainably is found in some of the seasonally flooded but well-drained areas where the annual flooding deposits a new layer of alluvial matter.

There may be little difference in appearance between forest on clay soils and forest on the poorer sandy soils. Both often appear to sustain a rich growth that would be classified as rainforest. However, as one walks from an area of clay soil into forest on white sand, one notices a difference underfoot. The ground is soft and spongy instead of firm and hard. This texture is due to the mass of fine, superficial roots amongst the leaf litter. Where the soil is so poor, the trees have adapted to invest more of their resources into the production of roots to capture whatever nutrients are available from the falling leaf litter. The presence of root mats in tropical forests is a sure indication of poor sandy soil. Ecologist Carl F. Jordan conducted extensive research in the white-sand forests of Amazonian Venezuela, where thick root mats abound. Jordan used radioactive calcium and phosphorus to study the uptake of nutrients by the mass of roots. He found that 99.9 percent of both elements became attached to the root mat either by roots or mycorrhizal fungi. This and other studies have demonstrated the incredible efficiency of the nutrient-recycling process.

# FUNGI

The numerous species of fungi in any tropical rainforest play a vital role in the process of decomposition. There are many fungi besides the mycorrhizae that invade tree roots and help the recycling of nutrients back to the trees. Any dead log or branch on the rainforest floor will play host to different wood-rotting fungi. The importance of these is that they are capable of breaking down the resistant lignin that is a principal component of wood. Travelers to the tropics who take leather shoes or belts are quickly aware of the ubiquitous fungi because any leather item is soon covered by a mass of green mildew, and photographers who do not take care of their equipment soon find fungi growing on the coating of their camera lenses.

Fungi belong to a separate kingdom from plants and animals. Unlike green plants they have no chlorophyll and so must obtain food from living or dead plants and animals. Some fungi are parasitic and attack living plants and animals and often cause disease. Other fungi are saprophytic, living off dead plant and animal

material. It is the saprophytic fungi that are so important as decomposers. If it were not for the action of both fungi and bacteria, the forest would soon be smothered by a rising mass of undecomposed leaf litter and branches. Fungi range from microscopic single-celled or threadlike organisms in the soil to the more familiar mushrooms, toadstools, and puffballs. The latter, which belong to the class Gasteromycetes, can be as large as 24 inches (60 cm) in diameter in the rainforests of the Far East. Perhaps the most common and most familiar of all the larger fungi are the bracket fungi, which belong to the order Aphyllophorales. These usually semicircular plates protrude from most dead logs and tree stumps. They too can reach enormous sizes. When growing on dead wood, they perform a useful task by decomposing the wood; when they occur on living trees, they are unpopular pathogens to foresters. The bracket fungi differ from mushrooms in that their lower surface is covered by tiny pores rather than the more familiar gills of mushrooms.

The exposed brackets on trees or the mushrooms emerging from the forest floor are only a small part of the total organism. These are the reproductive bodies that produce the spores that are dispersed and germinate to form the next generation. Inside a log infected with a bracket fungus or underground under a mushroom there is a mass of fungal hyphae, the threadlike structures of which the rest of the organism is composed.

*Fungi can attack and rot anything organic in the forest. This insect has succumbed to a pathogenic fungus.*

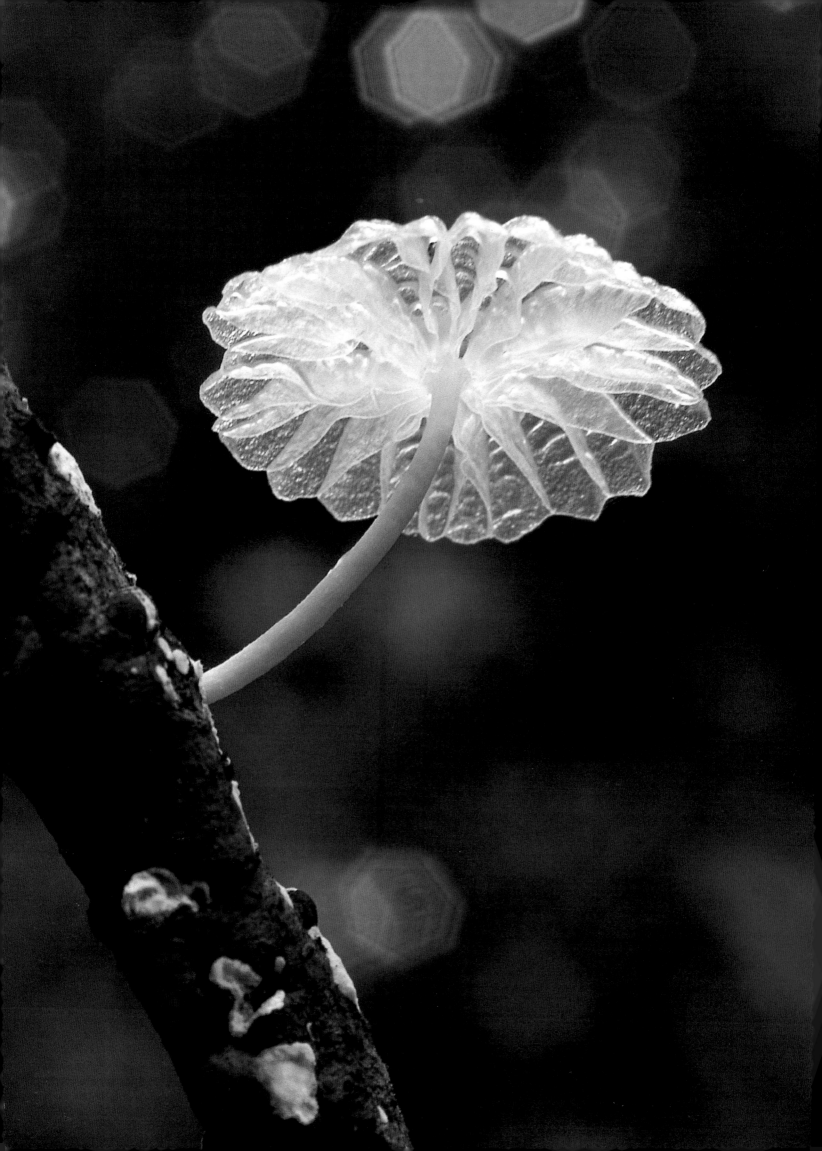

Besides their vital function in the life of a rainforest, fungi are also a good source of food to some forest peoples. The Yanomami Indians of the northwestern Amazon eat many species of fungi—I have collected thirty different such species in the various Yanomami villages I have visited. The edible species belong to both the gill fungi and the pored fungi. The Indians either boil the fungi or roast them in banana leaves. All their edible fungi are named with the suffix -amo. Many of the names that they give the fungi are derived from the resemblance of the fungi to familiar items, for example, hassamo, hassa being their name for a deer. There are porcupine, stingray, and other animal names used. Shiokoniamo, their name for Lentinus crinitus, means "hairy anus fungus," and one can see the resemblance! There is no doubt that fungi are an important part of the diet of the Yanomami. At the village of Toototobi the Indians have two words for eating, one for meat and one for other foods. The word for meat eating is also applied to fungus eating, perhaps implying that they regard this source of protein as a substitute for meat.

One of the most interesting aspects of the Yanomami consumption of fungi is the ecological conditions under which the fungi grow. Most of their edible fungi are

ABOVE: *A false boa snake* (Pseudoboa neuwiedii) *rests on a matching bracket fungus in the Tambopata National Park, Peru.*

FACING PAGE: *An elegant wood-rotting fungus on a twig in the rainforest of the Napo River region of Peru.*

species of Polyporaceae, which grow primarily on dead wood. The agricultural system of the Yanomami creates an ideal situation for the growth of fungi on the many logs that are left lying in their banana fields after they have cleared a patch of forest for agriculture. The Indians are therefore inadvertently cultivating a second crop, the fungi. Many of the fungi that they eat, such as *Favolus brasiliensis,* their favorite fungal food, and *Polyporus tricholoma,* flourish under the combination of humid climate and an abundance of fallen logs, pieces of half-burned rotting wood, and standing tree trunks. They are performing the function of breaking down and recycling the logs, but the Indians have also put them to culinary use.

However, the real importance of soil fungi is not that they feed human forest dwellers but that they are at the base of the food chain of the forest floor. The hordes of mites, springtails, and millipedes feed on the soil fungi, and those in turn are preyed upon by larger insects such as centipedes. The larger insects provide the food for spiders, frogs, lizards, and snakes, and so the food chain is gradually built up to the higher animals. In this process much of the energy is lost, which explains why the rainforest is not full of great quantities of large animals. Most tourists to the rainforest are disappointed by the apparent lack of animals on the forest floor, but in truth it is teeming with creatures microscopic in size rather than huge furry beasts.

# RAFFLESIA

The world's largest flower, rafflesia, grows on the rainforest floor of Sumatra and Borneo, although the plants that sustain it do not, for it is a parasite attached to the roots of climbers of the vine family Vitaceae. *Rafflesia arnoldii* has huge showy flowers that can reach 3 feet (1 m) in diameter. Since rafflesia is a parasite, it has no leaves and exists as a mesh of filaments growing inside the root of a vine until it is ready to flower. A cabbagelike bud first begins to emerge from the soil and then the gigantic flower unfurls. It has thick, leathery petals that are maroon in color and dotted with white patches. The petals surround a large cup, with the pollen-bearing stamens in a ring at the base. Although every traveler to the rainforests of Borneo or Sumatra wants to see this spectacular flower, it has a most unpleasant, putrid odor. But flies, deceived by the odor of carrion, swarm to it and so pollinate the flowers. The thousands of seeds that develop are small and hard-coated and become attached to the feet of large animals, which transport them through the forest. A few will land near the bruised roots of another vine and then germinate and gain entry to start a new generation. About twelve species of *Rafflesia* occur in West Malaysia, and a single one is found as far east as New Guinea. Unfortunately, rafflesia is becoming rarer and rarer because it is prized by local people as a medicine and because deforestation is rapidly causing loss of its habitat.

PAGE 184: *A red-eyed tree frog (*Agalychnis callidryas) *from Central America.*

PAGE 185: *A tree frog (*Hyla calcarata) *peers over a wood-rotting fungus in the Tambopata region of Peru.*

FACING PAGE: *This centipede hiding behind a palm leaf in the Tambopata River region of Peru is revealed only by its numerous legs.*

# SOIL ORGANISMS

All soils are full of living organisms, and these particularly abound in the superficial layer in rainforests where the rapid breakdown and recycling of nutrients is so important. German soil scientist L. Bach studied $2\frac{1}{2}$ acres (1 ha) of forest near Manaus, Brazil, and made an estimate of the quantity of soil fauna. He calculated that there were 727 million mites, 120 million springtail insects (order Collembola), 40 million aphids and scale insects, and 8.6 million ants! Clearly, these hordes of minute creatures that dominate the rainforest floor perform a vital function in the life of the forest.

*Large millipedes (Aphisto-goniulus sp.) are frequently encountered amongst the leaf litter of rainforest floors, here photographed in Madagascar.*

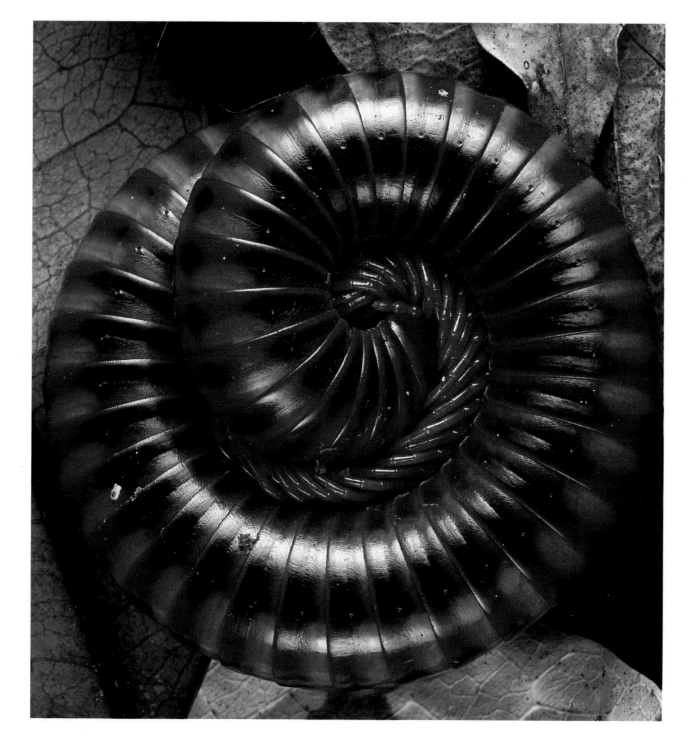

## TERMITES

Termites are not popular with people who dwell in wooden houses because of their capacity to cause severe damage. However, in the rainforest these insects play a crucial role in the process of decomposition and recycling of nutrients—it has been estimated that termites alone consume as much as 17 percent of the leaf litter in some Malaysian forests. Termites occur in almost all tropical forests and are social insects that make their nests in many weird and wonderful shapes either in the trees or in cavities in the ground. Termite colonies contain workers, soldiers, and queens. The latter are huge compared with the workers and are egg-laying machines. The

*The coiled leaf bud of a fern is often called a fiddlehead because of the resemblance to a violin, here photographed in the La Planada Nature Reserve, Colombia.*

worker termites have white abdomens and brown heads. The soldiers look similar but are larger. As their name would indicate, the soldiers are the protectors of a colony, and they can eject a sticky substance with a turpentine-like smell that is unpleasant to predators such as anteaters. The workers are blind and follow scents laid down by others as they pursue their foraging chores. Most termite species feed on dead wood and, aided by the organisms they host, are capable of breaking down both cellulose and lignin. Because cellulose and lignin are notably hard to digest, it is actually protozoans (small single-celled microorganisms) or bacteria that live inside the digestion system of the termites that perform this task. The higher termites (family Termitidae) rely on bacteria for digestion, while the lower termites use protozoans instead. Of particular "architectural" interest are the large pagoda-like mounds built by the African *Cubitermes* (higher termites), the design of which controls ventilation and ensures regulation of the temperature within the nest.

Termite nests contain higher concentrations of soil nutrients than the surrounding nutrient-poor soil and often serve as seedbeds for germinating tree seeds. The Kayapó Indians of Brazil have discovered that if they take pieces of abandoned termite nests into savanna areas and begin to plant trees, they can gradually build up small patches of forest using the nests as fertilizer. When these areas mature they contain useful plants, and formerly they also formed shelters for warfaring groups to conceal themselves in an otherwise open savanna area.

Many other insects such as millipedes and beetles are important decomposers of organic matter, but termites play the primary role in this process, inasmuch as earthworms are rather scarce in tropical soils. There are a few very large earthworms of the family Megascolecidae that can reach well over 3 feet (1 m) in length, but they are not nearly as important as other earthworms are in the temperate regions of the world. Members of the African subfamily of termites, Macrotermitinae, have a different source of food. These termites cultivate a basidiomycete fungus on fecal pellets that they deposit in underground fungal gardens similar to those of leaf-cutter ants.

## LEAF-CUTTER ANTS

In the New World tropics it is not termites but ants of the tribe Attini that cultivate fungus as a food. The leaf-cutter ants are abundant in Neotropical rainforests. As one walks through the forest, one frequently encounters well-worn trails with hordes of the worker ants carrying sizable leaf sections toward their large underground nesting colony from nearby trees and shrubs. Scurrying from the nest are other workers returning to get another load, which they scissor off in portable pieces. A mature colony of the species *Atta sexdens* may have up to 3 million workers, which can have quite an impact on the surrounding forest or on a crop field. It has been estimated that leaf-cutter ants consume 0.7 ton of foliage per acre (0.3 ton

per hectare) per year on Barro Colorado Island in Panama. This not only has an impact on the forest but also is another way in which decomposition and recycling of nutrients takes place.

The ants carry this huge quantity of foliage into the underground chambers not to eat but to use as food for the fungus that they cultivate. Leaf-cutters are the true gardeners of the insect world because they do not just dump leaves in their nest but have an elaborate process by which they tend their fungal gardens. A study made by Michael Martin in 1970 showed that once the ants have transported the leaves, they chew them and clean them. After laying this pulpy mass of leaf tissue on the fungal bed, they excrete a rectal fluid over it that is rich in ammonia and amino acids. These compounds are the source of nitrogen that nourishes the fungus. The rectal fluid even contains an enzyme that breaks down the amino acids, and the fungus is therefore completely dependent upon the action of the ants. With such assistance from the ants, the fungus can break down and digest the cellulose from the leaves. The fungus has not been found independently of the ant colonies, and so a complete

*Leaf-cutter ants (Atta sp.) are common in the rainforests of South and Central America. They play a key role in enriching and aerating the soil. Large chunks of leaf, which they carefully cut, can be seen moving along the leaf-cutters' trails. The ants take the leaves into underground chambers, where the leaves are used to grow the fungus upon which leaf-cutters feed.*

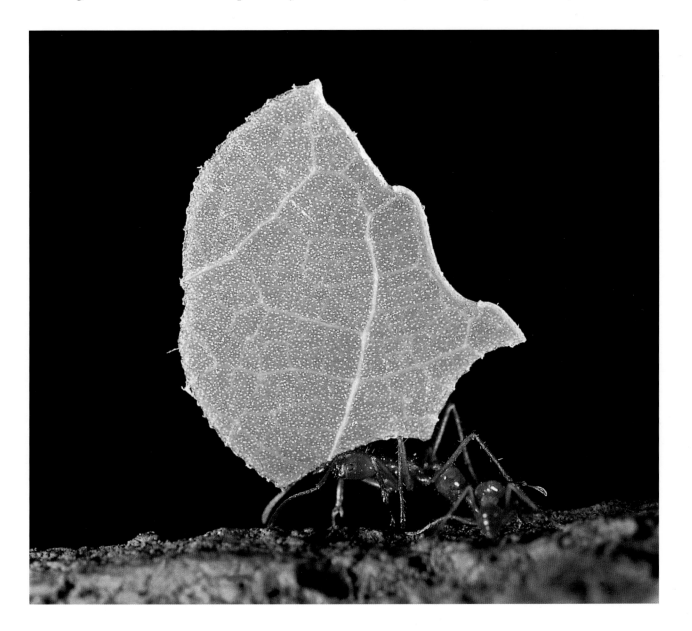

mutualism or dependence has evolved between the two. When a young queen ant emerges to found a new colony, she will always take some of the fungus in her mouth. This action assures the success of her new colony. And the ants, like all good gardeners, are also diligent weeders. The fungal colonies are always purely of a single species because the ants remove infestations of any other fungal species.

Like the African termite, the leaf-cutter colonies also have a caste of soldier ants. These are larger than the workers and can be seen around the entrance to a nest zealously guarding their colony. Everything in the rainforest has its predator, and the leaf-cutter workers are no exception. A small fly (*Apocephalus sp.*) hovers above the ants and attempts to lay eggs on their necks. The larvae of the fly hatch and feed on the ants' brain, causing death. In response to such a threat the ants have evolved another caste, smaller than the workers, termed minima. Like the soldiers the minimas' function is protection. These crafty small insects act as outriders, traveling on the backs of some of the workers and riding upside down with their pincers poised upward. They use their pincers to good effect to snap at the attacking flies.

Ecologist Stephen Hubbell has shown that leaf-cutter ants are selective about what leaves they tote into their gardens. For example, they do not take the leaves of the copal tree (*Hymenaea courbaril*), because it contains a chemical that is antifungal and would destroy their source of food. Such discretion on the part of the ants may lead researchers to new antifungal compounds.

There are about 200 different species of leaf-cutter ants, which cultivate several different species of fungi, but they all use this same fascinating process of gardening, one of the most sophisticated of all the many mutualisms that occur in the rainforest. Farmers may be upset when leaf-cutter ants invade their fields, but in the rainforest this is just another way of returning nutrients from the trees back to the soil. The ants carry huge amounts of plant material to their nests, thereby increasing the nutrients in the soil. The nests themselves modify physical properties of the soil such as density and porosity. Observations in Costa Rica on the leaf-cutter ant (*Atta cephalotes*) by Ivette Perfecto and John Vandermeer showed that there is a constant change of colonies as some die out and new ones are established. The scientists estimate that the soil in the forest that they studied can be expected to be fully turned over to a depth of $6\frac{1}{2}$ feet (2 m) in 200 to 300 years. Because of the ants' role in recycling soil nutrients, H. G. Fowler and associates have suggested that in Neotropical rainforest leaf-cutters are keystone species, that is, species upon which many others depend and whose loss would cause the loss of many other species.

## ARMY ANTS

The most notorious of all foragers on the rainforest floor are the battalions of army ants in the neotropics or their equivalent, the driver ants, in Africa. Their role has

FACING PAGE: *These wasp larvae are slowly killing this caterpillar in the Peruvian rainforest, where there is a constant battle between prey and predator.*

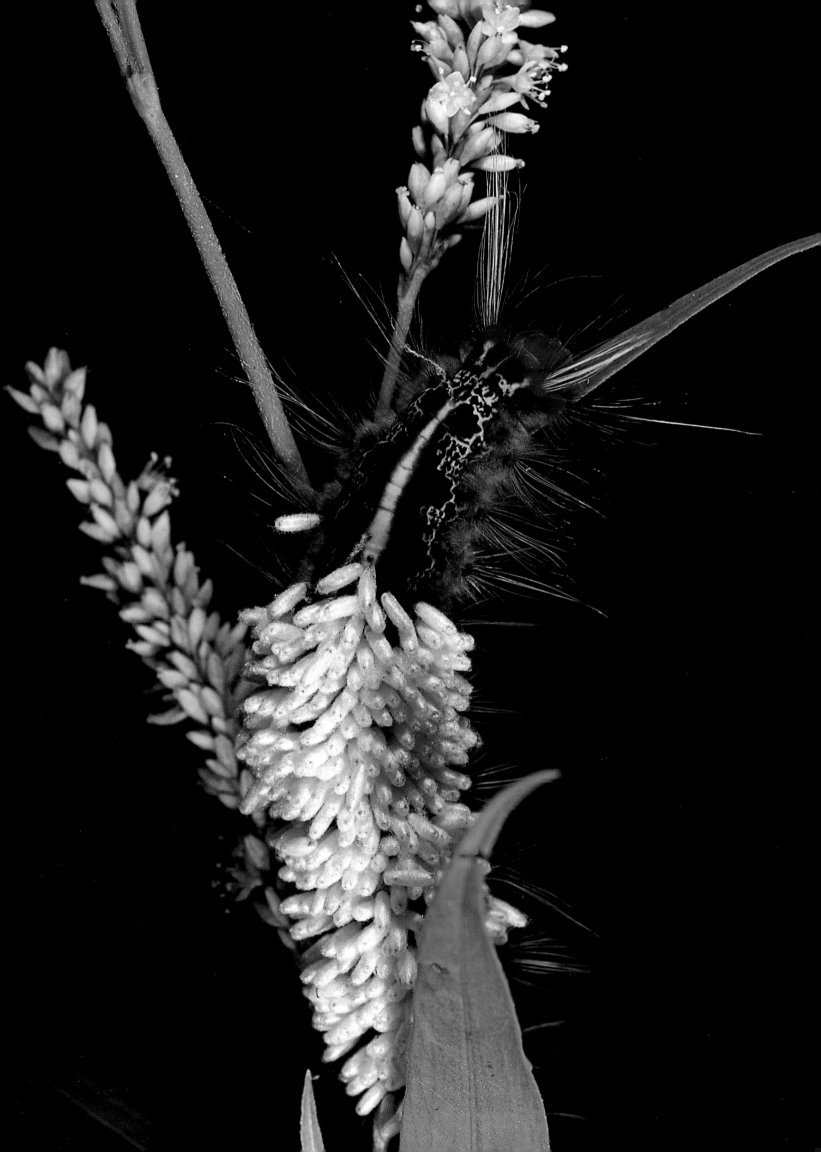

been vastly exaggerated by the media, but their determined columns of foraging ants can be quite scary. Driver ant colonies can number up to 20 million individuals and army ant colonies a mere 1 to 2 million. These ants are carnivorous and make their living by foraging through the forest floor, where they systematically capture any insect or other animal that is too slow to escape the advancing mass of scavengers. My first encounter with army ants was not in the forest but in our house on the wooded campus of the National Amazon Research Institute in Manaus, Brazil. I learned the hard way that it is better to follow the Indian method of simply ignoring an invasion of army ants in one's house, because as the columns arrived under the front door, my first reaction was to reach for the insect spray. All this did was cause confusion and spread the ants throughout the house. On later invasions we left the ants to their own devices, and they usually just entered by the front door, walked through the house, and exited by the back door. If you are lucky, they will even remove a few cockroaches along the way. When a column of army ants visits an Indian village, they merely calmly vacate the village, allow the ants to forage through it, and return later, grateful for the eradication of many insect pests that has taken place.

Army ants are permanently on the move and unlike the leaf-cutter ants do not have any permanent dwellings. They form huge clusters at night, which, in true army fashion, have been termed bivouacs. Thousands of worker ants form giant bivouacs by holding onto the legs of other ants by their mandibles. The queen always resides somewhere near the center of the bivouac. Generally a bivouac is made for one night, but from time to time the ants form a semipermanent bivouac for several weeks. During this time the queen enters into an egg-laying phase and new larvae are produced. Some workers stay behind in the encampment while others go out foraging and return with their prey. The colony remains in this position for several weeks until the pupae have matured and are ready to join the onward march. A queen can produce twenty to thirty thousand eggs in a two-day period, so the colony is quickly replenished with more workers. Various other insects have evolved a way of exploiting the columns of army ants by mimicking them chemically so that they are not differentiated by the ants. When these beetles and millipedes march with the ants, they are better able to prey on other species of beetles and millipedes that they encounter. These parasitic impostors are thus able to share in the spoils of the foraging ants.

The soldiers of the army ants have particularly large mandibles. Some Indian tribes have put this feature to good use. They will pick up these ants by the body and place them over a wound. The ant will snap its jaw shut over the wound, and the Indian will snip or twist off the ant's body from the head. The severed head will remain clasping the flesh of the wound and forms an excellent suture.

Walking in the Neotropical rainforest, one is often aware of army ants nearby not by catching sight of the marching column of ants but by the presence of a mixed flock of a variety of species of birds. These are the ant birds, which make their living by following army ant columns and feeding on the hapless insects that are alert enough to escape the advancing columns of ants. The flocks of ant birds are an ornithologist's delight because they are of mixed species such as the true antbirds, antwrens, antpittas, antshrikes, and ant-thrushes. Some species of birds forage with army ants exclusively, whereas others join the ants from time to time. Like the beaters of a shooting party, the ants stir up an excellent source of food for the birds. The ant birds sing and chirp as they happily snap up the insects flushed out by the ants and are consequently easily located by the bird-watcher. One can spend hours transfixed by the variety of birds that follow army ants. Ant birds range from Mexico to Argentina and belong to the family Formicariidae, which contains more than 220 species. They are generally small to medium sized, and the males and females have different plumages. Other birds likewise take advantage of foraging ants, and so it is also possible to find tanagers, woodcreepers, ground cuckoos, and other species joining in the feast.

# ARMADILLOS

These ground-dwelling mammals are ubiquitous in the neotropics and are the main predator of leaf-cutter ants. They live in burrows in the forests and savannas. There are 21 different species of armadillo. The bodies of armadillos are encased in transverse bands of bony scales beneath horny plates, with a flexible skin between the plates. This enables some species to roll into a ball with their soft vulnerable parts concealed as a defense mechanism against would-be predators. The diet of armadillos is by no means confined to leaf-cutter ants, since they are omnivorous animals, but insects and other arthropods are their preferred diet. However, their elongated tongue is characteristic of anteating animals, and the three to five claws on their front legs enable them to burrow into ant colonies. They help to increase the turnover of leaf-cutter ant colonies and thereby increase the soil turnover and fertility. The giant armadillo (*Priodontes giganteus*) reaches up to 5 feet (1.5 m) in length and can weigh up to 130 pounds (60 kg).

There is a most remarkable similarity between the giant armadillo of the neotropics and the terrestrial pangolin (*Manis gigantea*) of the African rainforests. The latter's protective "armor" consists of scales rather than plates. The existence of these two only distantly related animals on different continents demonstrates how different animals have evolved to fill the same niche and perform the same ecological function.

# FROGS, LIZARDS, AND SNAKES

The first vertebrates, or backboned animals, in the food chain on the rainforest floor are frogs and lizards. These animals forage for insects amongst the leaf litter. Zoologist Norman Scott showed that there are many more species of frogs in the forest litter layer in the neotropics than in Borneo but that there are many more lizards than frogs in the leaf litter of rainforests of Borneo. Interestingly, the Bornean forests produce only a tenth of the litter that those of Costa Rica do. In the neotropics, where frogs abound they are either well camouflaged and extremely difficult to spot, or poisonous and brightly colored to warn predators of their unpleasant taste or even fatal effect.

Frogs are classed as amphibians and so we expect them to inhabit wet places as does the bullfrog beside the ponds of North America. However, frogs have adapted to all strata of the rainforest, from the tops of trees to the forest floor. The most common forest-floor frogs in the neotropics are species of the genus *Eleutherodactylus*, which has more than four hundred different species. These frogs are able to inhabit rainforest litter because the eggs they deposit in damp patches under the litter, and then abandon, develop directly into miniature frogs without going through the familiar tadpole stage. Some species of *Eleutherodactylus*

*A coral snake from the Amazon Basin (*Micrurus sp.*) has no need to match the forest floor. Its deadly poison is enough to warn off predators.*

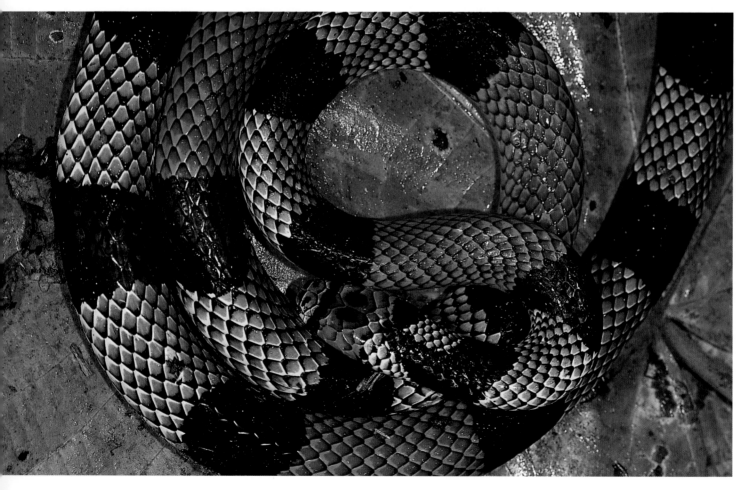

produce froglets directly without even going through the egg stage. In contrast to the dull colors of the *Eleutherodactylus* frogs, which match dead leaves so perfectly, are the brightly colored dendrobatid frogs, some species of which have an extremely toxic poison in the skin that is used as an arrow poison by indigenous tribes of western Colombia. These frogs also deposit their clutches of eggs in damp leaf litter, but the eggs hatch into tadpoles rather than froglets. The parent frogs, however, do not abandon their clutch. One of the parents—in some cases the male, in other species the female—closely guards the eggs. When the tadpoles hatch, they wriggle their way onto the back of the waiting parent. They are quite safe there because the bright colors of the parent warn predators that this is a poisonous frog that would not make a good meal. The tadpoles are unharmed by the poison of their parent. The poison, batrachotoxin, is the most powerful venom produced by any vertebrate.

Many species of salamander likewise have powerful toxins in their skin. Zoologist Edmund Brodie from the University of Texas showed that two species of salamander from Costa Rica adversely affect garter snakes (*Thamnophis*). He found that the toxin produced by the salamanders *Bolitiglossa rostrata* and *B. subpalmata* caused snakes to pause during ingestion when their mouths were paralyzed. The snakes often died after attempting to eat the more toxic *B. rostrata*. Many of the salamanders that the snakes tried to ingest recovered (17.6 percent of *B. subpalmata* and 71.4 percent of *B. rostrata*). With the snakes' lower jaw paralyzed by the salamander toxin, some of the amphibians could simply walk out of the jaws of their predator.

When poisonous rainforest animals are mentioned, most people think of snakes rather than frogs. There are a large number of both poisonous and nonpoisonous snakes, but they are much less common than the movies would have us believe. It is actually possible to spend a week in the rainforest without ever seeing a single snake. I have carried out expeditions with teams of botanists in the Amazon rainforest over the past thirty years, and although we have spent more time off tracks pushing into the bush to collect plants, not one person has been bitten by a snake. We have seen many and varied snakes, but they are mostly shy and nocturnal and so the danger has been vastly exaggerated. There seem to be many more snakes in agricultural areas and secondary forest, where there is more food for the animals. However, snakes should be treated with respect because fatalities from the fangs of poisonous snakes do occur. For example, it has been estimated that there are about 100 deaths a year from snakebite in isolated farms in Ghana. Again, this is more in farmland than inside the rainforest. Each area of the tropics has its poisonous snakes. In the neotropics there are bushmasters, coral snakes, rattlesnakes, and fer-de-lance. In Africa there are vipers, cobras, and mambas, and in tropical Asia there are also cobras, mangrove snakes, and many others.

*Snakes are not as common in rainforest as the movies would have us believe. However, there are a large number of snake species well disguised amongst the leaf litter of the forest floor.*

PAGE 198, TOP: *Dumeril's boa* (Acrantophis dumerili) *from Madagascar.*

PAGE 198, BOTTOM: *A rainbow boa* (Epicrates cenchira) *from Amazonian Brazil, one of the most attractive constrictor snakes.*

PAGE 199, TOP: *This Gaboon viper* (Bitis gabonica) *from West Africa blends well with the dead leaves on the forest floor.*

PAGE 199, BOTTOM: *A yellow-throated parrot snake* (Leptophis sp.) *from Tambopata, Peru.*

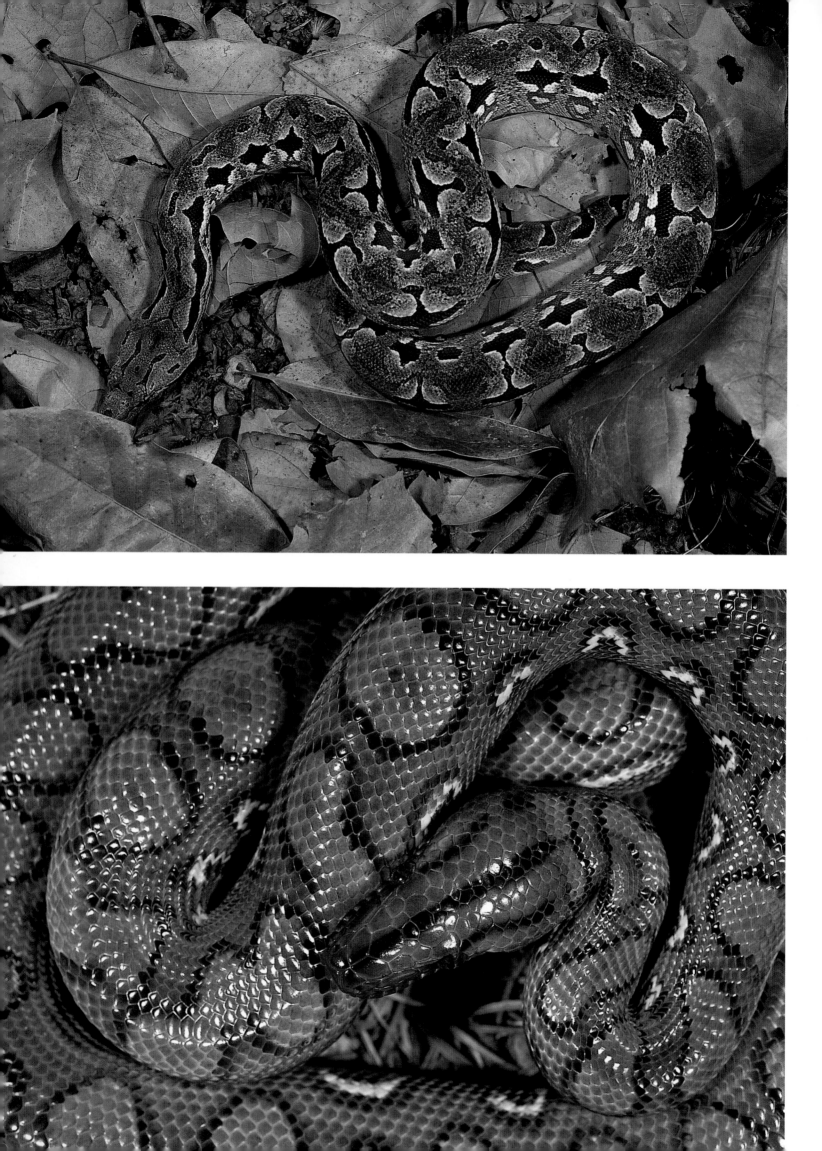

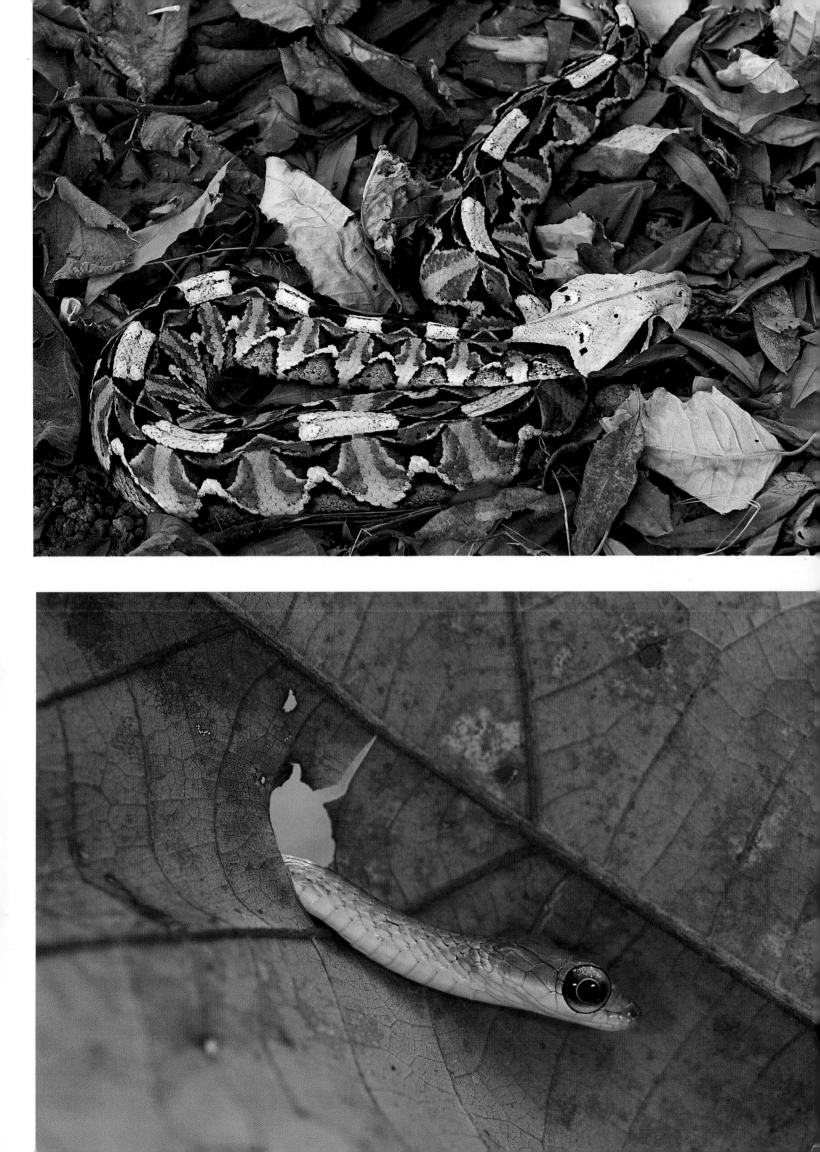

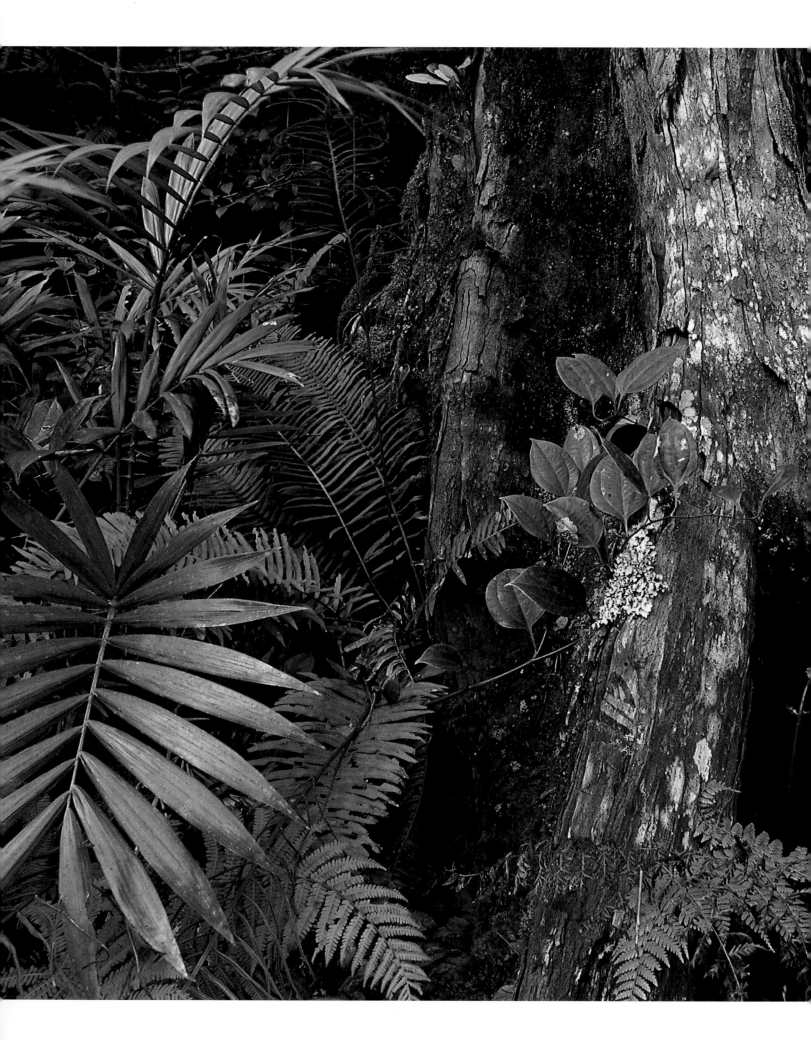

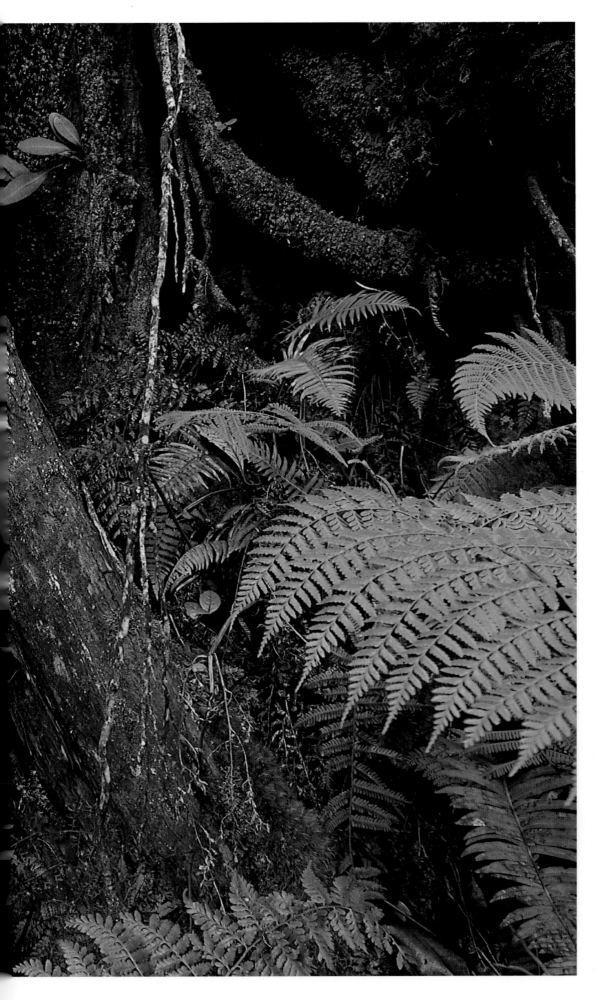

LEFT: *Buttressed trees are a feature of all rainforest regions. This one is in Borneo.*

FOLLOWING SPREAD: *Rainforest trees often have large buttressed trunks. This adaptation lends support to the trees because their root system must necessarily be shallow in order for them to obtain nutrients from the rotting soil litter. There is a three-toed sloth* (Bradypus infuscatus) *on one of the buttresses of this giant Amazonian tree.*

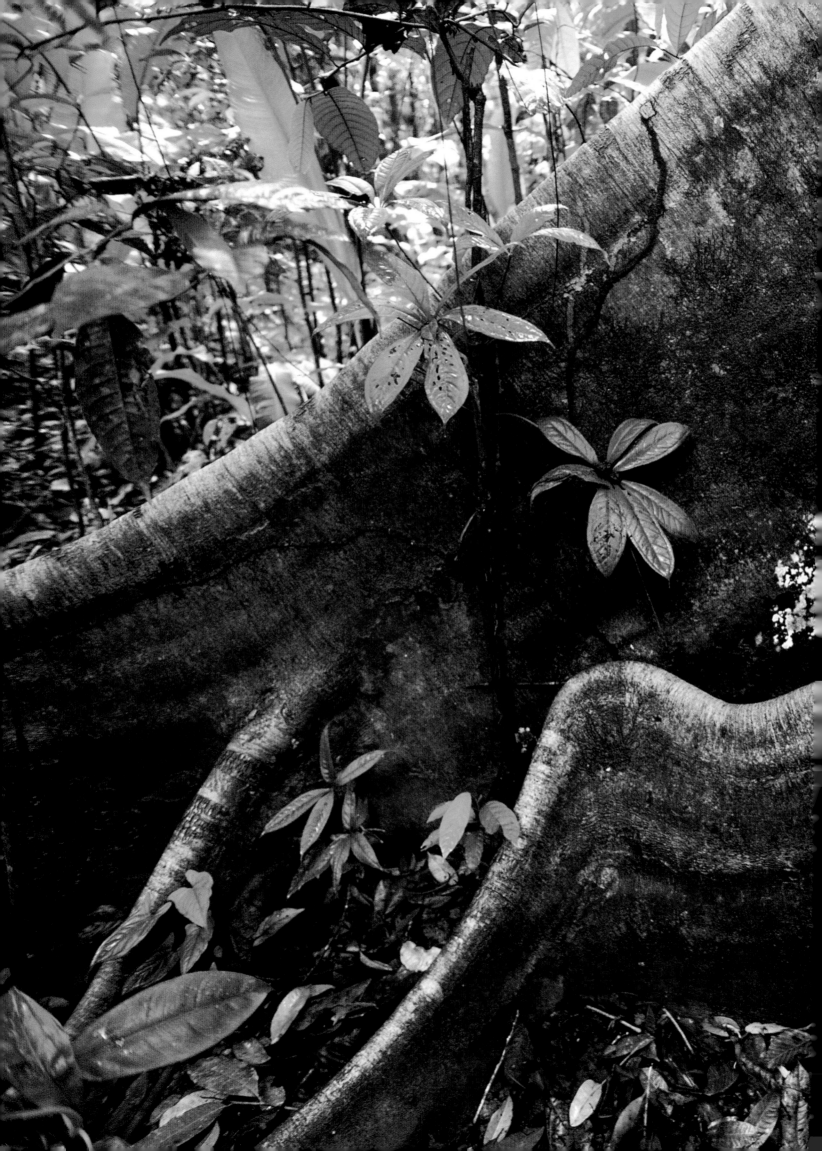

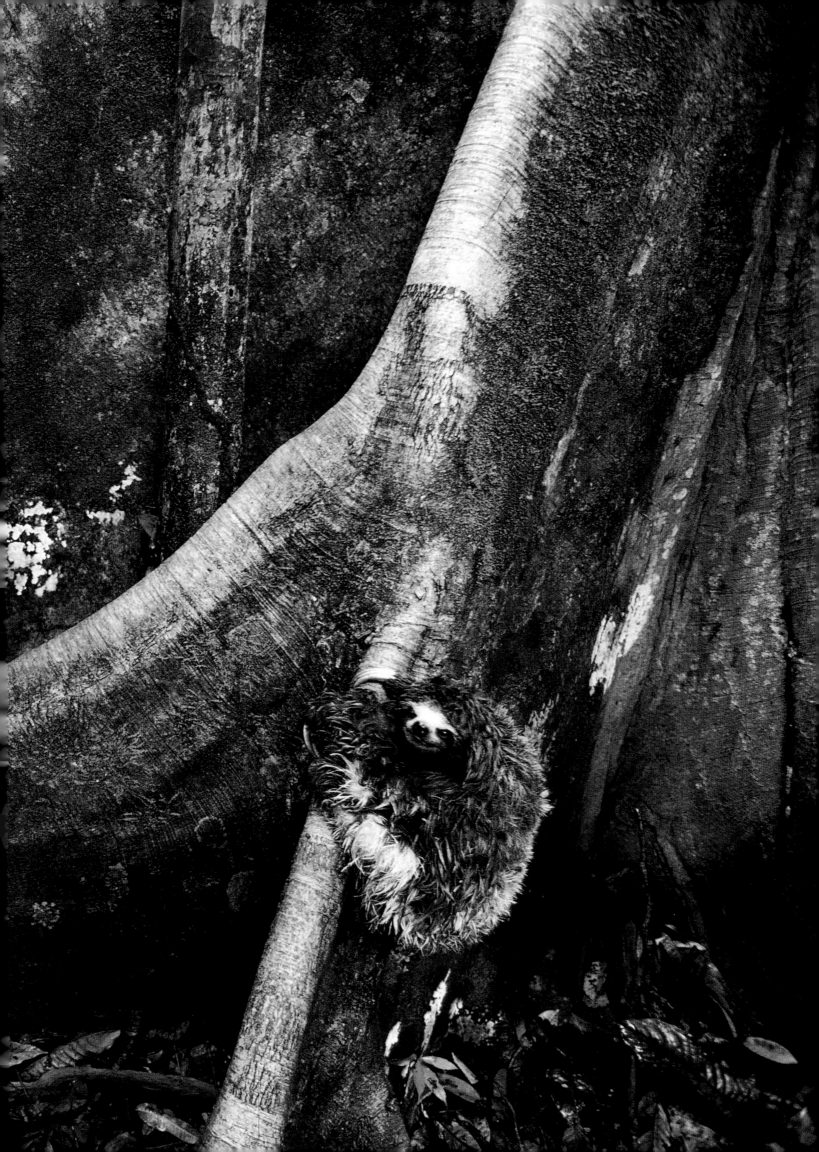

RIGHT: *One of the strangest-looking of all rainforest trunks is that of the strangler figs (*Ficus *sp.). Their roots extend around the trunk of another tree, gradually embracing it and becoming woody to form an interlacing network that eventually kills the host tree and leaves the fig to support itself.*

FACING PAGE: *The forest floor in Bwindi Impenetrable National Forest in Uganda.*

Many species of snake have no poison at all. The best known of these are the pythons and boa constrictors. The world's largest snake is the South American anaconda (*Eunectes murinus*). The pythons, boas, and anacondas all capture their prey by coiling around it and then killing it by constriction. They then swallow their prey whole and gradually digest it over an extremely long period of several weeks or even months before they hunt again. The South American boas (*Boa constrictor*) are beautifully colored snakes. They have spectacular patterns in many shades of brown. The largest boa ever captured was a mere 18½ feet (5.6 m) in length, but they are usually much smaller. The anaconda may not be as long as a python, but it is much wider in body and looks like a large fire hose. Anacondas typically live near rivers, and they feed on quite large animals such as capybara, pecaries, caimans, and herons. The other large constricting snakes feed on a great variety of mammals and birds rather than on the frogs and lizards that are the food of many smaller snakes.

For me the most beautiful of all snakes is the Amazonian emerald tree boa (*Corallus caninus*), which is colored deep green above and a paler yellowish green

*FACING PAGE: Sometimes fallen flowers from trees brighten up the usual brown floor of the rainforest. Here the flowers of a canon-ball tree* (Couroupita guianensis) *have fallen in great abundance.*

*BELOW: This forest floor in Panama is decorated by a flower from a legume vine* (Clitoria javitensis).

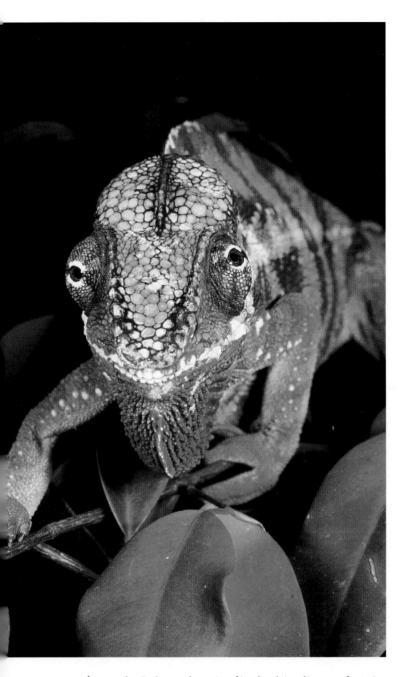

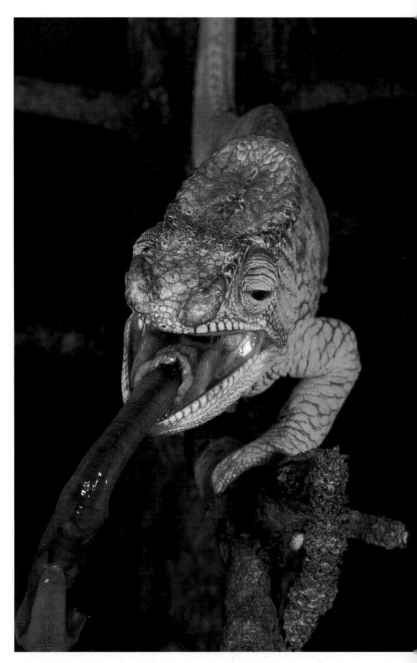

beneath. It has a longitudinal white line and various white dots and bright yellow eyes. This small boa lives in trees rather than on the forest floor.

It is a pity that snakes have such a bad reputation among humans because as a result many, even nonpoisonous ones, are killed unnecessarily. Snakes pose little danger to the rainforest traveler, yet they play a vital role in the ecology because, in addition to the reptiles that they eat, their other main food is small rodents. They keep these animals under control and perhaps even protect us from a plague of rodents. Many dwellers of the tropics welcome a snake in the rafters of their house because it kills the rats!

*The place to see a great variety of chameleons is Madagascar, where they come in many shapes and colors.*

Facing Page: *This tree frog* (Hyla vasta) *from the Napo River Region of Peru is well concealed by a rotting leaf.*

Above Left: *A panther chameleon* (Chamaeleo pardalis).

Above Right: *Parson's chameleon* (Chamaeleo parsonii), *extending its tongue to capture prey.*

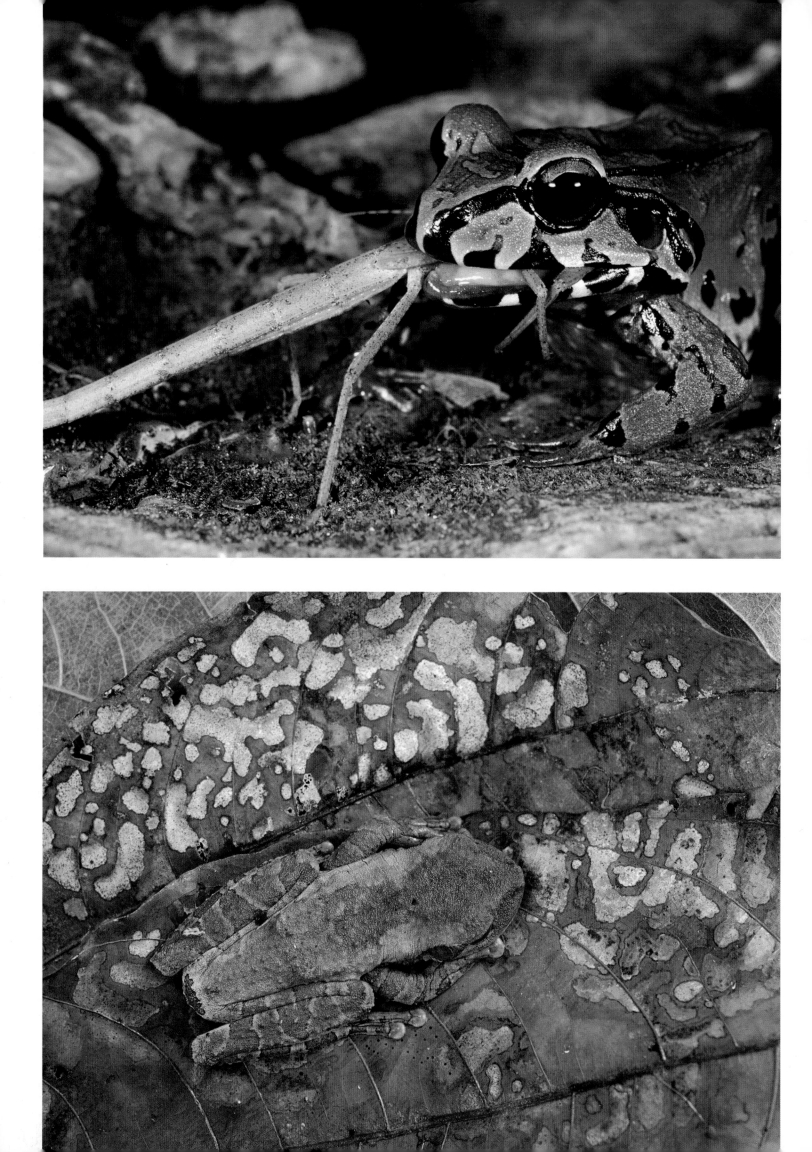

PAGE 210, TOP: *A South American bullfrog* (Leptodactylus pentadactylus) *eating a walking stick insect in the Tambopata National Park in Peru.*

PAGE 210, BOTTOM: *A casque-headed frog* (Osteocephalus taurinus) *from Tambopata National Park, Peru.*

PAGE 211, TOP: *A flat-tailed leaf gecko* (Uroplatus sikorae), *which has a flattened tail to avoid shadow, is hard to spot on this tree trunk in Madagascar.*

PAGE 211, BOTTOM: *This excellently camouflaged dead leaf moth* (Apetalodidae sp.) *on the forest floor in Barro Colorado Island, Panama, is a leaf mimic. It even has veins that resemble those of a leaf.*

LEFT: *The native peoples of the forest are often hard to spot when they blend into the environment like this swimming Yanomami boy from Venezuela.*

# MAMMALS OF THE RAINFOREST FLOOR

Whereas hordes of large animals are to be found in the tropical savannas, the majority of mammals that roam the rainforest are smaller rodents, whose size makes them better adapted for life amongst the dense mass of trees. In the neotropics two of the most common animals are the agouti (*Dasyprocta*) and the paca (*Cuniculus paca*). Both of these large, tailless rodents eat plants. The paca is a nocturnal animal and can weigh up to 22 pounds (10 kg) and reach up to 32 inches (80 cm) in length. The reddish brown coat of a paca has rows of white spots along each side. Pacas live in underground burrows, frequently under the roots of the giant trees. They eat mainly fruit and flowers. I have often been with local peoples who have shown me their platform to hunt paca in a tree next to a flowering tree, particularly a member of the Brazil nut family, that drops many flowers to the ground. When cataloging the use of trees with Indians, I have found that they will often say that the purpose of a particular tree is to attract game, and it is usually paca to which they are referring. The paca is widely hunted for its chickenlike meat.

The agouti is slightly smaller than the paca and there are about ten different species. The agouti also lives in burrows, but unlike the paca it is a diurnal animal. The reddish brown fur does not have the spots of a paca. Agoutis also eat primarily fruit. Like squirrels in the northern temperate forests, they tend to bury caches of nuts and seeds during times of plenty. They cart the seeds for some distance and bury them. They do not remember to return to all of their stashes, or perhaps an ocelot or a jaguar hunts the agouti and so the seeds escape further predation. Agoutis play an extremely important role in the dispersal of seeds around the forest.

The familiar Brazil nut (*Bertholletia excelsa*) is one such seed dispersed by agoutis. The nuts are borne inside a large, round, woody fruit and are arranged like the segments of an orange. Each fruit contains from ten to twenty-one nuts. The baseball-sized fruits are extremely hard, and they fall from the top of the trees in January and February. The agoutis are the only animals with teeth sharp enough to gnaw open the outer shell and extract the nuts, which they cart off to their hoards. They often nibble the shells of the nuts as well, which assists germination. The agoutis disperse the seeds of many other species of trees through this process of scatter-hoarding, as it is called. Their hoards are indeed widely scattered, which protects some of their stores from the foraging peccaries that raid them.

In the rainforest of Africa two relatives of the antelope fill the same niche as the pacas and agoutis of the Americas. Most antelopes are large grazing animals of the savannas, but some of their relatives have become smaller and more adapted to forest life. The chevrotain (*Tragulus*) fills the same niche as the paca, and the royal antelope (*Neotragus pygmaeus*) is the African equivalent of the agouti. The latter ani-

mal is Africa's smallest ungulate, or hoofed animal. Like the agouti it is much hunted for its meat, but as its common name implies, in some tribes only the chief is allowed to the eat the meat. There are also related species of *Tragulus* in the forests of tropical Asia.

The most abundant rodents of the forest floor of the neotropics are the spiny rats (family Echimyidae), but these sly nocturnal creatures are seldom seen. There are numerous species, which vary from 3 to 20 inches (7.5 to 50 cm) in size. The spiny rats, as their name indicates, have bristly hairs, some of which are sharp quills. They are therefore hedgehoglike in both appearance and habit. They also have very long tails that are often longer than the rest of their body. The quills, however, are not normally visible and are erected only when the animal is threatened, at which point they readily detach and can become embedded in the skin of the predator. Being by far the largest mammal population in the forest, spiny rats obviously play an important ecological role in the recycling process.

Along with the small animals that abound on the floor of the rainforest, some larger animals such as peccaries, deer, and jaguars are to be found. The rainforests of all three major regions are home to wild pigs or piglike animals. In the neotropics it is the peccaries that forage through the leaf litter, digging up fruits, roots, bulbs, insects, or any other animals they can catch. The peccaries resemble wild pigs and have piglike snouts ideal for foraging in the litter, but they belong to a separate family, the Tayassuidae. Unlike the tusklike canine teeth of wild pigs, the upper canines of peccaries are directed downward. The most widespread species is the collared peccary (*Tayassu tajacu*), which ranges from the deserts of the North American southwest to Argentina. Its common name derives from the band of white hairs at the base of its neck. These mammals roam the forest in small groups of five to thirty individuals. The larger white-lipped peccary (*Tayassu pecari*) forms much larger herds, often of more than a hundred beasts. This animal is named for the white hair around its mouth. White-lipped peccaries are much more aggressive than the quieter collared variety. They will attack people who are in their pathway even when unprovoked. I have twice had to scale a tree rapidly to escape from white-lipped peccaries. One time, they congregated around the rather small tree in which I had taken refuge and butted it to try to shake me out. Fortunately, the tree withstood the onslaught and I was able to hold on for the five minutes they retained an interest. The white-lipped peccary has extremely strong jaws and can crack open even some of the toughest palm fruits.

Peccaries have a large gland on their backs that secretes a musklike substance. The gland becomes visible from under the covering of hair only when the animals are under stress or excited and the hairs are erected. They use the gland to mark their territories by rubbing against trees and rolling on the ground.

The true pigs of the Old World tropics belong to the family Suidae. They are

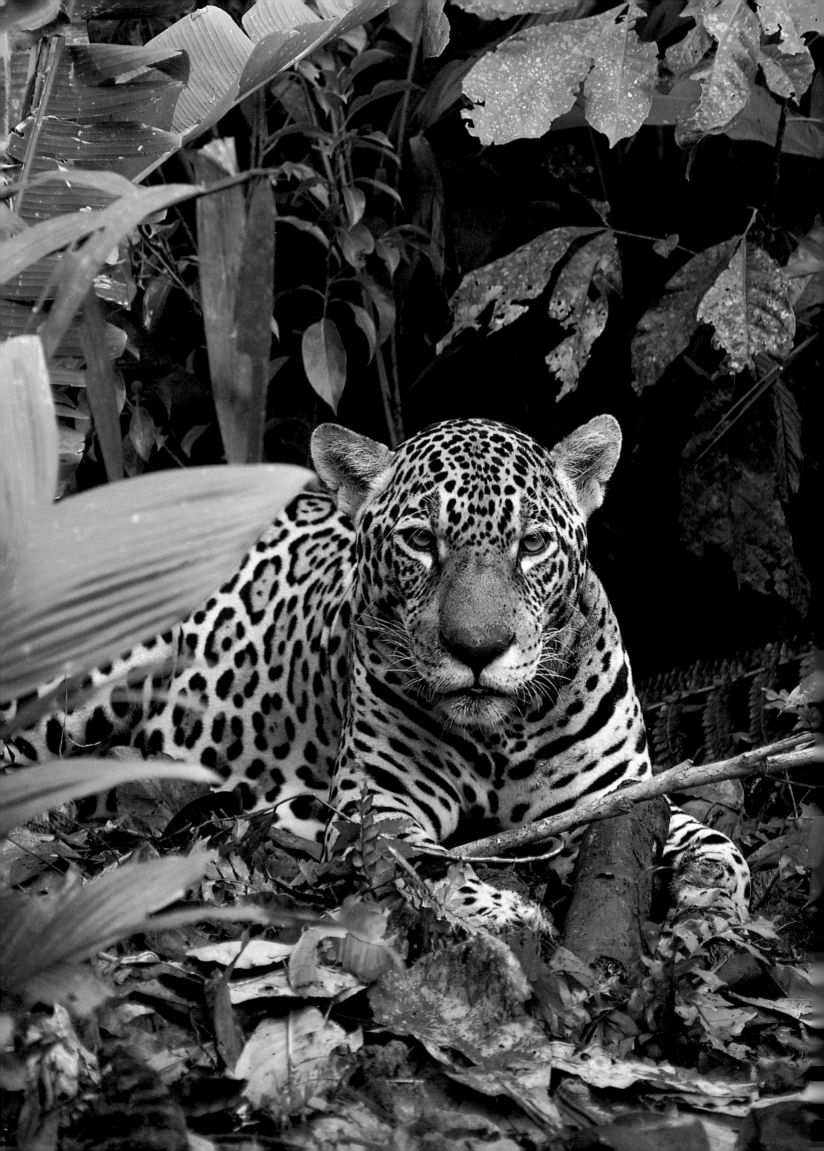

larger than peccaries, the largest of which weigh only 50 pounds (23 kg). The pigs never reached the neotropics until taken there by humans, but in Africa and Asia several different species developed. For example, the giant forest hog (*Hylochoeras meinertzhageni*) and the bush pig (*Potamochoerus porcus*) roam the rainforests of West Africa. The rare and endangered pygmy hog (*Sus salvanius*) of the forests of northeastern India is particularly well adapted to forest life because of its small size. The bearded pig (*S. barbata*), which has long beardlike hairs on the sides of its face, forages through the forests of Southeast Asia in search of most fruiting trees. Like many of the pig family, though, this species has been overhunted and is threatened with extinction.

Deer are comparatively recent arrivals to the South American rainforest, having spread there only after the isthmus of Panama connected North and South America. However, the familiar white-tailed deer (*Odocoileus virginianus*) has spread throughout Amazonia, where it is much smaller than its North American cousins, rarely exceeding 100 pounds (45 kg) in comparison to 300 pounds (136 kg) in the North. This is a better size for forest life. The smallest Neotropical deer are the brockets (*Mazama*), which weigh a mere 33 to 46 pounds (15 to 21 kg). Their small size suits them well for life in the forest undergrowth, where with their reddish brown coats they are well camouflaged. They feed on seedlings of trees, leaves of low vegetation, and fruit. The males have simple unbranched antlers, which are much better adapted for forest life than branched ones that would tangle in the vegetation. In the rainforest of Africa the small yellow-backed duiker (*Cephalophus silvicultor*) occupies exactly the same niche as the brockets in the neotropics. There are also several other species of small duiker in the African rainforests, such as the banded duiker (*C. zebra*) in the forests of Liberia. With its zebralike stripes this animal blends perfectly into the forest and is hard to spot. The ground-dwelling ungulates have evolved particularly well in the rainforests of Africa.

Most of the world's large cats roam the savannas and mountain habitats, but there is no doubt that the king of the Amazon rainforest is the jaguar (*Panthera onca*), the animal at the top of the food chain that hunts almost anything smaller. The jaguar is by no means confined to the rainforests of South America and is equally at home in dry thorny scrubland, savanna, and pampas. However, they have now been hunted out of most of these open habitats, and the much reduced population that remains consists mainly of those that have been able to conceal themselves in the depths of the rainforest. This once abundant animal has now become quite rare because it has been extensively hunted for its pelts. In all my wanderings in the rainforests of South America, I have seen a jaguar only four times, and two of these were in the headlights of the vehicle I was driving. Jaguars are either yellow-brown with black spots or black. They are not confined to the forest floor but both climb trees and swim in the rivers, preying on the fish and alligators that form part of

FACING PAGE: *The jaguar* (Panthera onca) *is at the top of the food chain in the Amazon rainforest. It is seen here in the Tambopata National Park, Peru.*

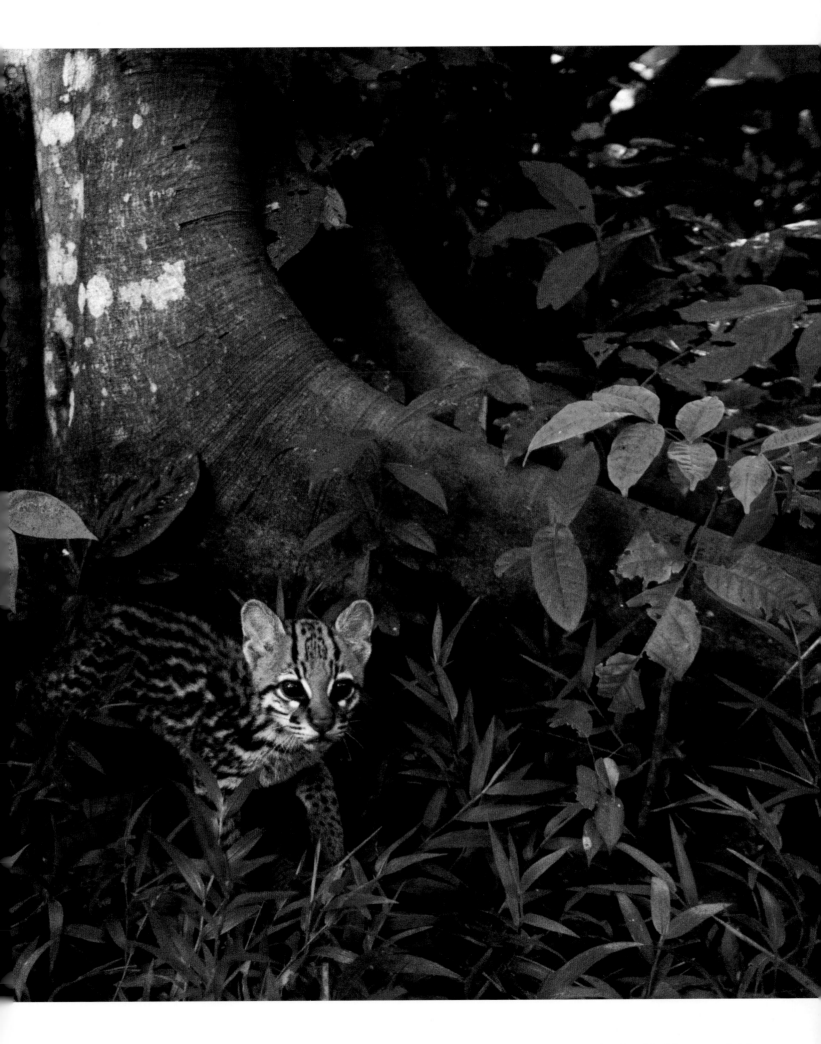

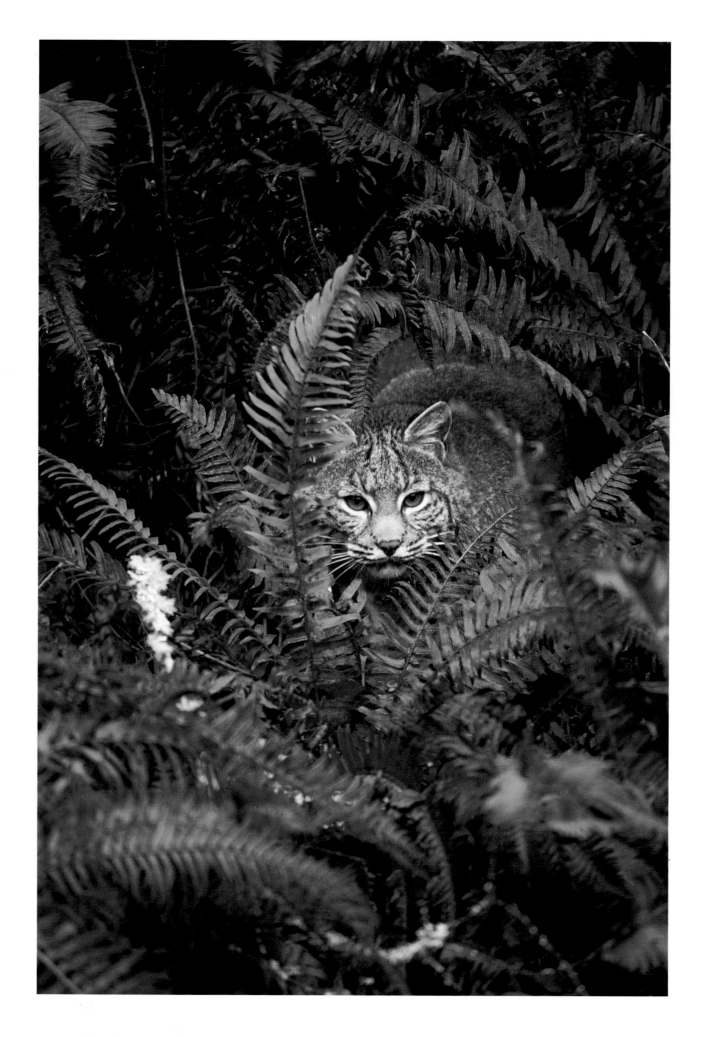

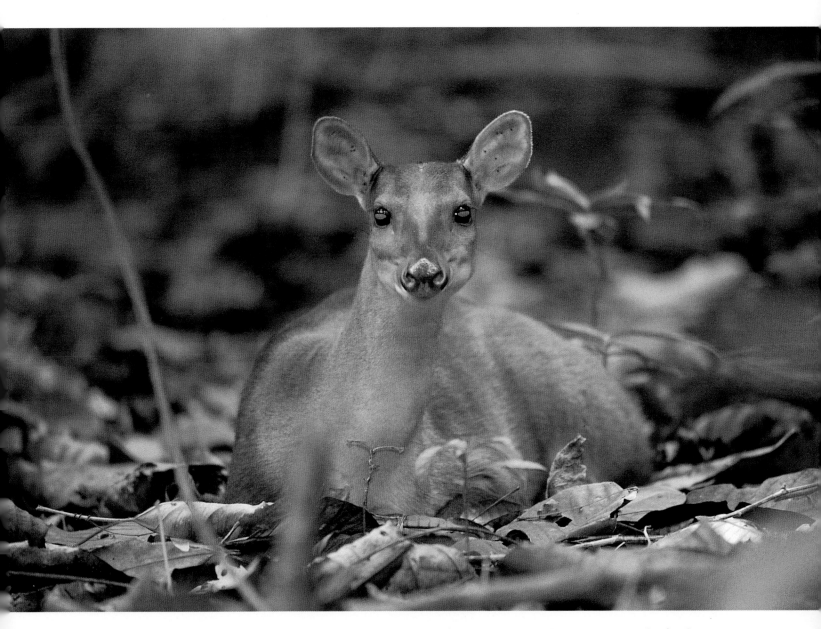

their diet. They hunt many of the larger ground-dwelling forest animals such as brocket deer, pacas, capybaras, and even the larger peccaries and tapir. However, they will eat anything that comes their way, including birds, small rodents, snakes, lizards, sloths, and monkeys. The jaguars hunt their prey either by stalking through the forest or by ambush. The cat may lie in wait beside a river or stretched out along a branch of a tree, from which it just drops down on its prey. Since jaguars themselves have now been so overhunted, they are wary beasts and keep their distance from people, and thus there is little danger from them unless they are cornered.

Three smaller species of cats that inhabit the South American rainforests are the ocelot (*Felis pardalis*), the jaguarundi (*Herpailurus yagouaroundi*), and the margay (*Felis wiedi*). The ocelot hunts both on the ground after frogs, lizards, agouti, and paca and also in the trees after birds and mammals. It is an excellent climber. The margay, which is closely related to the ocelot, is smaller and rarer. Both are nocturnal beasts and are spotted like the jaguar. The jaguarundi is a much more slender, streamlined beast often known as the otter-cat and is not spotted but occurs in sev-

ABOVE: *A brocket deer* (Mazama gouazoubira) *is a small deer whose body size is suited to life in the forest, photographed here in Panama.*

FACING PAGE: *The bobcat* (Felis rufus), *also known as the bay lynx or wildcat, inhabits the temperate rainforests of Washington State, USA, and can often be found as far south as central Mexico. Since it frequently raids livestock and poultry, it is not a very popular animal with farmers.*

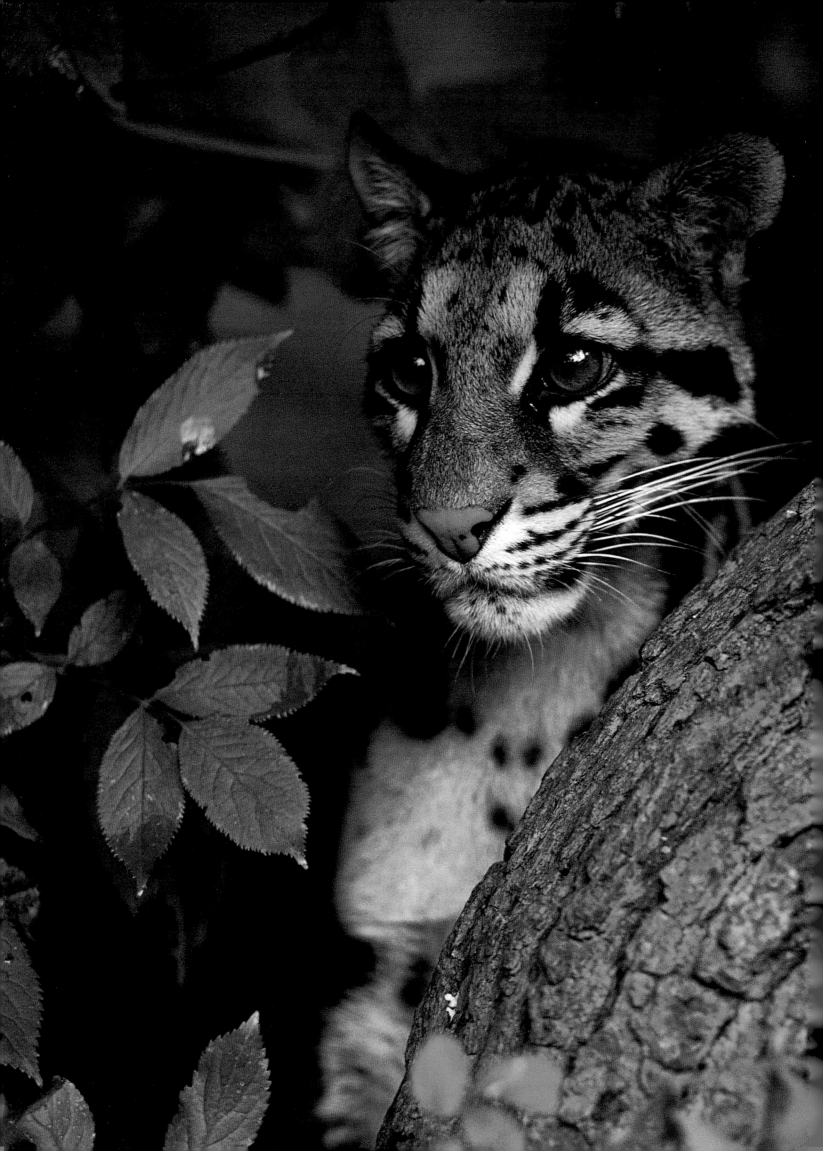

*The clouded leopard*
(Neofelis nebulosa) *is one of the spotted cats of the forests of Southeast Asia. It has stripes on the face and tail, spots on the limbs, and rosettes on the body. It is only distantly related to the common leopard.*

eral color varieties, the most common being gray and black. The jaguarundi hunts both by day and by night, is mainly terrestrial, and feeds on birds and small animals but also includes fruits in its diet.

In each of the major rainforest areas of the world, species of cats dominate the top of the food chain. In Africa it may be the golden cat (*Felis aurata*) or the leopard (*Panthera pardus*). The latter is found in both South Africa and Asia.

In the Old World tropics civets, genets, and mongooses of the family Viverridae are important carnivores. These short-legged, long-bodied animals are the only carnivores to have reached the island of Madagascar. The Madagascan fossa (*Cryptoprocta ferox*) looks much more like a cat than a civet or other Viverridae, but it is a case of parallel evolution. This sort of body shape and appearance is suitable for a forest carnivore.

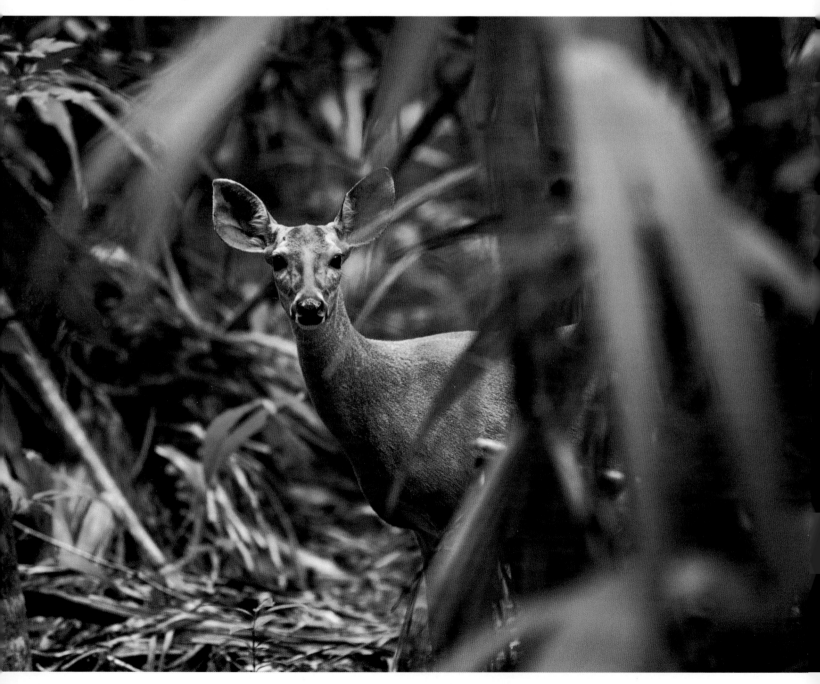

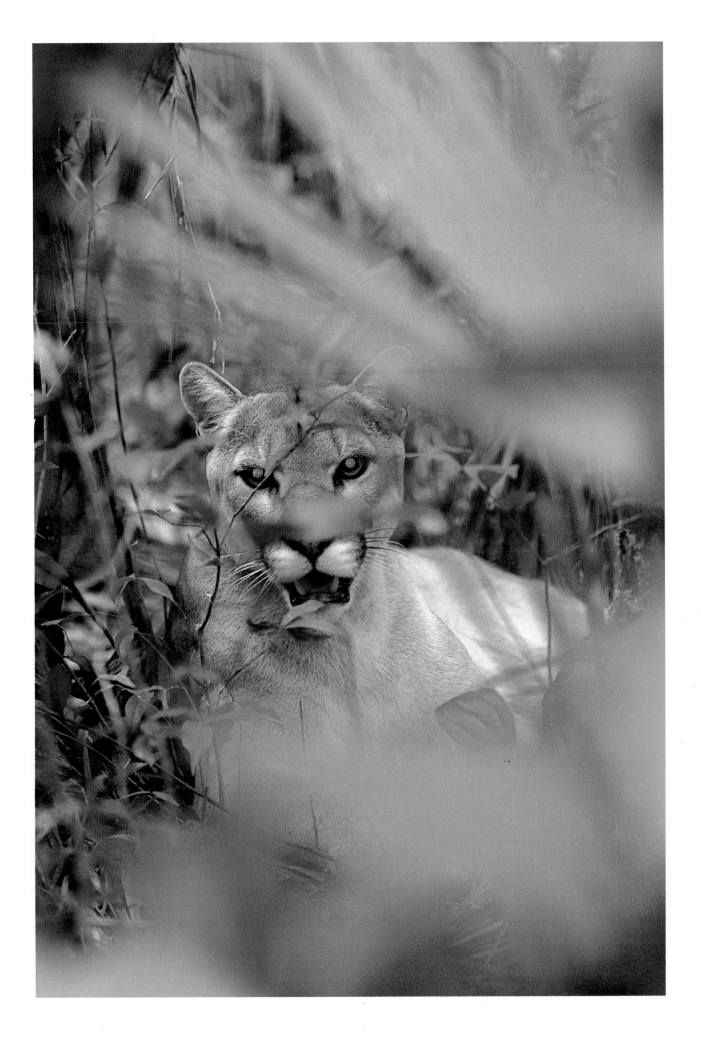

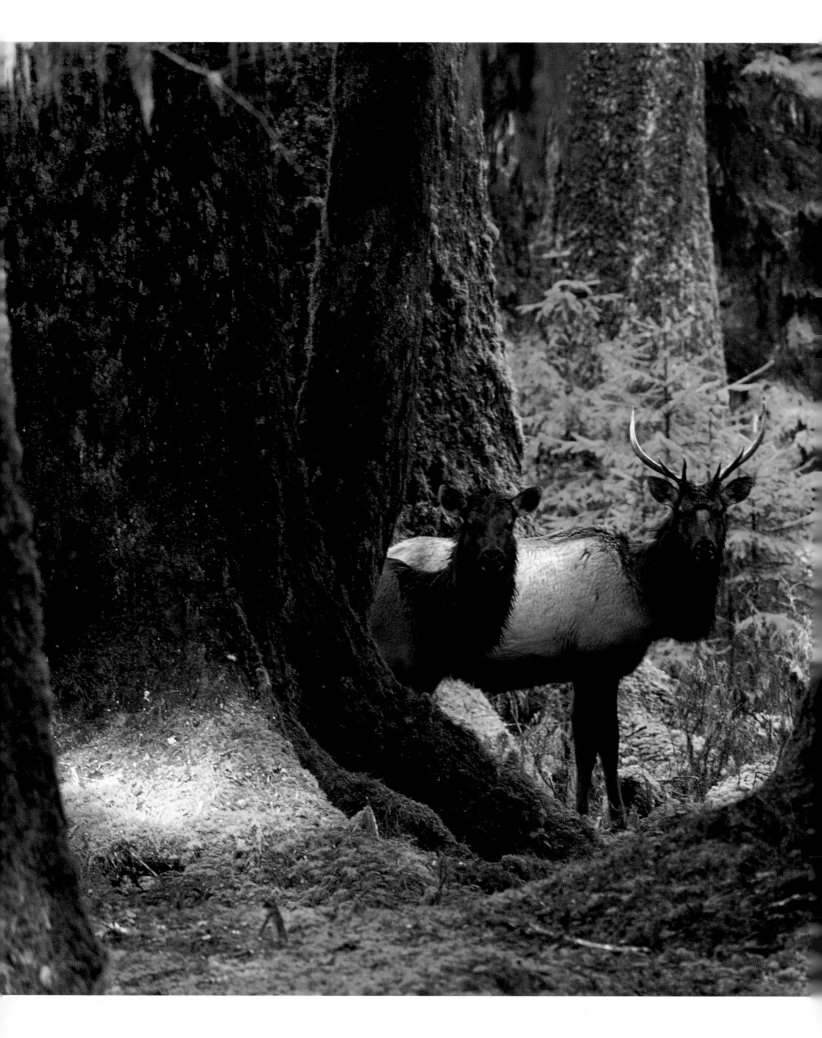

LEFT: *Roosevelt elk* (Cervus elaphus) *in Olympic National Park, Washington State, USA.*

ABOVE: *A swamp wallaby* (Wallabia bicolor) *from Australia. Members of the kangaroo family occur only in Australia and New Guinea, which were once connected together in times of lower sea levels, allowing animals to disperse between these two island landmasses.*

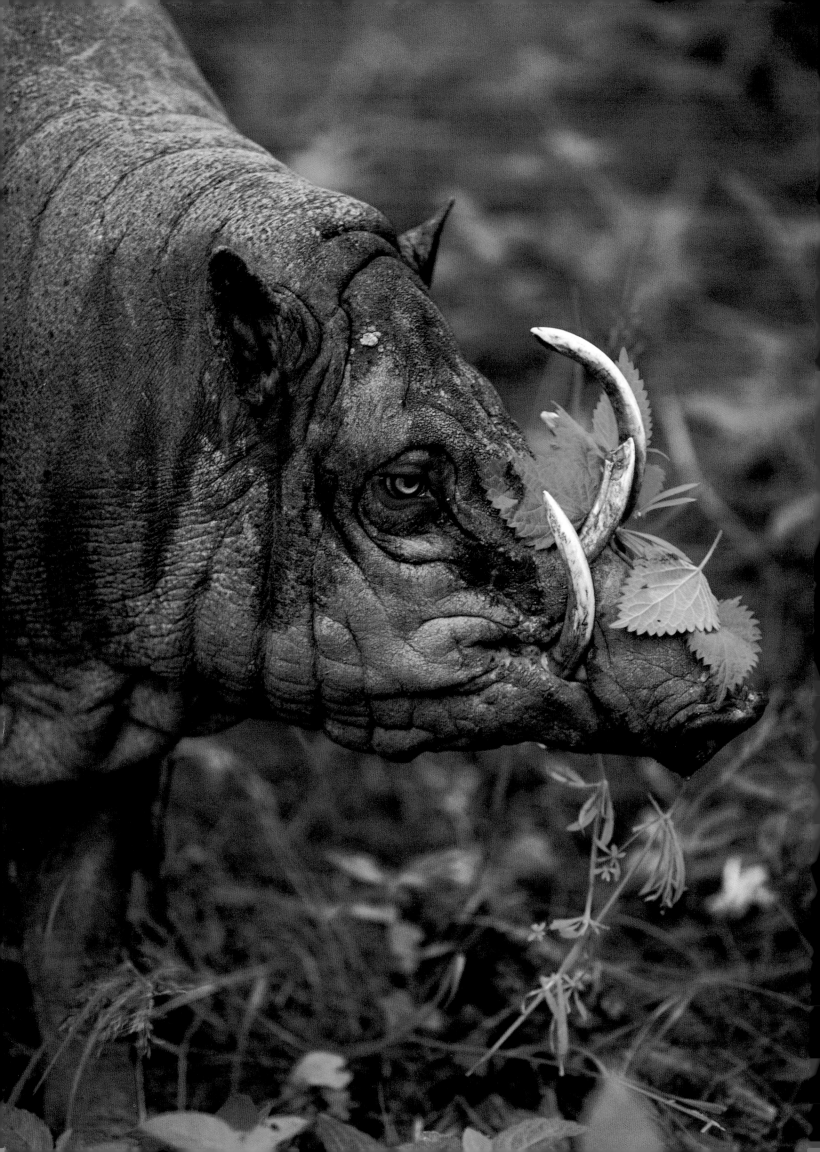

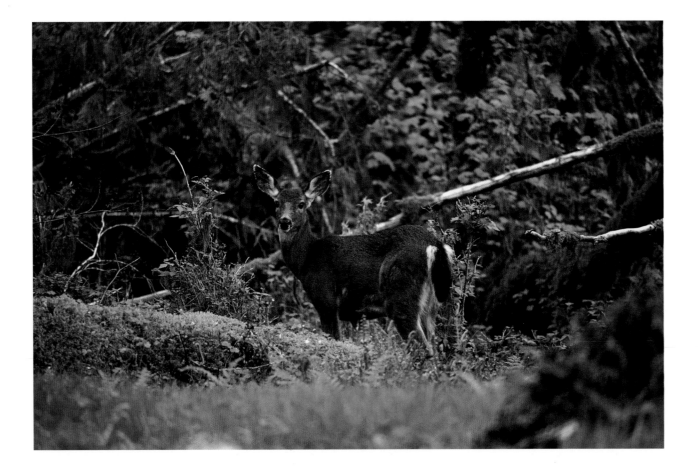

# GROUND BIRDS

There are various rainforest birds that are confined to the forest floor or fly only weakly. In the neotropics the most common are the tinamous (order Tinamiformes), which are quail-like birds that forage along the forest floor for seeds and insects. When disturbed they may fly for a short distance, but they usually just run into the undergrowth. The great tinamou (*Tinamus major*) has a haunting call at dusk. It sounds like an ascending scale on a musical instrument and echoes through the forest as the different birds signal to each other their position in the forest. The southern ground hornbill (*Bucorvus leadbeateri*) occupies a similar habitat to the tinamous in tropical Asia. Since New Guinea lacks most of the large terrestrial mammals that occur in other rainforest areas, to a great extent the role of seed eating and terrestrial seed dispersal here is taken up by the large, flightless ratite birds, the cassowaries (*Casuarius sp.*). These birds have hairlike plumage on their bodies, but their heads and necks are bare. Their short, strong bills enable them to open fruit. They feed principally on fruits and berries, many of the seeds of which pass through the bird's gut before they are excreted, making them germinate better. Cassowaries can be up to 6 feet (1.8 m) tall, which is small compared to the extinct elephant birds (family Aepyornithidae) of Madagascar. These giant ratites stood 10 feet (3 m) tall and produced eggs 12 inches (30 cm) long. Many of these large flightless birds evolved on islands such as New Guinea, Madagascar, and New Zealand.

ABOVE: *Mule deer* (Odocoileus hemionus) *in Olympic National Park, Washington State, USA.*

FACING PAGE: *A babirusa* (Babyrousa babyrussa) *from the forests of Indonesia.*

Ecologist A. Mack studied the role of cassowaries in the dispersal of seeds in the forests of New Guinea. The dwarf cassowary (*C. bennetti*) and the double-wattled cassowary (*C. casuarius*) both eat the seeds of species of trees of the mahogany family in the genus *Aglaia*. These large fruits are up to 7 inches (18 cm) in diameter and contain seeds that are about 4 inches (10 cm) long and 2 inches (5 cm) wide. Two-thirds of the seed is covered by a fat-rich, bright scarlet aril (an outgrowth of the seed coat) and one-third by a creamy white attachment scar. This vivid bicolored display is conspicuous to the dwarf cassowaries, which swallow the whole seed. The aril separates readily from the seed and is digested, and the seeds are excreted in the dung. Mack drove some coded nails into some *Aglaia* seeds and later was able to retrieve them from the dung of the cassowaries. He was thus able to demonstrate how far some of the seeds had been dispersed. He also showed that the diet of these flightless ratite birds is almost exclusively fruits and seeds that have fallen to the forest floor. The fruits receive a gentle treatment in the cassowary gut and are voided from one and a half to twelve hours after ingestion, undamaged by their passage through the gut. These larger rainforest birds as well as other ground birds play an important role in seed dispersal, and it appears that particularly large seeds have evolved in some species of *Aglaia* in line with a much bigger dispersal agent than the hornbills that disperse many smaller species of *Aglaia* in Borneo and other eastern areas. In addition to three species of cassowary, there are four genera of mound-building megapodes (family Megapodiidae), three genera of large ground pigeons (*Trugon, Otidiphaps,* and *Goura*), and many other smaller birds that forage on New Guinea's forest floor. There are also marsupials (bandicoots, phalangers, pygmy opossums, ringtails, and gliding opossums) in New Guinea, many of which also eat fruit.

One of the most spectacular of all ground birds is the argus pheasant (*Argusianus argus*) of the rainforests of Thailand, Malaysia, Borneo, and Sumatra. The male argus pheasant has a huge tail about 3 feet (1 m) in length and immense wing feathers with many eyelike spots all over them. Indeed, it is these eyes that earned the bird its common name, after the legendary Greek many-eyed monster Argus. A male argus pheasant clears a huge area of the forest floor about 20 feet (6 m) in diameter, removing all the debris and uprooting young seedlings by pulling them up with his beak. Once a female arrives, the male begins a most elaborate dance ritual in which he becomes gradually more and more excited. He erects his enormous tail and spreads his wing feathers in two great glittering fans, treating the female to a dazzling display of many lines of the golden eyespots. If she is sufficiently impressed, she will consent to mating. These birds can scarcely fly because their wings and tail have evolved more for the purpose of attracting the females. They roam the forest floor eating a wide range of food such as fruits, ants, slugs, and snails.

The male bowerbirds of New Guinea and Australia do not have such an

FACING PAGE: *The cassowaries are large, flightless birds that inhabit the rainforests of New Guinea and Australia. This is the double-wattled cassowary (Casuarius casuarius), a species which occurs in both New Guinea and Australia.*

*An ocellated turkey
(Agriocharis ocellata) in
the forests of the Rio Bravo
Conservation Area, Belize.*

FACING PAGE, TOP: *A walking leaf* (Phyllium pulchri-folium) *from Malaysia.*

FACING PAGE, BOTTOM: *It is hard to separate this orchid mantis* (Hymenopus coro-natus) *from the flower of this Malaysian orchid.*

BELOW: *The beautiful Victoria crowned pigeon* (Goura victoria) *forages mainly on the ground of the rainforests of Indonesia, but when disturbed, it flies up into the low branches of trees and makes a lot of noise.*

ornate plumage but instead attract their mates by building an elaborate bower on the forest floor. The male Vogelkop gardener bowerbird (*Ambylyornis inornatus*) of the rainforests of Irian Jaya in New Guinea is the least spectacular of all bower-birds, but it builds the finest bower of all. The bower is a miniature tepee of sticks covered with a carefully laid mat of moss that is decorated with colorful fruits and flowers.

The male satin bowerbird (*Ptilonorhynchus violaceus*) of the rainforests of north-ern Australia has a more ornate plumage but also takes great trouble with his bower. He builds an avenue up to his bower with a wall of sticks placed upright on a stick mat. The mat is adorned with many objects, particularly if they are blue. It is decorated with blue flowers, blue feathers, and even, these days, blue bottletops! Perhaps this is regarded as an extension of his own dark blue plumage.

The birds of the rainforest floor are some of the most interesting and varied of all birds.

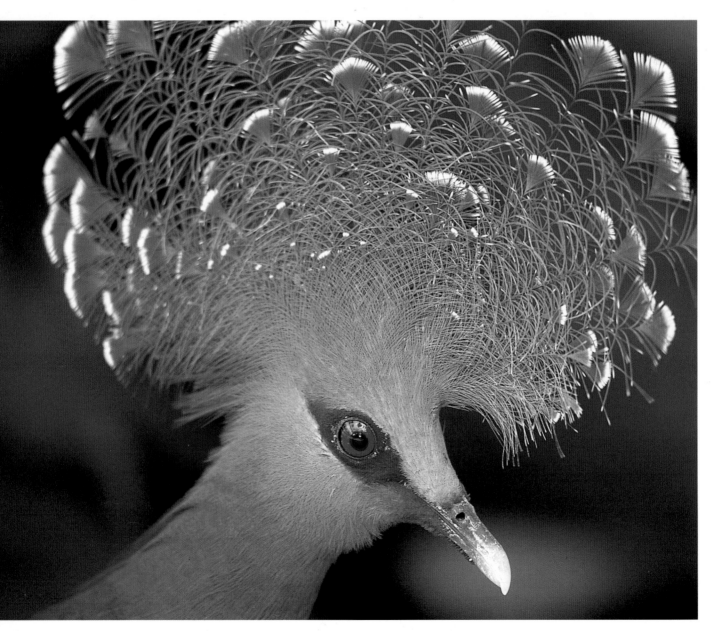

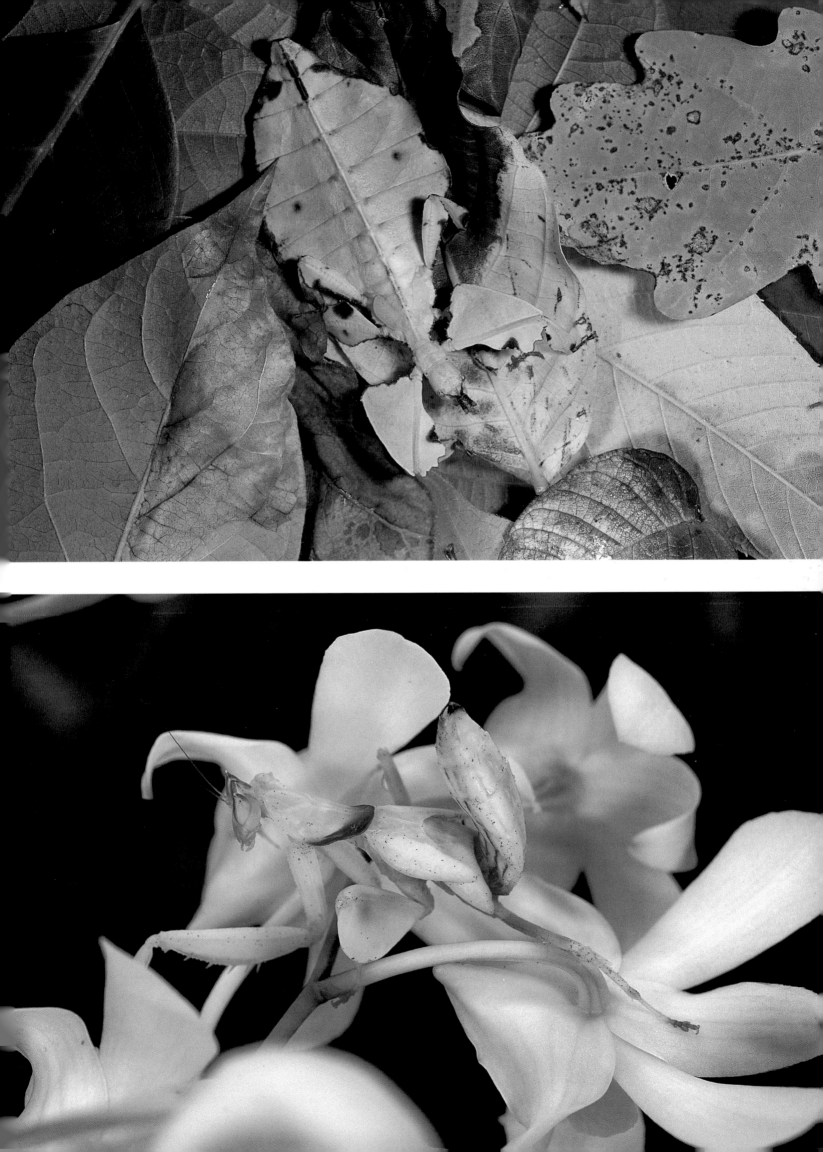

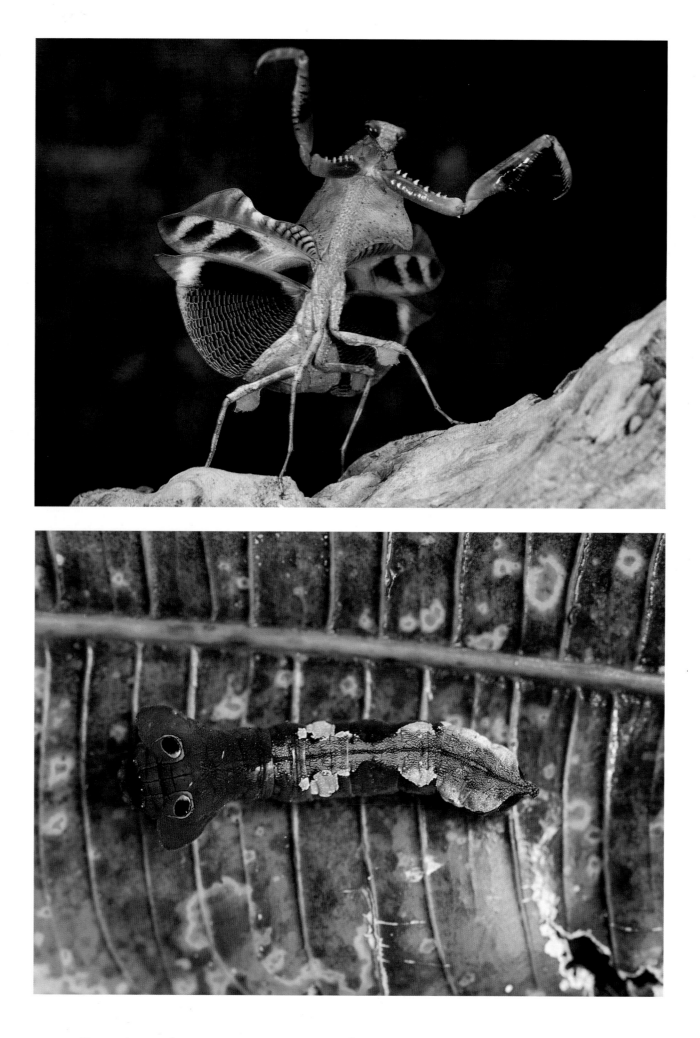

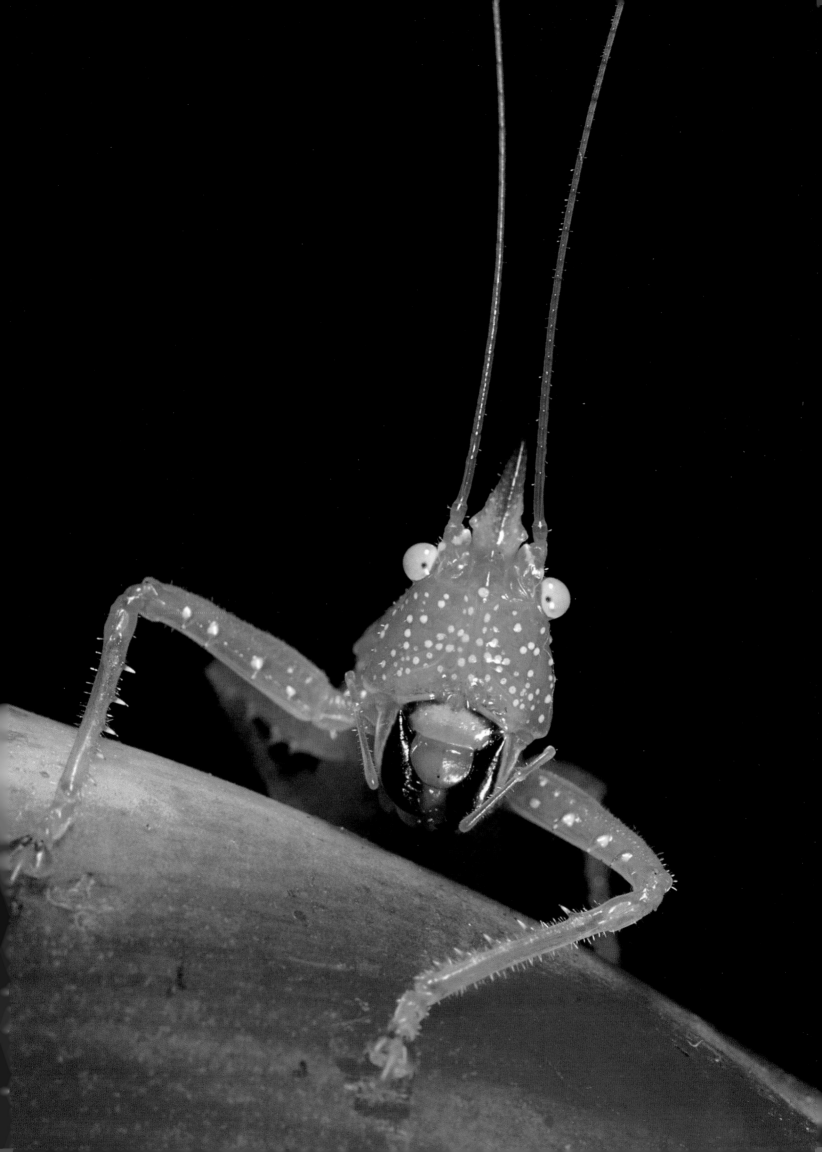

PAGE 236, TOP: *A dead-leaf mantis (*Deroplatys *sp.) from Malaysia.*

PAGE 236, BOTTOM: *This hawk moth (*Eumorpha *sp.) caterpillar from Peru has found a leaf that is a perfect match for its camouflage.*

PAGE 237: *A brightly colored cone-headed katydid (*Copiphora *sp.) from the Tambopata River region of Peru.*

ABOVE: *A hawk moth (*Eumorpha *sp.) caterpillar from Barro Colorado Island, Panama, with false eyes to ward off predators.*

FACING PAGE: *Detail of a fern leaf showing young sporangia.*

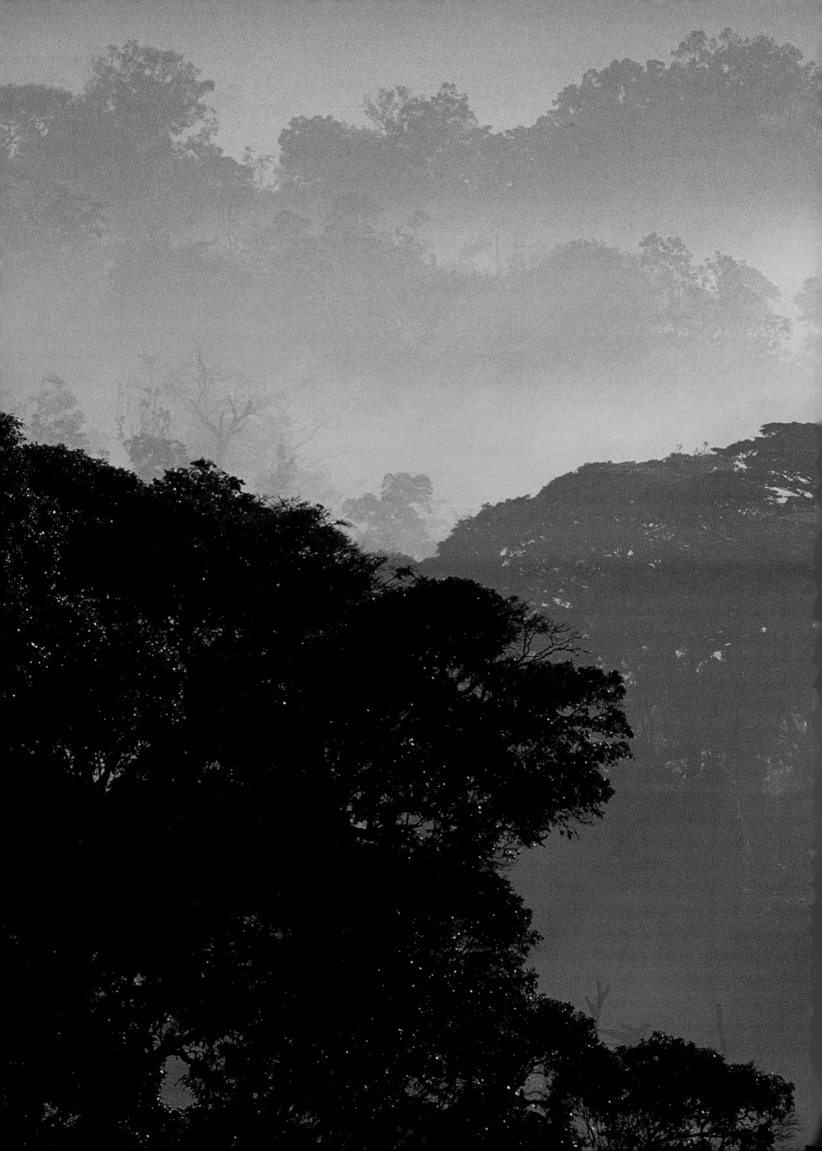

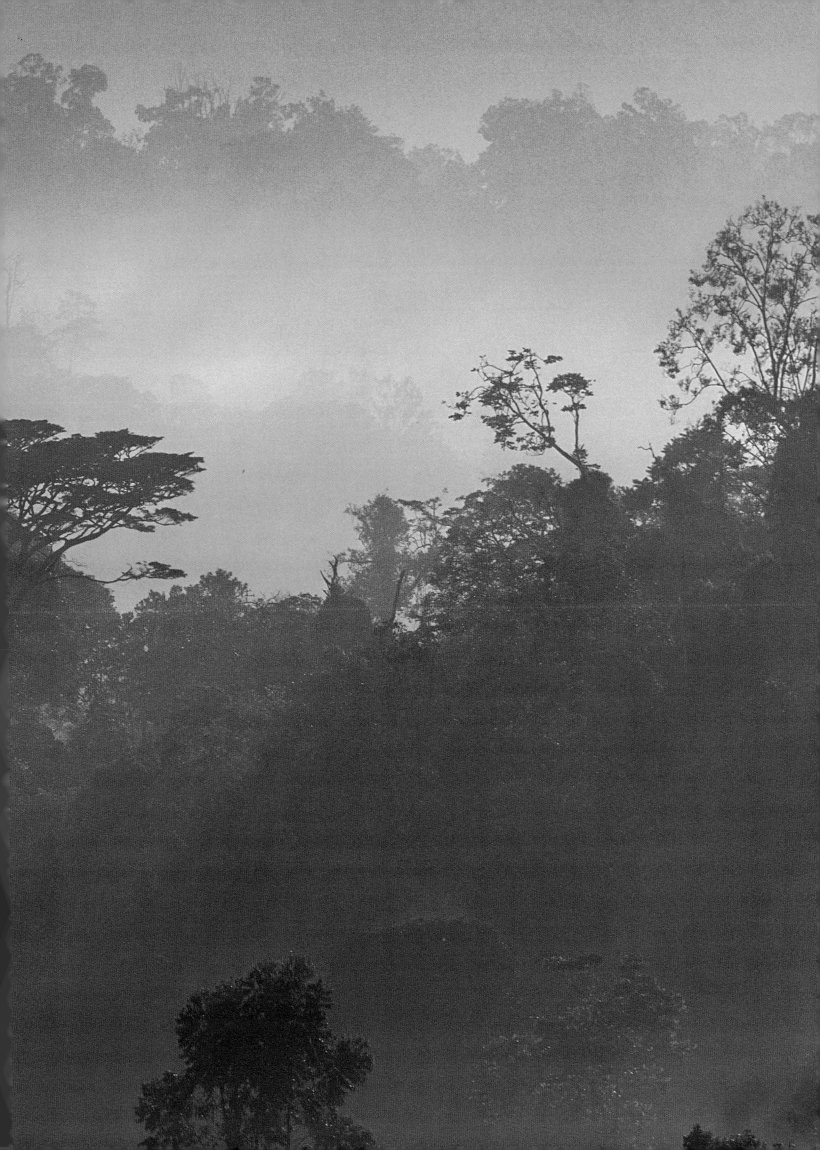

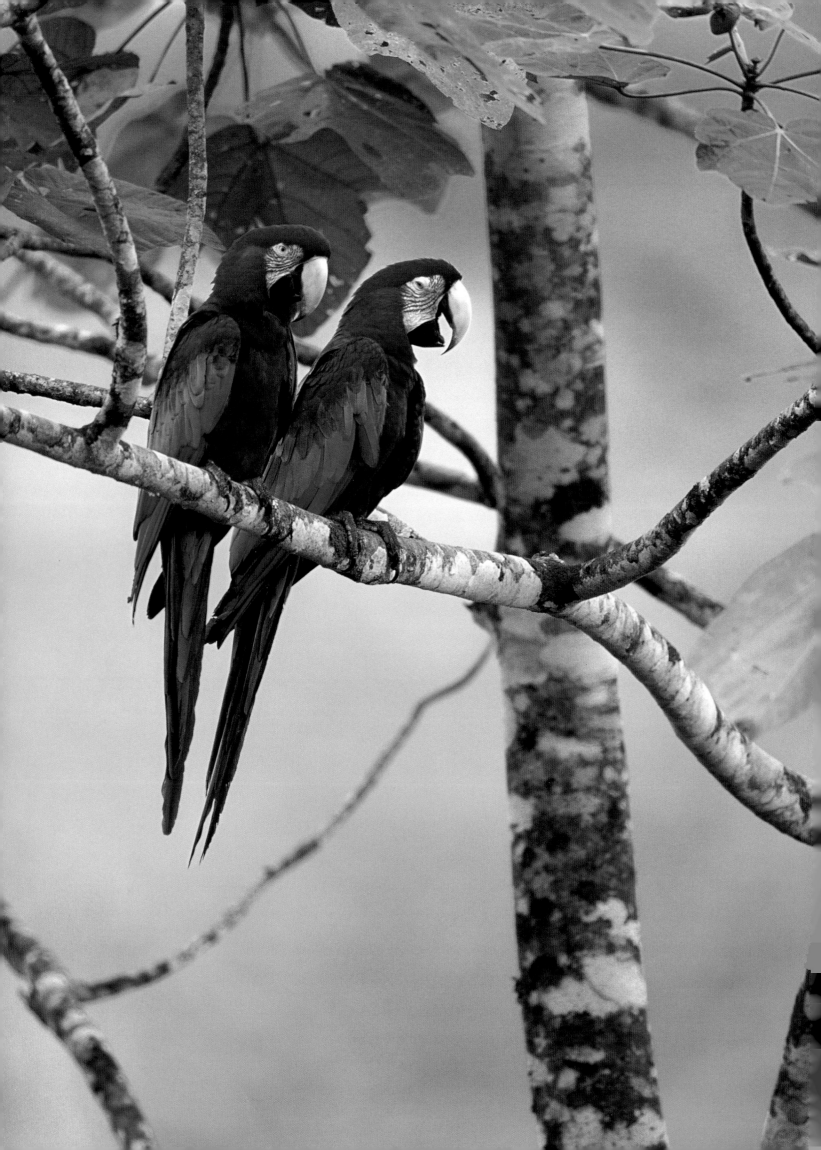

# Air

~~~~~~~~~~~~~~~~~~~~~~~~~~~~~~~~~~~~~~~~~~~~~~~~~~~
~~~~~~~~~~~~~~~~~~~~~~~~~~~~~~~~~~~~~~~~~~~~~~~~~~~

WE HAVE ALREADY SEEN THAT TROPICAL RAIN-forests are vital to the rainfall patterns of our planet. They are also essential to the atmosphere. Scientists are increasingly recognizing that the physical, chemical, and biological processes of the forests, oceans, and atmosphere form a closely linked and inter-dependent system. As more and more rainforest is lost, there is growing concern about the effect this loss is having on the entire world ecosystem. The quality of the air we breathe and the daily tempera-ture we experience are in some ways connected to the rainforest. However, I must begin by dispelling one myth that has so often been perpetuated by the press and other popular literature that the rain-forests are the lungs of the world and produce much of the oxygen that we breathe. This error was due to the misinterpretation by the press of a statement by well-known Amazonian limnologist Harald Sioli. In fact, rainforests do produce a great deal of oxygen through the process of photosynthesis, but they consume an equal amount through the process of respiration and so the net balance is close to zero. It is the host of microorganisms that live in the oceans that we should thank and protect for their role in the pro-duction of the oxygen upon which most living organisms depend.

It is carbon dioxide and not oxygen that should concern us as deforestation progresses. Tropical rainforests are one of the largest stores of carbon, which is both in the plants and animals and in the soil. When tropical forests are cut and burned, much of the carbon is released as the gas carbon dioxide ($CO_2$). The forests hold considerably more carbon per unit area than do the ecosystems such as cattle pasture or farmland that replace them. Tropical deforestation is contributing to the increase in atmospheric $CO_2$, which is the cause of

*PREVIOUS SPREAD: View of undisturbed part of the beautiful Bwindi Impenetrable Forest in Uganda.*

*FACING PAGE: Green-winged macaws (Ara chloroptera) perched on a branch in the Tambopata Forest Reserve in Peru.*

global warming. Estimates of just how much $CO_2$ is thus released vary because it is impossible to measure it accurately, but most carbon specialists believe that about a fourth of the additional atmospheric $CO_2$ comes from deforestation in the tropics. The rest comes from the burning of fossil fuels. The amount of carbon released by deforestation in the temperate and boreal regions is nearly balanced by the regrowth of forests in managed forests or on abandoned agricultural land. This means that one of the main reasons for concern about the loss of tropical forests is the fact that their destruction is contributing to global warming caused by the greenhouse effect. Like the panes of a greenhouse, carbon dioxide and other gases trap solar heat that would otherwise be reflected back into outer space. This is resulting in a gradual warming in worldwide climate. This is not an even rise from place to place, and one of the worst-affected areas is in Antarctica. It is also predicted that the midwestern United States will become warmer and drier and unsuitable for the present type of agriculture. On the other hand, it could become warmer and wetter in Siberia, making that region a potential breadbasket.

There is an additional problem with the burning of tropical forests because the burning releases 5 to 20 percent of the carbon as the gas carbon monoxide (CO). When this is oxidized in the atmosphere to produce $CO_2$, ozone ($O_3$, another greenhouse gas) is also produced. A series of joint Brazilian-U.S. scientific expeditions to the Amazon called the Amazon Boundary Layer Experiments (ABLE) found that in pristine rainforest, the concentrations of carbon monoxide, nitric oxide (NO), and ozone were low. However, when agricultural burning was taking place some distance away, those pollutants began to appear in significant quantities. Even the NASA space shuttle missions have shown that there is a large-scale increase in CO over tropical forest regions in the dry season when burning takes place.

The living rainforest has a considerable influence on the atmosphere, and when deforestation occurs, this influence is a negative one that will affect the rest of the world. This is a compelling reason for the industrialized world to help the rainforest countries develop affordable approaches to the conservation of their forests. We need to place a value on rainforest not solely for the timber and other products of economic use it yields but also for the vital environmental role it plays in the control of worldwide climatic patterns.

# WIND

Tropical weather systems are intense, and so high winds are quite frequent. We have already seen how windthrows in the Amazon forest can open up large light gaps. However, windstorms are much more of a factor in some of the island rainforests such as in the Caribbean and the islands of Indonesia. These vortices of low pressure have different names in different parts of the tropics: hurricanes in the

Americas, cyclones in the Indian Ocean, typhoons in the western Pacific, and, in Australia, the willy-willies. Whatever the name, these cyclonic storms can be devastating to both forests and cities.

In the rainforests of Puerto Rico, where hurricanes are relatively frequent, many of the trees are adapted to snap off their crowns at about 30 feet (10 m) above the ground. Once the storm has died down, the trees begin to resprout from the remaining part of the trunk.

In southern Asia there is an annual and regular change in the direction of the wind. This reversal also brings heavy rains and is known as the monsoon.

The winds can be useful for certain organisms as a means of dispersal. In the closed canopy of the rainforest, wind dispersal of seeds is not very effective. But for the emergent trees that stick up above the canopy, wind can be a good means of seed transport. It is therefore the emergent trees that are more likely to have winged seeds or other adaptations for wind dispersal. In tropical Asia, by far the most predominant plant family of trees is the Dipterocarpaceae. Many of the dipterocarps are extremely large trees that tower above the canopy, and most dipterocarps have winged seeds that spin through the air like the maple seeds of the northern forests. Since dipterocarps are characteristic of forests of Indonesia and the Malay Peninsula, areas that have frequent cyclones, the adaptation for wind dispersal is an effective way of getting seeds around.

In the Amazon rainforest, fewer trees have winged seeds, although several of the largest emergent species do. Most members of the Brazil nut family (Lecythidaceae) produce large capsular fruits with seeds that are dispersed by a variety of birds and mammals. However, two genera, *Cariniana* and *Couratari,* of the Lecythidaceae have winged seeds. It is notable that species of both these genera either are very tall trees that rise above the canopy or grow in open places beside rivers. In both cases wind dispersal is likely to be effective. In *Cariniana* the seeds have a wing on one side and so resemble a single maple seed; in *Couratari* the wing surrounds the entire seed.

The most majestic tree of Amazonian floodplain forest is the silk-cotton tree or kapok (*Ceiba pentandra*). The fruit capsules are filled by a fiber that surrounds the seeds, and it is these kapok fibers that have been widely used to stuff life preservers and cushions. The native peoples had many uses for kapok, varying from intricate fabrics to flights for their blowgun darts. The kapok tree can be enormous in height and diameter, often taking twenty people holding hands to encircle its girth. The trunk of a mature tree can exhibit huge buttresses. The crown of the tree, which rises to 160 feet (50 m), well above other trees in the *várzea* forest, is a most distinctive symmetrical umbrella shape. In the dry season the tree loses its leaves and the fruits mature, releasing the seeds surrounded by kapok to float through the air and be dispersed by the wind. Sometimes the river surface or the surrounding forest looks as if a snowstorm has just blanketed the area. Like the cotton of a poplar or

FOLLOWING SPREAD: *The rainforests play a major role in the distribution of climatic and rainfall patterns. However, it is a myth that they are the lungs of the world, since they consume as much oxygen as they produce. Rainforests are more important as sinks of carbon dioxide. Bwindi Impenetrable Forest, Uganda.*

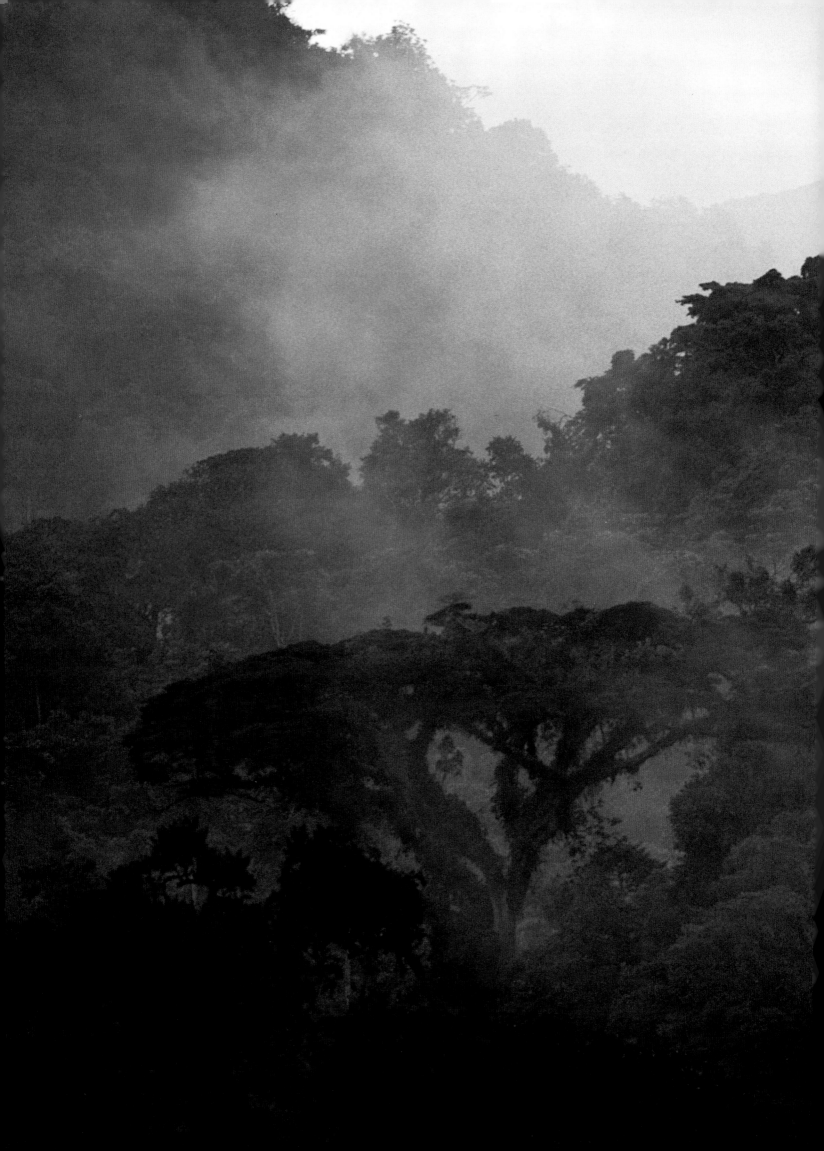

FACING PAGE: *The king vul-*
*tures (*Sarcorhamphus
papa*) soar above the rain-*
*forests of South America*
*watching for the smaller*
*turkey and black vultures to*
*locate a carcass. Their ornate*
*heads are bare of feathers,*
*which is an adaptation for a*
*bird that is poking its head*
*into dead animals.*

willow tree, the light, air-filled kapok fiber gives buoyancy to the seeds so that they will float in the air and drift to a new location by wind dispersal. As a result, the kapok tree has an extremely wide range and occurs in forests from Mexico to southern Brazil and has even established in the rainforests of Africa. It is no wonder that this majestic tree was sacred to the ancient Mayan people, who believed that souls ascended to heaven by rising up into a huge kapok tree, the branches of which were their heaven. The kapok was introduced into plantations in Southeast Asia for the commercial production of fiber and is now to be found throughout the tropics.

The kapok tree bears large white flowers that open in the evenings, leaving the long stamens and style protruding, but with a rather unpleasant musty odor. The flowers also produce abundant nectar that is sought after by bats. While feeding, the bats become dusted with pollen, which they then transport from flower to flower. Because the kapok tree produces only a few flowers each night over an extended period of time, one tree does not have enough flowers open at any one time to satiate the bats. This is a common strategy of many bat-pollinated trees and ensures that the bats carry pollen from one tree to another.

The kapok tree, dipterocarps, and a few other rainforest trees and vines have evolved dispersal systems that take advantage of the wind.

# VULTURES AND EAGLES

The princes of the air in the Neotropical rainforests are the vultures. The sight of an African vulture ripping apart a dead animal in the open savanna is a familiar one because it has been portrayed in so many nature films. However, many people are unaware of the New World vultures that soar above the rainforest. Their larger cousin, the Andean condor, has also been filmed frequently as these magnificent birds with a wingspan of over 10 feet (3 m) glide majestically for hours over the spectacular rugged scenery of the Andes. The New World vultures and the condor belong to the family Cathartidae, whereas the African vultures belong to the family Accipitridae and are more closely related to eagles and hawks than to the New World vultures. Their similar appearance is the result of convergent evolution adapting to the same lifestyle on both continents. For example, the bare, featherless heads of both kinds of vultures are convenient because they are often prying into bloody carcasses with their heads as they eat the flesh of their prey.

The turkey vulture (*Cathartes aura*), generally known as a buzzard in North America, is not exclusively a rainforest bird since it ranges from southern Canada to Tierra del Fuego and even to the Falkland Islands. However, it is commonly seen soaring over the Amazon rainforest with its characteristic wings raised at an angle and its body tilting from one side to another as it flies. These large birds, 25 to 32 inches (65 to 80 cm) long, wait for the morning air to warm up and for there

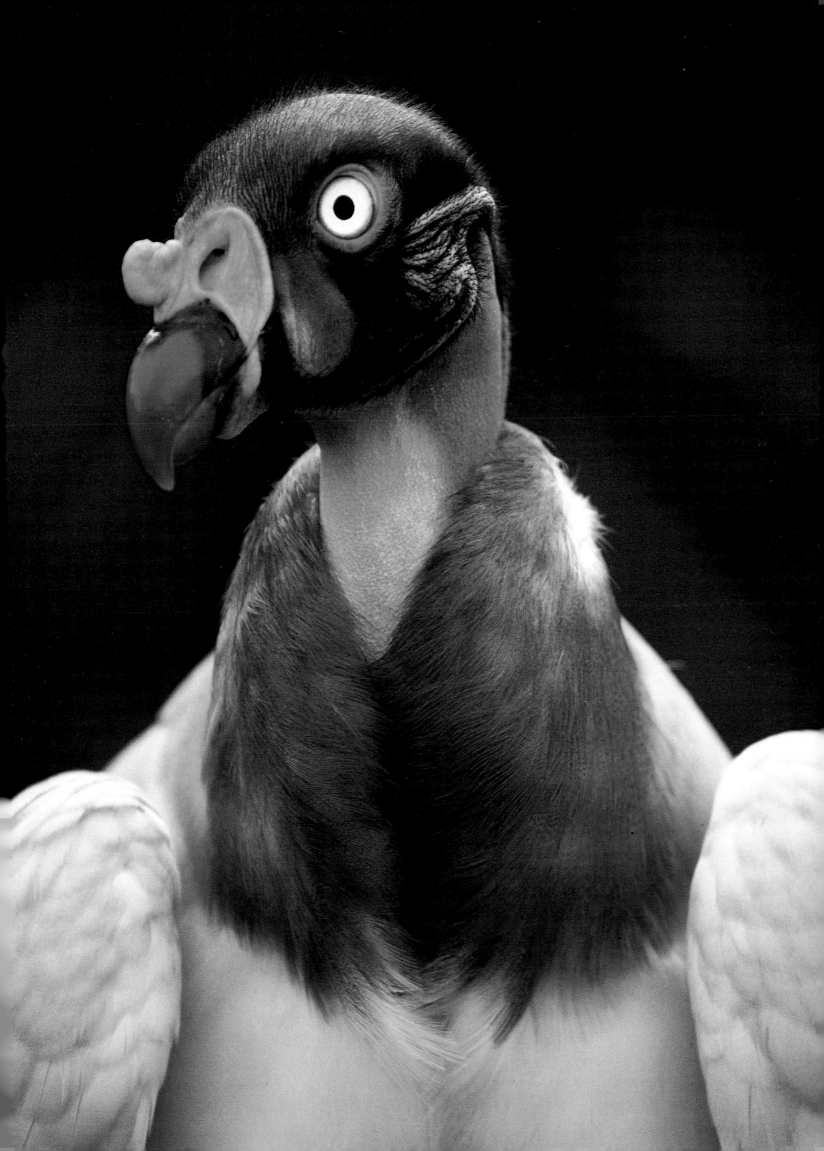

to be adequate thermals on which to cruise silently and constantly over the forest. While most birds have little or no sense of smell, the turkey vultures have two well-developed lobes in the front of the brain that give them a phenomenal sense of smell. They glide around quite low over the forest canopy until their olfactory ability enables them to sense the presence of carrion. Their sense of smell is so good that they can locate a carcass long before it is putrid. Once a meal has been detected, a turkey vulture will land on the top of a canopy tree and gradually fly and hop from branch to branch down to the ground to feed. Once one vulture is seen to land, other vultures soon follow and the feast begins.

The most spectacular of all Amazon rainforest vultures is the king vulture (*Sarcorhamphus papa*), which has a most striking head with an ornate pattern of orange and yellow bare skin and wattles, and, when mature, a white rather than black plumage. The king vultures are much less common than the turkey vultures, and they soar high above the forests, making good use of the thermals. As they soar they watch with their keen eyes, and when they see the turkey vultures landing for a repast, they follow and join in the feast. The king vulture is larger and has a stronger bill and will drive the other vultures away until it has had its meal. The poor turkey vultures that initially located the meal have to wait impatiently until the king vulture has had his fill.

The turkey vulture is so named because of its red turkeylike head. The greater yellow-headed vulture (*Cathartes melambrotus*) differs by the yellow color of its head and neck. It exhibits behavior similar to that of the turkey vulture but is restricted to the Amazon region. It is a frequent sight on river beaches and banks and appears to like feeding on dead fish. The widest ranging of all New World vultures is the ubiquitous black vulture or urubu (*Coragyps atratus*), which ranges from Washington State to Patagonia. Black vultures are much more gregarious than the other vultures and roost in large groups, and they surround a carcass in such numbers that some birds are inevitably excluded from the meal. When black vultures appear on the scene, the turkey and yellow vultures usually depart. Black vultures are not exclusively meat eaters. They are often found eating the fruits of oil palms and other fatty fruits, especially those with a strong smell.

Magnificent as the king vulture is, the real king of the Amazon rainforest birds is the harpy eagle (*Harpia harpyja*), the largest and most spectacular eagle in the New World. This rainforest species has immense feet and talons and is the strongest of all birds of prey. Yet it is agile in flight and flies and twists its path through foliage like many smaller hawks. The harpy is up to 43 inches (110 cm) long and has a fine crest of white-tipped black feathers. It does not soar but instead flies from tree to tree in short bursts, maneuvering with great skill amongst the branches when it is after prey. The harpy eagle feeds on quite large mammals such as monkeys, sloths, and porcupines. It also eats reptiles and many other species of birds.

Except during the breeding season, when their shrill calls echo constantly through the forest, harpies are silent birds that, despite their size, can be hard to detect. Recently I was privileged to be shown a nest of a harpy eagle in Amazonian Ecuador. It was a huge mass of sticks built in the crotch between the two main branches of an enormous silk-cotton tree (*Ceiba pentandra*), some 130 feet (40 m) above me. There was a single, rather mature chick moving around the nest.

Most rainforests of the world have their own particular large species of eagle that tops the food chain of the canopy. All these birds have large crests, relatively short wings, and long tails that give them agility in flight. In West Africa the crowned eagle (*Spizaetus coronatus*) is the top bird of prey and is to be seen gliding just above the treetops hunting Colobus monkeys. When an eagle approaches, the monkeys will often hurl themselves into the air and drop 65 feet (20 m) to the ground to avoid their most feared predator. This African eagle has been known to

*The bald eagle (*Haliaeetus leucocephalus*) is the mighty raptor of the forests of the western United States, here seen in Alaska.*

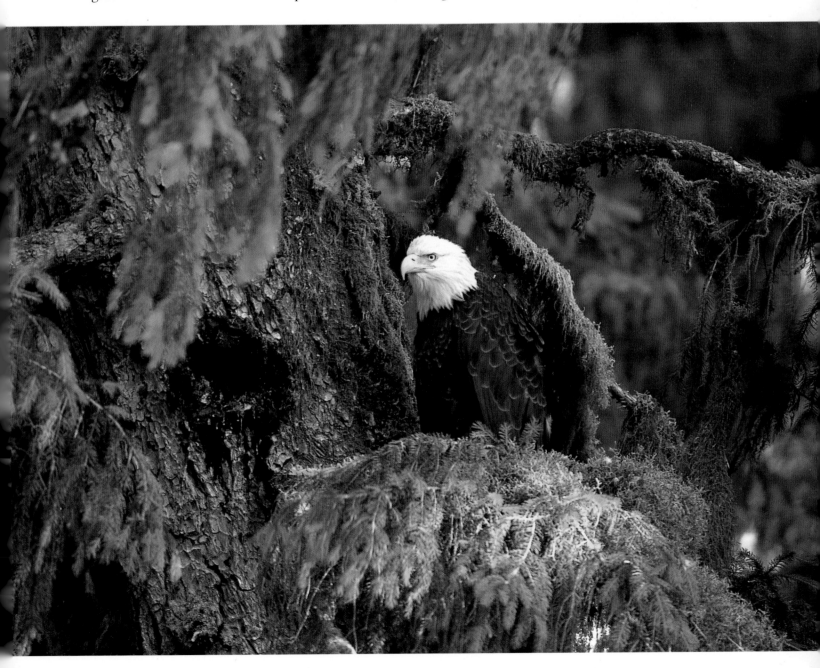

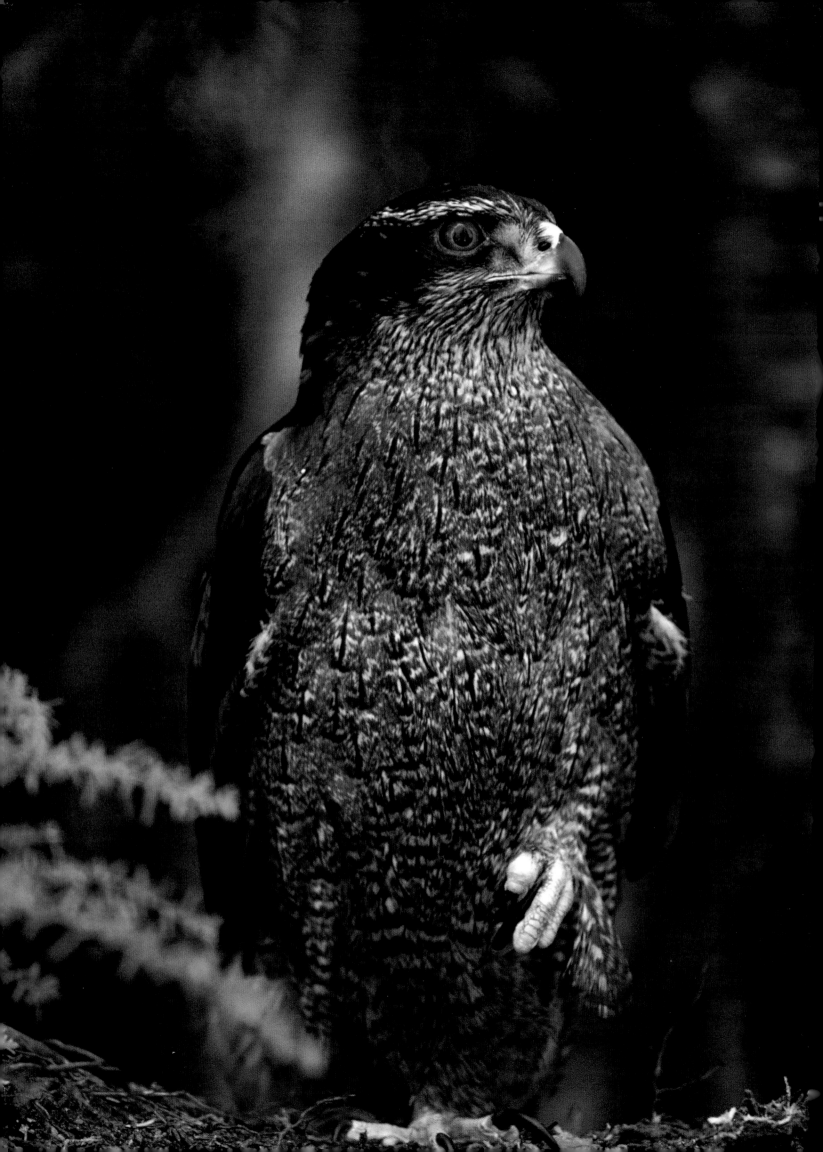

attack and kill 33-pound (15-kg) antelopes as well as many other mammals such as hyraxes and mongooses.

The rainforest of the Philippines also has (or had) a magnificent bird of prey, the Philippine eagle (*Pithecophaga jeffreyi*). The Latin name of this bird indicates that it too is a monkey-eating bird. Unfortunately, this bird is almost extinct because little of the Philippine rainforest remains and the birds have been hunted and trapped by specimen collectors. Fewer than two hundred individuals of this majestic rainforest bird survive today. It is a huge, powerful bird with short wings and a long tail that enable it to maneuver amongst the branches. This species hunts either by perching and waiting for movement in the canopy or by gliding low over the treetops rather than soaring. While monkeys form a minor part of its diet, it also hunts flying lemurs (colugos), small deer, and large birds such as hornbills.

The main prey of the Philippine eagle are the colugos (*Cynocephalus*), remarkable gliding animals that have a membrane (patagium) between their front and hind limbs that extends from the neck to the tip of the tail and is attached to the sides of the body. The patagium enables the colugos to glide for long distances between trees. Their digits are flattened and the soles of their paws form sucking disks for adhesion to tree trunks. After gliding from tree to tree, the colugo lands flat against the trunk. The flight of one colugo was measured at 443 feet (135 m) with an altitude loss of only 40 feet (12 m). When an eagle sees the movement of a gliding colugo, it swoops down, knowing that there is easy prey on the tree trunk below.

The Philippine eagle conservation trust was founded in 1969 by someone as familiar with the air as are the eagles, the famous aviator Charles Lindbergh. This has brought international attention to this magnificent bird of prey.

# GLIDING ANIMALS

The two species of colugos of the Philippines and Malaysia are not the only rainforest animals that have taken to gliding. For animals that live in treetops, gliding is a good means of escape from predators and so it has evolved in many unrelated animals. The largest animal to have flaps of skin from limb to limb is the giant red-and-white flying squirrel (*Petaurista alborufa*) of the forests of the Far East. Of course, "flying" is a misnomer because unlike bats these animals cannot flap their wings and truly fly. They glide and lose altitude. However, they are able to correct their flight path and change direction when necessary. In the rainforests of Africa, two different rodents have evolved the gliding habit, Beecroft's flying squirrel and Zenker's flying squirrel. Neither of these animals is a true squirrel, showing that gliding is a successful strategy and has evolved independently in different rainforests in Africa and Asia as well as in other areas, such as the eucalyptus forests of Australia, where there are gliding marsupials.

FACING PAGE: *An extremely powerful bird of prey, the harpy eagle (*Harpia harpyia*), grows to 42 inches in height and feeds on medium-size arboreal mammals such as sloths and monkeys.*

The Far East, with its tall, majestic rainforests, seems to have been the ideal place to encourage the evolution of gliding. The flying lizard (*Draco volans,* literally "flying dragon") inhabits the rainforests of the Philippines and Indonesia. The gliding is accomplished by a membrane that is attached to five or six enlarged posterior ribs and can be erected or retracted at will. This remarkable lizard is about 8 inches (20 cm) long and also parachutes from tree to tree. Wallace's flying frog (*Rhacophorus nigropalmatus*) is a flying tree frog. In this case its flight membrane is formed from the skin between its elongated toes. With four separate parachute-like gliding membranes, these frogs are extremely agile in the air and can change the direction of their glide. The flying snake (*Chrysopelea paradisi*) also inhabits the Far Eastern rainforests and is remarkable because it has adopted the habit of gliding without the aid of any appendage such as a flight membrane. This snake has a large enough surface area in comparison to its weight to be able to glide. It also increases its gliding efficiency by contracting its belly to create a concave surface. Even without any other adaptation, the flying snake can cross a distance of 165 feet (50 m) with relatively little loss in altitude.

The occurrence of all these different types of gliding animals gives us a few hints about the pathway of evolution from gliding to true flight. Early reptile gliders in the time of the dinosaurs evolved into birds, and gliding mammals evolved into bats. The culmination of this evolution is seen in the giant flying foxes (*Pteropus giganteus*) of the Far East, which can attain a wingspan of 5 feet (1.5 m). It is a spectacular sight to observe a roost of these creatures where thousands hang in the trees. They are noisy and quite destructive to the host trees. At dusk they all begin to take off and fly long distances to fruiting trees. They may cover 155 miles (250 km) on a single night of foraging. This also makes them extremely efficient dispersal agents for the seeds of many species of trees.

# A GIANT SWIFT

I will never forget standing on the open top of Bukit Belalong, a mountain in Brunei on Borneo, and watching each morning and evening one of the largest of all swifts, the brown spinetailed swift (*Hirundapus gigantea*). Despite its comparatively large size of 8 inches (20 cm), it is an extremely fast flier and performs all sorts of acrobatic stunts as it catches insects while in flight. As the swifts rushed past, there was a zooming sound as if a plane had flown by. This species spends much of its life on the wing and will even mate in flight. They build their nests in crevices in rocks or in hollow trees, and with their saliva they glue together a mass of leaves and feathers or any other material they can glean in flight. These swifts range from India throughout Southeast Asia.

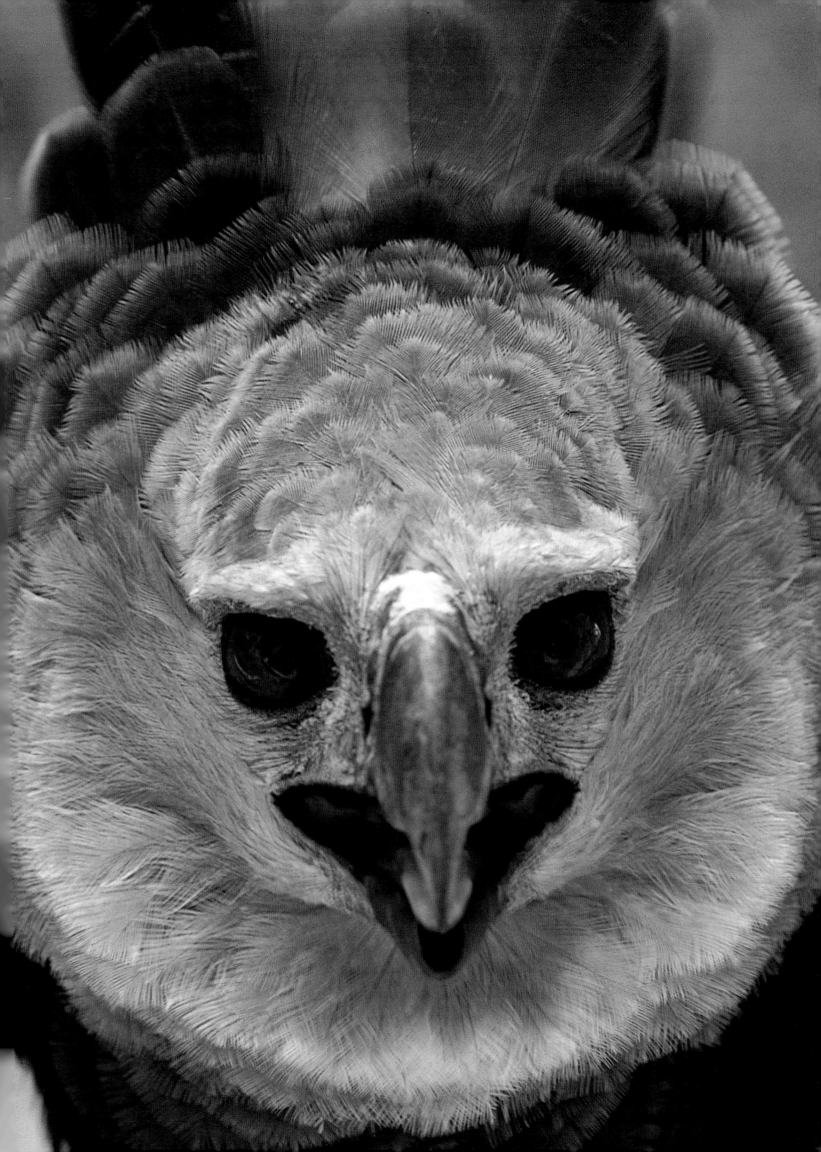

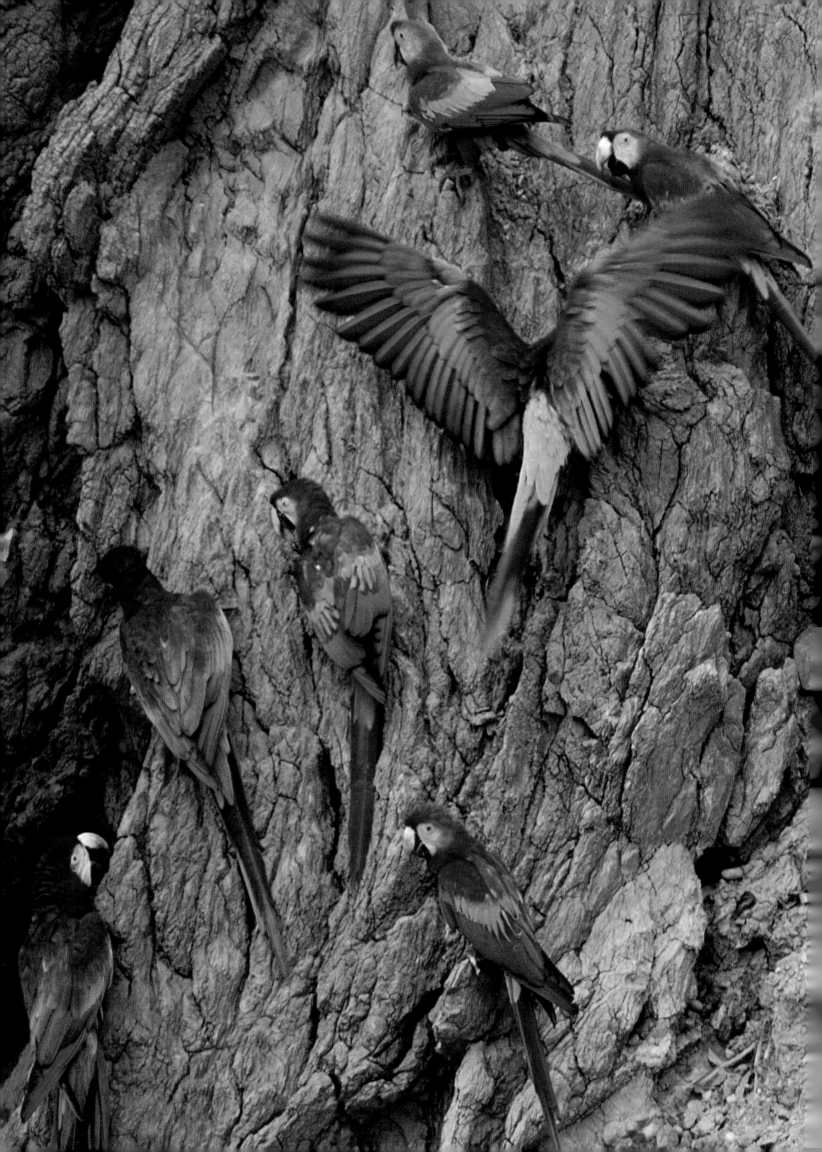

# PARROTS AND MACAWS

Perhaps the most characteristic of all rainforest birds are parrots. Almost all rain-forests have members of the Psittacidae, or parrot family, which also includes macaws, cockatoos, lories, and lorikeets. The largest of the parrots are the macaws. It is still a common sight at sunrise in the Amazon rainforest to see a pair of scarlet macaws (*Ara macao*) or blue-and-yellow macaws (*A. ararauna*) flying from their communal roosting site to their feeding place. As they fly, they tend to screech loudly, but they are silent or chatter quietly as they feed. They return to their roost at dusk after a busy day of foraging for fruits, seeds, and leaves in the canopy of the forest. Some of the most stunning photographs of macaws have been taken at their mineral licks, for both species like to congregate on clay riverbanks and cliffs, where they eat or lick the clay. It is thought that this helps to neutralize toxic compounds in their diet. Although these macaws have been hunted and trapped for the trade in caged birds, they are still relatively common from Central America to southern Brazil. Much rarer is the hyacinth macaw (*Anodorhychus hyacinthinus*) of Paraguay and central Brazil on the fringes of the Amazon rainforest. This is the largest and perhaps the most spectacular of all the parrots. It is about 39 inches (100 cm) in length and has a magnificent cobalt blue plumage. I am often asked to recount the most exciting experiences I have had on my travels in Amazonia. One of the most thrilling of all was when I was standing chatting to a farmer under a tree on the fringes of the Amazon rainforest in the state of Mato Grosso in Brazil. We heard the screeching of macaws and a pair of beautiful hyacinth macaws landed on a branch of a tree only 10 feet (3 m) above our heads. They stayed for about a precious thirty seconds, oblivious to our presence. Once they spotted the spellbound observers, they flew away screech-ing raucously, their long blue tails streaming behind them. I was so enthralled with watching that I did not even think of taking out my camera. Unfortunately, because of its beauty and rarity, the hyacinth macaw is an endangered species that has been excessively hunted for the pet trade, and fewer than three thousand individuals remain. Its fate is not as definite as that of the spix's macaw from the riverside forests of northeast Brazil, where a single individual now remains in the wild.

Eating pulpy fruit can be as messy as eating a bloody carcass, and there are at least two species of parrots that have, like the vultures, evolved bare, featherless heads. The vulturine parrot (*Gypopsitta vulturina*) of the riverside forests of north-east Brazil and Pesquet's parrot (*Psittrichas fulgidus*) from the forests of New Guinea are another example of convergent evolution, since both species have dis-tinctive bare foreheads.

There are fewer species of parrots in Africa and Madagascar than in South America and Southeast Asia. However, one species, the African grey parrot (*Psittacus erithacus*), makes up for the lack of species by the quantity of individuals.

*FACING PAGE: The Tambopata Forest Reserve in Peru is famous for its muddy cliffs that are visited by large groups of macaws such as these scarlet and green-winged species that lick the salt out of the mud.*

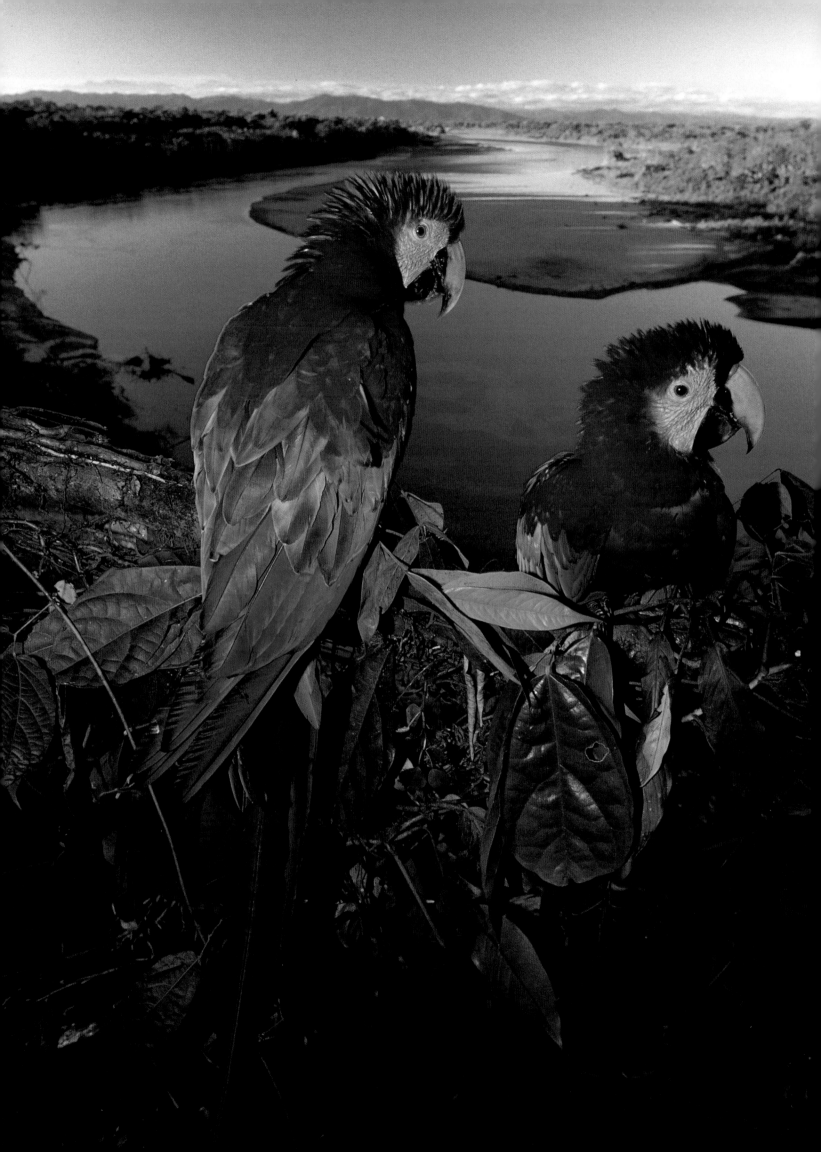

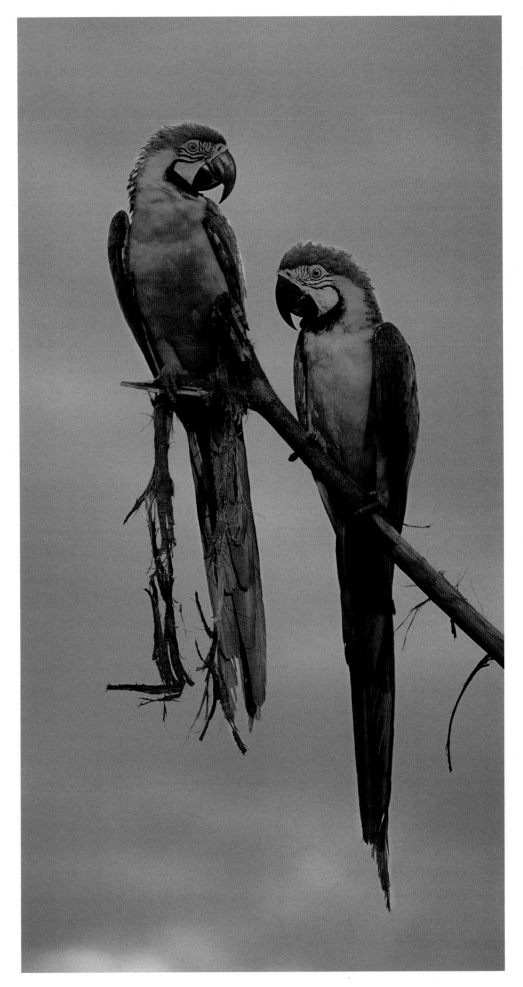

FACING PAGE: *Two juvenile scarlet macaws (*Ara macao*) perched above the Tambopata River in Peru.*

LEFT: *A pair of blue-and-yellow macaws (*Ara ara-rauna*) in the Tambopata Forest Reserve in Peru.*

FOLLOWING SPREAD: *A cluster of blue-headed parrots (*Pio-nus menstruus menstruus*) on a cliff face in the Tambo-pata Forest Reserve of Peru.*

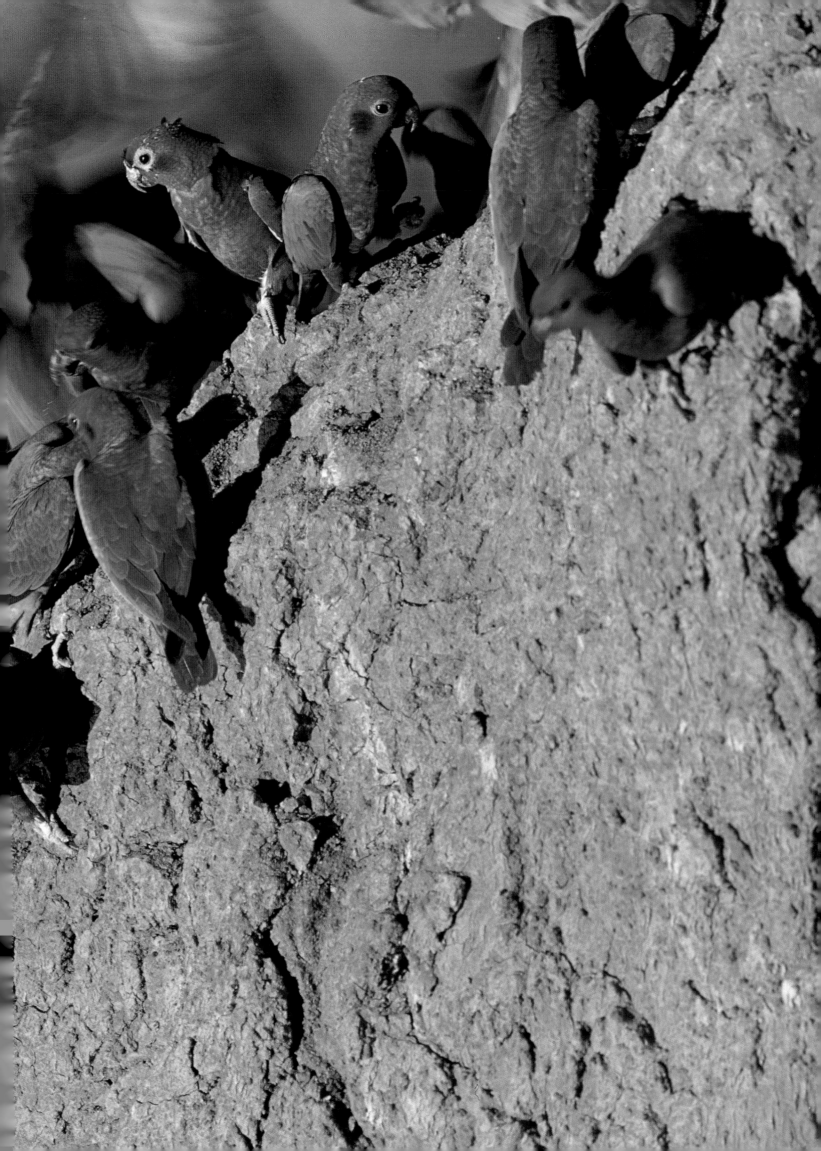

ABOVE: *A rainbow lorikeet* (Trichoglossus haematodus), *Australia.*

LEFT: *A red-winged parrot* (Aprosmictus erythropterus), *Australia.*

FACING PAGE: *A red-sided eclectus parrot* (Eclectus roratus polychloros), *Australia.*

PAGE 264: *The resplendent quetzal* (Pharomachrus mocinno), *found in Panama, sheds and regrows its strikingly long tail feathers after each breeding season.*

PAGE 265: *The rare and vivid cock-of-the-rock* (Rupicola peruviana) *can be found near the streams and in the wooded forests of Peru and Venezuela.*

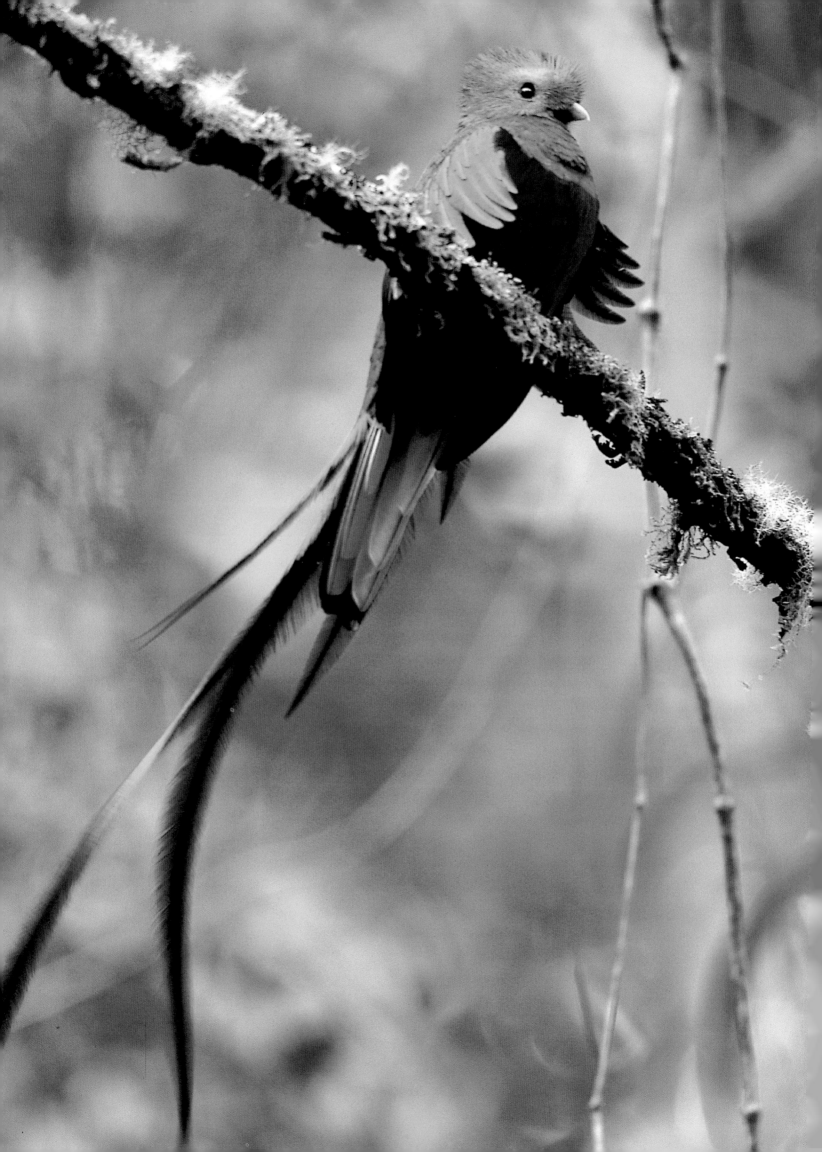

In the West African country of Gabon there are two places where between five thousand and ten thousand of these birds roost together on the fronds of oil palms. They leave the roosts in small groups to feed in the rainforest or to feast on the palm nuts in the plantations. This parrot is popular as a cage bird because of its uncanny ability to mimic human speech.

Most parrots are brightly colored, and so I was surprised to encounter black parrots in Madagascar. Two species, both dark colored, occur in Madagascar and the Comoro Islands: the vasa parrot (*Coracopsis vasa*) and its close relative the well-named black parrot (*C. nigra*). The vasa parrot often flies high above the forest canopy with distinctive, rather slow, crowlike wing beats. Like most parrots, both feed on fruits, nuts, and seeds in the canopy trees.

There are many other beautiful, interesting, and attractive parrots in the rainforest. The best time to observe them is at dawn and dusk as they fly to and from their roosts, but if you are lucky you may come across a pair or a group, depending on the species, feeding high above you in the canopy and emergent trees.

# TOUCANS AND HORNBILLS

No account of the rainforest would be complete without a mention of the two groups of rainforest birds that have independently evolved large bills: the toucans (family Rhamphastidae) and the hornbills (family Bucerotidae). Both toucans and hornbills eat fruit, insects, and small animals and nest in holes in trees, but they are not at all closely related and are placed in different orders.

Toucans inhabit the forests of Mexico and Central and South America and vary in size from the 24-inch- (61-cm-) long toco toucan (*Rhamphastos toco*) to the much smaller aracaris and toucanets, which may be only half that size, 12 inches (30 cm), including their bills. These strange-looking birds are remarkable for their large and brightly colored beaks. They appear clumsy in the air, flying in spurts of fast wing beats interspersed with gliding. It is not, however, the weight of the bill that hampers their flight, as it is surprisingly light, its inside simply a network of honeycombed fibers filled with air spaces in between. Toucans also have extremely narrow, straplike, flattened, long and stiff tongues. The tongue is quite unlike that of other birds and is also notched with deep indentations on either side. The large bill is useful for gathering fruit and other food. When a toucan picks a fruit from a tree, it tosses its head back until its bill is in a vertical position, which allows the fruit to be swallowed. Besides eating fruit, toucans raid the nests of other birds. The outsize bill additionally functions as a warning to other birds to keep their distance. When a toucan is around, other birds do not dare to attack it.

Hornbills occur in Africa and Southeast Asia but not in South America. The

FACING PAGE: *A bar-pouched wreathed hornbill (*Aceros undulatus*) from Malaysia.*

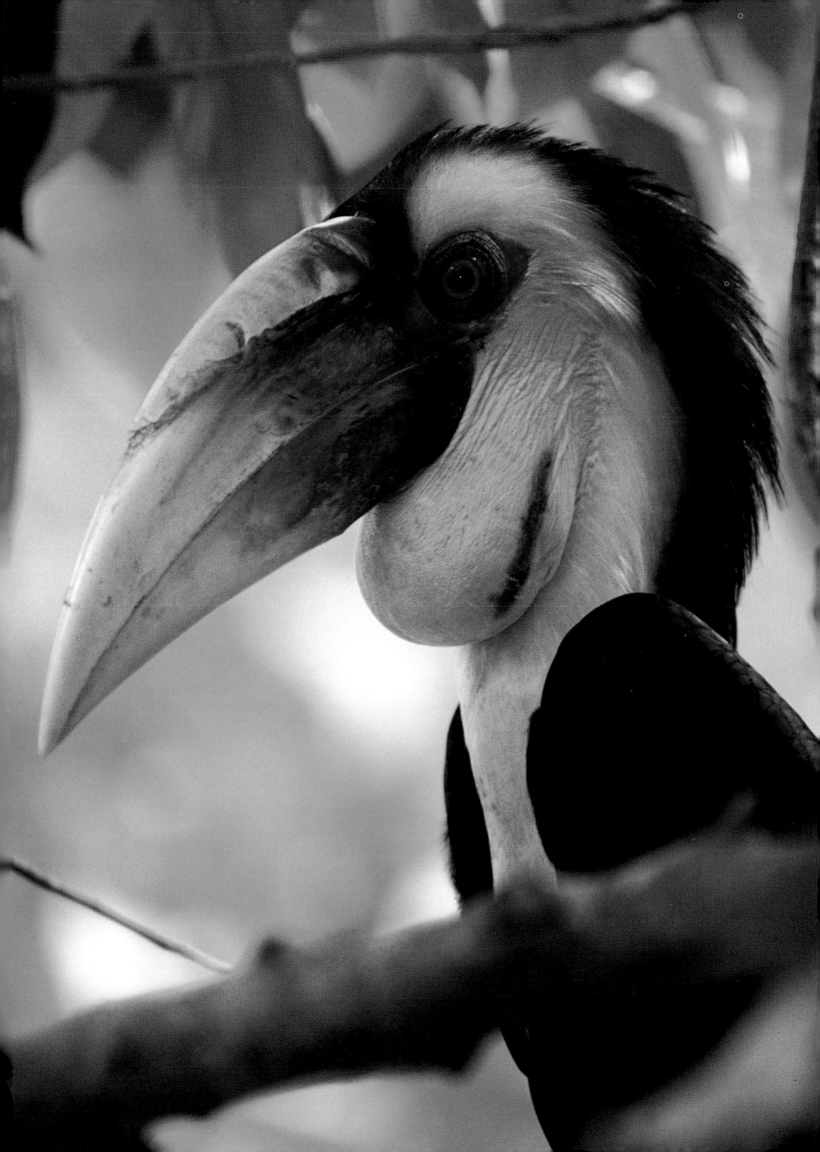

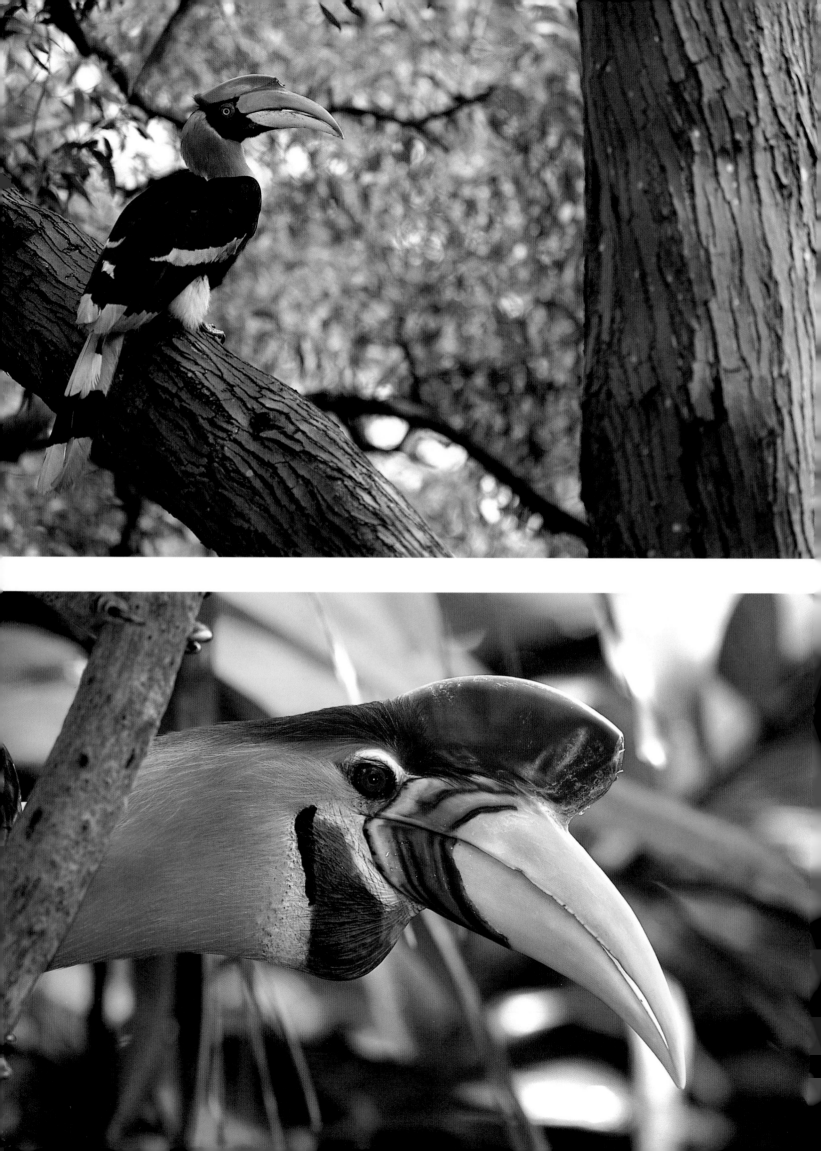

hornbill's oversize bill differs from that of the toucan by its large casque ( helmet), the appendage on top of its bill and head. Hornbills are also bigger than toucans, the largest being the southern ground hornbill (*Bucorvus leadbeateri*) of the African grassland savannas. This species is distinguished from the other hornbills in being carnivorous and living mainly on the ground. The magnificent rhinoceros hornbill (*Buceros rhinoceros*) of Sumatra and Borneo is four times heavier than the toco toucan, about 6 lb (3 kg). It is so named because of its large, upwardly pointing casque, reminiscent of the horn of a rhinoceros. These hornbills are inquisitive birds that will often check up on passersby in the forest below. Hornbills have serrated beaks but, unlike the toucans, only a short stubby tongue. When they eat a fruit, they too have to raise their bills to a vertical position.

Some species of hornbills have the remarkable habit of sealing the entrance to their nests with the female imprisoned inside. The great Indian hornbill (*Buceros bicornis*) plasters the entrance to its nest cavity in a tree trunk with a mixture of mud, saliva, and feces until only a narrow slit remains. The female stays imprisoned for four to five months, safe from predators and fed by the male and young birds from the previous clutch. She is adept at excreting her feces out of the slit with both accuracy and high power so that the nest does not become too soiled. When the young chicks are ready to fledge, the entrance hole is pecked open and the young birds emerge, ready to make their first flight over the forest.

FACING PAGE, TOP: *A great pied hornbill* (Buceros bicornis) *from Malaysia.*

FACING PAGE, BOTTOM: *The large bills of hornbills and toucans have evolved separately in the Old and New Worlds. They are apparently quite frightening to many smaller birds. This is a Sulawesi red-knobbed hornbill* (Rhyticeros cassidix).

BELOW: *A toco toucan* (Rhamphastos toco) *from the Amazon rainforest, with its enormous bill that is actually lightweight because it is filled with a network of honeycombed fibers with air spaces in between.*

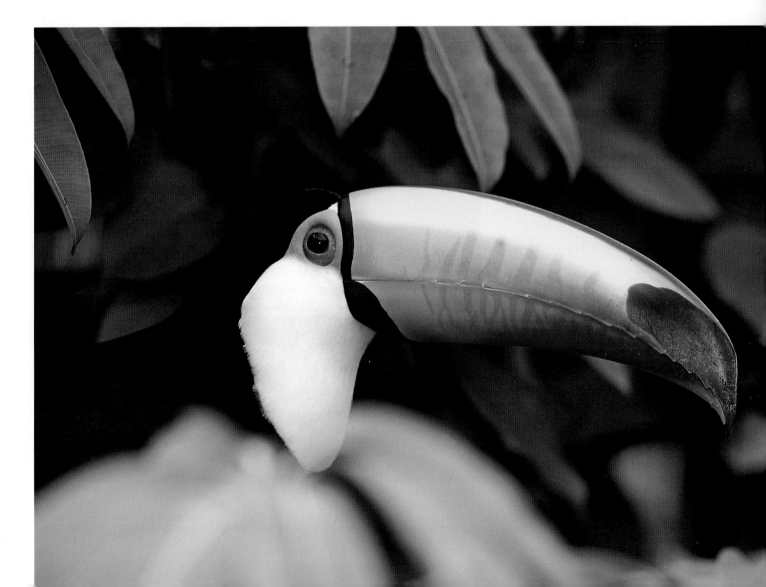

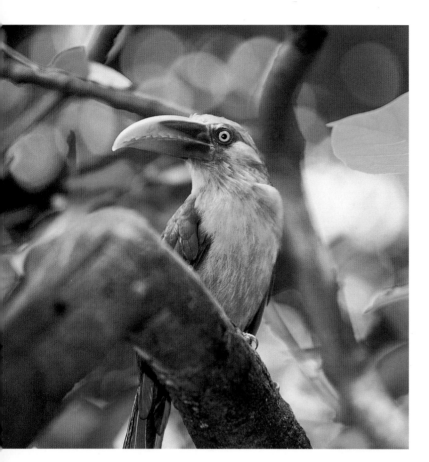

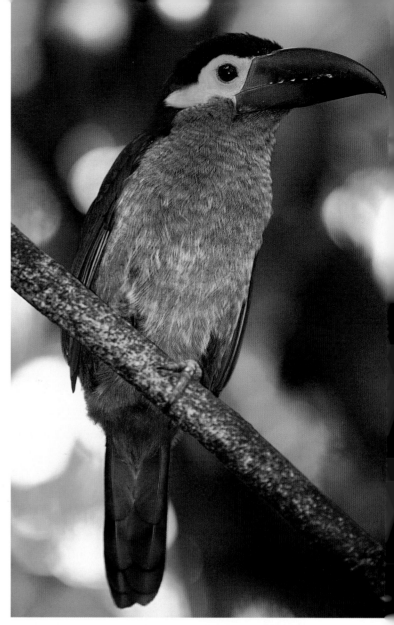

ABOVE: *A saffron toucanet
(Baillonius bailloni) from Brazil.
Its large bill is an adaptation for
gathering fruit.*

ABOVE RIGHT: *This toucanet
(Selenidera sp.) from Peru is much
smaller than a toucan but has a
similarly shaped bill.*

RIGHT: *The keel-billed toucan
(Ramphastos sulfuratus) in
Panama uses its rainbow-colored bill
to feed on fruit, insects, and small
lizards.*

FACING PAGE: *A scarlet ibis
(Eudocimus ruber) at rest in
the Caroni Swamp of Trinidad's
tropical rainforest.*

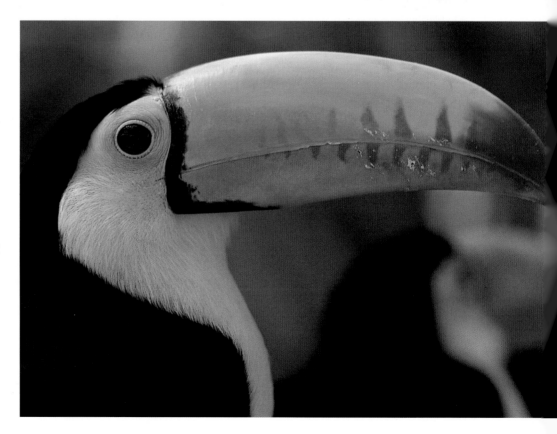

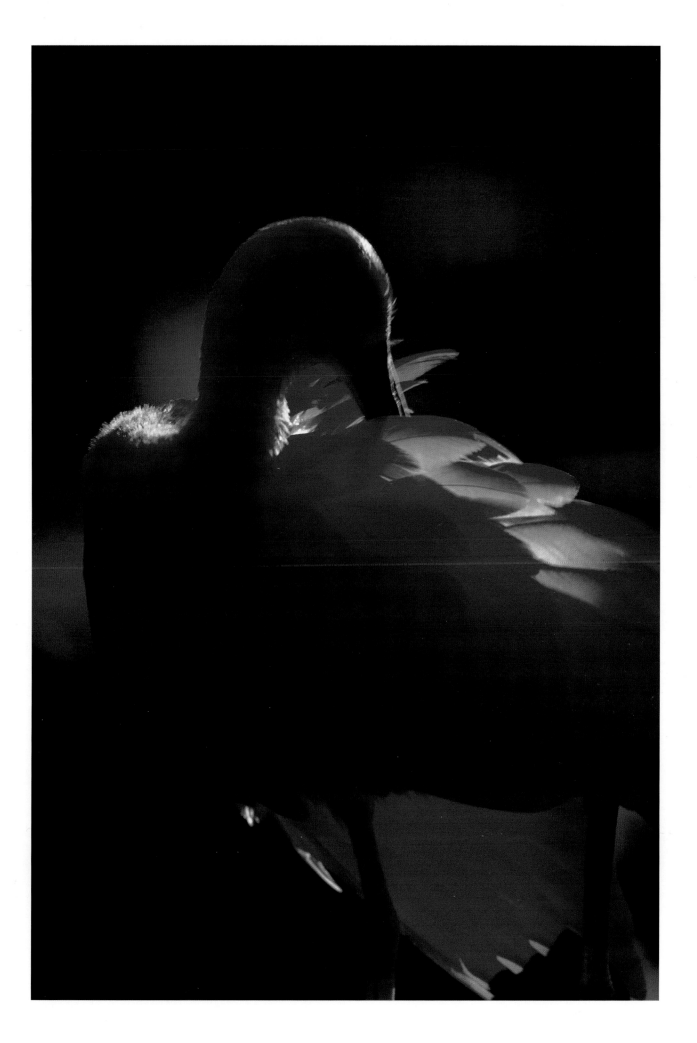

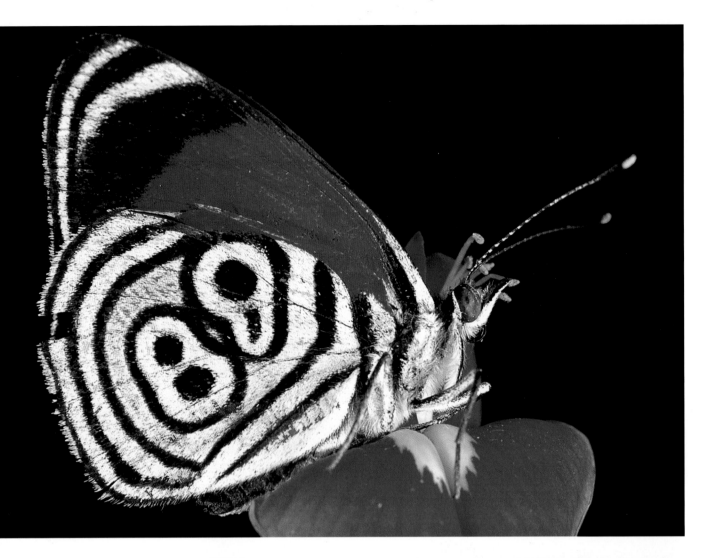

ABOVE: *Many colorful butter-flies grace the rainforests of the world. This is* Diaethria neglecta *from the Tambo-pata Forest Reserve in Peru.*

RIGHT: *These comet or silk (*Argema mittrei*) moths from Madagascar are resting on a half-dried banana leaf, which matches them well and gives them some protection.*

FACING PAGE: *Nature's abstract art is to be found on the wings of many rainforest butterflies.*

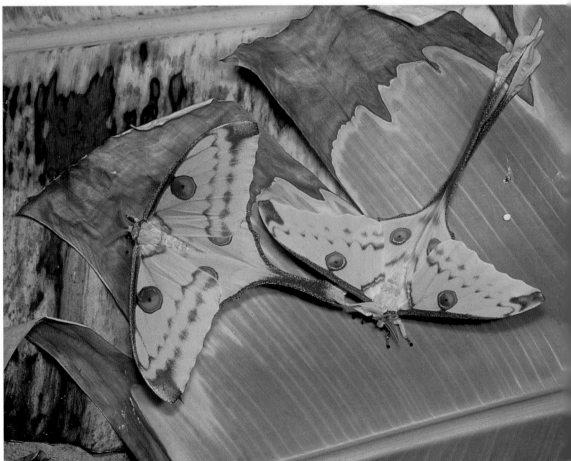

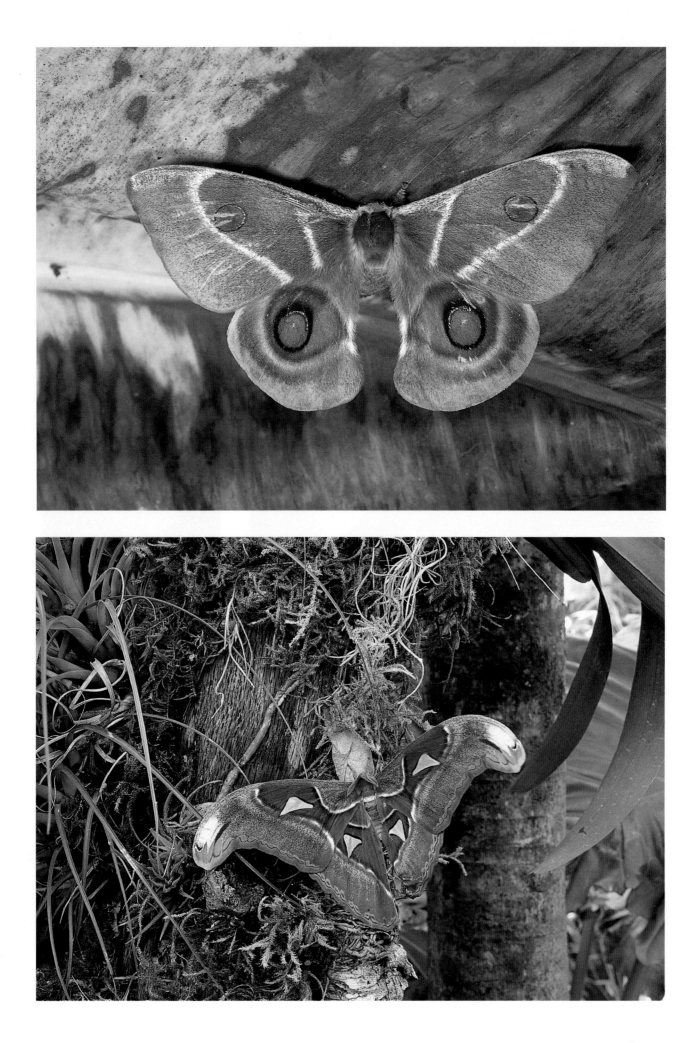

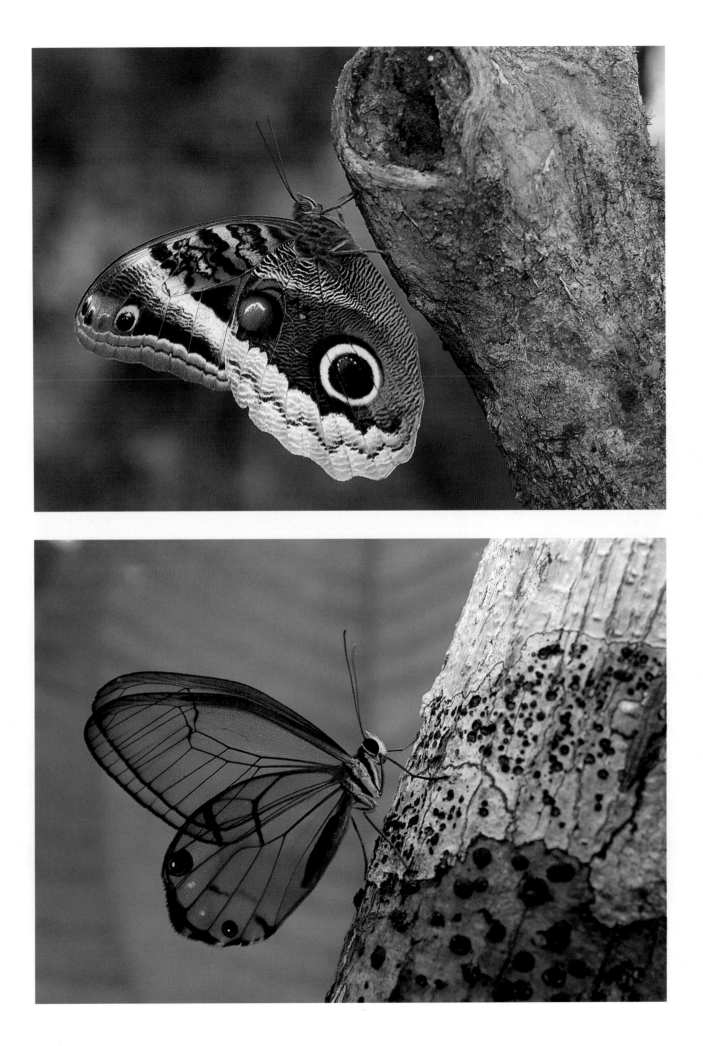

Replacing the day-flying butterflies at night in the rainforest are many species of moths that play an important role as the pollinators of numerous night-flowering plants.

PAGE 274, TOP: *Silk moth* (Antherina suraka) *from Madagascar.*

PAGE 274, BOTTOM: *Atlas moth* (Attacus atlas) *from Malaysia.*

PAGE 275, TOP: *The patterns on the wings of this caligo butterfly* (Caligo memnon) *from Venezuela have a frightening appearance that would deter some would-be predators.*

PAGE 275, BOTTOM: *The clear-wing butterfly* (Haetera piera) *from the Napo River region of Peru has evolved transparent wings that are not easily spotted by predators.*

LEFT: *The feather against a natural oil seepage in the Tambopata Forest Reserve of Peru is a reminder of the current threat to the world's most diverse tract of rainforest. Large deposits of oil and natural gas are being discovered in Amazonian Peru. The current plans for oil exploration in the reserve could seriously disturb one of the most important forests in the world.*

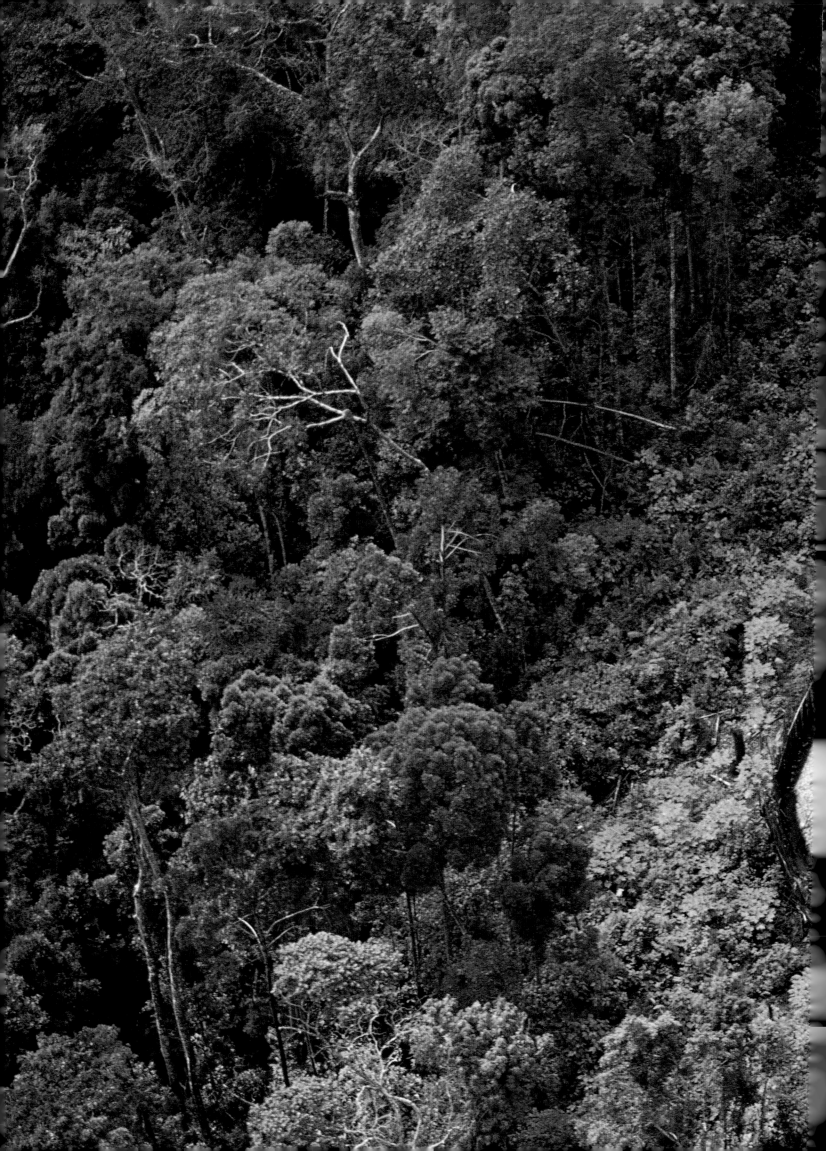

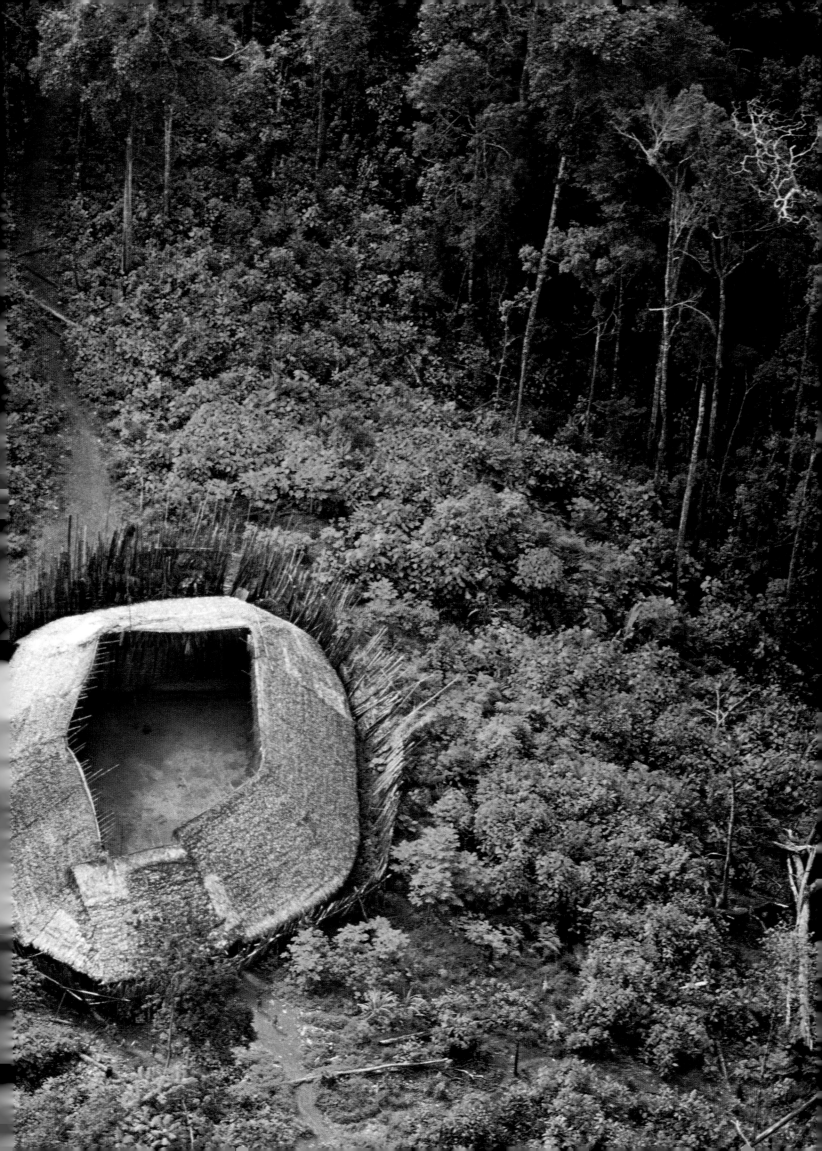

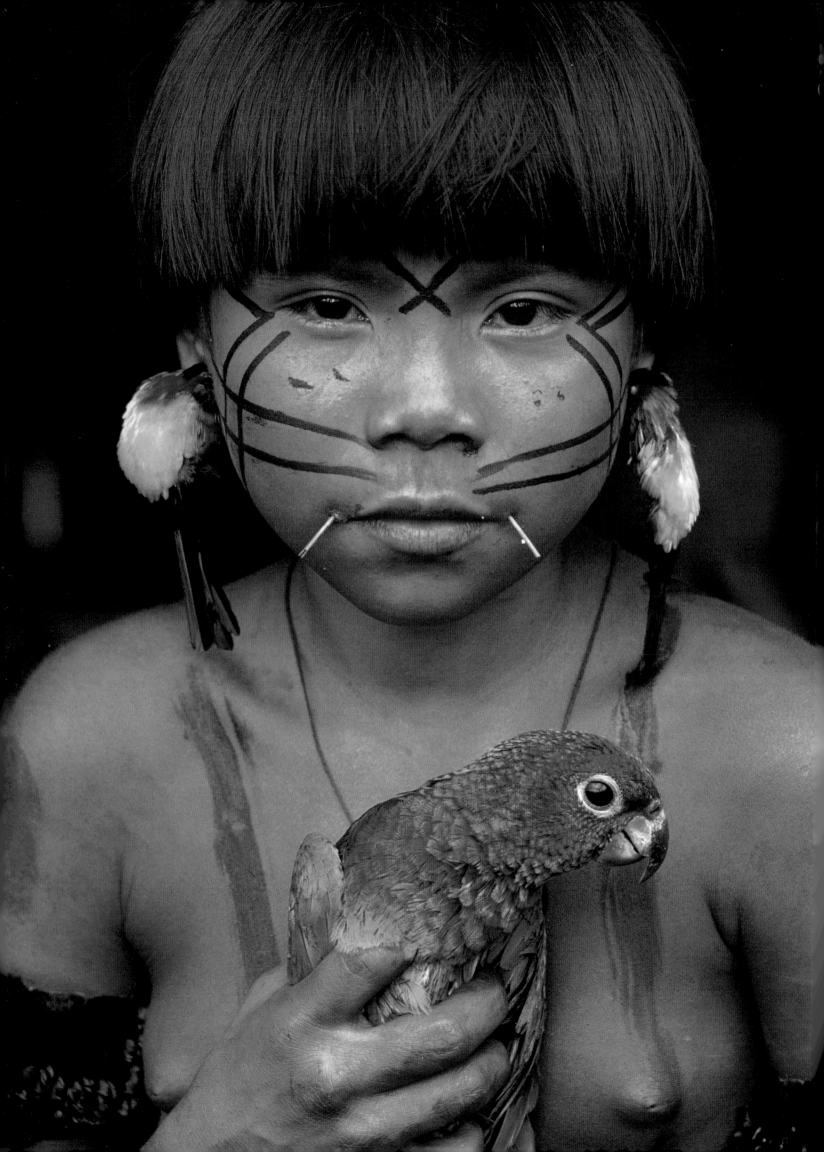

# C o n c l u s i o n

THROUGH BEAUTIFUL PHOTOGRAPHS AND THROUGH
a text grounded in the basic elements of the ancient Greeks, we have tried to demonstrate something of the marvels of the world's rainforests. Their diversity, the fascinating creatures and plants that they harbor, and the way in which everything interacts make rainforests exciting places to visit. They are also vital to the survival of humankind because of the environmental functions they perform and because of the number of useful resources they contain. Rainforest covers only about 7 percent of the total land surface of our planet, yet it nurtures well over 50 percent of the total animal and plant species. Therefore, to destroy rainforest is to eradicate species, to alter world climatic patterns, and perhaps eventually to

condemn the human species to extinction.

The destruction of this vital resource continues unabated despite the warnings of biologists, ecologists, and climatologists. Today only 50 percent of the original rainforest cover that existed a hundred years ago remains. As forests of the Far East and West Africa are destroyed for their timber, as cattle pasture supplants rainforest in the Amazon, as the growing population of Madagascar replaces forest with farms, and as oil fields, mines, and other activities open up access for colonizers in the Ecuadorian and Peruvian Amazon, we narrow our options for the future. With ever increasing population pressure in most tropical rainforest countries, it is inevitable that deforestation will continue. However, so far much of the deforestation has been a haphazard process without any planning. The recent calls for sustainable use of natural ecosystems in such documents as the World Conservation Strategy, produced by three of the world's leading conservation

*PREVIOUS SPREAD: Indigenous peoples have lived in the rainforest for many generations without destroying it, and there is a fascinating array of cultures adapted to life in all the major rainforest regions of the world. The Yanomami Indians of the northwestern Amazon live in circular houses, called* shabonos, *with an open center and a sheltered margin where they sleep.*

*FACING PAGE: A young Yanomami girl in Parima Tapirapecó National Park in Venezuela.*

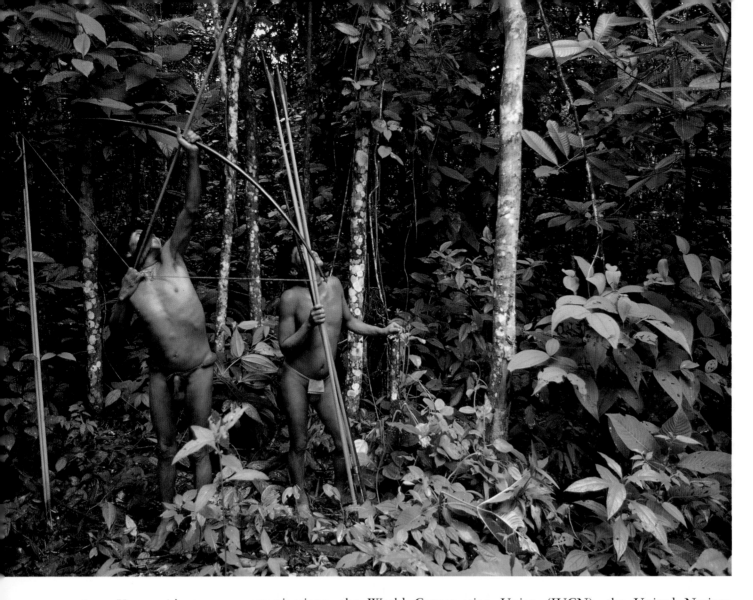

FACING PAGE: *The Yanomami children like to keep pet birds.*

PAGE 284: *The Kayapó Indians live in the southwestern part of Amazonia and have a very different culture from that of the Yanomami. This man has a magnificent headdress made from parrot feathers.*

PAGE 285: *A selection of Yanomami ceremonial objects, including monkey skulls, toucan tail feathers, and the tails of monkeys.*

organizations, the World Conservation Union (IUCN), the United Nations Environmental Programme (UNEP) and the World Wide Fund for Nature (WWF), and the Convention on Biological Diversity drafted at the 1992 Earth Summit in Rio de Janeiro highlight one of the future solutions. The forests must be managed and not plundered if they are to survive and perform their vital functions. This is not solely a problem of the developing rainforest nations that are so often criticized for their role in deforestation. It is a worldwide issue because it is frequently the greed of the industrialized world that has caused deforestation of the tropics. The demand for timber, often for chipboard, and for cheap minerals is commonly the reason for rainforest destruction. In addition, the developed world has pushed countries of the developing world into enormous national debt. As a result, their resources go into the payment of interest on their debt to such an extent that they can neither stop the further selling off of their forests nor afford to put any resources into conservation. The way in which we live in the developed world, the products we buy, the banks we use all affect the rainforest. Unless we, too, play our part through living an environmentally sustainable style of life, there is little hope for the rainforest and the myriad of organisms that it contains. There is probably little hope for the air we breathe, the soil we till, and the water that we drink if we do not take care of one of the most precious of all our resources, the rainforests of the world.

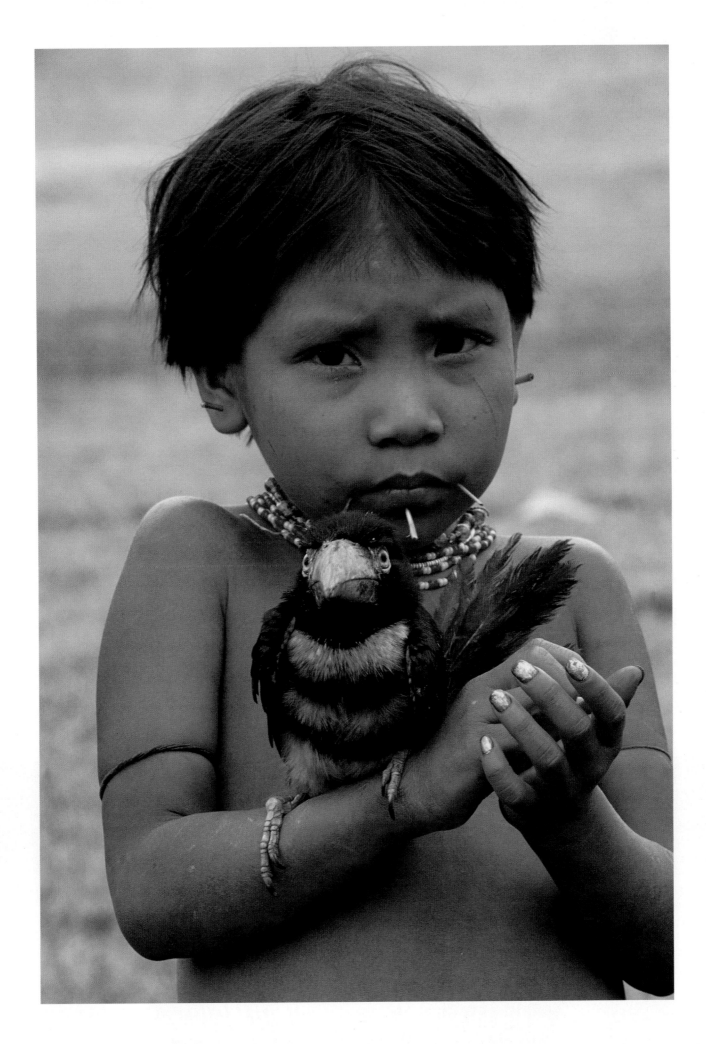

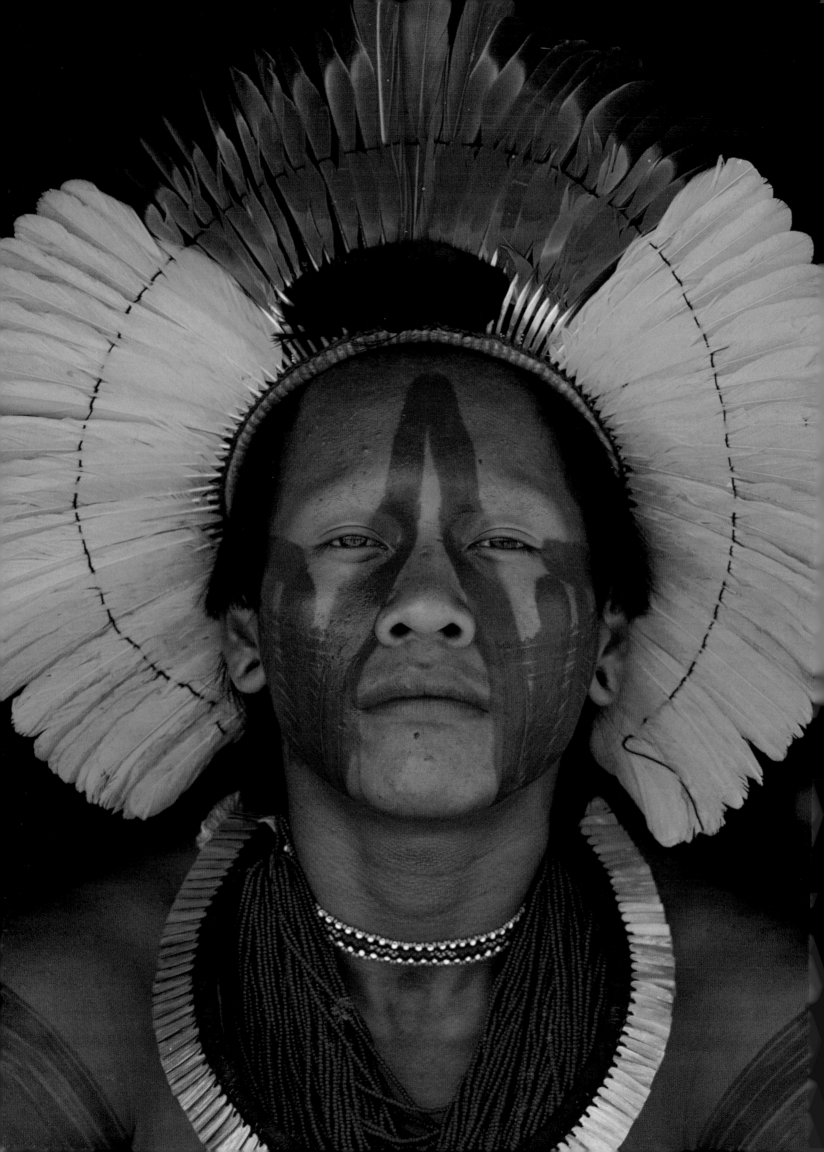

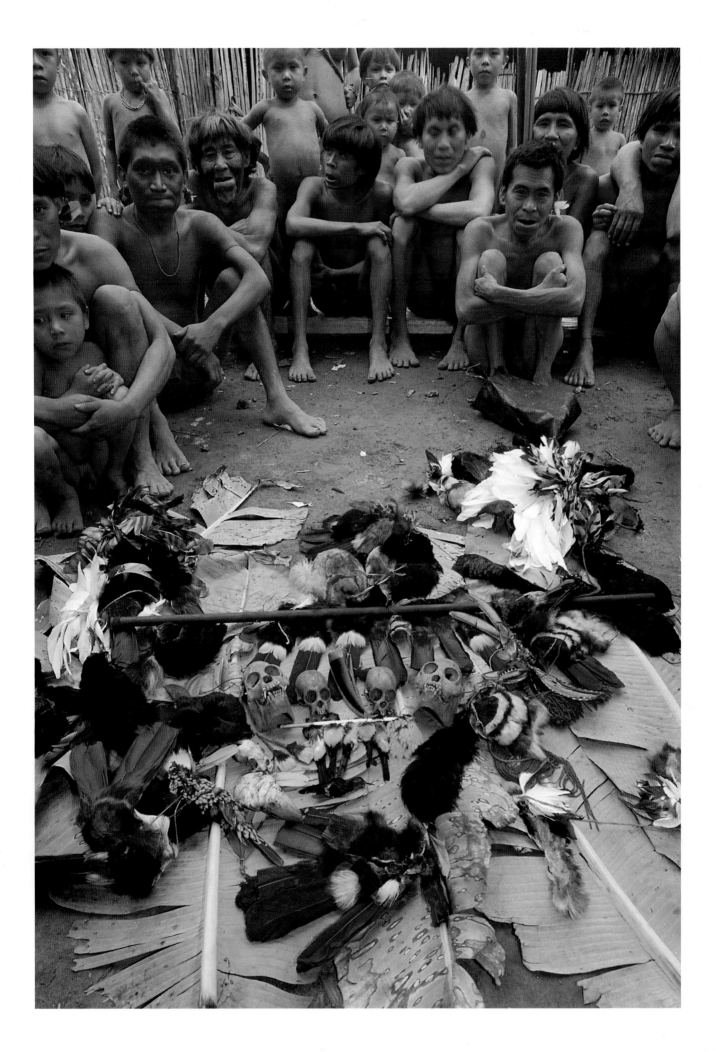

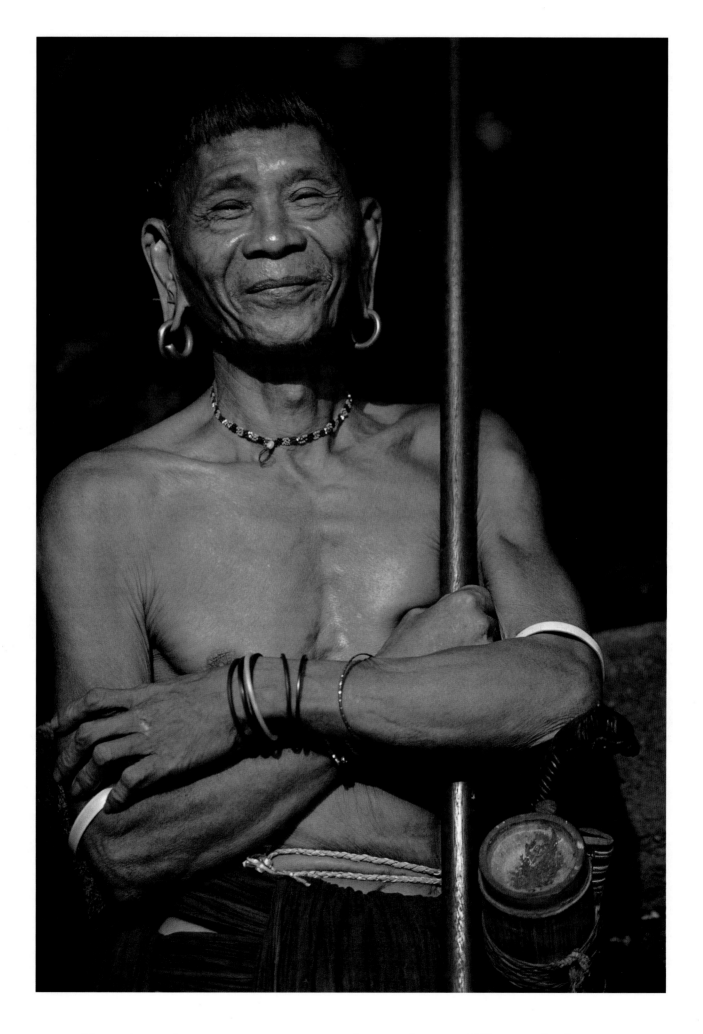

FACING PAGE: *The forests of Borneo once had many different tribes, which have become severely threatened by the deforestation for the extraction of timber. This is a Penan tribesman from Sarawak.*

LEFT: *Penan tribesmen of Sarawak, Borneo, hunting with a blowgun. This method of shooting poison darts was developed by forest peoples in both the Amazon and the Far East.*

BELOW: *Penan tribesmen of Sarawak, Borneo, building a quick shelter.*

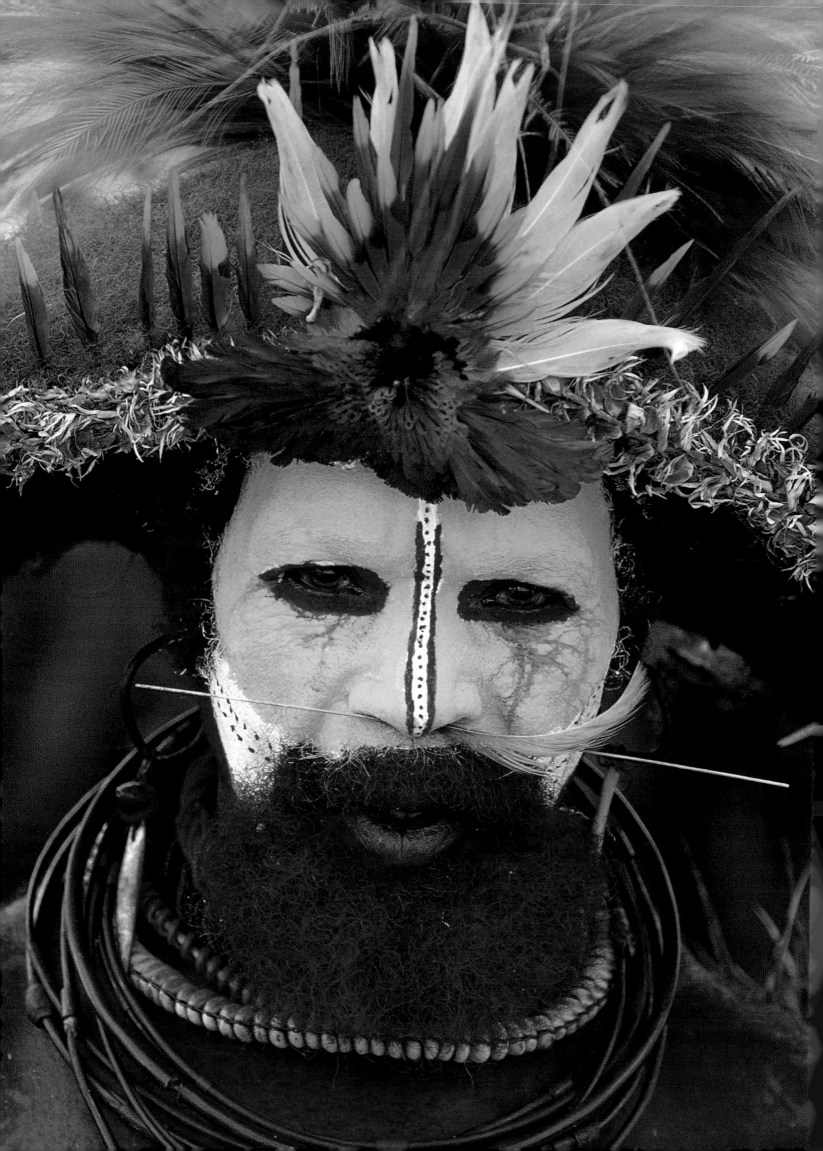

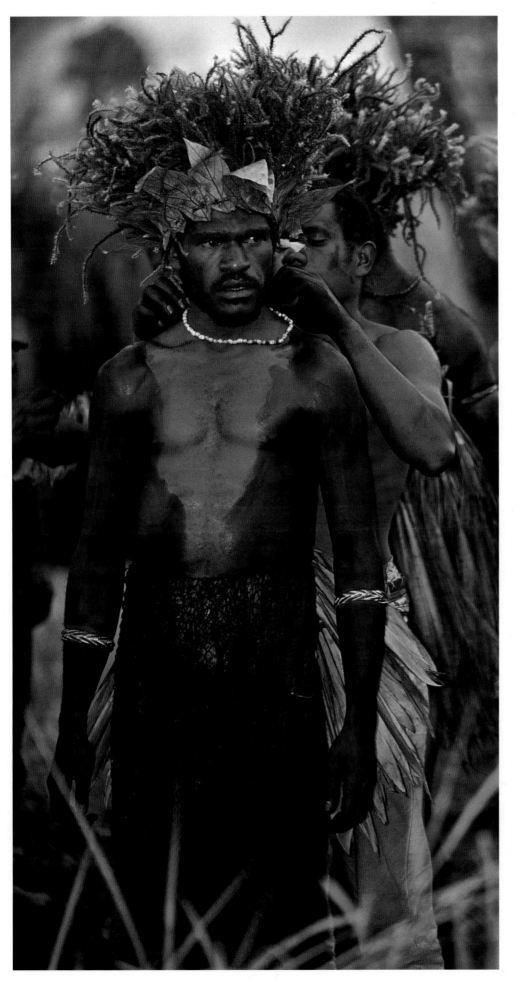

FACING PAGE: *Some of the most exotic-looking of all rainforest peoples are the tribes of New Guinea. They have many different ways of ornamenting their faces and bodies, shown by this Huli man from Papua New Guinea.*

LEFT: *To take part in a sing-sing ceremony, these dancers in Papua New Guinea have painted their bodies black.*

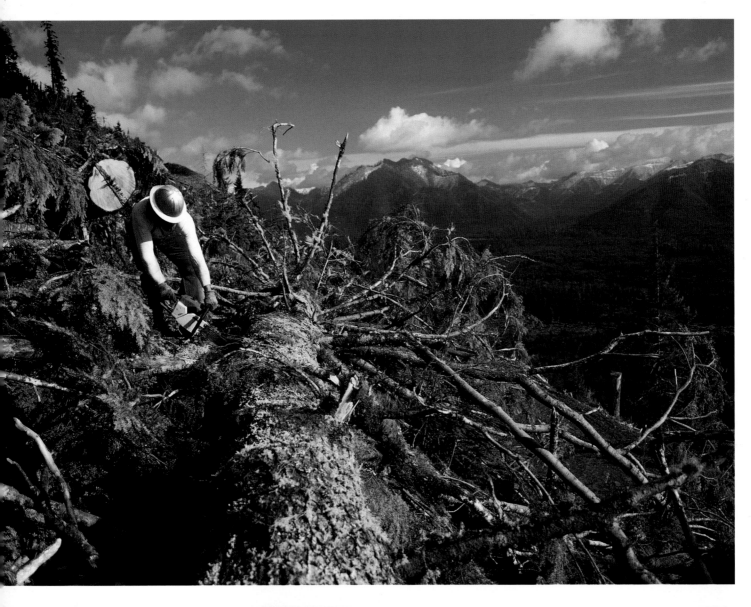

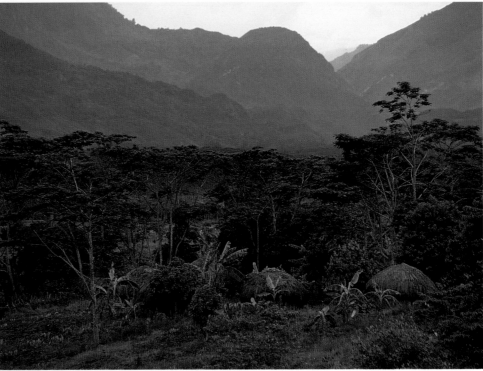

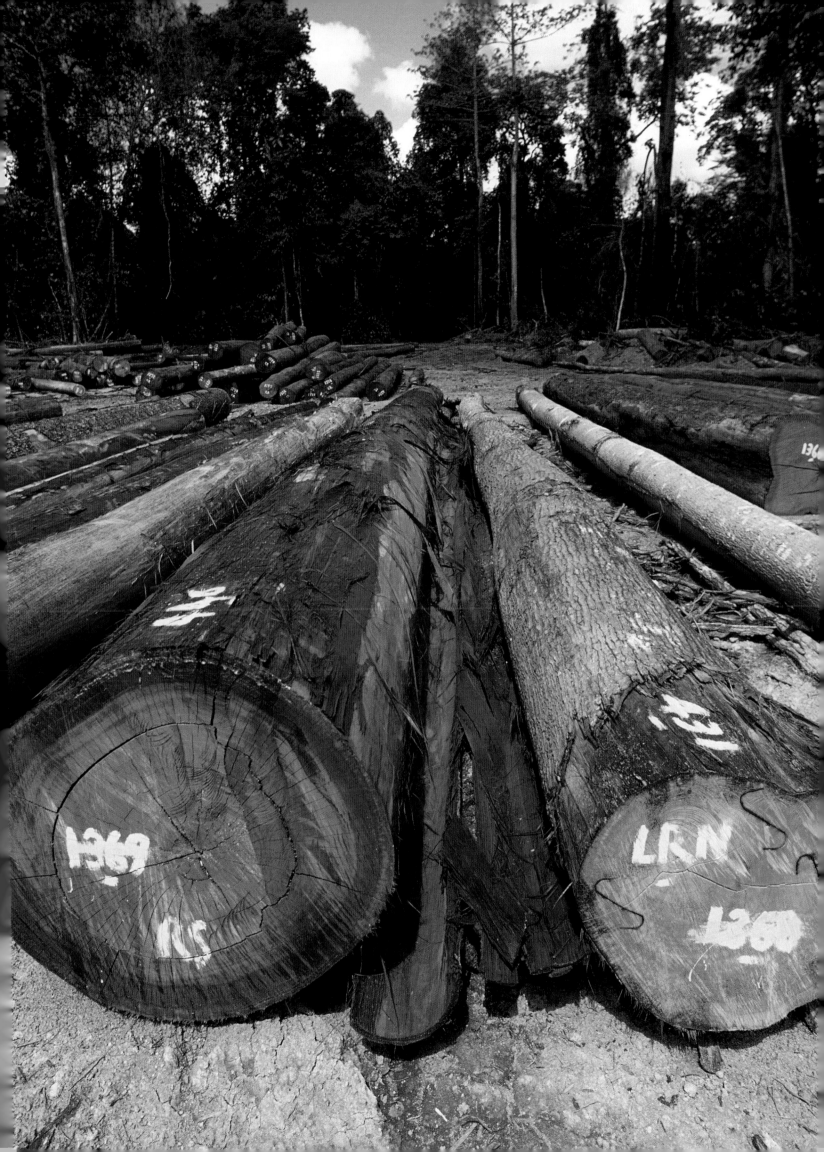

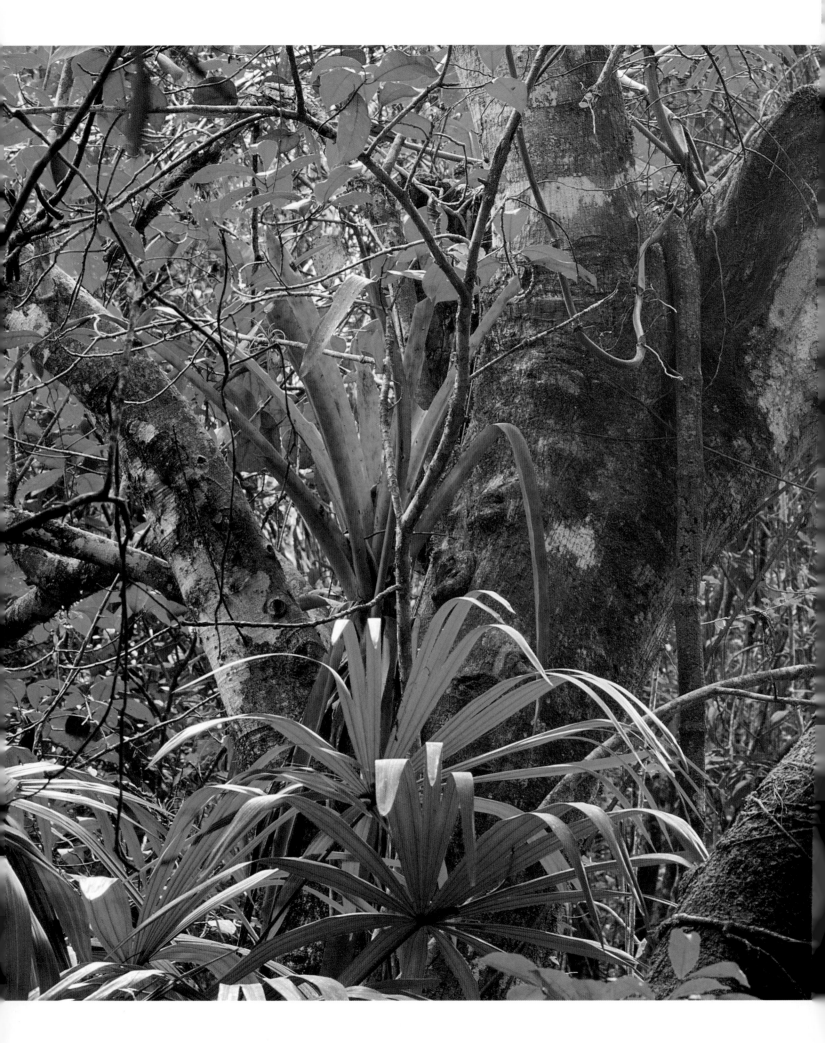

LEFT: *This rainforest landscape of the Rio Bravo Conservation Area of Belize, dominated by bromeliads, serves to remind us of the beauty and mystery of the undisturbed forest. May it be preserved for future generations.*

FOLLOWING SPREAD: *Even though this forest in Uganda is called the Bwindi Impenetrable Forest, it abuts agricultural areas that are likely to expand into the forest.*

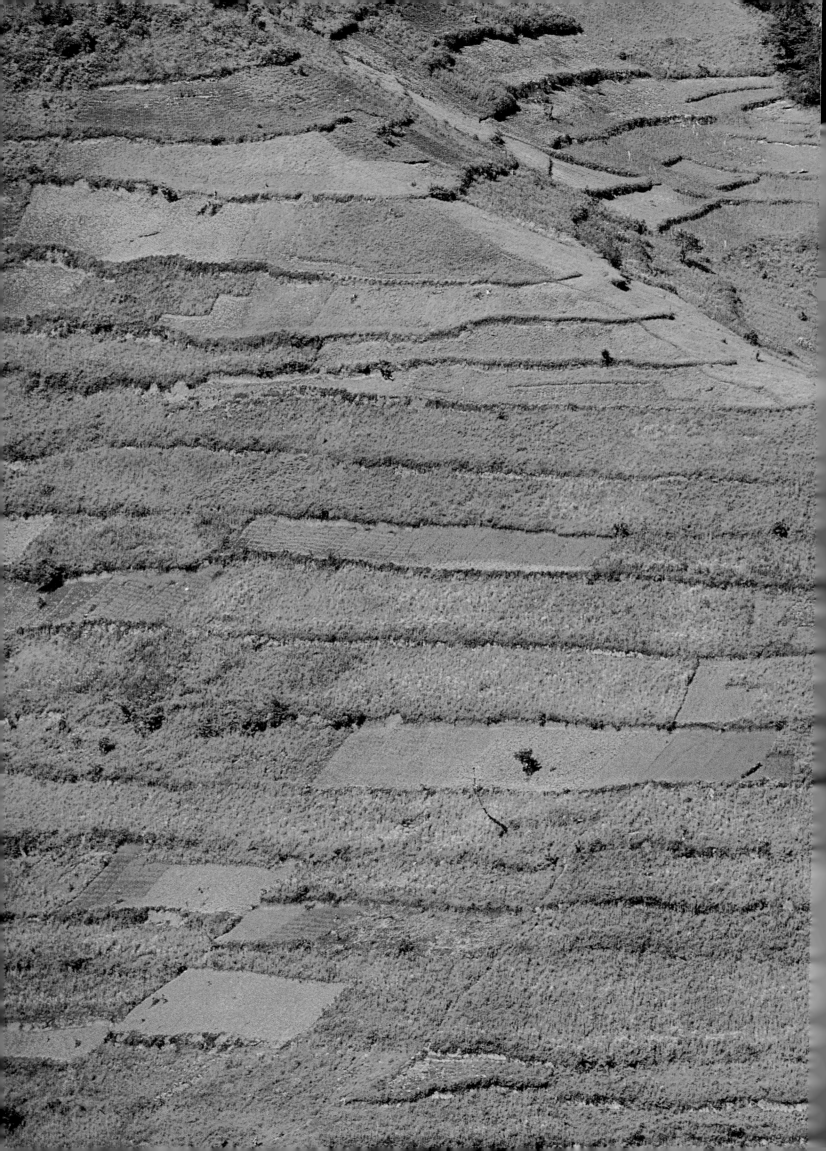

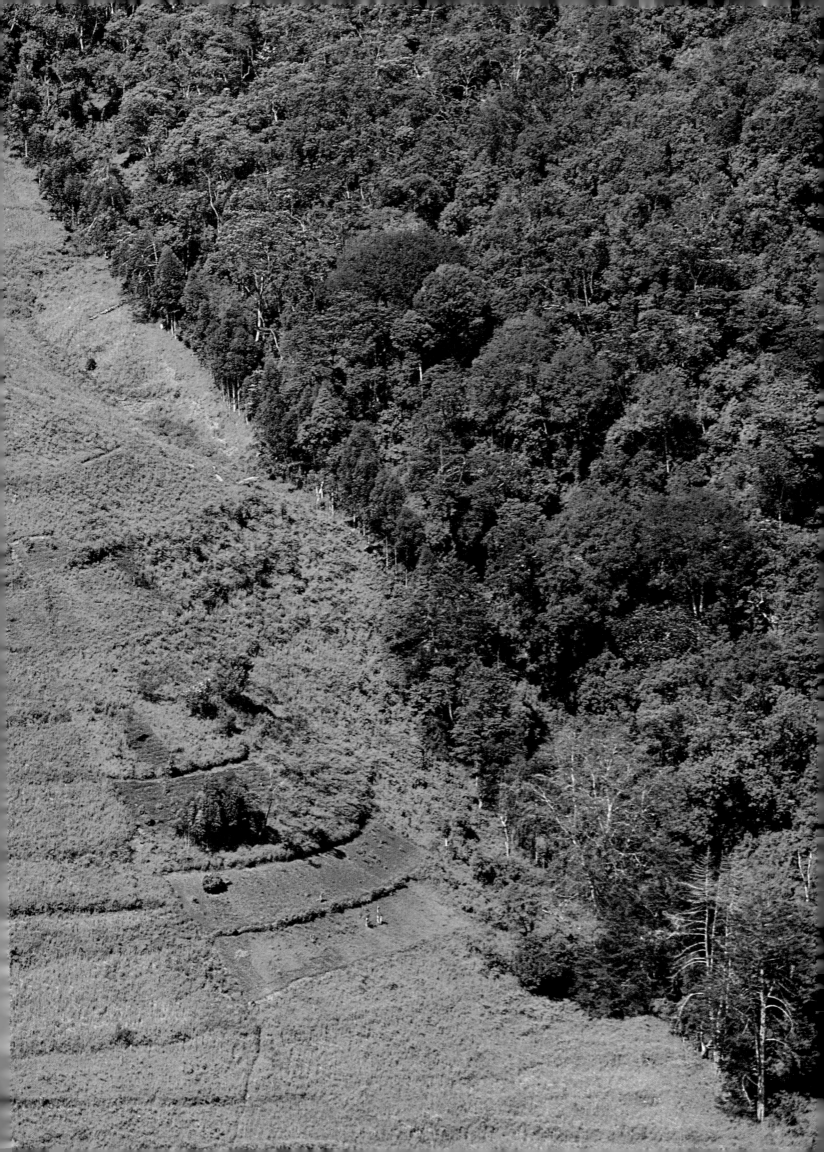

# A Selection of
# Rainforest Organizations

We hope that this book will stimulate concern and action on behalf of the rainforests of the world, so we have provided details of a few organizations concerned with rainforests. The authors of this book have contributed part of their royalties to the Rainforest Alliance.

Accin Ecolgica (Ecuador)
Casilla 17-15-246-C
Quito, Ecuador
Tel 593-2-527583
Fax 593-2-543344
email: verde@acecol.ecuanex.net.ec
web: www.lgc.apc.org/ecuanex

Amigos del Bosque
Mr. Noe Adalberto Ventura Loyo
9 a Calle 2-23 zona 1
01001 Guatemala City
Guatemala
Tel 502-2-21-14-40

Australian Rainforest Conservation
    Society, Inc.
19 Colorado Avenue
Bardon Qld 4065
Australia
Tel 61-7-3368-1318
Fax 61-7-3368-3938
email: arcs@gil.com.au
web: www.uq.oz.au/~dnbpolak/
    rainfore.html

Conservation Foundation
1 Kensington Gore
London SW7 2AR
United Kingdom
Tel 44-171-591-3111
Fax 44-171-591-3110
email: conservef@gn.apc.org

Conservation International
2501 M Street, Suite 200
Washington, DC 20037
USA
Tel (202) 429-5660
Fax (202) 887-0193
web: www.conservation.org

Cultural Survival
96 Mount Auburn Street
Cambridge, MA 02138
USA
Tel (617) 441-5400
Fax (617) 441-5417
email: csinc@cs.org
web: www.cs.org

Defensores de la Naturaleza
Avendia Las Americas 20-21, zona 14
Guatemala City
Guatemala
Tel 502-337-03-19
email: defensores@pronet.net.gt

Earth Love Fund (UK)
Belsyre Court, 1st Floor
57 Woodstock Road
Oxford OX2 6HU
United Kingdom
Fax 44-1865-311383
email: earthlove@gn.apc.org

Earthwatch Australia
1st Floor, 453-457 Elizabeth Street
Melbourne 3000
Australia
Tel 61-3-9600-9100
Fax 61-3-9600-9066
email: jgilmore@creative.access.
    com.au

Earthwatch (Europe)
Belsyre Court, 57 Woodstock Road
Oxford OX2 6HU
United Kingdom
Tel 44-1865-311-600
Fax 44-1865-311-383
email: info@uk.earthwatch.org
web: ewoxford@vax.oxford.ac.uk

Earthwatch Headquarters
680 Mount Auburn Street
PO Box 9104
Watertown, MA 02272-9104
USA
Tel (617) 926-8200
Fax (617) 926-8532
email: info@earthwatch.org
web: www.earthwatch.org

Earthwatch Japan
Technova Inc.
13th Floor, Fukoku Building
2-2-Uchisaiwai-Cho, 2 Chome
Chiyoda-Ku, Tokyo 100
Japan
Tel 81-3-3508-2280
Fax 81-3-3508-7578
email: mikekoba@po.iijnet.or.jp

Environmental Defense Fund
257 Park Avenue South
New York, NY 10010
USA
Tel (212) 505-2100
Fax (212) 505-2375
email/web site: www.edf.org

FERN/Forest Peoples Programme
The Fosseway Business Centre,
   Unit 1C
Stratford Road
Moreton-in-Marsh GL56 9NQ
United Kingdom
email: saskia@ozinga.demon.co.uk
   and wrm@gn.apc.org

The Forest Stewardship Council AC
Avenida Hidalgo 502
68000 Oaxaca
Mexico
Tel 52-951-46905, 63244
Fax 52-951-62110
email: FSCOAX@antequera.
   antequera.com

Friends of the Earth (International)
PO Box 19199
1000 GD, Amsterdam
The Netherlands
Tel 31-20622-1369
Fax 31-20639-2181
email: foeint@antenna.nl

Friends of the Earth (UK)
26-28 Underwood Street
London N1 7JQ
United Kingdom
Tel 44-171-490-1555

Friends of the Earth (US)
1025 Vermont Avenue NW,
   3rd floor
Washington, DC 20005
USA
Tel (202) 783-7400
Fax (202) 783-0444
email: foe@foe.org
web: http://www.foe.org

Friends of the Peruvian Rainforest
668 Public Ledger Building
Philadelphia, PA 19106
USA
Fax (215) 923-5535

Fundação Botánica Margaret Mee
Av. General Justo 171/8e Andar
CEP 2222-1-090
Centro
Rio de Janeiro
RJ Brazil
Tel 55-21-533-1486
email: mmee@ax.apc.org

Fundação Vitória Amazonica
Rua R/S Quadra Q, Casa 7
Conjunto Morado do Sol
Manaus, Amazonas 69060-080
Brazil
Tel 55-92-642-1336
Fax 55-92-236-3257

Fundary
20 Avendia A 18-11, Zona 10
Blvd Los Proceres
Guatemala City
Guatemala
Tel 502-333-55-50
email: fundary@pronet.net.gt

Fundaselva
10 a Avendia 2-44, Zona 14
Guatemala City, C A 01014
Guatemala
Tel 502-3-337-491

Gaia Amazonas/COAMA
   (Columbia)
Carrera 4 # 26B-31 Of. 101
Bogota
Colombia
Tel 57-1-281-4925, 281-4985
Fax 57-1-281-4945
email: gaiabog@colnodo.apc.org
web: www.coama.org.co

Gaia Foundation
18 Well Walk
London NW3 1LD
United Kingdom
Tel 44-171-435-5000
Fax 44-171-431-0551
email: gaiafund@gn.apc.org

International Institute for Environ-
   ment and Development (IIED)
3 Endsleigh Street
London WC1H 6DD
United Kingdom
Tel 44-171-388-2117
Fax 44-171-388-2826

International Institute for
   Environment and
   Development (IIED)
1717 Massachusetts Avenue NW
Washington, DC 20036
USA

International Union for the
   Conservation of Nature and
   Natural Resources
The World Conservation Union,
   IUCN
28 rue Mauverney
1196 Gland
Switzerland
Tel 41-22-999-00-01
Fax 41-22-999-00-02
email: mail@hq.iucn.org
web: www.iucn.org

Living Earth
4 Great James Street
London WC2/N 3DA
United Kingdom
Tel 44-171-242-3816
Fax 44-171-242-3817
email: liveearth@gn.apc.org
web: www.gn.apc.org/Living Earth/

National Audubon Society
700 Broadway
New York, NY 10003
USA
Tel (212) 979-3000
web: www.audubon.org

National Wildlife Federation
8925 Leesburg Pike
Vienna, VA 22184
USA
Tel (202) 797-6800
web: http://www.nws.org/nws

Natural Resources Defense Council
40 West 20th Street
New York, NY 10011
USA
Tel (212) 727-2700
Fax (212) 727-1773
web: http://www.nrdc.org

Nature Conservancy
1815 North Lynn Street
Arlington, VA 22209
USA
Tel (703) 841-5300
web: http://www.tnc.org

Pro Natura Brazil
Ave. Beira Mar 406
Sala 708/709
Castelo
Rio de Janeiro 20021.060
Brazil
Tel 55-21-262-8214
Fax 55-21-286-0055

Pro Natura International
51, rue d'Anjou
75008 Paris
France
Tel 33-1-49-24-14-98
Fax 33-1-49-24-15-66
email: pro10@calva.net

Rainforest Action Network
221 Pine Street, Suite 500
San Francisco, CA 94104
USA
Tel (415) 398-4404
web: www.ran.org

The Rainforest Alliance
65 Bleeker Street, 6th Floor
New York, NY 10012-2420
USA
Tel (212) 677-1900
Fax (212) 677-2187
email: canopy@ra.org
web: www.rainforest-alliance.org

The Rainforest Foundation
Suite A5
City Cloisters
188/196 Old Street
London EC1V 9FR
United Kingdom
Tel 44-171-251-6345
Fax 44-171-251-4969
email: rainforestuk@gn.apc.org

Rainforest Foundation
    International
270 Lafayette Street, Suite 1107
New York, NY 10012
Tel (212) 431-9098
Fax (212) 431-9197
email: ffny@rffny.org

Sierra Club
85 Second Street, 2d Floor
San Franciso, CA 94105
Tel (415) 977-5500
Fax (415) 977-5799
web: www.sierraclub.org

Survival International
11-15 Emerald Street
London WC1N 3QL
United Kingdom
Tel 0171-242-1441
Fax 0171-242-1771
email: survival@gn.apc.org
web: www.survival.org.uk

Vereniging Millieudefensie
Hart voor Hout
Postbus 19199
1000 GD Amsterdam
The Netherlands
Tel 31-20-622-1366
Fax 31-20-627-5287
email: infor@foenl.antenna.nl

World Rainforest Movement
    (WRM)
Jackson 1136
11200 Montevideo
Uruguay
email: rcarrerre@chasque.apc.org
web: www.chasque.apc.org/item

Worldwide Fund for Nature
Avenue du Mont-Blanc
1196 Gland
Switzerland
Tel 4122-364-91-11
Fax 4122-364-5358
email: first initial and full last
    name@WWFNet.Org
web: www.Panda.Org

World Wildlife Fund (WWF)
    Malaysia
49 Jalan SS 23/15
47301 Petaling Jaya
Locked bag no. 911
Jun Sultan PO 46990
Petaling Jaya
Malaysia
Tel 603-703-3772
Fax 603-703-5157

World Wildlife Fund (WWF) UK
Panda House
Weyside Park, Catteshall Lane
Godalming, Surrey GU7 1XR
United Kingdom
Tel 44-1483-426444
Fax 44-1483-426409
web: www.wwf-uk.org

World Wildlife Fund (WWF)
1250 24th Street NW, Suite 500
Washington, DC 20037
USA
Tel (202) 293-4800
Fax (202) 293-9211

World Wildlife Fund for Nature
    Australia
Level 1, 71 York Street
GPO Box 528
Sydney NSW 2000
Australia
Tel 61-2-92-99-63-66
Fax 61-2-92-99-66-56
email: wwfaust@ozemail.com.au

# Index

*With the destruction of the world's rainforests and the cultures that live in them, the future of people such as this Mayoruna woman from Amazonian Peru is uncertain. May we strive to preserve the cultures as well as the rainforests of the world, the gardens of the gods.*